# Toulouse-Lautrec

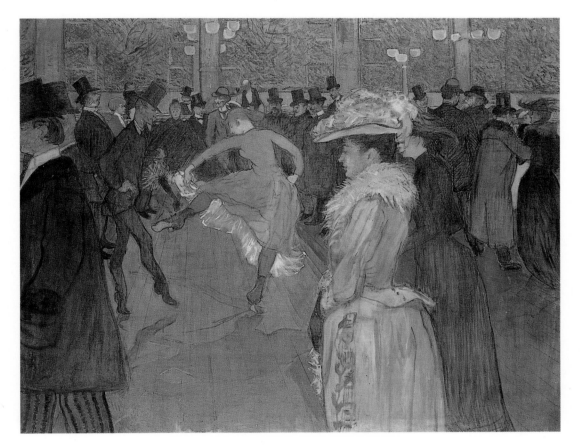

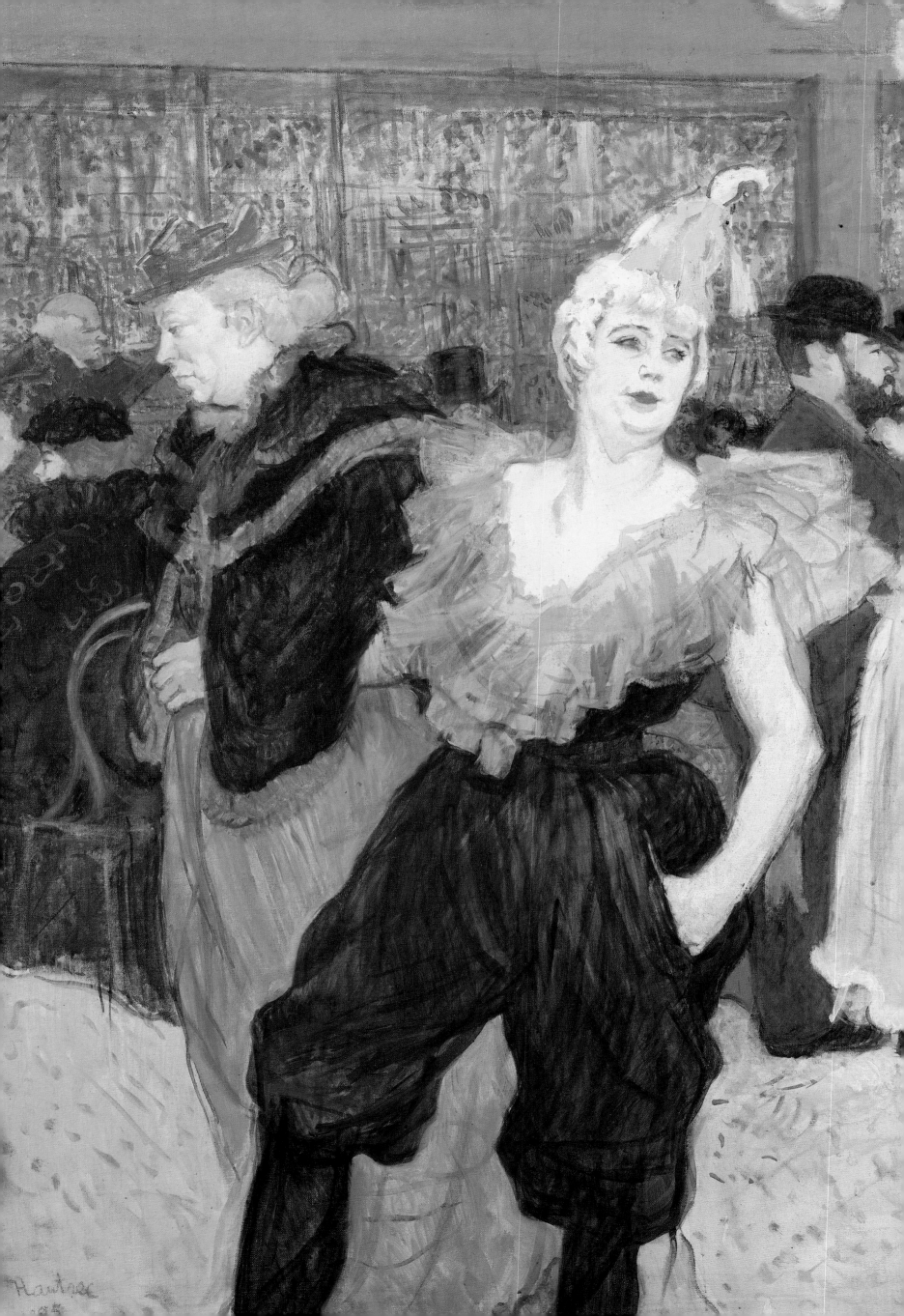

# Toulouse-Lautrec

### FRANK MILNER

SMITHMARK

This edition published in 1992
by SMITHMARK Publishers Inc.,
16 East 32nd Street
New York, New York 10016

SMITHMARK books are available for
bulk purchase for sales promotion and
premium use. For details write or call the
Manager of Special Sales, SMITHMARK
Publishers Inc., 16 East 32nd Street, New
York, NY 10016. (212) 532-6600.

Produced by Brompton Books Corp.,
15 Sherwood Place
Greenwich, CT 06830

ISBN 0-8317-5449-4

Printed in Hong Kong

10 9 8 7 6 5 4 3

FOR MY FAVORITE LEAP YEAR
TWINS, ERICA AND MARIA

**Page 2:** *At the Moulin Rouge, The Clown Cha-U-
Kao*, 1895, Oskar Reinhart Collection, Winterthur.

**Page 3:** *At the Moulin Rouge: The Dance*, 1890,
Philadelphia Museum of Art, Henry P McIlhenny
Collection.

# Contents and List of Plates

# Introduction

The popular notion of Toulouse-Lautrec is of an aristocratic alcoholic dwarf, incapable of forming a stable relationship with a woman because of insecurity about his height and physical appearance. Yet another variant on the myth of the artist as victim, this interpretation has also tended to view his art as a kind of compensatory creative outlet for social inadequacy. Enshrined in John Huston's famous film *Moulin Rouge*, the Lautrec myth is known to millions, most of whom have never seen nor are ever likely to see his original pictures. The publicity for the film described it thus:

This is the story of Paris's most famous artist, Toulouse-Lautrec, a gifted painter and tortured soul. His art reflected the joy around him that he so rarely knew.

The essential difficulties that this, and the many similar biographical simplifications about Lautrec, poses in relation to his art were well put by the critic Robert Hughes, when he reviewed the major show of Lautrec's paintings staged in Chicago in 1979:

No reputation can quite survive a movie like *Moulin Rouge*, and ever since its release in 1952 the popular image of Lautrec has been shaped by the sight of José Ferrer, legs bound, peering with lugubriously feigned interest up at the boilerplated buttocks of Zsa Zsa Gabor . . . One enters (the exhibition) expecting the familiar recorder of a vanished culture, the café and boulevard life of the *Belle Époque*, the lowlife of cabarets, the usual suspects – May Milton, Jane Avril, La Goulue. One leaves with an impression of precocious modernity, partly because Lautrec's caustic and tender view of the world speaks directly to our culture of narcissistic display.

Lautrec's dispassionate views of *fin-de-siècle* Paris have, as Hughes intimated, often been regarded as superbly illustrative of a colorful decadent past. His claims to being a major painter, however, have been more difficult to sustain. Many art historians have been less generous than Hughes and, while acknowledging Lautrec's commanding graphic skills in poster and print, have tended to view his paintings as essentially an adjunct to this reprographic activity. Lautrec never quite came out of the shadow cast by Impressionists like Degas, whose work he admired and imitated, nor did he quite belong with the Expressionists, the Nabis, Symbolists or proto-Fauves. Despite being connected with just about every literary and artistic avant-garde movement in Paris during the 1890s, Lautrec's supposed 'modernity' and distinct place in the unfolding history of late nineteenth-century avant-garde painting has not until very recently been satisfactorily charted. In part, this was because Lautrec's art was not, in a sense, 'traditionally' Modern. His is essentially an art of brilliant fusion rather than of any mold-breaking fission. Even the watery, dissonant, non-tactile use of stained color that was his most individual contribution to paint handling found few enthusiasts. Most critics have preferred to dwell on the unquestionable genius of his line.

Henri Marie Raymond de Toulouse-Lautrec-Monfa was born on November 24th, 1864. His father, Alphonse Charles Jean Marie, was the Count of Toulouse-Lautrec. His mother, Countess Adèle Zoë Marie Marquette, *née* Tapié de Céleyran,

was his father's first cousin; their mothers were sisters, the last in line of the ancient family d'Imbert du Bosc. Lautrec spent his early years at his birthplace, the Hôtel du Bosc in the centre of Albi, at the Château de Céleyran near Narbonne, and at the Château du Bosc about 20 miles north of Albi. He grew up surrounded by a large extended family of cousins, uncles and aunts who gathered at different seasons and festivals in the various family houses. In the large nursery at the Château du Bosc are preserved many of Lautrec's boyhood toys, books and drawings. On one wall are scratched marks showing the increase in height of Lautrec and several of his cousins. Lautrec's marks cease at approximately 4′ 9″ while, rather insensitively, the heights of his cousin Madeleine continue to ascend.

Earlier Counts of Lautrec had played a major part in French history. Connected at various times with the royal families of France, England and Spain, they had been important brokers of dynastic and territorial power during the medieval period in the south of France. Centuries of decline, however, had preceded Lautrec's birth. Failure to adapt to changed circumstances had left them prosperous enough and locally important, but without serious political influence or national significance. Lautrec's father found both Bonapartist and republican governments anathema. An eccentric, ultra-conservative royalist, the Count spent a great deal of his time hunting, hawking or racing. He had a particular penchant for dressing up and loved to be photographed, especially in the role of an exotic warrior. Photographs survive of him as a Highland falconer and as a Saracen knight in full armor. On one occasion, he is reputed to have milked his own mare in the Bois de Boulogne when he was thirsty, and on another to have washed his own linen in the gutter. In contrast, Lautrec's mother appears to have been a quiet, retiring, rather pious woman who was utterly devoted to her son. She and Lautrec's father became estranged when Lautrec was about five. It was also around this time that her second son Richard died, aged just under a year. Lautrec had no other brothers or sisters.

### Education 1872-83
In 1872, when Lautrec was eight, his family moved to Paris where they rented an apartment at the Hôtel Perey near the Faubourg Saint-Honoré. Lautrec lived with his mother; his father had his own rooms in the same building. Lautrec's schooling started in October 1872 at the Lycée Fontanes. His earliest letters, dating from between 1872 and 1875 and mostly written to his aunts and grandmothers, are full of typically childish details of sweets, treats, pets and outings, but they also evidence a developed sense of humor, and a gift for irony, exaggeration and punning. He was a clever child and at ten won first prize in French, Latin and English. He could write letters in English, which pleased his anglophile family. The first mention in his letters of any interest in art dates from December 1875 when, aged eleven, he was taken by his mother to the Paris studio of René Princeteau (1843-1914), a deaf-mute Bordeaux painter who was a friend of Lautrec's father and who specialized in horse and hunting

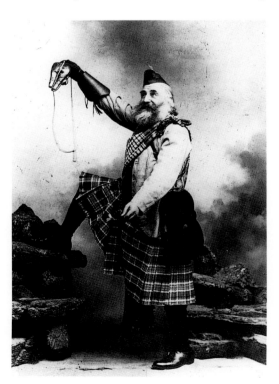

pictures. Lautrec was impressed by the large picture of *George Washington on Horseback* (American Embassy, Paris) that Princeteau was preparing to send to the 1876 United States Centennial Exhibition in Philadelphia. In the same letter, he refers to his own recent purchase of a book illustrated by Victor Géruzez (c. 1840-1900), nicknamed 'Crafty', an artist who also specialized in horse pictures. Perhaps not surprisingly, given the field sports that obsessed his family, the young Lautrec was keen on horses and dogs. Among his earliest books, now kept at the Château du Bosc, are *John Gilpin* illustrated by Randolph Caldecott and *The Three Jolly Huntsmen* by Major Seccombe. Lautrec's earliest childhood drawings suggest that he was copying and imitating illustrations from these and related books.

From as early as 1874, Lautrec had difficulties with walking. In winter 1875 he was withdrawn from school in order to receive medical treatment, and his education was continued under tutors. Diagnosed as having circulatory problems, he was given electric friction brush treatment. What he in fact had was a disease that was not properly identified by medical science until 1962. *Pycnodysostosis* is a rare genetic bone disorder, frequently linked with the consanguinity of parents. Symptoms include small stature, short legs, normal body size, small hands and feet, coarse facial features and a general tendency to bone fractures and stiffness in the joints. Without knowing the name, his parents were probably aware that the cause lay in the generations of intermarrying that their families had engaged in with the purpose of consolidating estates and fortunes.

<b>Below:</b> This pencil sketch of <i>Horse and Carriage</i> may be a preliminary study for <i>The Mail Coach, a Four in Hand</i> (page 26), an early work.

Lautrec fractured his left leg in May 1878 as the result of a fall, followed in November 1879 by a break in his right leg. For approximately two years he was a semi-invalid, attended by his mother in various family homes and in the series of spas and fashionable seaside resorts that they visited together. During this period, from 1878-80, Lautrec developed a more concentrated interest in art and painting. From 1879 he began making drawings after family prints and paintings, some by Princeteau who, on visits to the family, gave the young invalid helpful advice. Lautrec's father and uncle already painted in a competent but desultory fashion. The first signs that Lautrec was taking art a great deal more seriously was the letter he wrote from Nice to his ex-schoolfriend Etienne Devismes, apologizing for his increasing lack of interest in a model boat that they were designing together; he had been taken over, he said with 'a rage for painting'. When Lautrec finally made the decision to become an artist in early 1881, it does not appear that his family put any opposition in his way. As a gentleman he was not expected to 'be' anything. Becoming a gentleman-artist was as diverting as any other occupation.

In spring 1881 Lautrec returned to Paris and worked under the guidance of Princeteau. His first major objective, not connected directly to his art, was to sit his Baccalaureate exams, the difficult school graduation that entitled him to access to a university or similar institute of higher education. He failed in July 1881 but passed in November of the same year. He was still only sixteen (Degas and Cézanne were both nineteen before they obtained their certificate).

In the letter that he wrote to his favorite Uncle Charles in May 1881, Lautrec spelt out clearly his proposals for his artistic future:

The plan that I think has the best chance of success – Ecole des Beaux Arts, Cabanel's studio and attendance at René's [i.e. Princeteau's] studio.

What Lautrec was in fact proposing was a rather safe conservative artistic education. Alexandre Cabanel (1823-89) was an important academic artist, who is principally remembered nowadays as the winner of a gold medal for his erotically charged <i>Birth of Venus</i> at the Salon of 1863. Because this coincided with the condemnation of Manet's <i>Déjeuner sur l'Herbe</i> as obscene in its showing at the Salon des Refusés in the same year, Cabanel has become rather a <i>bête noire</i> of Impressionist historians. Lautrec's main interest in Cabanel was as a teacher who might help him reach the required standard in his academic figure studies to enable him to obtain entry into the state-run Ecole des Beaux Arts. Nothing seems to have come of this plan, and after continuing to work with Princeteau he was accepted in April 1882 into the studio of Joseph Florentin Léon Bonnat (1833-1922), one of the most fashionable portrait painters of the day. In his youth Bonnat had been a more avant-garde Realist artist, but had settled to a highly suc-cessful idiosyncratic style of painting using dark Realist contrasts combined with a very highly finished paint facture. Bonnat's opinion of Lautrec was not high, but during the short period that he was under Bonnat's supervision Lautrec's drawing improved markedly. Part of the problem lay in the fact that Lautrec arrived with an accumulation of bad painting habits. His little stylistic tricks of surface animation, learned or borrowed from Princeteau and other artists, hid a lack of facility with more carefully structured modelling. Bonnat's approach to drawing was rigorous and not conservatively academic. He retained a link with his own earlier Realist schooling, and encouraged his pupils to use strongly modeled forms with clear contrasts using charcoal, rather than the pencilled delineation of more traditional practice. Lautrec's summer 1882 portraits done at Céleyran clearly show the tauter structuring that had entered his art in a matter of months.

In September 1882 Lautrec was forced to find another master, when Bonnat gave up teaching students in his own studio follow-ing his appointment as Professor at the Ecole des Beaux Arts. Along with several fellow students, Lautrec migrated to the studio of Fernand Cormon (1845-1924), an ex-pupil of Cabanel's who also painted in a watered-down Realist fashion and who had developed a particularly strong line in prehistoric subject matter. His enormous painting of <i>The Flight of the Family of Cain</i> (Musée d'Orsay) had been something of a sensation at the 1880 Salon. Cormon was an extremely tolerant master, perhaps too tolerant: Lautrec said later that he missed the 'lash' of Bonnat. Lautrec was still concerned about the standard of his drawing. He wrote to his father, explaining that he 'would have liked to have tried Carolus (i.e. Carolus-Duran) but this prince of color provides only mediocre draftsmen which would be fatal for me.' Carolus-Duran (1838-1917) ran a very successful studio and trained his students by getting them to paint directly without elaborate preparatory drawing. His own fashionable portraits employed a rather flashy touch that owed a debt to the simplified tonal structure used by Manet. Again, what is striking about Lautrec's weighing up of options is his stolidly cautious approach.

As late as December 1882, Lautrec was still indicating in his letters that he wished to use the official channels of artistic success; competing for the Ecole and subse-quently for state prizes. His paintings made earlier that summer show him experiment-

ing with various branches of dilute Realism related to those used by artists that he admired. However, a significant sea change is suggested in the letter to his mother in April 1883 in which he wrote

Vive la Révolution! Vive Manet. The breeze of Impressionism is blowing through the studio. I'm overjoyed because for a good while I've been the sole recipient of Cormon's thunderbolts.

It may possibly have been Manet's death in the same month and the public focus on his work in various newspaper obituaries that contributed to this outburst. Quite what Lautrec understood at this stage by Impressionism is not easy to pin down, and just how he had stood out from other students in receiving his master's criticism is also unclear. It is perhaps appropriate to try and isolate what 'Impressionism' would have meant to a young artist at this time.

## Impressionist and Post-Impressionist Options 1884-86

A decade after the first Impressionist exhibition, 'Impressionism' had come to be viewed by many of the public as a convenient umbrella term to cover loosely the several branches of the avant-garde. In part the diversity of their art and the evident divisions between the Impressionist exhibitors contributed to this view of its plural-

ity. Throughout the period from 1874 until about 1880, the group was split broadly into two spheres. Those more or less aligned with Monet, Renoir and Pissarro painted bright candid glimpses of nature, which tended to concentrate on the appearance of foliage, figures, water and objects under sunlight, and which used a novel modelling without tonal gradations from dark to light, relying on contrasts and relations between colors and the subtlety within colors. The second group, more or less aligned with Degas, were less concerned with landscape, more interested in aspects of the human urban environment. They saw themselves as more closely connected with literary 'Naturalist' pursuits. Using darker colors and at times traditional tonal modelling, they also regarded themselves as intellectually superior to their co-exhibitors. Both sides shared certain compositional and technical affinities, such as the quirky off-center viewpoints and curious perspectives which were in part derived from Japanese prints, in part inspired by snapshot photography. Manet, while refusing to exhibit in the Impressionist exhibitions, had moved between both these broad groupings, for a while experimenting with painting similar to Monet's but by the later 1870s realigning himself with urban Naturalism and portraiture. Lautrec's invoking of Manet in his letter to his mother suggests the branch

that he preferred, and clearly places his art within the Naturalist camp. While citing Manet, however, he had already come strongly to admire Degas, who had a studio in the same building as his apartment.

From the beginning of the 1880s the divisions within the French avant-garde multiplied further. Several young artists, including Lautrec, questioned the intellectual weight of landscape Impressionism: an art apparently dedicated to nothing more than the capturing of mere appearance. New positions emerged and broadly these also divided into two groups. A first group of artists from about 1884 onward wished to bring increased system to Impressionism and to adopt a more scientific approach to the construction of landscape. Seurat and his follower Signac led the way in this direction, with little dot-like strokes of pure color organized according to various laws of color mixing. Calling themselves Pointillists (literally 'dottists') they were successful in winning over Pissarro from the Impressionist landscape camp. A second group of artists sought to give an extended meaning to their art by emphasizing symbolic and emotional content. They used mytho-poetic themes and employed bright exaggerated colors and forms which had only a limited link to nature as actually seen but a much closer connection with subjective feeling. Gauguin's advocacy of subjects inspired by

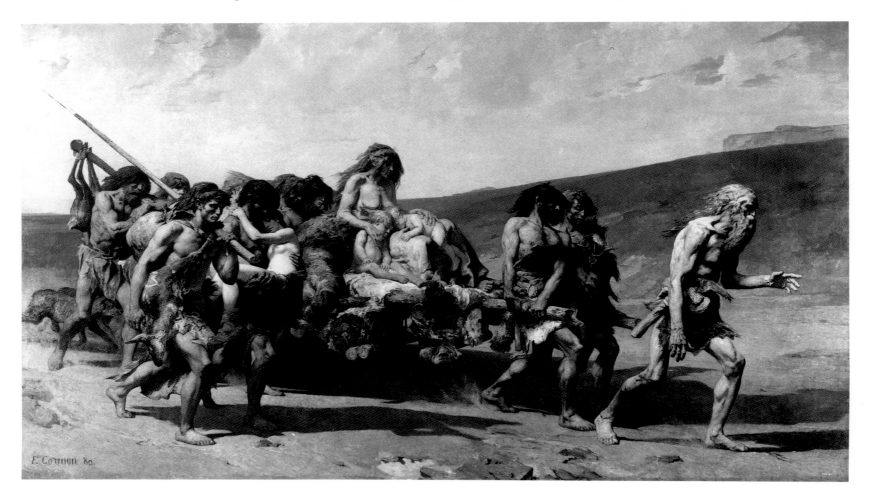

Right: Lautrec with his fellow students at
Cormon's atelier, c. 1883.

Below: Renoir's *Moulin de la Galette* of 1876 may
have been the inspiration for Lautrec's own more
squalid depiction of the same scene (see page 62).

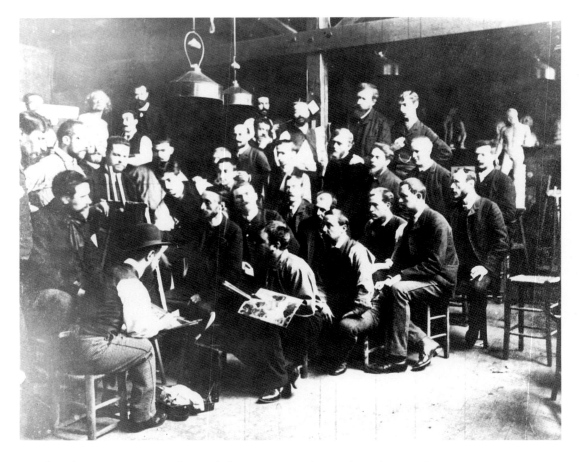

Brittany and the South Seas and his distinctive bright raw color influenced several younger artists. In addition to these major divisions, there were many other splits and sub-groupings, particularly in the various branches of Symbolism.

In a more conservative, more mainstream vein there was also to be found, among several Salon artists, what virtually amounted to an international style of landscape and peasant subject painting, combining elements of Barbizon, Realism and Impressionism with a more conventional use of traditional spatial recession and tonal modelling. Princeteau fitted in with this grouping.

Lautrec and his fellow students at Cormon's studio took sides in these divisions, and their paintings show it. Emile Bernand, who joined Cormon's studio in 1885 and whom Lautrec painted, at first advocated Pointillism before switching to a position closer to that of Gauguin in around 1886. The young Vincent van Gogh, who arrived in Paris in February 1886 and regis-tered with Cormon, went through his own exploration of conflicting Post-Impressionist strands. Lautrec tried out in a rather half-hearted way during 1885-86 the dot-like stroke of Pointillism, but also flirted for a while with another group, calling themselves the '*Incohérents*', who exhibited from 1882. Their parodies of the inflated rhetoric of Salon art now make them appear almost as forerunners of Dada.

In yet another direction, Lautrec also admired the paintings and illustrations of

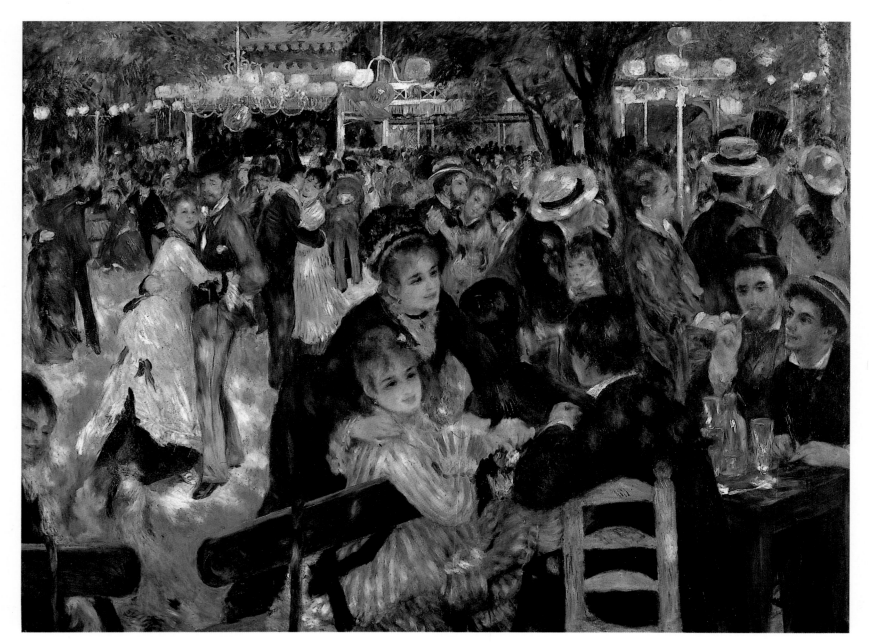

**Below:** *The Client* or *The Brothel*, 1878, by Forain, a friend of Lautrec's father, whose subject matter and involvement with journalistic illustration influenced Lautrec.

**Bottom:** *Bearded Man; Academic Study* demonstrates the increased discipline Lautrec brought to his drawing under the influence of Bonnat and Cormon.

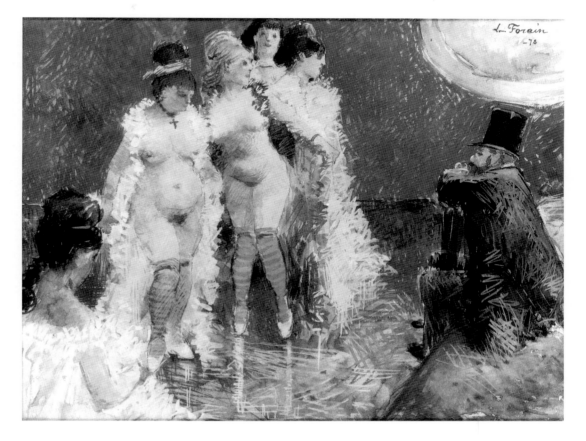

Jean-Louis Forain (1852-1931), who was a friend of his father's. Forain showed in four of the Impressionist exhibitions and was strongly influenced by Degas's approach and subject matter. His café interiors, brothels, actresses' dressing-rooms and Parisian streets are less dispassionately distant and more vulgarly conceived than Degas's, and he was valued for his witty exploration of the foppery and corruption of Paris nightlife. The critic Octave Maus (1856-1919) described him in 1886 as:

An uneven artist, slipping often on the slope of anecdotal illustration. . . . J.L. Forain frequently succeeds, when he studies our elegant and vicious customs from life, in giving his works a particular flavor. He is the poet of corruption in evening clothes, of dandyism in the boudoirs, of high living masking empty hearts.

Arsène Houssaye, reviewing Forain's first appearance in an Impressionist exhibition in 1879, described his work as one that:

Unrolls before us the life of the dandies who parade their dismal stupification from the cafés of the boulevards to the lobbies of the little theaters.

These quotes might almost be prophetic of Lautrec's own mature art. Forain's influence upon Lautrec is first seen in the group of works that he produced connected with the Le Mirliton cabaret owned by Aristide Bruant. In Forain's lack of boundaries between exhibited paintings or pastels and illustrative work, he also perhaps acted as a model for Lautrec's own eventual blurring of the distinction between Fine Art and journalistic illustration.

Lautrec's experiments and his eventual decision as to the type of artist that he was to become, formulated in a climate of conflicting modernity, may also have been partly influenced by the official rejection that his works received. His pictures sent to the Salon of 1883 and 1886 were both refused; the latter was apparently an uncontroversial still-life of a cheese (he may have been mocking the jury). In aligning himself with what he described as 'the purple flag of Impressionism', Lautrec linked his own Naturalist art with that of Manet, but more closely still with that of Degas.

During the period from late 1886 until 1891 Lautrec came of age as an artist. Pictures produced during this period fall into two broad groups: there are a large number of portraits, and a smaller group depicting the nocturnal social life of Montmartre, with which he was becoming increasingly involved.

## Portraits 1885-1891

Portrait painting lay at the heart of the Naturalist pursuit. For other Impressionists, concerned with the appearance of light's fall upon nature, it was of lesser significance. The debate on appropriate modes of portraiture that might be explored by Naturalists elided with speculation on the physiological and environmental bases of human character and more general discussion on the classification of 'types' based upon their outward appearance. There was considerable curiosity about 'scientific' taxonomies of various kinds of criminal. The phrenological measuring of skull-bumps

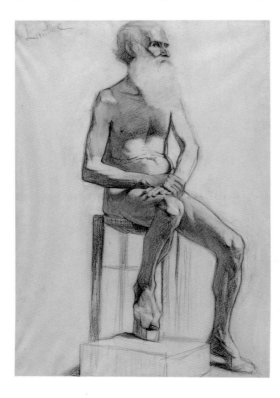

was by no means discredited. Where traditionally portraiture relied upon stock gestures and poses which bespoke the dignity or gentility of the sitter, usually augmented by whatever were the prevailing notions of fashionable beauty, Naturalist portraiture sought the more honest truth of a telling gesture: how, for example, a particular way of moving, or standing, might perfectly distill a character, more acutely than any accurate transcriptions of the face. In fact the face, while never becoming secondary, was certainly, for some Naturalists, simply on a par with other features. Lautrec's remark, 'Monsieur, I would be honored if you would come to my house and pose for a portrait. Although it will probably not look like you; that is unimportant', should be understood in this light.

Not altogether surprisingly, it was Degas who had most trenchantly advanced the cause of the Naturalist portrait within the Impressionist circle, and who had made common cause with critics like Duranty to promote the criteria for their production and evaluation. Lautrec's many portraits painted between 1885-91, indicate a fairly systematic exploration of Naturalist possibilities and suggest that, while he had been looking at the portraits of Manet, Morisot, Tissot, Whistler and others, he was working out a practice that took account of Degas's pictures and Duranty's writings. An early group are the pictures of *Carmen Gaudin* (see page 45): dark close-toned paintings that in their facture are redolent

of earlier nineteenth-century Realist pictures. He painted Carmen in profile and with her face hidden by hair, and he often transcribed her features from photographs. She was a poor young woman, a laundress. Where Degas in his laundress paintings sought to pin down the distinctive vocabulary of their working movements, Lautrec sought to capture the rawness of what he perceived as an unsocialized and timid individual; these are portraits which chart awkwardness. A second group of paintings showing women representative of different *quartiers* of Paris, made for Aristide Bruant's cabaret (see page 50), while successful enough as a series of individual portraits, has not generally been considered especially revealing as 'types' or even stereotypes of the localities that they purport to represent.

A third group are of men and women out of doors, which Lautrec described as his 'punishment works', painted in a friend's Montmartre garden (page 74). That they were made in bright sunlight made little difference, it seems, to how they were painted. Apart from a lightness of tone,

there is little to distinguish this group from the many studio portraits that Lautrec worked on at the same time, and no suggestion of an Impressionist integration of light and object. The complexities of back views, side views and appropriate props seem to have been of more paramount concern.

The group of male portraits that Lautrec made in 1890-91 have usually been regarded as the culmination of his early portrait practice (see pages 76-77), and his most systematic attempt to reconcile simplicity with Naturalistic precision. Using pale Whistlerian harmonies and Japanese-inspired structuring of mass and positioning of the figure, Lautrec depicted several of his friends as elegant *boulevardiers*. In these works his exploration of Japanese-inspired principles goes beyond the usual spatial dissonance, cropping of figures or outlining of forms. Lautrec was aware of the discussion among certain late nineteenth-century Naturalists which took the view that Japanese art had an especial precision resulting from selectivity and simplification. Potentially it was seen as a

liberating model for pared-down accuracy. A not untypical summation of this view was put forward by an English artist, George Clausen, in his 1904 lectures to students at the Royal Academy:

Our own art appeals through representation and imitation, creating an illusion of nature in its three dimensions, while the Japanese representation of Nature is not imitative but selective, certain things being chosen and the rest ignored. And their art seems in this respect to have developed to its final perfection on the lines of the earliest forms of art. . . . to the Egyptian wall paintings, to the Greek vase paintings and to the earliest Italians . . . such as *The Battle of San Romano* by Paolo Uccello in the National Gallery [London] which is extremely like a Japanese picture . . . the early Italian point of view was very similar to that of the Japanese.

Lautrec's simplifications, his recurrent use of profiles reminiscent of Uccello and Pisanello, suggest that for him too the delineation of modern character could be achieved by borrowing from older, more emphatically linear and economical modes

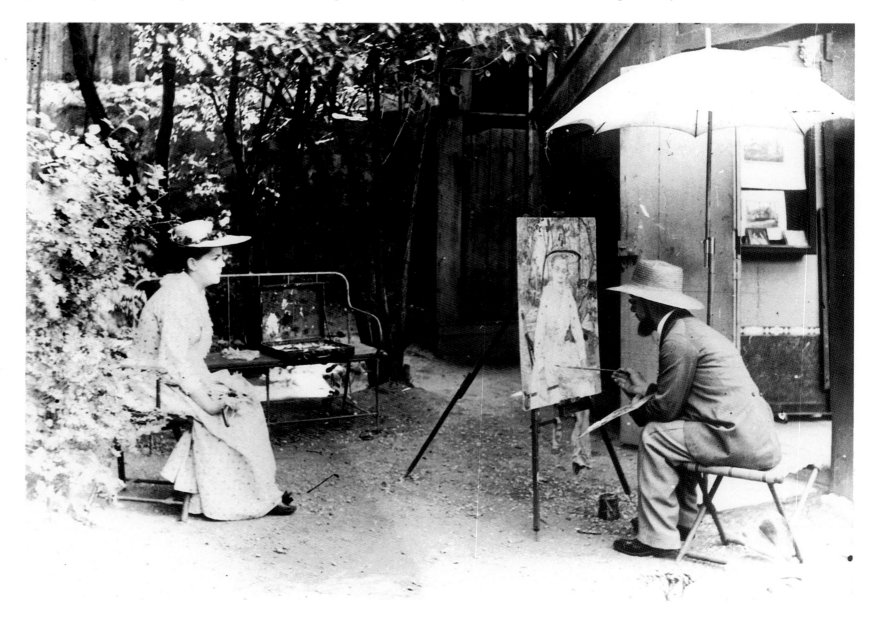

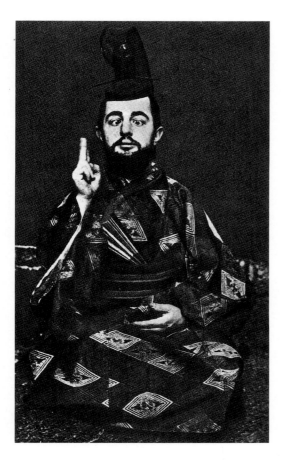

years, the area expanded into a distinctive leisure center, at first with a slightly raffish edge but soon with an altogether more stylish tone. Paris had marketed itself to the world through a series of international fairs and exhibitions. The rapid improvement of railway travel made it easily accessible from neighboring European countries. Lautrec's many famous pictures of circuses, café-concerts, and especially the Moulin Rouge cabaret, are records not simply of the city's own expanded pleasures but of a new thriving international tourism, of which it was at the very heart.

Lautrec's earliest absorption into the nocturnal pleasures of Montmartre came from about 1884 onward, probably in the company of René Grenier, with whom he shared an apartment. The Chat Noir, a *cabaret-chantant*, later to become the Mirliton managed by Aristide Bruant, was one of several centers of an artistic and literary social life which attracted a *demi-mondaine* clientele that included the prosperous in search of distraction as well as pimps, prostitutes and other providers of pleasure. Major investment in Montmartre as a leisure center went on throughout the

of representation, whether from East or West. The climate within which Lautrec's Naturalist practice developed was complex, and to modern eyes seems also perhaps rather contradictory. After 1891 Lautrec's portraits were more closely connected to his other art; less simple and with a more involved contextualizing of the individual figure within busy social environments, and in particular the Montmartre nightlife that took up so much of his time.

### Lautrec's Montmartre

Throughout his time in Paris, Lautrec studied, lived and had his studio within an area of approximately half a square mile in Montmartre. The boulevard de Clichy and its continuation, the boulevard de Rochechouart, with streets branching off on either side, formed the principal axis for his social and working life. Montmartre's hill had been a village outside Paris until it was included within the city by the fortifications erected by order of Louis-Philippe. Brought closer to the life of the city, it still kept its reputation for criminality, bohemianism and cheap living. Lautrec's Montmartre, however, was not this decrepit and scrubby *maquis*, or the semi-rural peak of the Butte proper, but rather the improved boulevard at its base, widened during the 1860s as part of Baron Haussmann's massive beautification of the capital for Louis-Napoleon. Here were many new buildings; apartments, cafés, even purpose-built artists' studios. During Lautrec's student

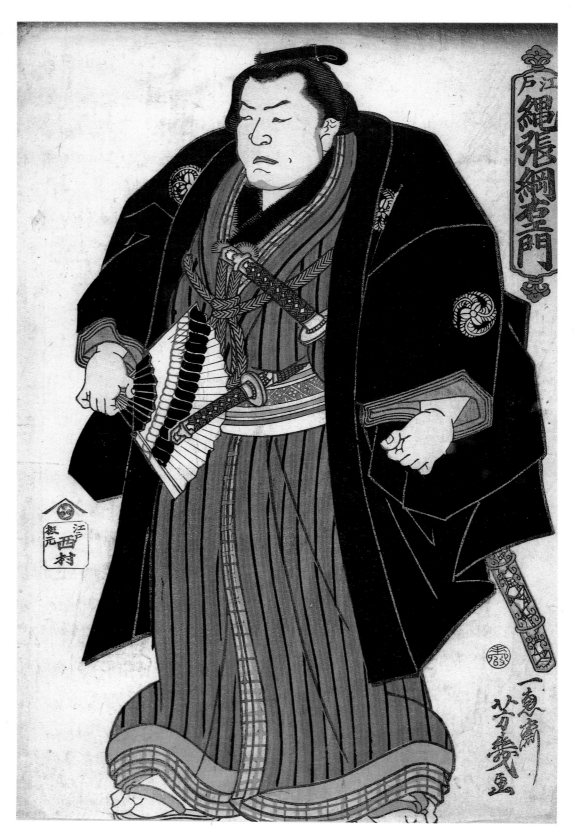

**Below:** This map of Paris shows Lautrec's principal haunts in Montmartre and surrounding areas.

1 Lautrec's studio
2 Moulin de la Galette
3 Le Mirliton
4 L'Elysée Montmartre
5 Cormon's studio
6 Moulin Rouge
7 Le Rat Mort
8 Divan Japonais
9 Lautrec's mother's apartment
10 Lautrec's apartment
11 Nouvelles Athènes café
12 Cirque Fernando
13 Webers
14 American Bar
15 Les Ambassadeurs
16 Rue des Moulins brothel

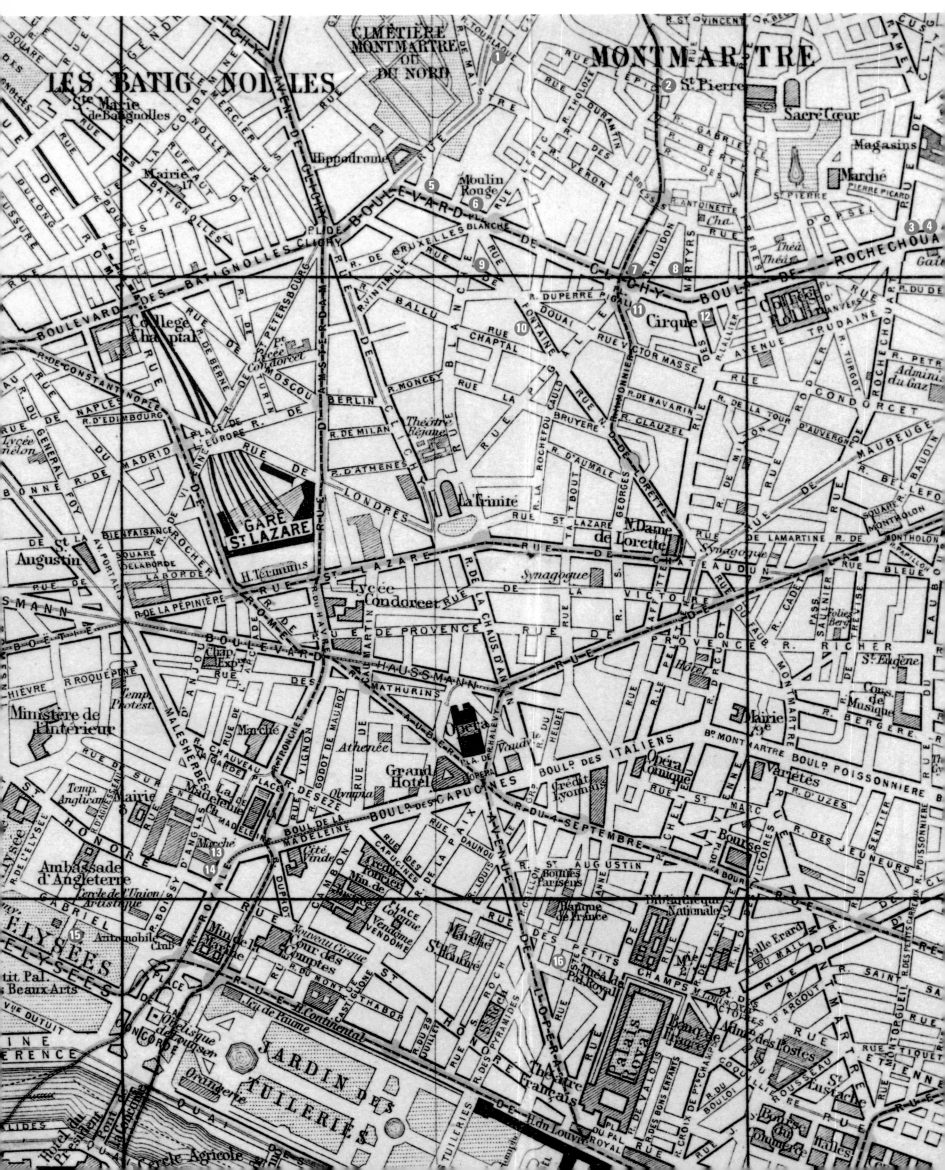

1880s. The Moulin Rouge opened in 1889, following the enormously successful International Exposition of that summer. Lautrec's pictures of cabarets from 1885 until approximately 1893 chart the fashionable rise of Montmartre and focus particularly upon the revived can-can, *chahut, quadrille-naturaliste* – the various names that were given to the popular dance.

Lautrec's recording of the transient, the ephemeral, the precisely fashionable, was in itself an established mode of Naturalist literary and artistic activity. Earlier, during the 1870s, Degas had focused upon café concerts like the Ambassadeurs in the Champs Elysées and had, to a limited extent, painted Montmartre life at the Cirque Fernando and the Café Nouvelles Athenes, where Ellen André posed for *L'Absinthe*. By the time Lautrec commenced his recording of cabaret life, however, Degas had virtually ceased to paint identifiable metropolitan subjects. Lautrec's work in this area is a continuation of Degas's activity, conceived within the same dispassionate framework. When Degas first saw Lautrec's work *en masse* at the 1893 Goupil's exhibition, his remark, 'Well, Lautrec, you're clearly one of us', is supposed to have caused Lautrec to beam with pleasure.

### Managing His Reputation: Public Exhibitions 1883 Onward

Lautrec was a most calculating and assiduous promoter of his own reputation, and was especially conscious of the need to keep both his name and his work before the public. Denied access to the Salon by the unacceptability of his entries, and aware that his work would never be safely

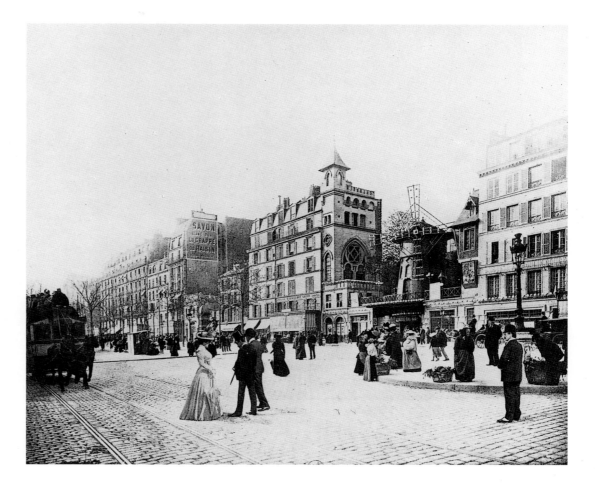

successful, Lautrec used any suitable opportunity to exhibit, ranging from regular structured group showings to much less formal occasions. Moreover, he also kept his work before the metropolitan public by his illustrative contributions to a variety of journals. Although Lautrec had a dealer in Maurice Joyant, on the whole he himself managed the public projection of his art. While his letters do not perhaps reveal a great deal about his personality or opinions, they certainly do show that he was, almost to the end of his life, a very careful organizer of his public displays. The principal venues where his paintings

appeared in public exhibitions were Paris, Brussels and London, but he also displayed pictures from 1883 onward in provincial French cities, and his works were seen during his lifetime in Antwerp, Berlin and Budapest. Transport arrangements, framing details and even the currying of favor with a group of avant-garde critics, were regular preludes to exhibiting. At the peak of his exhibiting activity, between 1892 and 1897, Lautrec was showing at a fresh venue on average every three months, and regular rhythms developed to his exhibiting year. From 1888 onward, he showed with the avant-garde Belgian group *'Les*

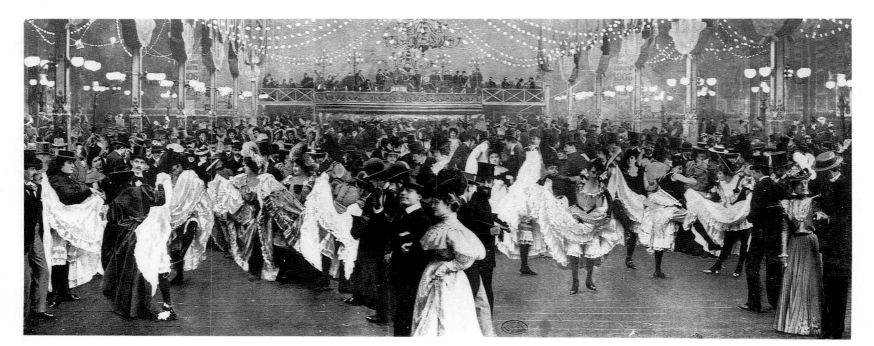

**Below right:** The clown and gymnast Cha-U-Kao as an adolescent, demonstrating her agility by doing the splits.

**Bottom:** La Goulue and her partner Valentin Le Désossé feature on the charcoal and oil study for Lautrec's poster, *The Moulin Rouge: La Goulue*.

**Right:** The singer Yvette Guilbert in characteristic pose, wearing the long black gloves that were her trademark.

**Far right:** Aristide Bruant, singer, club-owner and earliest patron of Lautrec, wearing the distinctive suit shown in Lautrec's famous 1892 poster.

*Vingts'*, and from 1892 with their successors, *'La Libre Esthetique'*. This January/February showing was followed in the spring with a display at The Independents, the no-selection, no-jury exhibition that presented itself as a competitor to the official Salon. From 1889 until 1892 he exhibited with the Cercle Volney, a more conservative grouping which also showed in late Spring. In 1886 and 1887, Lautrec exhibited with The Incoherents. Here, under the name of Tolav Segroeg, 'a pupil of Pubis de Cheval', Lautrec showed spoofs of high salon art. When van Gogh organized two café shows at the Grand Boullon Restaurant and the Café Tambourin in 1887-88, he included Lautrec's work. Much grander exhibitions were the two

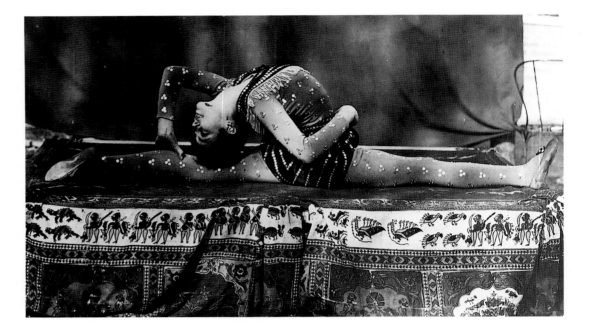

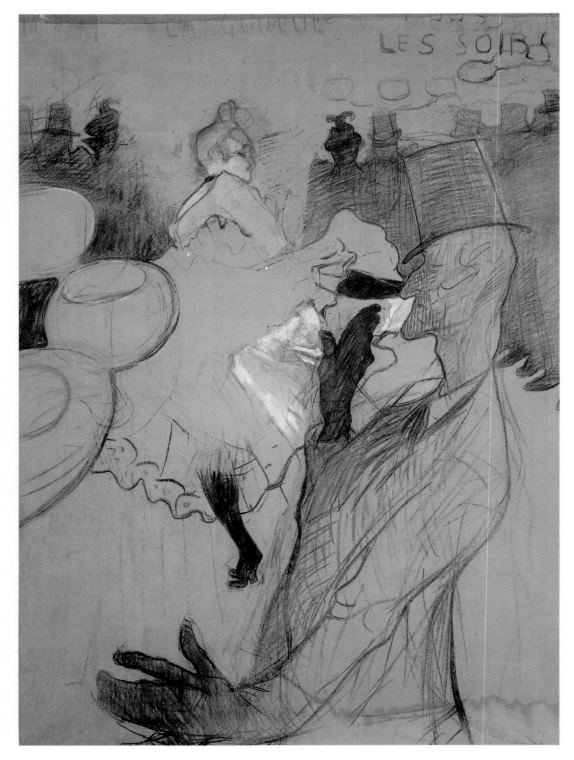

one-man shows that Lautrec had in Paris and London in 1896 and 1898 respectively (at the opening of the latter, the future King Edward VII attended while Lautrec slept throughout in an armchair). In 1893 he shared a show with another artist, Maurin. The Royal Aquarium in London displayed posters by Lautrec at least twice, in 1894 and 1895.

Lautrec was not, however, unselective about where he showed. It seems possible that he turned down the opportunity in 1889 to exhibit at the Café Volpini alongside Gauguin, Bernard and their Pont-Aven followers – possibly not wishing to be dominated by, or too closely identified with, a group whose expressionist and spiritual inclinations ran counter to his own more narrative instincts.

Perhaps the two most prominent public exhibition spaces that Lautrec was able to command were the foyer of the Moulin Rouge where, from 1889, his huge painting of *In the Circus Fernando: The Ringmaster* (see page 54) was hung, and the street walls and poster kiosks of Paris itself, where his posters were displayed to great acclaim from 1891. Critics potentially sympathetic to his art were informed of the advent of a new poster, as they might be about the opening of a new exhibition. Indeed, Lautrec's graphic art attracted public attention to his paintings, and from 1891 the two co-existed in advantageously symbiotic union.

### Graphic Work : Posters and Prints
Lautrec's first major graphic undertaking was the 1884 commission that he received, along with other of Cormon's pupils, to illustrate a complete edition of Victor Hugo's works; although the project proved abortive, he still received 500 francs. Be-

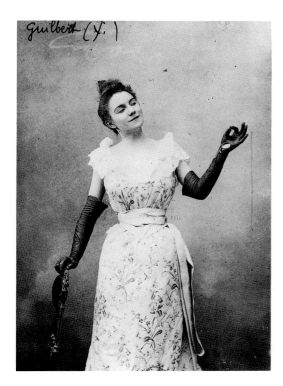

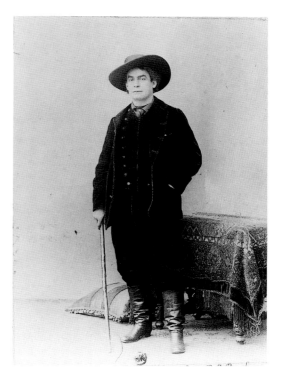

**Below:** Lautrec and Zidler pose with Chéret's 1889 Moulin Rouge poster, which was superseded by Lautrec's own 1891 poster.

tween 1884 and 1891 his illustrative activities were altogether less elevated and he provided a number of drawings for journals and magazines, in most cases preceded or accompanied by a similar image made as a painting. The expansion of Paris as an international leisure center was accompanied by a considerable body of illustrative publicity – guidebooks, journals, newspaper supplements – many of them reinforcing the city's reputation for *risqué* attractions and easygoing tolerance. Caricatures and humorous illustrations of cabarets, café-concerts, dance halls, brothels and low-life, were a well-established genre of illustrative activity; Forain, Willette and Steinlen all fed the demand. Inexpensive illustrative printing techniques using color stencils or chromolithography, the absence of punitive newspaper or journal taxes, and, above all, the expansion of public demand, fueled a growing journalistic industry. Dickens's 1882 *Dictionary to Paris* listed 89 different journals and newspapers, published on a daily, twice-daily or weekly basis, and this represents only a selection of those on offer. The gossipy self-referring world of Montmartre was able to keep afloat for a while a paper like *Le Courier Français*, which, despite the grandeur of its title, was essentially a local rag. For it, Lautrec provided a number of illustrations (see page 56, *The Hangover* or *The Drinker*). Maurice Joyant, Lautrec's ex-schoolfriend, ran a magazine called *Paris Illustré*, for which Lautrec also provided a group of four street scenes (see page 52, *The Day of the First Communion*), and Aristide Bruant, owner of the Mirliton, produced what amounted to a monthly house journal to publish his songs and advertise his cabaret. Lautrec did a few images for this too, linked with the portraits of women that he provided to hang in Bruant's cabaret. Most of these were photomechanically reproduced and colored by adding hand stenciled areas.

Lautrec's great leap forward in reproductive printing came in 1891, with his large lithographed poster made for the 1891 season at the Moulin Rouge (see page 82, *Moulin Rouge: La Goulue*). Lautrec's genius with regard to poster art lay in his understanding of the need for simplification and absolute clarity of form and color. He deliberately avoided complex tonal modelling and traditional perspectival recession, and instead used flat areas of pure unmodulated color. It is difficult to believe that this poster was Lautrec's first lithograph, so commanding is its presence and so fully resolved is it in all areas.

Over the next ten years, Lautrec produced a further 357 lithographs, working in most cases in very close contact with his printer. Thirty of his lithographs were posters and include some of his most famous images (see page 108, *Divan Japonais*), and several more were made for song sheets (see page 113, *Carnot Malade*). The majority, however, were smaller, limited-edition prints produced singly, in pairs or

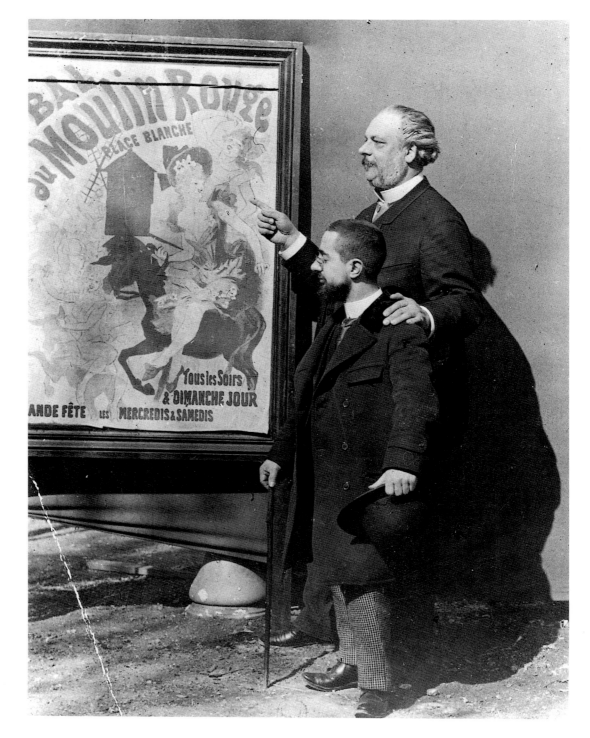

in portfolios, and targeted at collectors who were prepared to pay for slight variations in state, or differences in paper quality. The majority were black and white but a large minority were color. Lautrec benefited from the breakdown, during the late 1880s, of the traditional hostility among print collectors to colored prints; the print section of the Salon, for example, had snobbishly banned all but black and white images. His prints were not especially expensive and his subject matter was drawn principally from the familiar leisure scene of Paris. Music hall stars, theatrical scenes with famous actresses, and cabaret artists, make up the bulk of his images.

Lautrec experimented with novel combinations of color and with new textural effects, in one case achieved by firing a gun of ink at a plate. In 1898 André Mellerio, in his history of *La Lithographie Originale* summed up Lautrec's achievement:

His remarkable inspiration and procedures, his knowledge that was slowly forged by a training which he evolved himself, has rightly given him a starring role in original color lithography.

The print project on which he perhaps lavished most attention and which proved to be a financial disaster was the *Elles* series (see page 126), published in 1896. Focusing upon the lesbian intimacies of brothel life, they reflect a new subject area which Lautrec developed from about 1892 onward. If the first phase of Lautrec's maturity as an artist was characterized by the cabaret-related and Moulin Rouge subjects and portraits, the second phase is especially noteworthy for his development of lesbian and brothel themes and for an increased interest in theatrical subjects. To an extent this was also connected with a shift in Lautrec's own lifestyle. Although he continued to live in Montmartre, his nocturnal activities took him further down the hill and into the more fashionable boulevards of the city. Montmartre's high fashion status was waning by 1894, while by the late 1890s reviews and more complex dance spectacles were displacing the can-can as the principal public attraction.

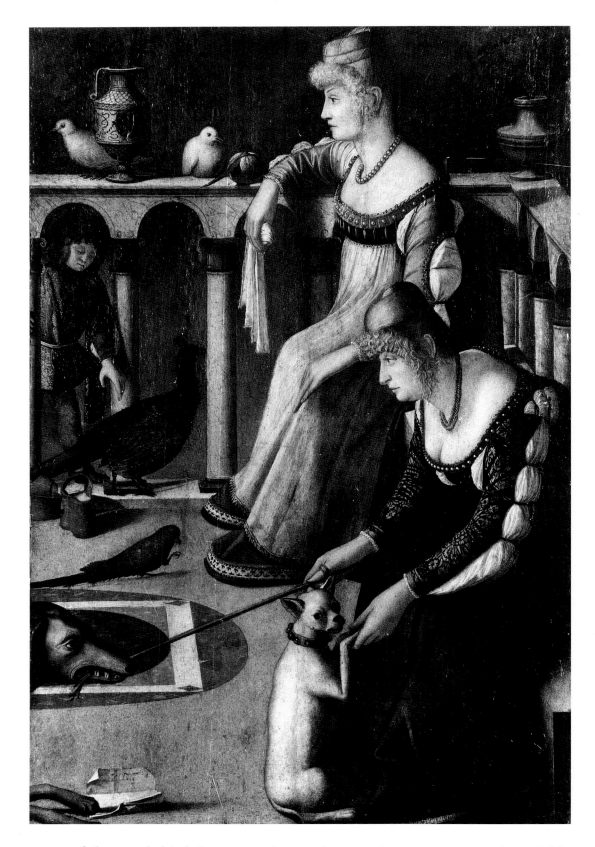

## Prostitutes and Brothels 1892-96

Each evening at about 10.00 pm, coaches discreetly but regularly left from the Jockey Club, the Automobile Club and other fashionable male gathering points, and made their way with their passengers to the prestigious brothels of Paris, sited since the seventeenth century by law and by tradition in the cul-de-sacs and side streets of the area behind the avenue de l'Opéra. These grand establishments catered not only for a domestic trade but for the expanding international sexual tourism that helped make Paris's reputation in the last decade of the nineteenth century akin to that nowadays enjoyed by Bangkok. Although the number of brothels in Paris was actually in decline, and the growth area in prostitution lay with women working alone, a luxurious house like that which opened in 1894 at the rue des Moulins was able to command a worldwide clientele for its expensive and exotic pleasures. Lautrec is supposed (probably apocryphally) to have taken up temporary residence there after transferring his custom from a similar but less splendid establishment in the rue d'Amboise.

Exploration of Lautrec's involvement with prostitutes and brothel life have, at times, focused upon the compensatory emotional and sexual comfort that he obtained, in an environment where love was irrelevant and his own physical repulsiveness went unremarked. Anecdotes enough survive to suggest that he enjoyed boasting about, or at very least being baldly matter-

of-fact about, his use of brothels; for example, giving the address of one as his own to potential purchasers of his pictures, and on another occasion meeting his embarrassed dealer in the salon of the rue des Moulins. Lautrec's friend François Jourdain's considered view of his patronage of them was that:

Lautrec's attachment to brothels would take on a tragic aspect, would it not, if we were sure that it was simply the result of despair – the miserable consolation of an outcast, or the refuge of a pariah. One can imagine how pathetically Dostoyevsky would have described this life of shame, but we have no grounds for supposing that he would have recognized such a tale as a true account of his fate.

Jourdain's suggested distinction between any Dostoyevskian high morality or personal torment and Lautrec's detached congress with his subject is apposite, since it is principally in the literary realm, and in particular within the field of the Naturalist French novel, that one finds parallels with Lautrec's approach to this subject. During the 1870s and 1880s prostitution had become a fashionable theme for fiction, and it would seem that no Naturalist novelist worthy of the title could avoid charting the sexual commerce that was such a manifest aspect of French society. The Goncourts' portentous *La Fille Elisa*, which dealt with the fateful degeneration of a prostitute, sold 10,000 copies when it first appeared in 1876, and had gone through 30 editions by the time Lautrec commenced painting brothels (Lautrec at one point started illustrating this novel). Zola's *Nana* of 1880, in what was essentially a socialist attack on the triviality of the Second Empire, traced the rise to the station of *grand monde* courtesan of a young girl from the Opéra and then her tragic fall and graphically described death from smallpox. De Maupassant's *Maison Tellier* of 1881, a bawdy account of golden-hearted whores who cheerfully oblige, revolved around the humorous story of a provincial brothel closed for the first communion of the Madame's niece. These three most popular works represented different possibilities within the Naturalist discourse; what united their disparate approaches was a common concern to confront a readership with the true life of a section of their own society and possibly their own life, and to highlight bourgeois hypocrisy.

Lautrec had no single approach to prostitutes and brothels in his art. Subjects like *The Salon* (page 122) explore the monu-

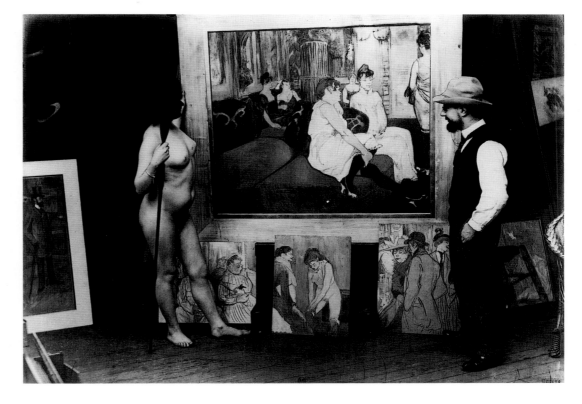

**Below**: Lautrec poses in his studio in 1894 with his vast picture of *The Salon at the Rue des Moulins*, possibly with one of the models he used.

mental tedium of the brothel, dispassionately viewed. *Rue des Moulins* (page 124) comes close to criticizing the humiliation imposed by legal requirements, while *Monsieur, Madame and the Dog* (page 116) is essentially humorous. A few of his pictures and drawings employ the traditional vocabulary of pornographic prints, suggesting that they were intended for private perusal. While accounts from Yvette Guilbert and Vuillard suggest that Lautrec was sympathetic toward the prostitutes he knew, Lautrec himself seems to have viewed the existence of prostitution as being almost as natural as hunting. He did not see any part of his artistic role as being the reform of society, whatever sympathies or affection he felt for individual women. The traditional critical view of his most famous brothel pictures has tended to emphasize his detached, unhypocritical and 'honest' approach to the subject.

Lautrec especially admired Manet's two most important prostitute pictures. He regularly visited Victorine Muerent, the model who posed for the courtesan in *Olympia* in 1865, describing her once as 'more important than the President of France' and he seems to have had Manet's 1876 *Nana* in mind in constructing the *Elles* pictures (see page 146). It is unlikely that Lautrec knew Degas's brothel monotypes, and very few of his own images suggest the grossness of life within the brothel that is such a characteristic of this side of Degas's work. He was probably aware, however, of the critical reception accorded to Degas's statue of the *Little Fourteen Year Old Dancer* in 1881 and his bather series in

1886. In both cases critics, including those within the Naturalist camp, condemned the works as characteristically depraved.

Modern criticism of Lautrec's brothel images, especially from more radical cultural historians, has tended to locate his pictures within the very broad context of late nineteenth-century French social and economic life, and to ask how far they are indicative of the dominant ideology. Unlike the brothel pictures of his contemporaries such as Willette or Forain, Lautrec's images have not so easily sustained a reading that suggests misogynistic or patriarchal disdain. Nor, with their general lack of nudity and their rather mundane-looking women, do they invite the devouring male gaze viewed by some feminist historians as such a residually erotic and titillating feature of certain Naturalist pictures, including Manet's *Olympia*. The reception that these pictures received during Lautrec's lifetime and the critical reaction that they provoked is difficult to chart, but they do not seem to have aroused the cacophony of unpleasant and misogynistic comments that Degas's pictures did. In part, however, this was due to the discretion with which Lautrec exhibited them, for example, in a private room off one exhibition.

### Lesbian Themes 1892-1898
Lautrec's lesbian paintings, aside from a few images of women dancing together, drinking in the lesbian bars of Montmartre or attending the theater, have usually been treated as a subsection of his brothel pictures. Lesbianism was common among

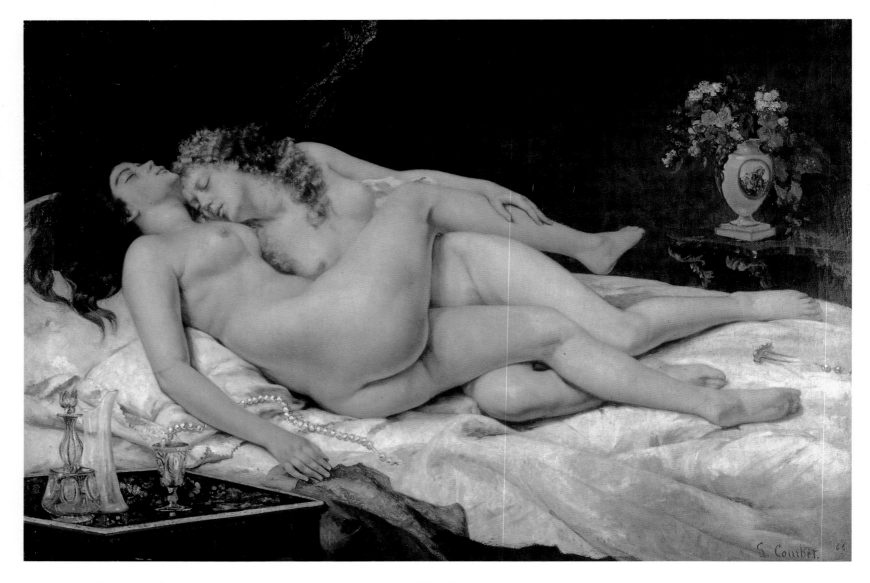

prostitutes living in brothels, and both male and female visitors to the major Paris establishments could pay to voyeuristically enjoy displays of active sex. As one of the most clichéd and potent of male fantasies concerning women, it enjoyed then, as it does now, a substantial market in the sale of pornographic photographs and prints. Lautrec was reputed to have organized lesbian orgies in which he took part. His paintings dealing with the shared intimacy between working prostitutes fall into two broad groups: the various series of couples who kiss, embrace or contemplate each other; and the paintings and studies charting the more mundane side of their shared life, which were made in connection with the *Elles* series of prints. Within the first group there are a few summarily painted pictures which are more active and crudely conceived accounts of physical intimacy (page 126, *The Divan: Rolande*). Another series focuses specifically on a particular couple kissing or snuggled together under a deep coverlet (page 98, *In Bed*). A third group showing still, chemise-clad couples lying together on couches is usually regarded as the apogee of Lautrec's work in

this vein (pages 127-29), and is viewed by many as the finest of all his paintings, while a fourth group suggests humorous possibilities (page 118, *Women in a Refectory*). There is only one painting among Lautrec's images of lesbian couples that even approaches the kind of spectacle that would have been on offer for brothel-attending voyeurs. The majority are characterized by a tender and rather chaste tranquillity which provides a private counterpoint to the public activity of many of his cabaret paintings.

Some present-day cultural historians have scrutinized Lautrec's lesbian paintings for their ideological resonances. Richard Thomson, while strongly defending their sensitivity, has suggested that they nevertheless express a 'double voyeurism': that of Lautrec in constructing them, using prostitutes or models to pose; and also that of the collectors, who were often Lautrec's friends, who bought the pictures for their private delectation. In showing forbidden fruit and a private female activity, Lautrec's lesbian images have troubled certain critics because of the place that they occupy in the more general

scenario of male domination of women in late nineteenth-century life. Thomson considers the fact that they sold better than Lautrec's other paintings to be important, a judgement based upon their being proportionately under-represented in Lautrec's final studio contents.

One feature that continues to make the images 'ambiguous' is that the figures employed by Lautrec sympathetically celebrate not just lesbian love, but human physical affection generally. For example, the short-haired androgynous young couple seen in *In Bed* represent not only a rare Naturalist painting of lesbian intimacy, but also one of the few convincing Naturalist images of any couple in bed. Even the more active pictures within this group, showing the couple kissing, do not immediately read as definitely male or female – a fact upon which Lautrec may have deliberately played.

Any possible revulsion that Lautrec may have felt toward certain of these women, and any more ambiguous connection with certain Decadent stances of disdain toward their perceived venality, are touched upon in the entries on individual paintings.

Below: Lautrec's many black and white lithographs of avant-garde and conventional theater include this 1894 print, *The Swoon*.

Bottom: Lautrec painting *The Dance at the Moulin Rouge*, c.1894; various other paintings can be identified in the background, including *In The Circus Fernando*, with the stepladder that Lautrec used to paint it.

## Stage and Theater Pictures 1885-1900

Lautrec's involvement from 1893 onward with the Natansons and the *Revue Blanche* circle brought him into much greater contact with avant-garde intellectuals. The editorial secretary of the *Revue Blanche* was the anarchist civil servant, Félix Fénéon (1861-1944), who had written reviews supportive of Lautrec since his appearance in the Independents in 1889. Fénéon, whose many roles in life included bombing bourgeois restaurants, was involved with several small experimental Symbolist and Naturalist theater groups, such as the Théâtre l'Oeuvre, run by Lugné Poë (1869-1940), and the Théâtre Libre, organized by the actor André Antoine (1858-1943). In January 1895, for the play *The Terracotta Cart* performed at the Théâtre l'Oeuvre, Lautrec designed a lithographed program which depicted Fénéon declaiming from a howdah atop an elephant (the beast had a curiously close resemblance to that in papier mâché which stood in the garden of the Moulin Rouge). He also designed the scenery for the fifth act. The play, translated from Sanskrit, Lautrec found 'very interesting but not easy'; its subject concerned courtesans which at least was familiar territory to him. Lautrec designed various posters, handbills, programs and stage sets for Lugné Poë. His busiest involvement was 1893-96. He worked alongside Vuillard and Bonnard on the scenery for a production of Alfred Jarry's notorious *Ubu Roi* in 1896, but unfortunately no visual record of this venture survives.

Among writers whose works were premiered or performed within these two theaters were Gide, Gorky and Oscar Wilde; other artists involved included Vallotton, Maurice Denis and Edvard Munch. The overlap between *demi-mondaine* Montmartre cabaret life and this intellectual milieu is evidenced in, for example, Munch's program design for the performance by Jane Avril in the 1896 Théâtre l'Oeuvre production of Ibsen's *Peer Gynt*. Similarly in Lautrec's famous 1892 poster for the *Divan Japonais* (page 108), the Symbolist critic Edouard Dujardin (1861-1949), editor of the *Revue Wagnérienne*, occupies the foreground of the cabaret along with Jane Avril. Despite Lautrec's four-year involvement with avant-garde theater, however, there is virtually nothing in his letters or in other reports to suggest that he was intellectually engaged by this pantheon of *fin-de-siècle* giants; in fact, the contrary seems to have been the case. He managed to fall out with Mallarmé after parodying him in front of mutual friends.

Typical of the sort of anecdote that survives about Lautrec is the famous occasion when, at one of Natanson's parties, Lautrec took the role of barman and, for once remaining sober himself, dispensed lethal cocktails all night, which left the cream of Symbolist Paris dead drunk. The opportunity that contact with the group gave him to design sets and three-dimensional spectacles was perhaps of more interest to him than theory or argument.

Lautrec's earliest theater paintings are his invented views of dancers performing, which he made in the mid-1880s, in imitation of works by Degas (pages 38, 42).

Unlike Degas, Lautrec did not pursue backstage knowledge or try to learn the exact steps used by dancers at the Opéra. Nor was he particularly attracted by the interstices in performances – those moments of exhaustion, collapse or off-guard relaxation that Degas liked to catch. Lautrec's generally preferred viewpoint was from the front stalls or the stageside box. Monsieur Samary (page 58), Marcelle Lender (page 132) and the clown Caudieux (page 114), are spot-lit, close up and face forward. In his oils and in the many black and white lithographs that he made during the 1890s of both avant-garde and more established theater productions, Lautrec usually adopted a viewpoint reminiscent of the performance as potential purchasers might have seen it, rather than more complex back views, top views or indeed, any of the experimental angles or positions he used for portraits and other subjects.

Lautrec's interest in theater was extremely catholic, ranging from Molière performed at the Comédie Française to light-hearted operetta. Curiously, his most serious and systematic essays in theater painting came not as a result of involvement with the metropolitan avant-garde, but toward the end of his life, when he was living in Bordeaux, where he was inspired by the altogether more traditional lyric drama of Messalina (pages 166 and 168). These conservative and rather menacing pictures, structured in certain cases like history paintings, suggest a more reflective viewpoint and have been read as indicative of Lautrec's concern about his own physical decline.

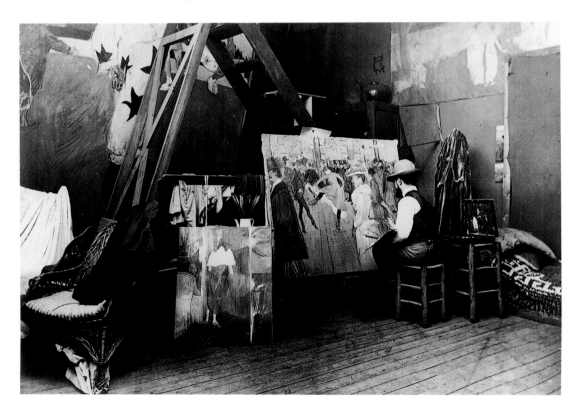

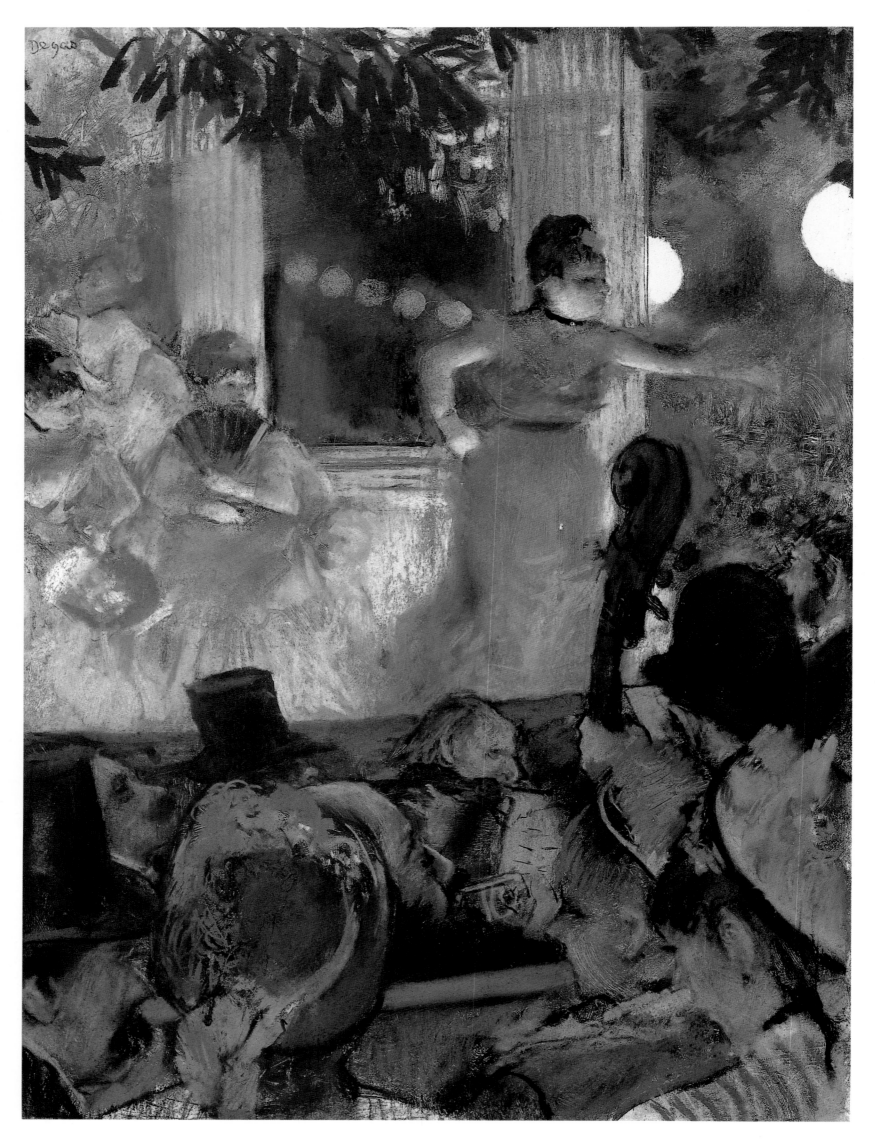

Below: Lautrec at Malromé, his mother's home, two weeks before his death in 1901 at the age of 36.

Bottom: José Ferrer as Lautrec with Zsa Zsa Gabor in John Huston's film of the artist's life, *Moulin Rouge*, 1952.

## Physical Disintegration 1899-1901

The simple facts about Lautrec's chosen lifestyle are that he was probably alcoholic by his mid-twenties and syphilitic by about the same time. Although the number of paintings that he produced each year declined after about 1895, there is little evidence, contrary to what has often been suggested, that Lautrec's artistic powers seriously declined. There are, of course, examples of poor drawings or prints hurriedly made when he was half crazed with drink, but when placed alongside wonderful later pictures like *Tête-à-Tête Supper* (page 160), or *The Milliner* (page 170), they do not appear typical.

Lautrec was well aware that he was killing himself. In the calculation of his options, there were considerations that are perhaps known only to those who suffer from great disability or live, as he did, with severe pain. The urge to live life fully, albeit recklessly, to cheat the early death that would probably have been his lot anyway, is not an unfamiliar choice. Lautrec, who was so dispassionate in his paintings and drawings of all around him, was equally and unromantically clear about his own emotions and possibilities. During the sixteen years of his mature artistic career, from leaving Cormon's studio in about 1885 until his death at his mother's chateau at Malromé in 1901, he produced a very large body of work. It is simply not possible to paint over 700 oils, and produce over 350 prints and posters of the quality that he did, without being an extremely dedicated artist. Despite the reports of sitters like Paul Leclerc which suggest that Lautrec had a disdainful attitude to long working hours, the pictures themselves, not least Leclerc's own portrait (page 152), belie any such suggestion. Lautrec may indeed have managed the myth of his own effortless facility as carefully as he organized his public showings. Monet was given to a similar vanity.

Crisis for Lautrec came in early 1899. His drinking had become increasingly heavy, he was showing signs of temporary insanity and the surviving reports from his many friends suggest that he was becoming uncharacteristically rude and offensive. His mother, having lived around the corner in an unfashionable street in order to be close to him, left Paris. Lautrec's collapse thereafter was fairly rapid. He was compulsorily confined for a few months to a detoxification clinic at Neuilly, where he made a rapid mental if not physical recovery. For a further two years his family deliberately rationed his allowance and appointed as his guardian Paul Viaud; 'my

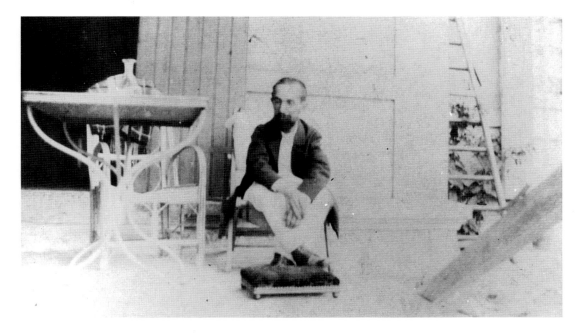

elephant keeper' was how Lautrec described him. Attempts to prevent him drinking failed, and on September 9th, 1901, following a paralytic stroke, he died.

Lautrec's brief life had been surprisingly structured. He kept each year to more or less consistent patterns of visiting family or friends, hunting, sea sailing and travel. Although his early art shows the countryside and its sports, most of his subsequent work is focused upon Paris or upon individuals. Yet Lautrec was generally absent for months at a time from the capital, in the country or at the sea with his friends. Little of this found its way into his art. Lautrec had many close friends and he seems to have inspired great loyalty. Following his death, Maurice Joyant and others worked for three decades to establish a Lautrec Museum at Albi, for the display of the pictures left in his studio at his death and also of others like the Dihau portraits (pages 66, 68) which were bought back. Many of Lautrec's paintings, including his masterpiece of brothel life *The Salon at the Rue des Moulins* (page 122), now hang in the rooms of the disused bishop's palace sited alongside Albi cathedral: a delicious irony that Lautrec himself would have enjoyed, not simply for its incongruity, but also for its suggestion of universal human weakness and corruptibility.

## Self-Portrait in Front of a Mirror

1880

Oil on board

16×12⅞ inches (40.5×32.5 cm)

Musée d'Albi

The only serious oil portrait Lautrec ever made of himself was this, painted when he was 16. Although he subsequently painted and drew many self-caricatures and showed himself in several minor walk-on or bystanding parts in his paintings of Montmartre nightlife, Lautrec seems to have been reluctant to pin down too closely his own features, despite a lifelong fondness for having his photograph taken. The recent publication of all Lautrec's surviving letters suggests that he had a similar reluctance to chronicle his own feelings or reactions.

Despite its small scale, this is an ambitious painting in which the young Lautrec displays his control of close-toned modelling and subdued facture, and a readiness to experiment with complex spatial relations. There is little evidence of the rhetorical *brio* copied from Princeteau's paintings which is seen in the following picture. Although traditionally dated to 1880, the greater sophistication of handling in certain parts has led to suggestions that Lautrec may have reworked this (or painted it entirely) in 1883, following his training with Bonnat and Cormon and after seeing portraits by Manet.

As well as being his earliest and only autonomous portrait, this is one of Lautrec's very few concentrated attempts at still-life painting. The clock surmounted by a boar and the dull silver candlestick have a greater physical solidity and more immediate presence than the rather distant mirrored figure of the artist, who seems to hide within the half-shadows. The very obvious symbolic associations that clocks and candles have, evoking passing time and the inevitability of death, are just the sort of morbid clutter that one expects from a young artist making his first stab at *gravitas*.

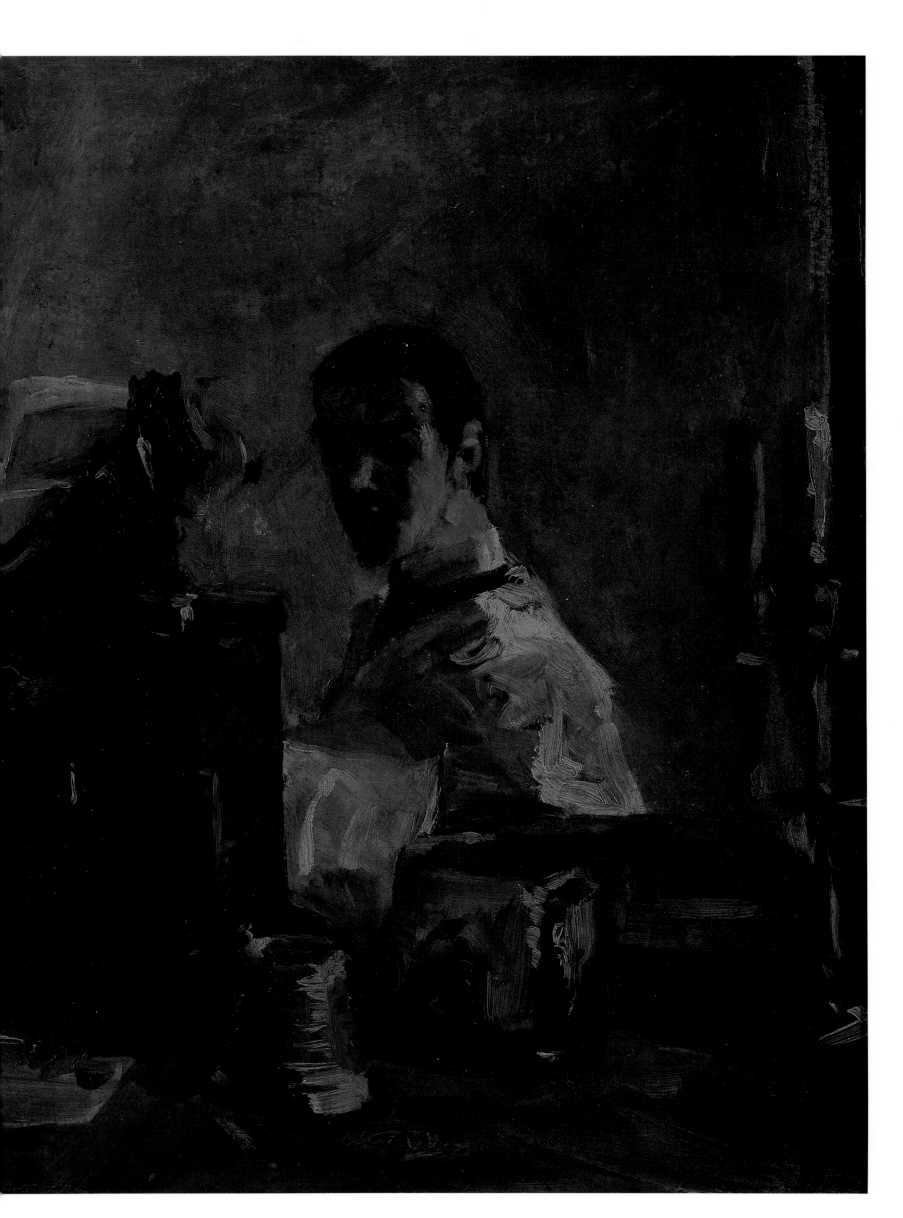

## The Mail Coach, A Four in Hand

1881
Oil on canvas
15½×19¾ inches (39×50 cm)
Musée du Petit Palais, Paris

The majority of Lautrec's many adolescent drawings and paintings are of horses and hunting. Both his father and his uncle Charles were reasonably talented gentlemen-amateur artists, and there was a family tradition of field painting and drawing that stretched back three generations. This painting, inscribed *'Souvenir de la Promenade des Anglais'*, was made while Lautrec was convalescing in Nice in early 1881, and is one of a group of portraits of his father made at this period. Showing him hunting, hawking and riding, these exuberantly active depictions of the Comte contrast with the placid contemporaneous portraits made of his wife. For Lautrec, cooped up at the Hotel Pensione Internationale and bored with the bad weather and dull company, this and related works were a reminder of the busy summer outdoor activity of family life centered upon the Château du Bosc. Although partly painted from preparatory sketches, it was probably principally made from memory.

In his approach to his subject and in the use of large emphatic brush strokes, Lautrec was strongly influenced by the work of René Princeteau (1839-1914), his father's favorite artist, who was a regular visitor to the family home and was his first professional mentor. Lautrec made copies of Princeteau's work at about this time and gradually acquired the superficially facile paint handling evident here, which masks his own lack of any deeper understanding of form or pictorial structuring. With pictures like this he may have been trying to impress his family. When Lautrec was 12, his father had inscribed a book on falconry for him:

Never forget my son that the only really healthy life is lived in the open air and in daylight. Once freedom is removed things wither and die. . . . If ever you should feel the bitterness of life you will find horses, hounds and falcons will be boon companions who will help you to forget your suffering.

While analysis of Lautrec's life and art has sometimes tended to place too great an emphasis on links between his disabilities and his subject matter, these early horse paintings, which so forcefully chronicle the robust lifestyle from which he was excluded, are especially poignant.

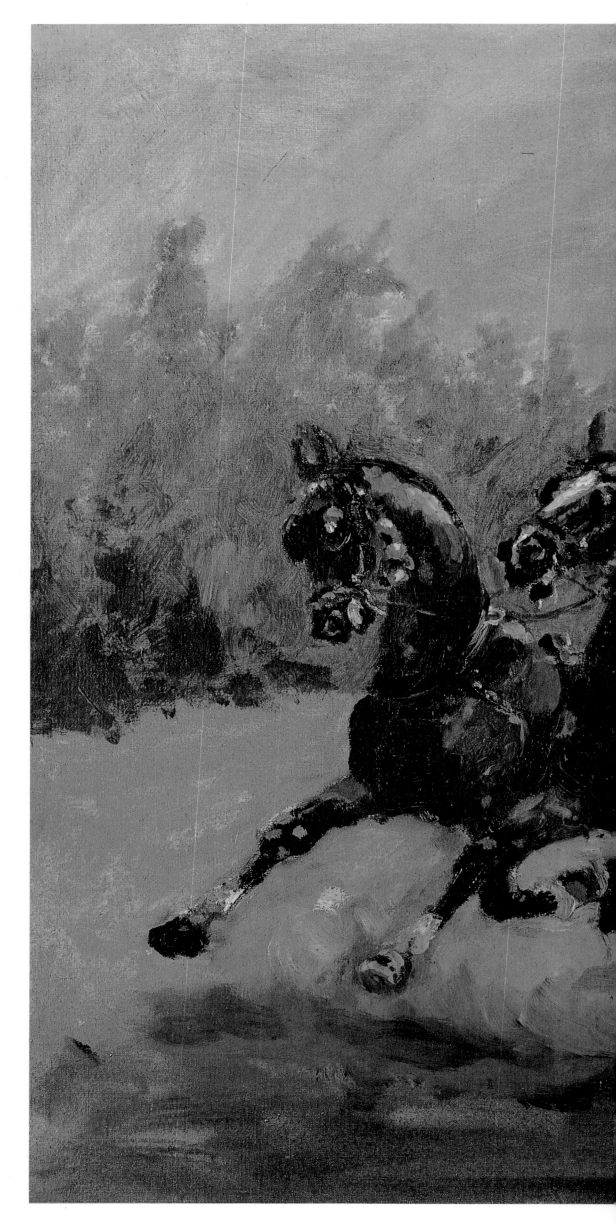

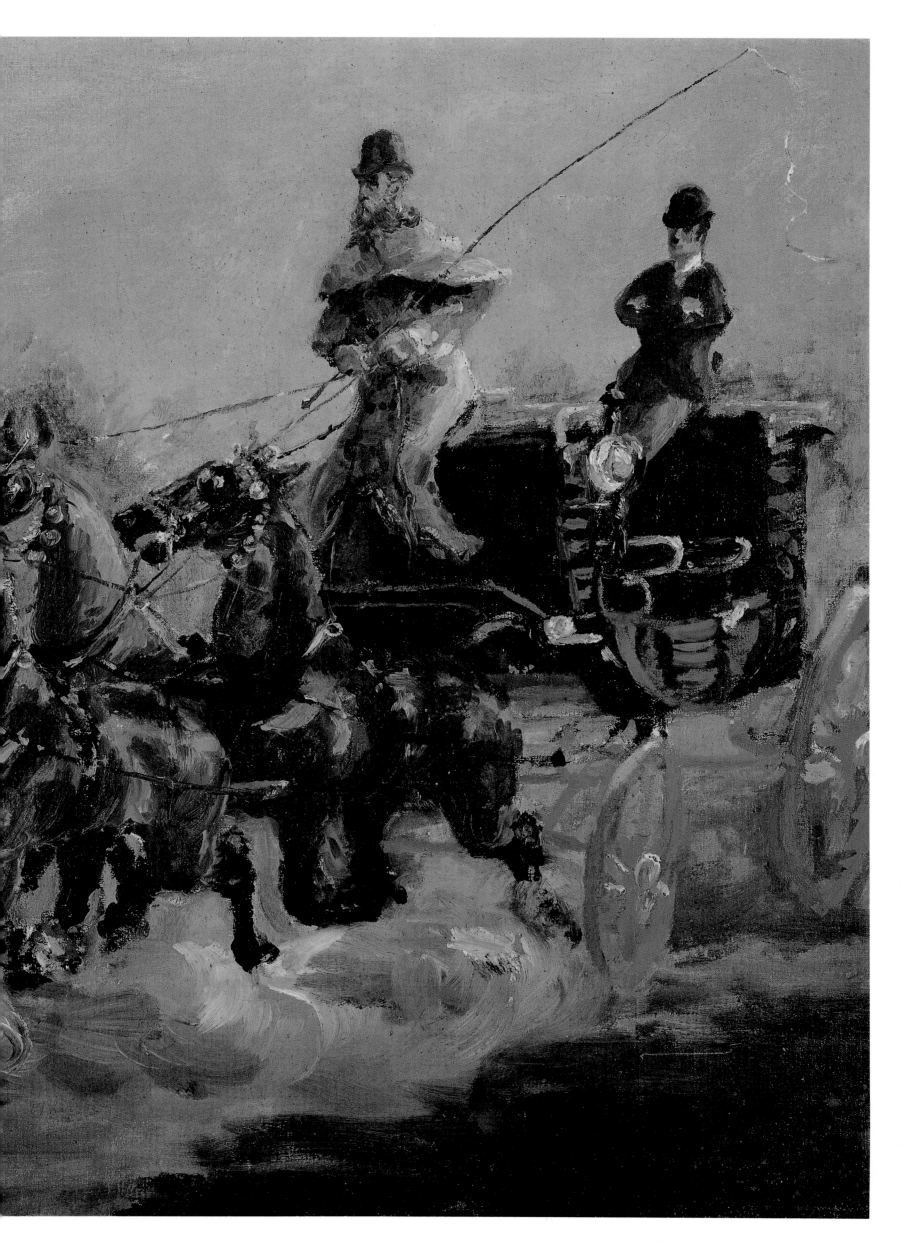

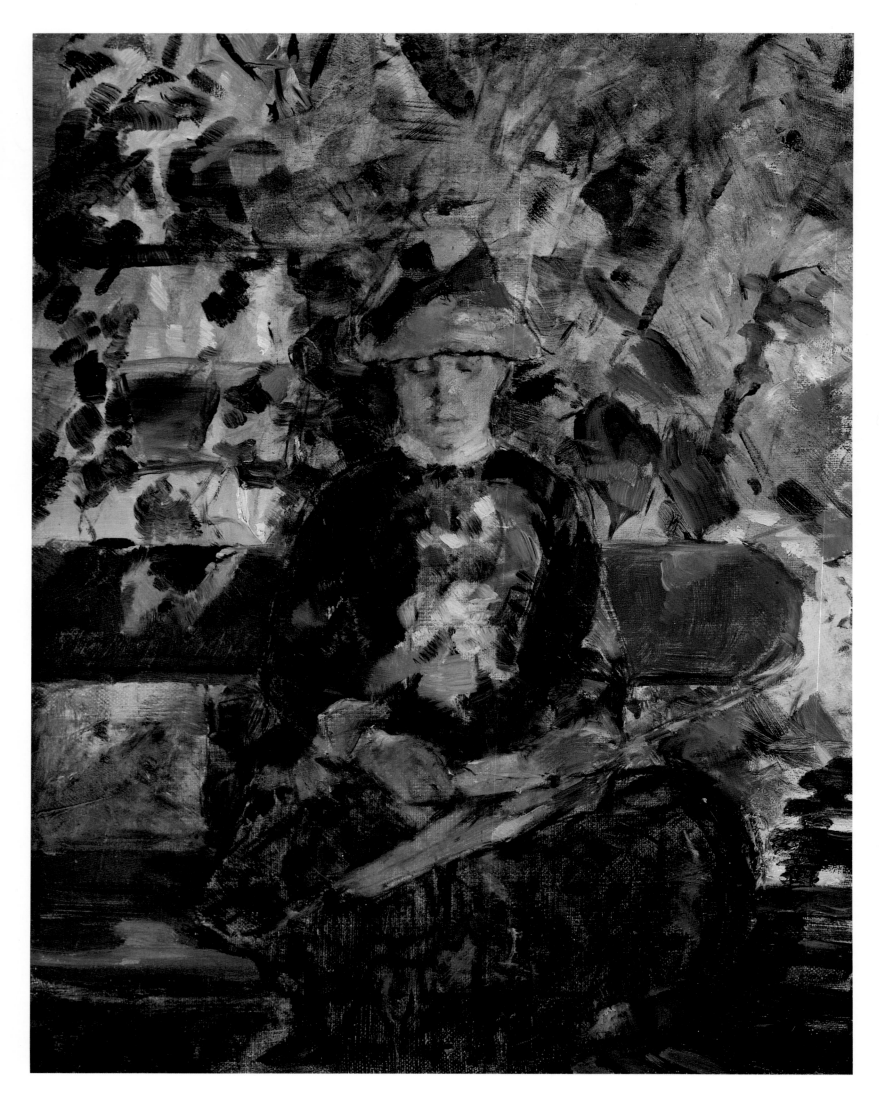

## Comtesse Adèle de Toulouse-Lautrec 1882

Oil on canvas
16¼×12⅞ inches (41×32.5 cm)
Musée d'Albi

'Vive la Revolution! Vive Manet! The breeze of Impressionism is blowing through the studio', wrote Lautrec to his mother in April 1883. This portrait of the Comtesse, painted nine months earlier, is among his first experiments with impressionist technique. With its sunlight falling through a canopy of leaves and casting dappled patches of dark and light across Madame Lautrec, it is redolent of similar subjects painted during the 1870s by Monet, Renoir and others. Direct connections may be made with three Impressionist pictures that were possibly seen by Lautrec in 1879-80. The first, *In the Conservatory*, painted by Manet and exhibited at the 1879 Salon, shows a woman seated on a bench. The second, *Le Jardin* by Mary Cassatt, has a similarly bonneted woman seated out of doors and was exhibited at the Sixth Impressionist Exhibition of 1881. The third, shown at the same exhibition, is Berthe Morisot's *Nurse and Baby*, portraying a woman on a bench in a pose similar to

that of Lautrec's mother. Indeed, it is the broken, open paint handling of Morisot rather than Manet's closer and more compact touch that is most strongly evoked in this picture.

Lautrec's reluctance to write down or state precisely his artistic influences makes it difficult at times to chart his progress. All young artists borrow, usually more than they realize or are prepared to admit. In the pursuit of precedents for this picture there is, however, another possible candidate whose works were not at this time on public display, except for one picture at the 1882 salon and in the Montmartre shop of Père Tanguy, who supplied several Impressionist painters with materials in exchange for pictures. Here works by Cézanne could be seen: pictures with large loose slabs of varied dark and pale green, with flat abutting and overlapping patches of blue and with pale ocher backgrounds, all of which have a curious affinity with the handling in this painting.

## The Young Routy at Céleyran

1882

Oil on canvas
24⅛×19¾ inches (61×50 cm)
Musée d'Albi

Probably painted during summer 1882 at Céleyran, this portrait of Routy, a young worker on the family estate, was preceded by several elaborate charcoal and pencil studies, one of whch is the basis for this picture. There is also a similarly posed oil version, much darker and with a more elaborate build-up of foliage. Both oils and the related drawings are displayed together at Albi, and they indicate well the advances that Lautrec's figure drawing had made following a few months' study with Bonnat, as well as revealing the problems that he continued to have with tonal modelling in oil.

In the first oil version, Lautrec attempted a layered build-up of close-toned pigment that ended up as a murky and undifferentiated gloom. In this second version he plays safer, using dilute glazes applied by brush, and with substantial areas of paint scraped down with a palette knife to reveal the pale canvas weave. Although the foreground is delicately modulated, it is not rigorously modeled. While sufficient visual interest is maintained by using a dapple of gray and ocher at the front and variegated greens and yellow at the rear, paint in this work is ultimately subordinate to the drawing of the

central figure and has been used to go over and strengthen line and shadow already delineated in charcoal.

Connections have often been suggested between this work and Lautrec's burgeoning interest in Impressionism. However, there is no evidence that he painted this work out of doors, and although there is a superficial similarity between the paint facture and that used by Renoir and Monet, there does not appear to have been any attempt to model form, or describe foliage as it appears under the complexity of direct or indirect sunlight. Lautrec was undoubtedly concerned to explore the depiction of figures in landscape, as the portrait of his mother (page 28) and other pictures of family estate workers made at this time show. But the pedigree for this kind of subject lies in pictures by Millet and others who sought to depict the integrity of agricultural labor. As such, it is better seen as part of Lautrec's more general quest in 1882 to resolve his own connection with Realism.

The conflict between line and pigment remained central to all Lautrec's art. At the very end of his life he was still seeking the resolution of the problem that he tackled in this painting, made when he was 18.

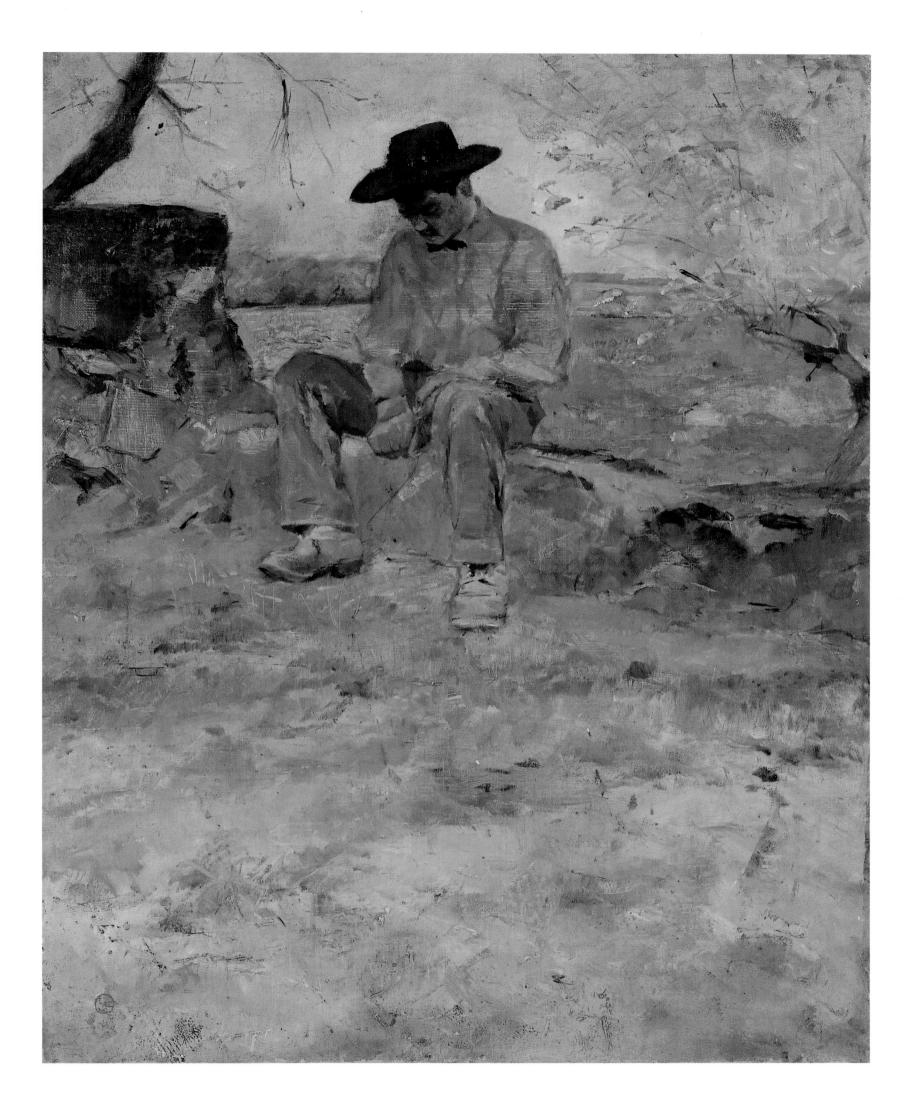

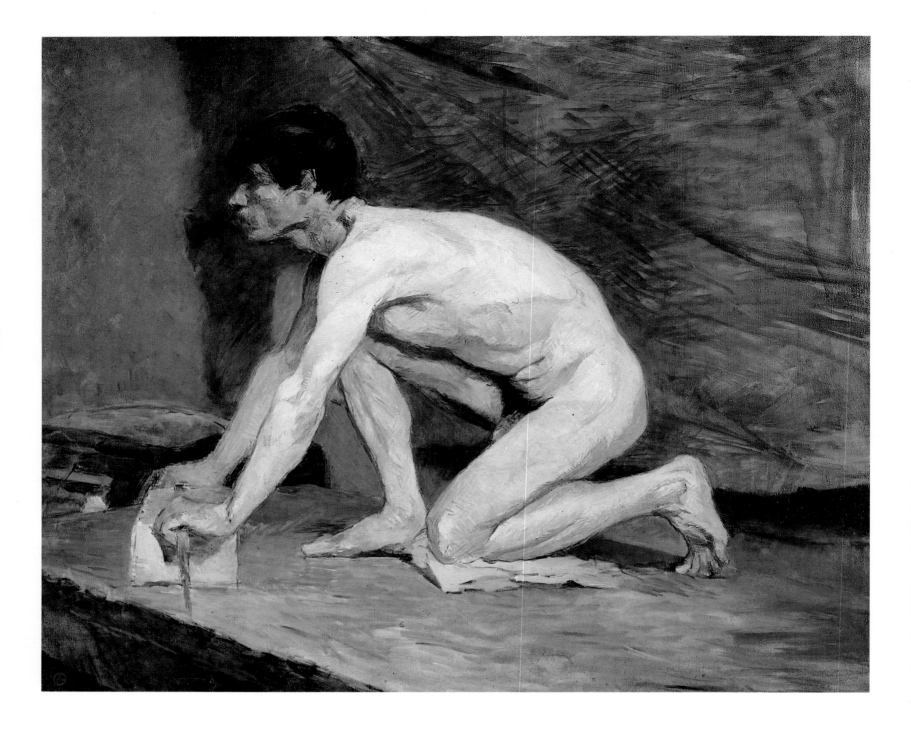

## Academic Study of a Male Nude

1882

Oil on canvas
25½×32 inches (65×79 cm)
The *Forbes Magazine* Collection,
New York

This study of a male nude polishing a piece of marble was possibly the first work done by Lautrec in April 1882 under the supervision of his new master Léon Bonnat (1833-1922). Bonnat by this date, in his own fashionable portraits, employed a synthesis of his initial youthful Realism with safe academicism. In setting up the pose of this model for his students, he reveals the duality of his approach.

As a young scholarship student at the Villa Medici in Rome, Bonnat studied alongside Degas. Together they had explored Realist themes, encouraged by the Director of the Académie de France, Jean Victor Schmetz. The problem of how the nude might be treated in a Naturalist fashion, while at the same time retaining the universal formal significance that it had aspired to within classical values, was an issue that preoccupied certain Naturalists. It ultimately influenced Degas's

approach in his 1886 *Bather* series. Lautrec's figure, while posed in the action of ordinary work, also has something of the static grandeur of more traditional poses inspired by classical sculpture, such as the statue of the so-called *Arrotino* or *Roman Slave Whetting his Knife*, in the Uffizi.

Lautrec's handling is unsure, and his colors imitate the dark residually Realist palette for which his master was famous. Lautrec respected the strictness of Bonnat's regime and modified his own drawing to fit the vigorous style that Bonnat favored. In May 1882, after a few weeks study, Bonnat commented upon Lautrec's work: 'Your painting is not bad, it has flair which is not bad, but your drawing is quite honestly atrocious'. Despite this discouragement, Lautrec continued to improve and strengthen his graphic line and later spoke with approval of the 'lash' of Bonnat that had helped to tighten up his art.

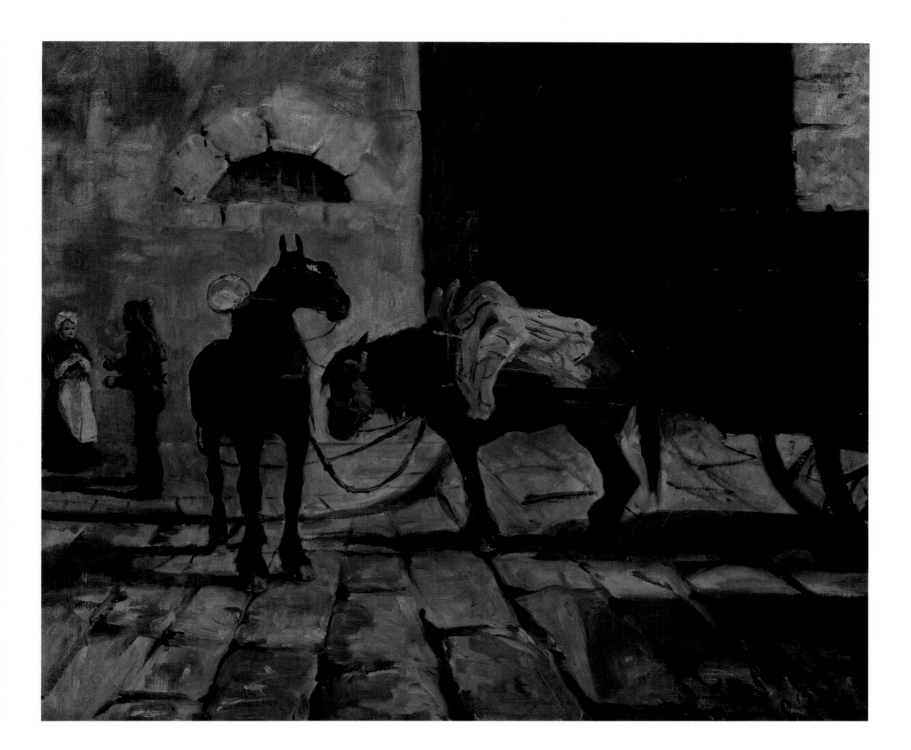

## Céleyran; A Waggonful 1882

Oil on canvas
19⅝×24 inches (49.7×60.9 cm)
Musée d'Albi

This claustrophobic picture is the only example in Lautrec's early work to suggest a more socially-committed Realism. As one of several 1882 pictures in which he explored differing approaches to Realist subject matter, it is of particular interest in charting the parameters that Lautrec developed for his art. It shows a servant woman, and a carter delivering coal or some other fuel, accompanied by two horses and a cart. The paint is predominantly gray, green and cream, loosely applied. This drabness of color and the absence of a horizon helps to create a rather somber, even depressive mood. The decrepitude of the horse between the shafts also seems to invite spectator sympathy. What is difficult to determine is whether Lautrec had more ambitious intentions for this subject – as a narrative painting, for example, or as some more profound statement about the events depicted. Although the woman and man are talking together, and her clasped hands and his open-armed gesture could just about be read as indicative of conflict, this is not enough to give a clear lead.

What principally fuels speculation about any possible grander intentions that Lautrec might have had is the way that the painting is structured. The composition is simple and clear, with crudely outlined orthogonals of stone-flagged road receding toward the uniform plane of the back walls. The figures are organized into a frieze across the picture. Behind them, the dense flat block of background shadow is almost square in shape. A simple, dark, semi-circular window in the back wall shares this geometric lucidity. Lautrec's construction evokes the pared-down organization of Neoclassical pictures, and within such a format one might legitimately seek for gravity of subject.

In approach, this picture has a curious affinity with the dark drawings and muddy pictures made about this time by Van Gogh. Lautrec, however, did not share Van Gogh's wish to save the poor, nor was he temperamentally inclined to highlight their maltreatment. He soon shifted his attention to portraits and the altogether more exotic metropolitan nocturnal *demi-monde*.

## Woman Seated on a Divan 1883

Oil on canvas
21⅝×18⅛ inches (55×46 cm)
Musée d'Albi

Previously dated to early April 1882, before Lautrec came under Bonnat's tuition, this study is now believed to have been painted in the following year and is possibly set in the studio of Cormon, Lautrec's second Parisian master.

Commentators upon this work have usually mentioned, but have tended to play down, the suggestion of any voluptuousness, and have emphasized rather its formal qualities and the still dignity and air of defencelessness of the woman. Posed thus by Lautrec, however, naked but for her shoes, stockings and garters and sucking at the tip of her forefinger, this model hovers rather ambiguously between calculated archness and a more straightforwardly innocent image.

Positioned in profile with her torso in the center of the picture and her stockinged legs describing a partial diagonal, the model has an almost diagrammatic formal clarity. Lautrec here explores the positioning of a figure in relation to an interior and describes the fall of light upon both. His muted neutral-toned palette is deliberately limited. Paint has been put on with a similar feathery edge to that used in parts of the Routy portrait of the previous year. While Lautrec's accommodation to the forceful modelling taught by Bonnat is evident in other nudes painted during 1882-84 (see pages 32, 36), here he appears to be attempting something softer and less dependent upon strong line. The approach did not last long; from 1884, apart from his dalliance with pointillism, line became his dominant mode for describing form.

Lautrec in this painting also evinces an early interest in depicting the female model with her eyes covered by her hair, a mildly erotic touch that further suggests the titillatory approach that Lautrec took with this work.

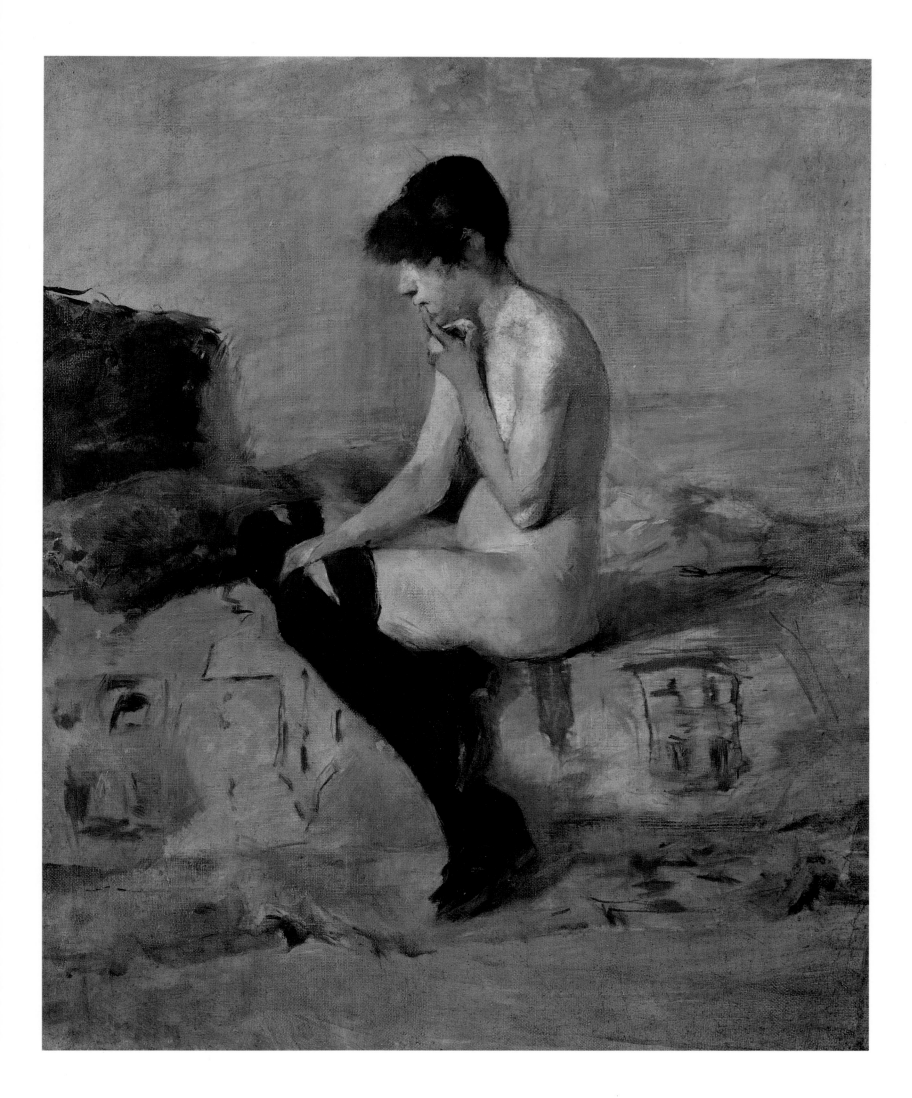

## La Grosse Maria 1884

Oil on canvas
31⅛×25¼ inches (79×64 cm)
Von der Heydt Museum, Wuppertal

La Grosse Maria, who modeled this figure study, was a Montmartre prostitute. Lautrec possibly chose her from among the many men, women and children who gathered each morning in the Place Pigalle to offer themselves as models to the artists of the locality. Unlike *Woman Seated on a Divan*, 1883 (page 34), in which distance was maintained between the viewing spectator and the posing figure, here an almost confrontational directness is used. The model is made to stare straight ahead. Her legs are cropped by the bottom edge of the picture, which helps to thrust her into uncomfortable proximity with the viewer, and Lautrec has positioned her so that her pubic hair is central to a pose of confident lolling availability.

This was probably the first time that Lautrec used a prostitute as a model. His subsequent pictures of them as individuals or groups tend to be affectionate and very specific accounts of their work or rest. Here, however, he seems to be attempting something symbolic or even archetypal.

Joyant's alternative title for this picture, *The Venus of Montmartre*, also suggests such a universal reading.

On either side of the model's head, floating against the dark background, are two masks. One is indistinct and seems to have a feathered, bird-like tail. The other is a Japanese actor's mask but shown without eyes; the effect is disconcerting, even faintly menacing. If Lautrec was seeking to describe a 'type', a metropolitan Venus of the streets, then this mask may possibly be read as a symbol of blind Cupid awaiting the bidding of his enthroned mother. The use of such detached, unreal images, intended as some symbolic amplification of the essential theme of the picture, is most unusual in Lautrec's art, and more characteristic of the work of some of the younger Symbolist artists that Lautrec later exhibited with. Mytho-poetic generalizations, and the quest for any significance beyond the realm of mere appearance, were not of great concern to an artist for whom reportage was paramount.

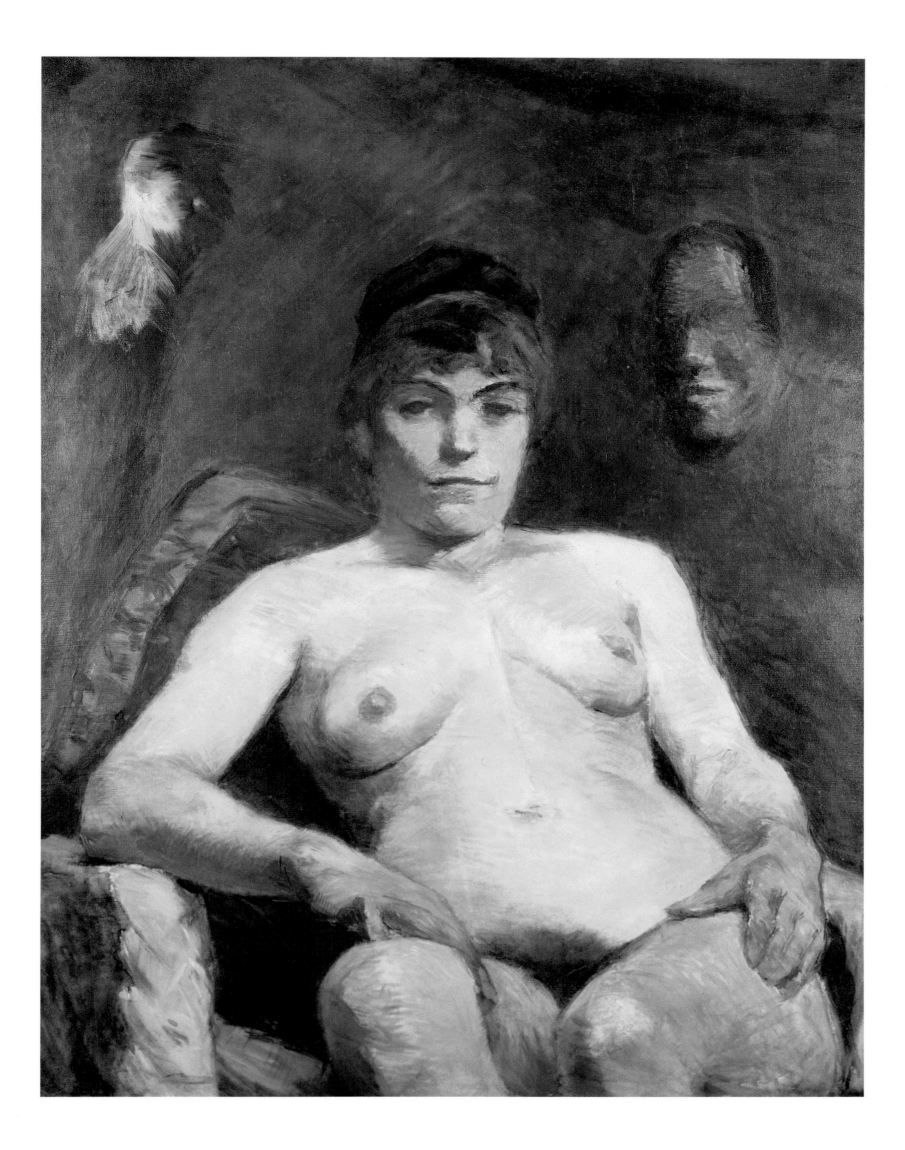

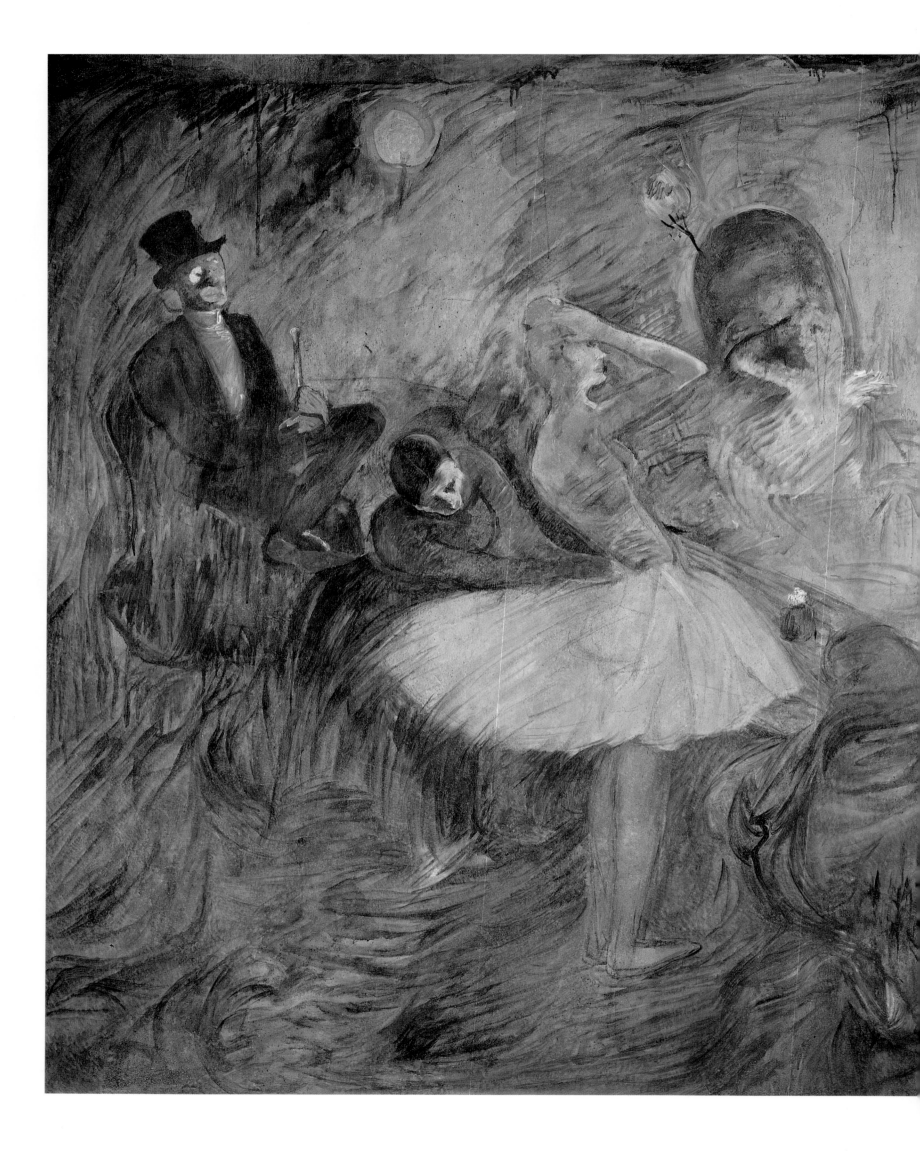

## Dancer in her Dressing Room

1885
Fresco transferred to canvas
45¼×39¾ inches (115×101 cm)
Private Collection

Parisian ballet dancers had as potential 'protectors', the rich *abonnés* of the Opéra. Among the most select of these were the 50 members of the French Jockey Club, who had exclusive use of the seven boxes that flanked the Opéra's stage. Low wages for dancers, long apprenticeship and the difficulty of achieving individual success, contributed to the conditions of borderline prostitution that prevailed within the dance. Lautrec's picture shows a 'star', successful enough to have her own dresser and a dressing room, where she can entertain the protector who here watches her undressing with such beaming proprietorial approval. Manet's painting of *Nana*, rejected on moral grounds by the Salon jury of 1877, was perhaps the first major Naturalist painting to starkly highlight the easy relationship betwen a rich male and a half-dressed woman in her stage dressing room. Degas too showed the *abonnés* of the Opera, less often in dressing rooms but rather in the wings or backstage during a performance, exploiting the almost complete freedom that they had to use the building. Lautrec's painting suggests the

influence of both these artists. He may have attended the sale of Manet's studio contents in February 1884, where *Nana* was sold for 3,000 francs.

Lautrec made this and three other dance murals to amuse himself for a local inn, L'Auberge Aucelin, at Villiers-sur-Morin, some time in 1885-86 while on one of his visits to his friends the Greniers, who owned a house in the village. The other subjects, which were either painted on plaster like this or on to panel, are a chorus line of dancers with the conductor's hands, the gallery of a theater, and a stagehand summoning dancers to rehearsal. When these were clumsily removed from the walls of the inn after 1913, surface cracking was substantial and there was some loss of paint. This was partly because they were not true frescoes painted in watercolors, which would have sunk into the plaster, but were executed in oil which remained a brittle surface skin.

Although connected with Lautrec's dance paintings on canvas at this time, this group as a whole is more loosely composed and more humorous in conception.

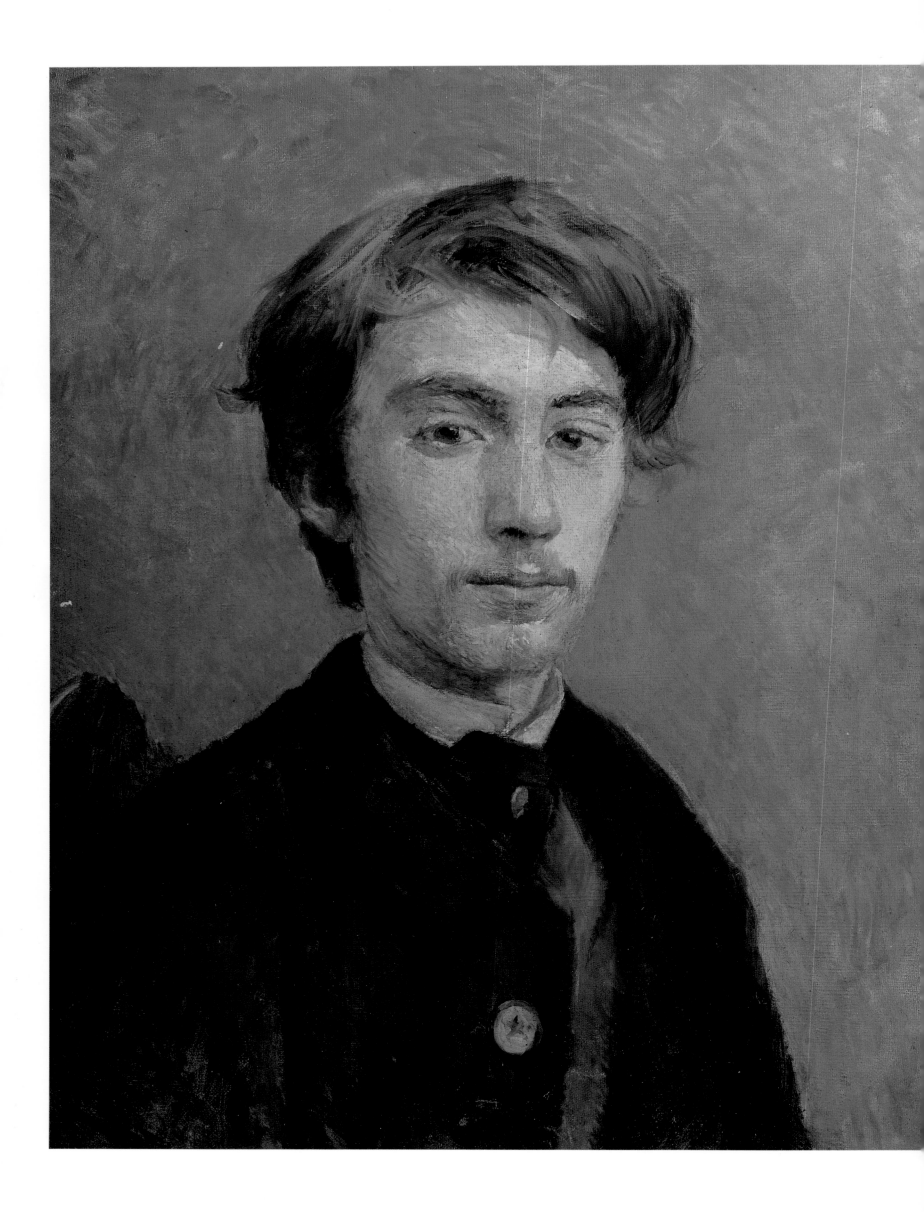

## Portrait of Emile Bernard 1885

Oil on canvas
21¼×17¾ inches (54.5×45.5 cm)
Tate Gallery, London

Emile Bernard (1868-1941) studied with Lautrec at Cormon's atelier from 1884 until 1886, when he was expelled for 'insubordination' by the normally tolerant master. Bernard's adolescent opposition to Cormon's academic training was vocal but not particularly consistent, and by summer 1886 he had shifted from broad support for Impressionism to advocating the more doctrinaire Pointillist theories of Seurat. Bernard's own contribution to avant-garde theory was his evolution from 1887 onwards of 'Cloisonnism', a style of painting using flat colored shapes within clearly defined black or blue contours, which superficially resembled cloisonné enamels and had a more obvious affinity with Japanese prints.

In his memoirs Bernard recalled that, for this portrait, Lautrec needed twenty sittings, 'because he could not harmonize the background and the face.' Using a dense, small brushstroke that follows the contours of Bernard's cheek and chin, Lautrec succeeds in capturing the seriousness of the young artist but, as Bernard himself hints, it is a rather over-wrought image and Lautrec did not subsequently employ such a loaded brush or such minutely detailed skin modelling.

Although Lautrec and Bernard were, for a while, on friendly terms, the younger artist did not have any significant influence on Lautrec's art, other than perhaps the part that he played in the general discussion of contemporary ideas. Lautrec's indifference to precise theory or doctrinaire codification distanced him from Bernard's reductive theorizing. Later, Cézanne too became impatient with Bernard's doctrinaire descriptions and wrote to him in 1904 suggesting that he should abandon his 'literary spirit' that led to 'intangible speculations' and 'obstructions'. Bernard's later painting career, which lasted well into the twentieth century, was taken up with rather bland pious Symbolist landscapes that never fulfilled his youthful promise.

## Dancers 1886

Oil on canvas
17⅜×34 inches (44×86cm)
Thielska Galleriet, Stockholm

This is the largest and most fully-resolved
ballet painting by Lautrec, and one that is
most imitative of Degas's contempora-
neous ballet pictures. Lautrec's principal
access to work by Degas was at the galleries
of Paul Durand-Ruel and Boussod and
Valadon. During the mid-1880s, these
were kept supplied with a steady trickle of
his more easily saleable ballet pastels. So
many features in this work seem to derive
from Degas's pastel of *The Entrance of the
Masked Dancers in Mozart's 'Don Giovanni'*,
c. 1884, that direct borrowing seems pos-
sible. There are even indications that
Lautrec may have been trying to 'out-
Degas Degas' in the employment of his
own pictorial vocabulary. One of Degas's
most frequently used devices in his ballet
pictures was particularly dramatic crop-
ping of figures and faces in the foreground,
which gave a sense of spectator proximity
and heightened immediacy. He always,
however, managed to retain compositional
tautness. On the left of this picture the
wedge of aqua green decorated with pink
flowers is difficult to decipher; it may be
read either as a stage scenery flat of a bush
or, alternatively, as the erect tutu of a
dancer who has bent forward. The right-
hand foreground cropped figure, while im-
itating Degas's practice is rather more
severe in its cropping than he would have
used. It tends to break up the picture's
overall legibility.

Against the coolness of the green cos-
tumes and scenery, Lautrec sets up con-
flicting, eye-catching areas of warm color:
a red patch behind the head of the *abonné*
of the Opéra who lurks on the left, and also
the peach glow of the line of background
dancers on the right. The raked stage, with
its dramatic receding orthogonals, pulls
vision in toward the stage center, but in the
absence of any clear central focus the pic-
ture remains uncomfortably fractured, a
dissonance that Lautrec may deliberately
have sought.

Degas always meticulously planned the
appearance of chance or accident in his
paintings, and his dancers were based
upon prolonged study or rehearsals at the
Opéra. Lautrec's contact with ballet was
minimal. This recycled collection of
second-hand motifs as yet lacks the sophis-
tication of Degas's constructive clarity.

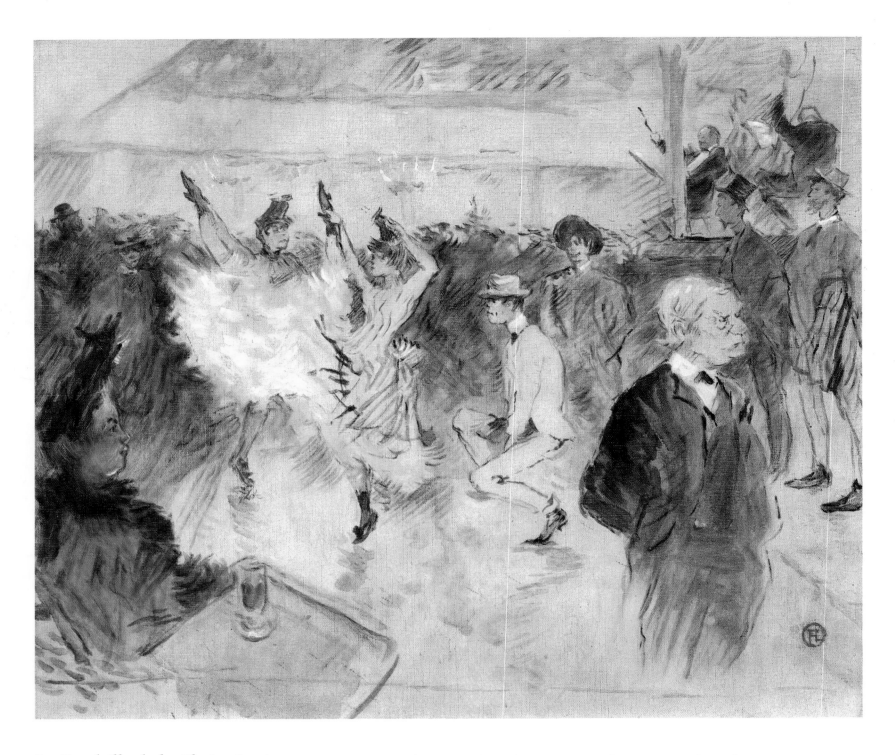

### Le Quadrille de la Chaise Louis XIII à l'Elysée Montmartre 1886

Oil on canvas
18⅛×21⅞ inches (46×55.5 cm)
Private Collection

Mark Twain, after witnessing the cancan on his visit to Paris in 1867 wrote:

The idea is to dance as wildly, as noisily, as furiously as you can; expose yourself as much as possible if you are a woman, and kick as high as you can, no matter which sex you belong to . . . I suppose French morality is not of the straitlaced description which is shocked by trifles.

The impropriety that amused Twain and also attracted so many prurient visitors to Paris was nevertheless kept within certain bounds. The monocled foreground figure in this picture is Commissar Coutelat du Roché, known around Montmartre as 'le père de la pudeur' (father of modesty), whose official function was to ensure that the dancers wore sufficient underwear.

The setting for this, the first of Lautrec's nocturnal cabaret pictures, is the Elysée Montmartre cabaret on the boulevard Rochechouart, which had gained recent notoriety for its revival of the cancan or 'chahut' under the euphemistic title of 'the naturalist quadrille.' Here the three dancers include Grille d'Egôut and the famous La Goulue, who went on to gain an international reputation at the Moulin Rouge. Watching the dancers are the broad-hatted Aristide Bruant and Lautrec's fellow students from Cormon's atelier, Louis Anquetin (1861-1932) and François Gauzi (1851-1925).

Lautrec painted a first version of this picture as the basis for a black and white illustration in Aristide Bruant's magazine *Le Mirliton* (hence the distinctive black and white *grisaille* technique). This second, almost identical, version was commissioned by Bruant for his own collection. The origin of the painting's curious title lies in the Louis XIII chair which was left behind at the Chat Noir cabaret by the owner Louis Salis, when he moved his furniture to larger premises on the rue Laval. Bruant took over the old Chat Noir, renamed it Le Mirliton and refused to return the chair. He hung it high on the wall of his cabaret, and later composed a ridiculous song about it. Lautrec shows him looking extremely pleased at the chair's further misuse in this dance at the Elysée Montmartre, the cabaret next door to his own.

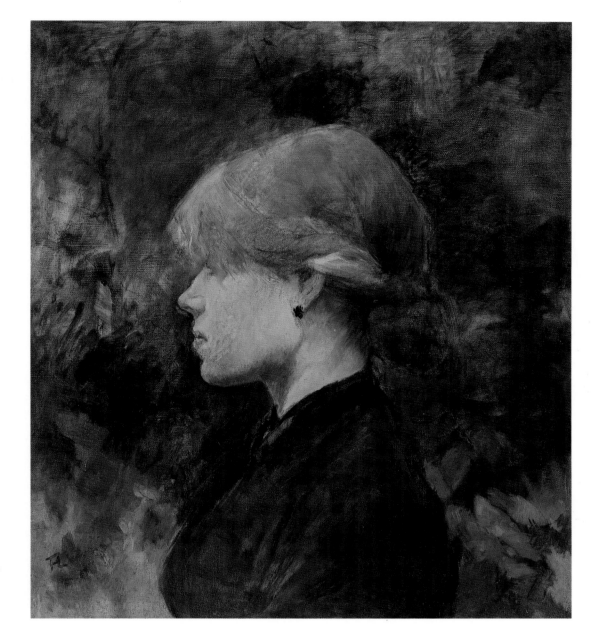

### The Redheaded Girl 1886-87

Oil on canvas
21⅝×19⅝ inches (55×50 cm)
Private Collection

'What an air of spoiled meat she has,' Lautrec remarked to Henri Rachou when they first saw Carmen Gaudin outside a Paris restaurant in 1885. Attracted by the quality of rawness that he perceived in her face, he persuaded her to pose for him. This dark close-toned picture, and four related portraits of her made during 1884-87, represent a more conservative side of Lautrec's early Realist pursuit. As a group they have similarities with the more Salon-safe Realist style of artists like Bastien-Lepage.

Carmen Gaudin is traditionally believed to have been a laundress, a job commonly connected in Paris at this time with casual prostitution, and Lautrec's unpleasant comparison of her to rotting flesh may have been prompted by this fact. In all the portraits that he did of her, however, she is shown in a modest plain white blouse or, as here, wearing a high-collared dress. In this picture she stares sideways; in the majority she is shown looking rather abashed, with eyes averted or hidden by her curiously protruding bifurcated mound of red hair. Lautrec had photographs of Carmen Gaudin taken by Gauzi, and in the side and front views that he painted of her it seems likely that he worked at first or second hand from these photographs. Her pose in this picture is redolent of the severe profiled portraits made by mid-fifteenth-century Italian artists. The background is token landscape and ill-defined, and is not allowed to distract from the insistently hieratic face.

Throughout his life Lautrec preferred to use red-headed models. This has led at times to confusion. Carmen Gaudin has been linked with 'Rosa the Redhead', another model used at about this time. Lautrec later portrayed Carmen Gaudin in two of the 1890 series of outdoor pictures painted in M. Forest's Montmartre garden.

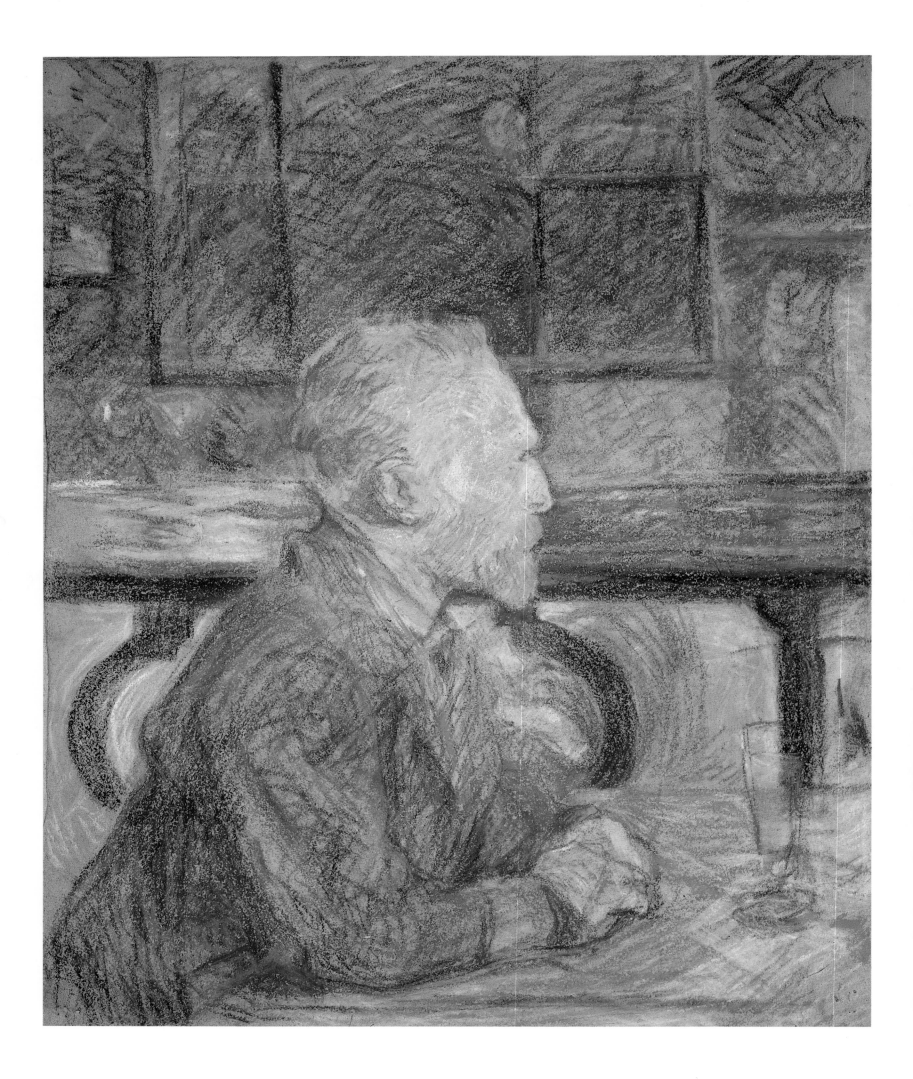

## Portrait of Vincent Van Gogh

1887

Pastel on board
22½×18⅜ inches (57×46.5 cm)
Vincent van Gogh Foundation/Vincent
van Gogh Museum, Amsterdam

Shortly after his arrival in Paris in February 1886, Vincent van Gogh (1853-1890) became a fellow student with Lautrec at the Cormon atelier. Although van Gogh was eleven years older, altogether more earnest and lacked Lautrec's social ease, they nevertheless were on friendly, if not close, terms. Each respected the other's art and there is evidence of cross-fertilization of ideas for subjects (see *Rice Powder*, page 48) and common technical experimentation. At van Gogh's initiative, an exhibition which included works by both artists was organized in 1887 at the Café du Tambourin on the boulevard de Clichy, and this is possibly the setting for this portrait, which was painted at about the same time.

Unusually, Lautrec in this picture used pastel (one of Degas's favored media), and employed the strict profile that he developed for portrait use from 1886. Long, looping, cross-hatched strokes of pastel are used to define forms in a manner similar to that which he was concurrently developing using thinned oil paint.

Van Gogh may have been unaware that he was being sketched. With his hand abstractedly playing, his brow furrowed and the muzzle of his ruddy face thrust forward, he seems absorbed, possibly in discussion. He wrote that he had a habit in his Parisian discussions of taking each argument 'by the throat' and it is this thought-

ful but bellicose side of his character that this work most strongly evokes.

Lautrec is usually credited with suggesting to van Gogh in early 1888 that, in order to escape the exhaustion that he felt with Paris, he should seek refuge in his own 'Japan' in the South of France at Arles. When van Gogh wrote from Arles to his brother Theo, he intimated that he was still in touch with Lautrec but no correspondence now survives. When van Gogh returned to Paris in February 1890, the two artists took up the threads of their limited friendship.

Lautrec's most famous and certainly most theatrical defence of van Gogh's art occurred in Brussels in early 1890, at the dinner to celebrate the opening of an exhibition by the Belgian group of avant-garde artists called *Les Vingts*. Among van Gogh's exhibits was a sunflower picture that a co-exhibitor, Henri de Groux, described as 'abominable'. De Groux's continued criticism led Lautrec to challenge him to a duel. Seconds were appointed and the combat was only prevented after de Groux grudgingly apologized and was expelled from the *Les Vingts* group. Signac, who was also at the dinner, declared that, had Lautrec been killed, he would have taken up the duel; instead he was simply appointed to take de Groux's place in the group.

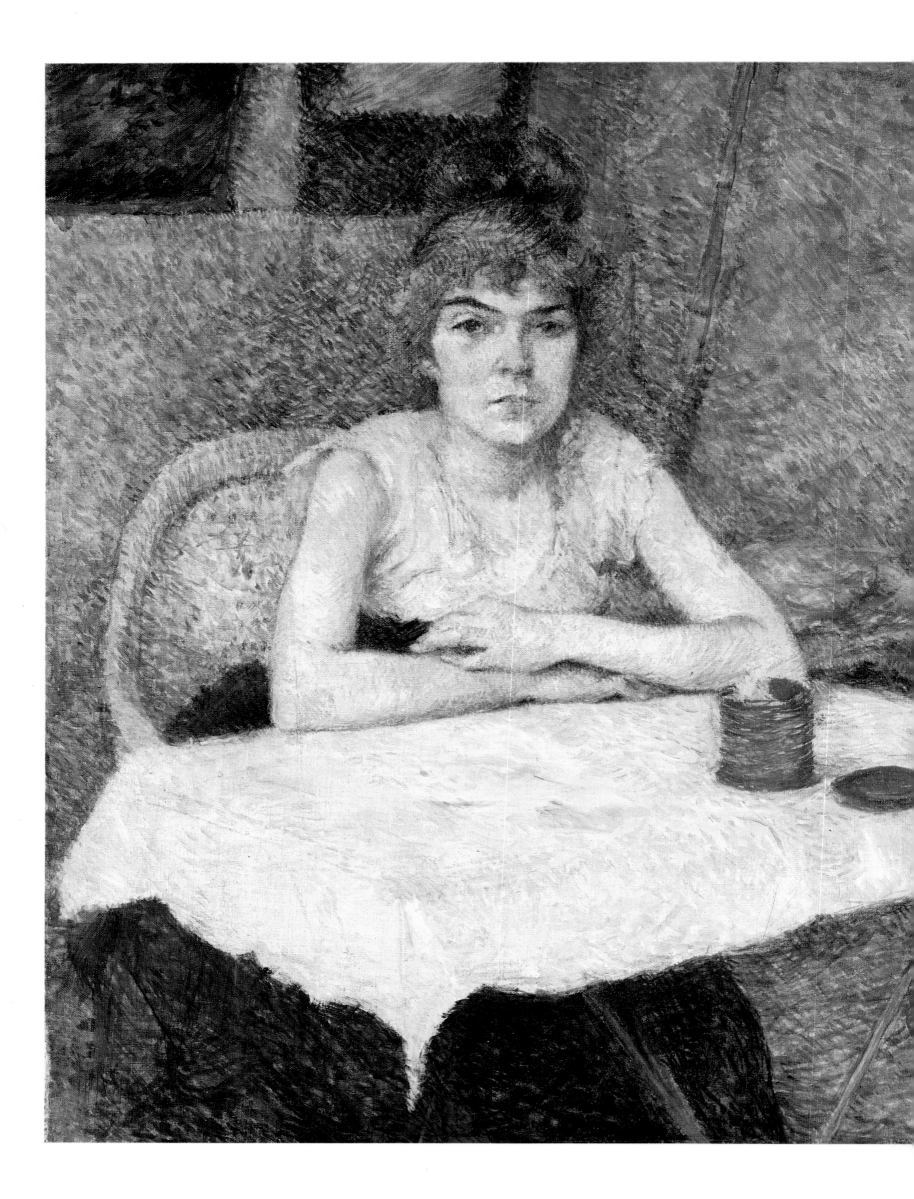

48

## Rice Powder c.1887

Oil on board
25⅝×22⅞ inches (65×58 cm)
Vincent van Gogh Foundation/Vincent
van Gogh Museum, Amsterdam

Degas's *L'Absinthe*, Manet's *La Prune* and van Gogh's 1887 portrait of his Italian lover, Agostina Segatori, sitting at a table in her own *Café du Tambourin*, are the three most important of many contemporary images of a solitary woman seated in reverie which possibly influenced Lautrec in the treatment of this subject. Using a model posed in his studio, Lautrec ambiguously suggests both a café table in public and the privacy of a bedroom dressing-table where rice-powder (face powder) might more appropriately be applied by a woman prior to donning her jacket or blouse. The model who gazes so intently is probably Suzanne Valadon, who also posed for the related picture of *The Hangover* or *the Drinker* (see page 56).

Technically, this picture is the most Pointillist of Lautrec's entire oeuvre. At this time, along with van Gogh and Bernard, he briefly flirted with separate dots and short caterpillar-like brushstrokes. They are most noticeable in the dotted nimbus around this figure, and in the textured chairback. However, Lautrec's Pointillism was not employed according to any precise rules of color combination and is ultimately more an experiment in decorative effect.

When exhibited at the February 1888 *Les Vingts* exhibition in Brussels, this picture already belonged to van Gogh's art-dealing brother Theo. In April 1888, Vincent wrote asking Theo if Lautrec had actually completed the picture. Five months later he mentioned it again and suggested that a painting that he was currently working on, of the cowherd *Patience Escalier*, would look well if hung next to Lautrec's work in Theo's apartment. The 'sunburned, tanned and airswept' quality of his picture would, he thought, contrast with the metropolitan 'elegance' of Lautrec's powdered woman. While not wishing to deprecate Lautrec's efforts, van Gogh implied that his own southern palette was superior to the rather bloodless color range Lautrec adopted in his portrayal of the Parisians.

## A La Bastille: Jeanne Wenz 1888

Oil on canvas
28½×19⅝ inches (72×49 cm)
National Gallery of Art, Washington,
Collection of Mr and Mrs Paul Mellon

Among the paintings that Lautrec exhibited at Bruant's Le Mirliton cabaret were four images of single women, painted between 1886 and 1888. Each shows a seated or standing figure and each is titled with the name of a Parisian locality. A picture of a haughty woman in a garden was intended to evoke the nearby middle-class Batignolles quarter. A painting of Carmen Gaudin was entitled *At Montrouge, Rosa the Redhead*. A fat and ageing prostitute depicted *At Grenelle, the Absinthe Drinker* and this portrait of Jeanne Wenz is intended to be the temptress Nini Peau-de-Chien from the Bastille quarter, the heroine of one of Bruant's songs.

Using single female figures as a symbol or an allegory was of course one of the most hackneyed of artistic conventions, and in late nineteenth-century Paris few government buildings or railway stations lacked a collection of naked female sculpture, representing this or that deity, crop,

virtue or locality. But the problem of how to create genuine 'types' based upon the specific conditions of locale and social context was one that occupied several contemporary Realist and Naturalist writers and artists. Toward the end of the nineteenth century, it was hoped that the scientific dissection of human conduct might produce a more precise taxonomy of type rooted in region or district or quarter. While Lautrec's group of women may be broadly sited within such a Realist pursuit, they are nevertheless a rather lurid collection; dressed-up models, acting out their various parts.

Jeanne Wenz was the sister of Frederick Wenz, a fellow student of Lautrec's at Cormon's atelier. When Lautrec first painted her sharp, fine features in 1886, he worked with the help of a photograph. For this painting and the others in this group, photographs of the model in costume may have been copied.

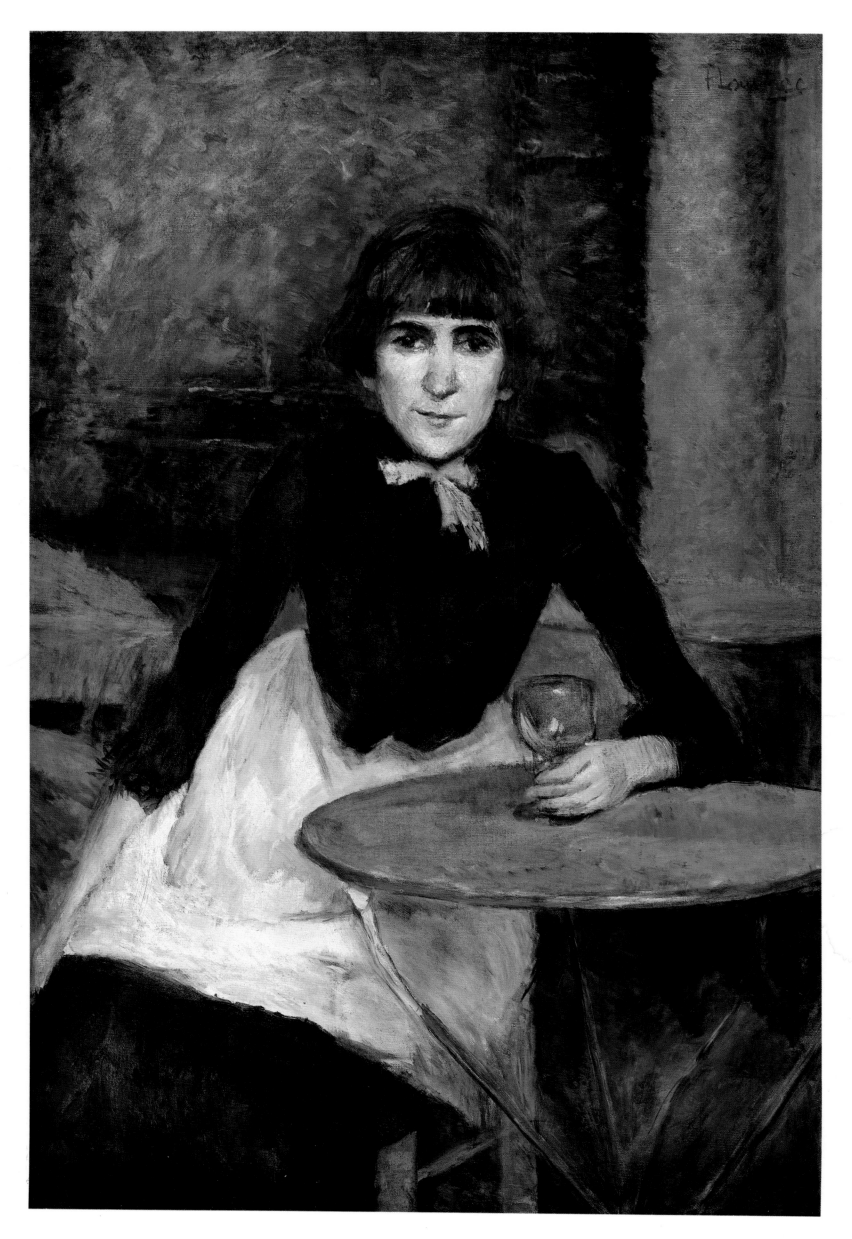

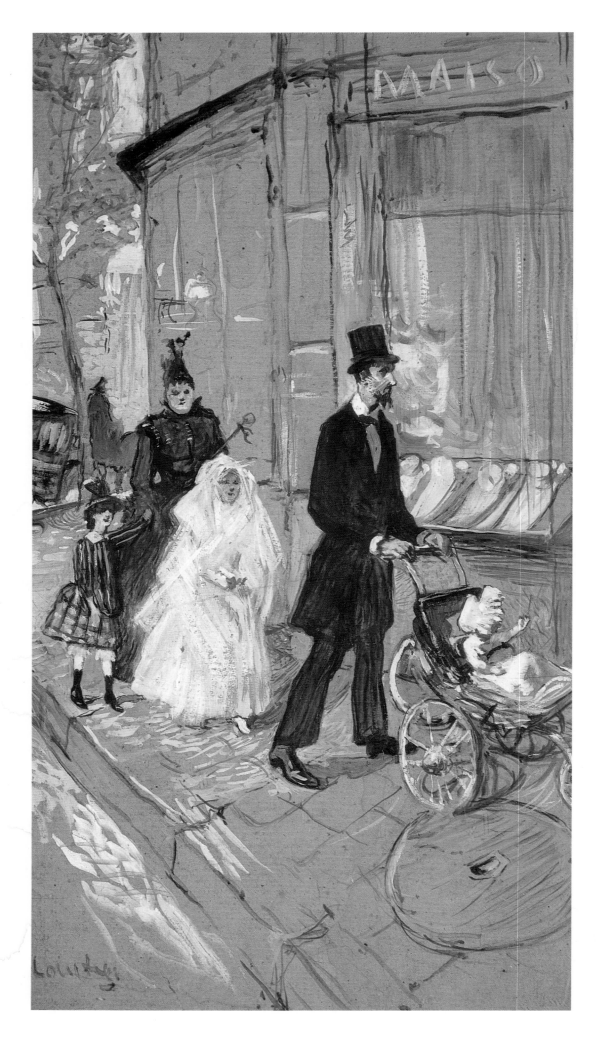

## The Day of the First Communion
1888

Charcoal and oil on board
24⅞×14¼ inches (63×36 cm)
Musée des Augustins, Toulouse

This is one of four illustrations made to accompany an article on 'Summer in Paris' by Emile Michelet that appeared in the July 7, 1888 edition of *Paris Illustré*, the journal run by Lautrec's ex-schoolfriend Maurice Joyant. All four depict busy streetlife: changing a tramcar horse, a poor girl delivering laundry, the rich riding in the Bois de Boulogne and, here, a petit-bourgeois family scurrying to their daughter's first communion ceremony. Although this group relates in conception to the series of four women which includes the previous picture (page 50), they are an altogether less highly-colored and more mundane conspectus of Parisian types. They also lack that faintly claustrophobic indoor intimacy that was already becoming a characteristic of Lautrec's art. Others in the series use large cropped foreground motifs that suggest borrowings from the vocabulary of Japanese prints, but here only the raked tilt of the pavement and the slightly cropped front perambulator wheel indicate any conscious deviation from traditional European spatial conventions.

François Gauzi, the original owner of this picture, posed (holding the back of a chair in Lautrec's studio) for the figure of the *paterfamilias* pushing the pram. The other figures, according to him, were made up by Lautrec from memory. Lautrec's intentions with this series are not clear; the images suggest that he was at this stage prepared to explore a more conservative approach to magazine or periodical illustration, adapting to rather more bland market requirements. Wit or humor are almost entirely absent from this group. Only the faintly ridiculous look of the father and baby in this picture, and the visual pun of the stiff starched shirts in the background shop window, suggest a hint of levity.

## Madame Lily Grenier 1888

Oil on canvas
21¾×18 inches (55.5×46 cm)
Collection, The Museum of Modern Art,
New York, William. S. Paley Collection

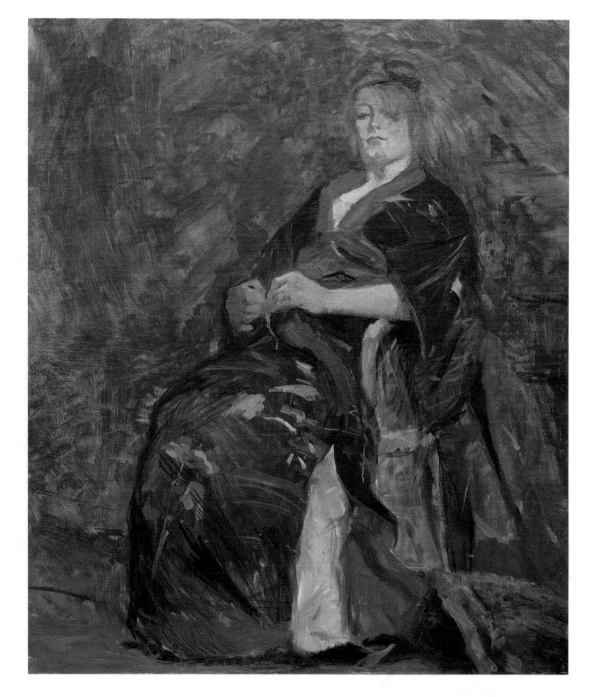

Lily Grenier, who modeled for Degas and other artists, was a beautiful blonde peasant girl from the Brie-Comte-Roberte region who married René Grenier (1861-1917) a fellow student of Lautrec's. Against the wishes of his mother, Lautrec moved into the Grenier apartment at 19 bis rue Fontaine in summer 1884. Grenier's private income of 12,000 gold francs a year, from his father's Toulouse property holdings, made it possible for him to indulge his taste for exuberant socializing, and he was instrumental in fostering Lautrec's involvement in the artistic circle surrounding the Chat Noir cabaret. Lautrec lived with the couple for at least five months and possibly for as long as two years. They remained close friends throughout the 1880s. A number of photographs show them indulging their general predilection for dressing up, as well as René's and Lautrec's more specific tastes for transvestism. Lily is seen here in a rich kimono which was part of their exotic wardrobe and which she wore for the two portraits that Lautrec painted of her.

Lautrec was certainly at least flirtatiously involved with Lily whom he nicknamed 'Duchesse', punning on its meaning of a four-poster bed and a luscious pear. There is a group of over 30 pornographic drawings made by Lautrec which originally belonged to the Greniers and includes one of Lily performing fellatio on Lautrec, hinting at an altogether more complex ménage at the rue Fontaine.

Lily Grenier was apparently reluctant to model for Lautrec. In both portraits Lautrec gives a rather jowly emphasis to her face and here he includes the same slatternly fall of hair across one eye that he had used for his portraits of Carmen Gaudin (see page 45); almost as though his taste for poor muscle tone and loose hair predetermined the portrait's final appearance. Despite the oriental costume, Lautrec did not in this painting adopt strong Japanese pictorial structuring. While the single figure set against a plain simple backdrop does suggest Japanese prints, the emphasis given to slick surface texture and the frontal view of Lily Grenier is more palpably European, redolent of the full-length portraits by James Tissot.

## In the Circus Fernando: The Ringmaster 1888

Oil on canvas
39⅜×63⅜ inches (100×161 cm)
Art Institute of Chicago, the Joseph
Winterbotham Collection, 1925.523

During Lautrec's lifetime, this was one of
his best known pictures. Owned by Joseph
Oller, a director of the Moulin Rouge, it
hung against a striking purple backcloth in
the entrance hall of his cabaret from its
opening in 1889. The Circus Fernando,
which first opened in 1875, was about a
hundred metres from the Moulin Rouge
and sited on the junction of the rue des
Martyrs and the boulevard Rochechouart
(see map page 14). It had been a favorite
haunt of Degas's who, in 1879, painted the
acrobat Madame LaLa being hauled into its
rafters holding on to a rope by her teeth.
Lautrec probably first visited here with his
father and returned again around 1882
with his earliest master, the equestrian
artist Princeteau, for whom the complex
discipline of trained circus horses in action
was of particular professional interest.

The moment depicted is just before the
tutu-clad equestrienne leaps from her
horse through a paper-covered hoop car-
ried by a clown. The ringmaster is M Loyal
and Lautrec posed Suzanne Valadon for
the woman rider, the first time that he used
his future mistress as a model.

Forming part of a series of six or seven
circus paintings that Lautrec made during
1887-88, this is one of his largest canvases,
and was preceded or accompanied by an
even larger work to which it is composi-
tionally related and which is now des-
troyed. The photograph taken c. 1893 of
Lautrec painting the Moulin Rouge (see
page 21), clearly shows this enormous
work behind the tall stepladder that
Lautrec needed to paint it.

Seurat saw this work at the Moulin
Rouge before making his own famous cir-
cus painting in 1890-91 and borrowed cer-
tain motifs, such as the semi-circular
sweep of the ring from left to right and the
horizonless viewpoint.

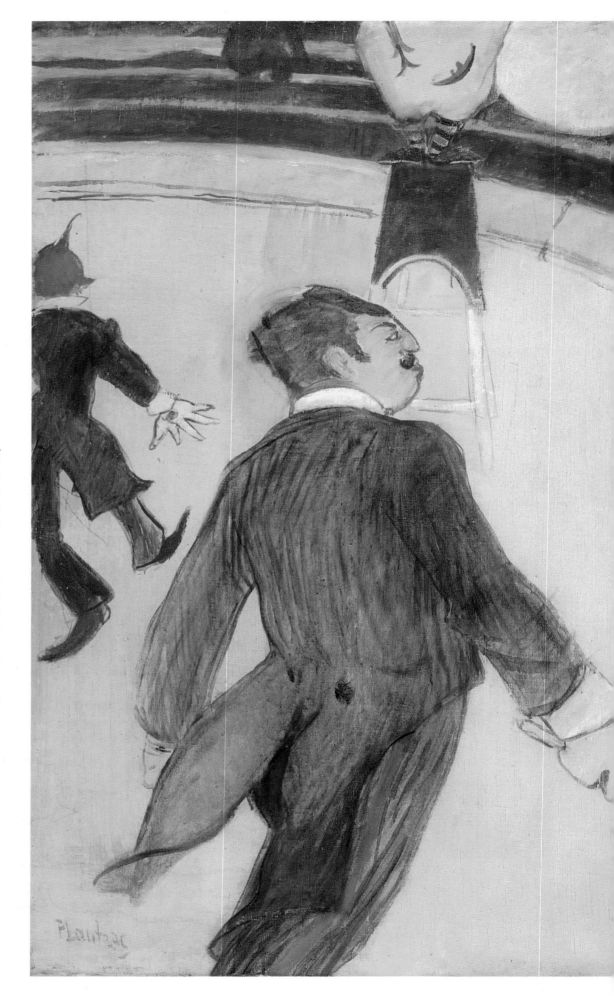

54

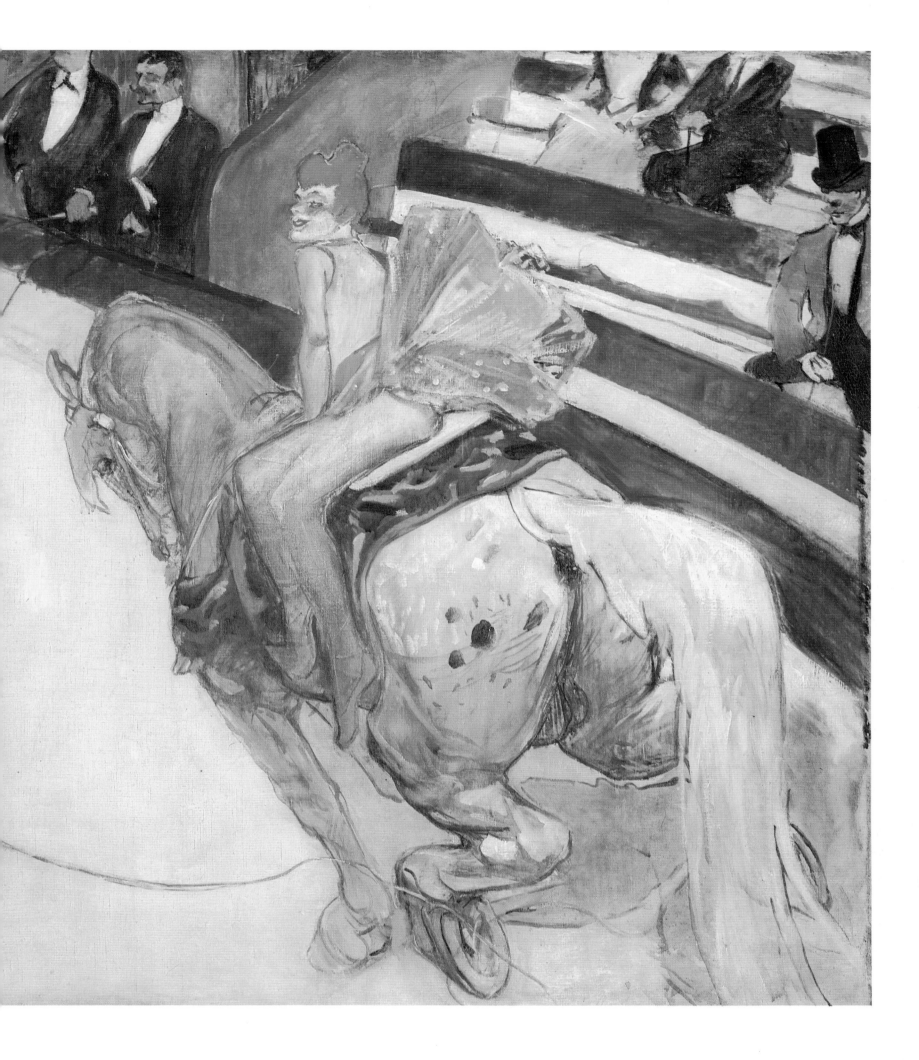

55

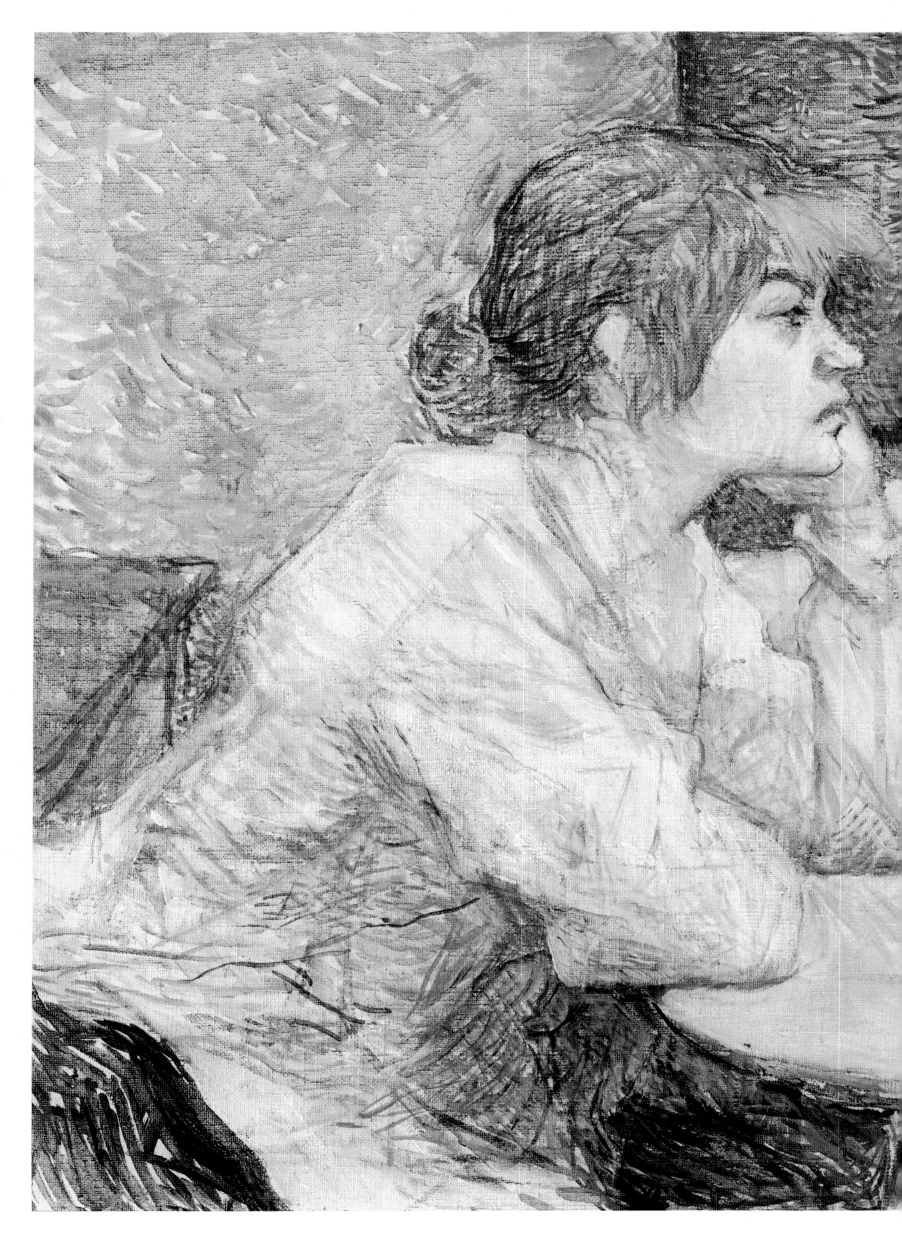

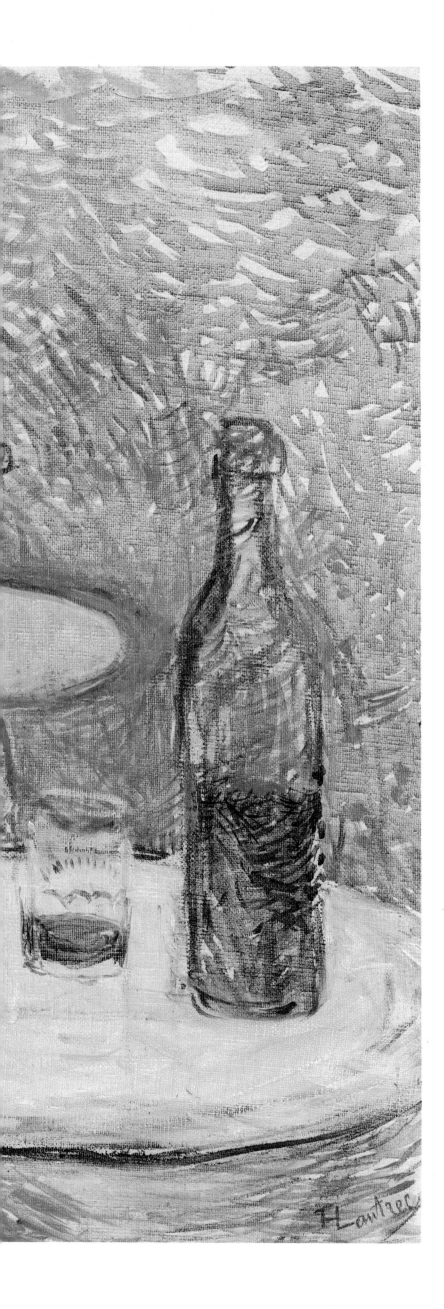

## The Hangover or The Drinker

1888/89

Oil and black crayon (or chalk)
on canvas
18½×21¾ inches (47.1×55.5 cm)
Harvard University Art Museums,
Bequest of the Collection of Maurice
Wertheim, class of 1906

This picture is closely related in theme to the four paintings of single women that Lautrec produced between 1886-88 for Aristide Bruant's cabaret (see page 50). Like two of that group, it was also copied by Lautrec as a simple black- and blue-lined drawing for use as an illustration in *Le Courrier Français*. Its French title, *Gueule de Bois*, translates literally as 'Wooden Face', more accurately as 'Hangover'.

The woman slumped over the round metal café table is Suzanne Valadon (1865-1938) who had modeled for Lautrec's earlier painting *In the Circus Fernando* (see page 54). For a while she was Lautrec's lover, and lived with her laundress mother in the building that his studio occupied on the rue Tournaque. Traditionally it is believed that Suzanne Valadon's mother encouraged her to try and marry Lautrec, and that when he overheard them discussing financial arrangements he terminated the relationship. Whatever the truth of this story, she certainly had good reason to need security. From the age of 15 she earned her living as an artist's model, following a bad fall that prevented her continuing as a bareback rider. From 1883, aged 18, she began to draw and paint, and by this time already had a child fathered by a singer from the Lapin Agile cabaret. A Spaniard with whom she was also intimate gave his surname to her baby – who grew up to be the artist Maurice Utrillo. It has often been seen as ironic that she should have sat as a young woman for this visual homily against heavy drinking, for Utrillo was to cause her great stress with his own adolescent alcoholism.

## Monsieur Samary at the
## Comédie Française 1889

Oil on board
29½×20½ inches (75×52 cm)
Musée d'Orsay, Paris

Looking rather older than his 24 years, the actor Henri Samary (1865-1902) jauntily quizzes the audience of the Théâtre Français, while playing the part of Raoul de Vaubert in the play *Mademoiselle de la Seiglière* by Jules Sandeau. This picture is a deviation from Lautrec's usual subjects during this period. It was not until 1893 that he showed any substantial interest in stage drama, after he moved away from Moulin Rouge and Montmartre cabaret themes. The absence of any surviving drawings or watercolors on any connected theatrical motif make it difficult to deduce his intentions. The Comédie Française, of which Samary was an associate, was the premier state-subsidized private theater company in France, and its role in keeping in performance the best of past French drama gave it a reputation for conservatism.

Lautrec's color range of lilacs, blues and greens has a cool, sharp and especially artificial quality; synthetic colors removed from nature act almost as a metaphor for the unreality of the stage itself. Rather like the landscapes of Holman Hunt, which employ a similar interplay of purples and greens, the resultant stridency is uncomfortable. These are the colors of petrol on a puddle.

Lautrec employs a double viewpoint, looking down at the stage as though from a high box, and yet directly at the face of Monsieur Samary. By this time such a viewpoint had become almost a cliché within avant-garde art. It derives, like so much else, from Japanese prints; the most common of these available in Europe showed popular *kabuki* actors. The solitary, centralized and outlined figure of Samary against the blocks of separate background shapes evokes these prints, while at the same time reflecting an established European taste for paintings of famous actors in role.

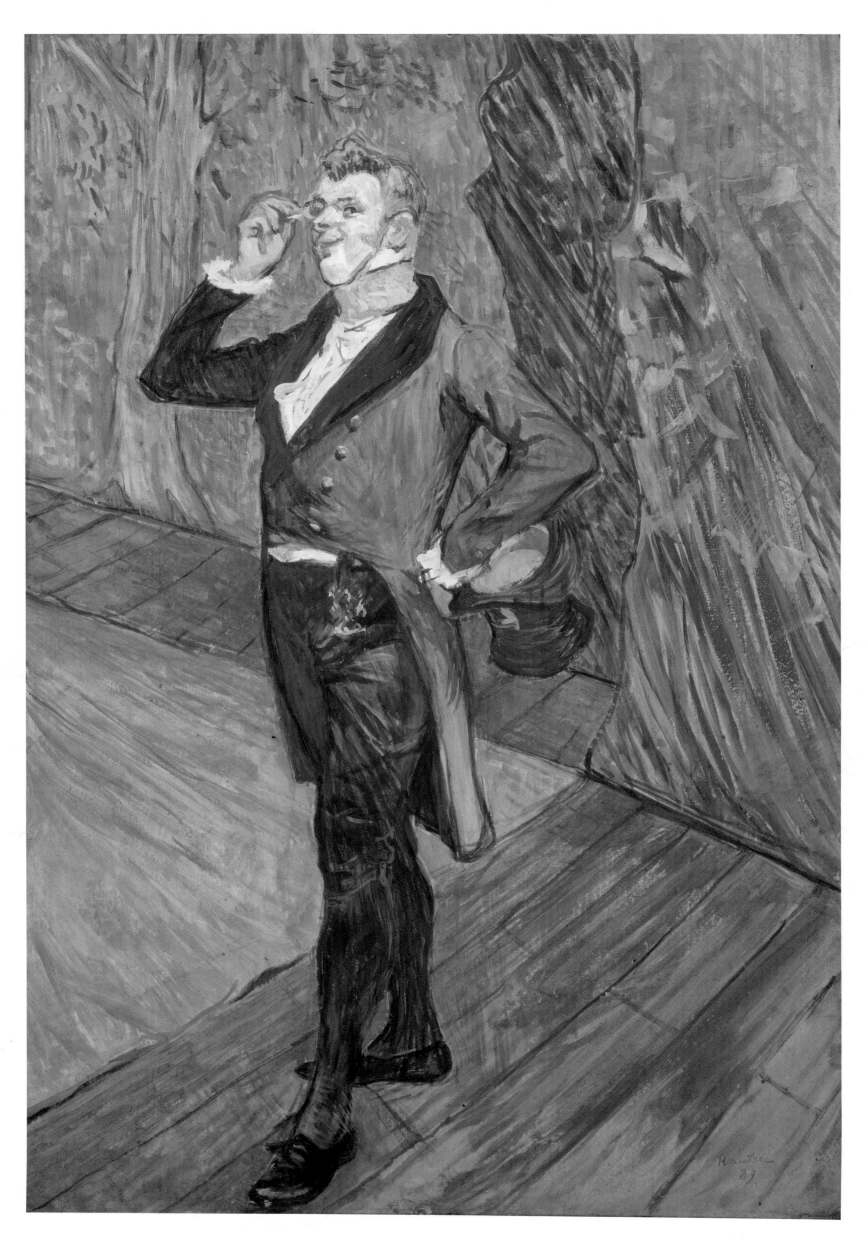

## Woman in Evening Dress at the Entrance to a Theater Box

1889/90

Oil on canvas
31½×20¼ inches (81×51.5 cm)
Musée d'Albi

Using a back view, mirrored reflections and complex spatial cues which are at first sight difficult to unravel, Lautrec in this disconcerting picture plays games with appearance and reality. Appropriately, the whole is set within a theater box. On the right, a mirror reflects both the main theater auditorium and stage and also the woman's companion, who wears evening dress and whose face, for no apparent reason, has been left without features. Above the woman's head, in the narrow gap where the door has been opened, is a sketchily described but strikingly bright patch of red and yellow. This too may be a mirrored reflection and therefore possibly also part of the auditorium. The woman's own bright yellow dress and red hair and the richly striated surface of the carpet are in warm vibrant colors that catch attention and appear much closer to the viewer than the cool white foreground armchair. *Pentimenti* visible as a result of fading or lack of sufficient over-painting generate further ghostly half-images in front of and beside the figure.

This picture appears in the photograph taken c.1890 of Lautrec working in his studio (see page 21). In its present form, it is much cut down on the right; from the photograph it appears that Lautrec originally included a further mirror with reflections of the main theater.

This exploration by Lautrec of dissonant color cues and ambiguous reflected images was taken up again for his 1894 portrait of *Doctor Tapié de Céleyran in a Theater Corridor* (page 121). The similarity of approach between these two pictures led in the past to this work also being dated to 1894. Greater stylistic affinities are now seen to exist between this work and the last picture showing *Monsieur Samary at the Comédie Française*. Both share an almost caricature-like approach in the figure, and long parallel hatching brushmarks.

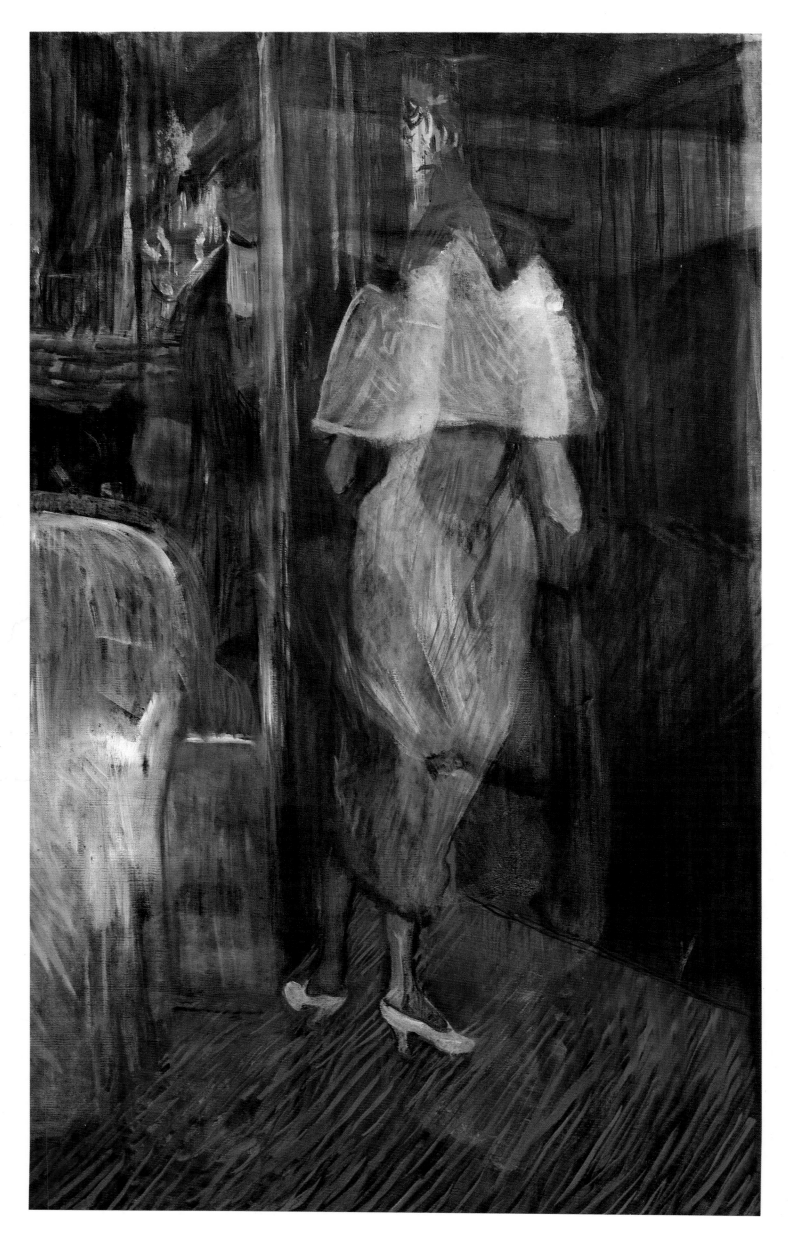

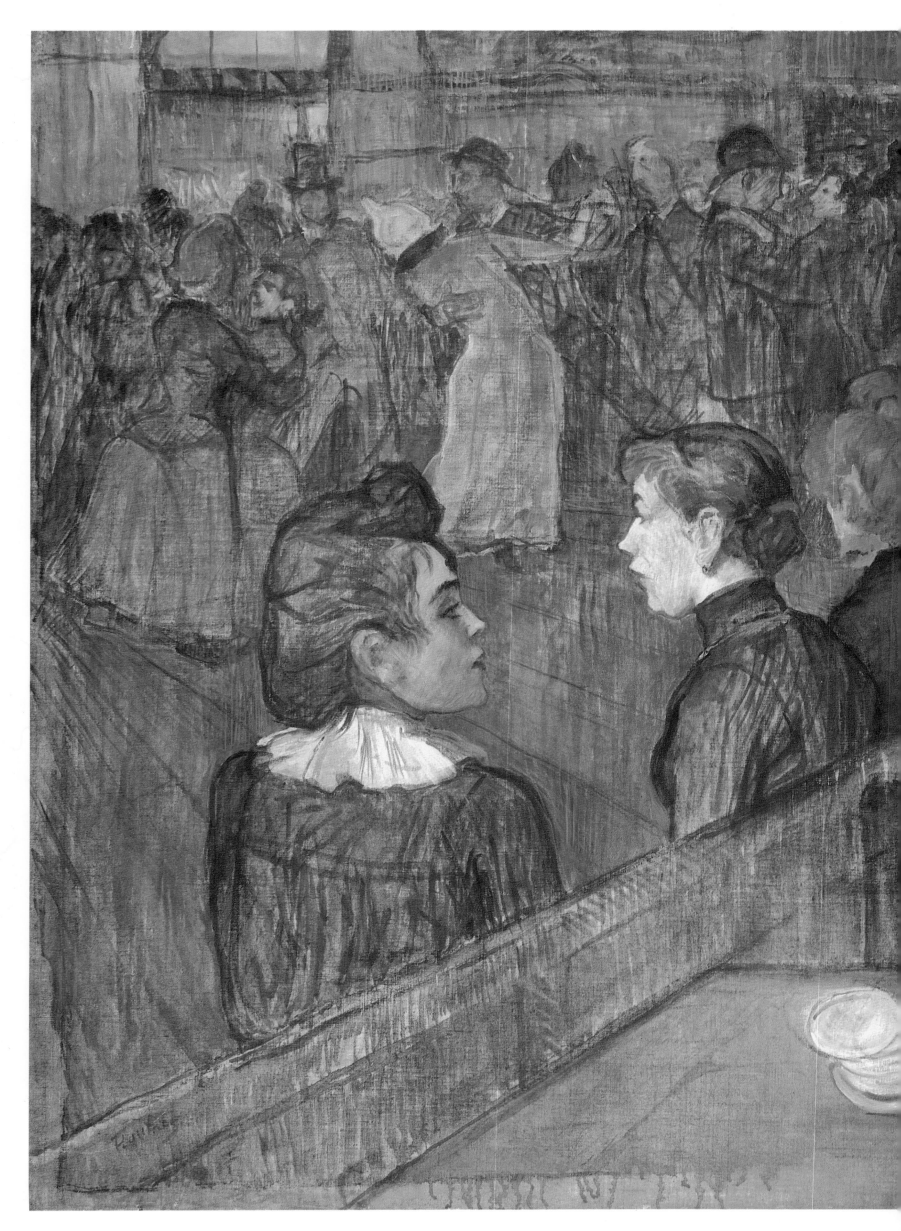

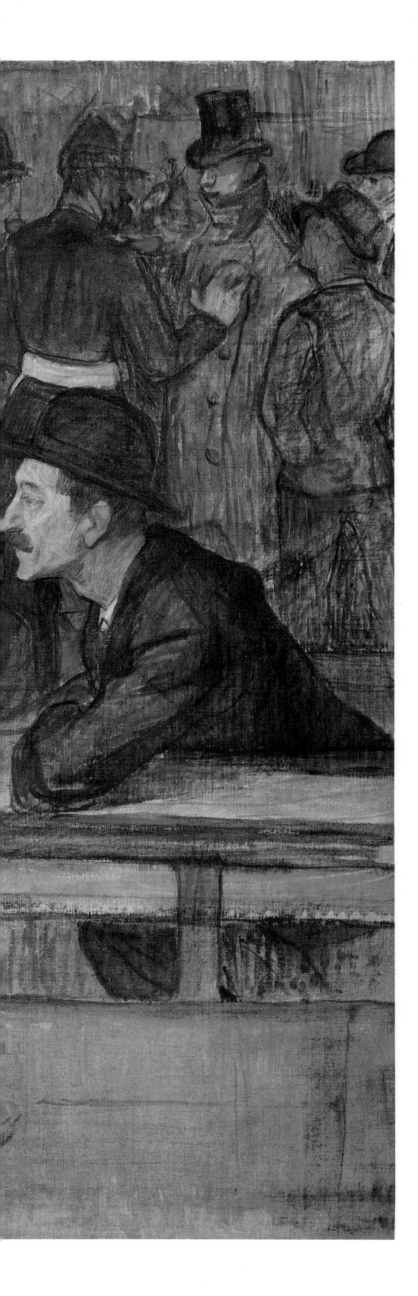

## A Dance at The Moulin de la Galette 1889

Oil on canvas
35½×39⅝ inches (88.5×101.3 cm)
Art Institute of Chicago, Mr and Mrs
Lewis Larned Coburn Memorial
Collection, 1938.458

Above the modernized boulevard de Clichy on the Butte Montmartre, amid steep lanes and ramshackle rural houses, stood the Moulin de la Galette, a big shed constructed around two disused windmills: a dance hall described simply in one contemporary English guidebook as 'largely patronized by working girls.' Renoir painted it in 1876, and produced his famous effulgent vision of Sunday afternoon sociability, full of dappled sunlight falling on to the crisp bright clothes of his middle-class friends and their various female companions. According to his son, Renoir had been attracted to it because 'its simple amusements typified so well the good-natured side of the common people of Paris.' According to Gauzi, Lautrec painted this ambitious canvas in emulation of Renoir's earlier picture. While the viewpoint is similar, however, the feeling is altogether different.

What Lautrec depicts is the cheap, rather rough, gathering place and pick-up joint that was the real Moulin de la Galette. Painted in muddy blues and greens, it evokes busy indoor night-time life rather than open-air Sunday respectability. A Zoave soldier squares up to a cab-driver, a bowler-hatted shop boy chats up a girl during a slow dance, while the three rather miserable-looking women sit alone on the edge of the dance floor awaiting a dance or other business. Contemporary critical comment suggested that they were possibly prostitutes.

The profiled man gazing at the dance floor is the artist Joseph Albert, the original owner of this picture. Charles Stuckey has suggested that Lautrec's own presence is also implied in this picture by the tipsily stacked saucers. Each one was delivered with a glass of mulled wine, a cheap speciality of the Moulin de la Galette that Lautrec enjoyed.

Now that Montmartre has become very smart, the Moulin de la Galette sits, much restored, atop a huddle of rather grand houses and behind a gate that warns potential intruders that it is guarded by dogs, radar and electronic devices.

## At the Moulin Rouge: The Dance
1890

Oil on canvas
45½ × 59 inches (115 × 150 cm)
Philadelphia Museum of Art,
The Henry P. McIlhenny Collection

The Moulin Rouge, the largest, the brashest and the most successful of Montmartre cabarets, opened in October 1889. By paying large fees, the director Charles Zidler was able to lure star quadrille dancers away from the nearby Elysée Montmartre cabaret, and to get leading acts like the famous musical farter Pétomané, who sometimes performed his gross and amusing act at the Moulin Rouge from within the papier-mâché elephant in the cabaret's garden.

Described by one Parisian newspaper as 'a typical Parisian spectacle to which husbands may come with their wives,' the Moulin Rouge was more guardedly listed in *Black's Guide to Paris* as a place where 'there is dancing of a not too decent kind'. The *Guide de Plaisirs à Paris* gives perhaps the clearest picture of its exotic and erotic charms:

The smell of tobacco and rice powder envelops the visitor. To the left sitting at small tables are the 'petites dames'. Always thirsty, they will order a drink hoping for someone to pay for it. If this should happen their overwhelming gratitude includes the offer of their whole heart – provided you will pay. At each side of the room is a raised broad open gallery where one can sit at leisure and watch the dancers and all the women who display themselves in their finery in this huge market place of love. . . . By the orchestra stand in the middle are the young girls ready to dance the heavenly Parisian *chahut* – they too are paid. From all over the world people come to partake of this enormous spectacle. A few English families are shocked to see women dancing alone without male partners, and with a flexibility as they do the splits that suggests that their morals are equally elastic. Through the lace edge of their underclothes and their transparent stockings one often catches a glimpse of rosy or white skin – a tempting sample displayed by these merchants of love.

Lautrec's viewpoint is toward an unknown female dancer with red stockings and her companion, the famous Valentin le Désossé. Among the back row of top-hatted spectators are several friends and acquaintances of Lautrec's including Maurice Guibert, Paul Sescau, Marcellin Desboutin and Gauzi.

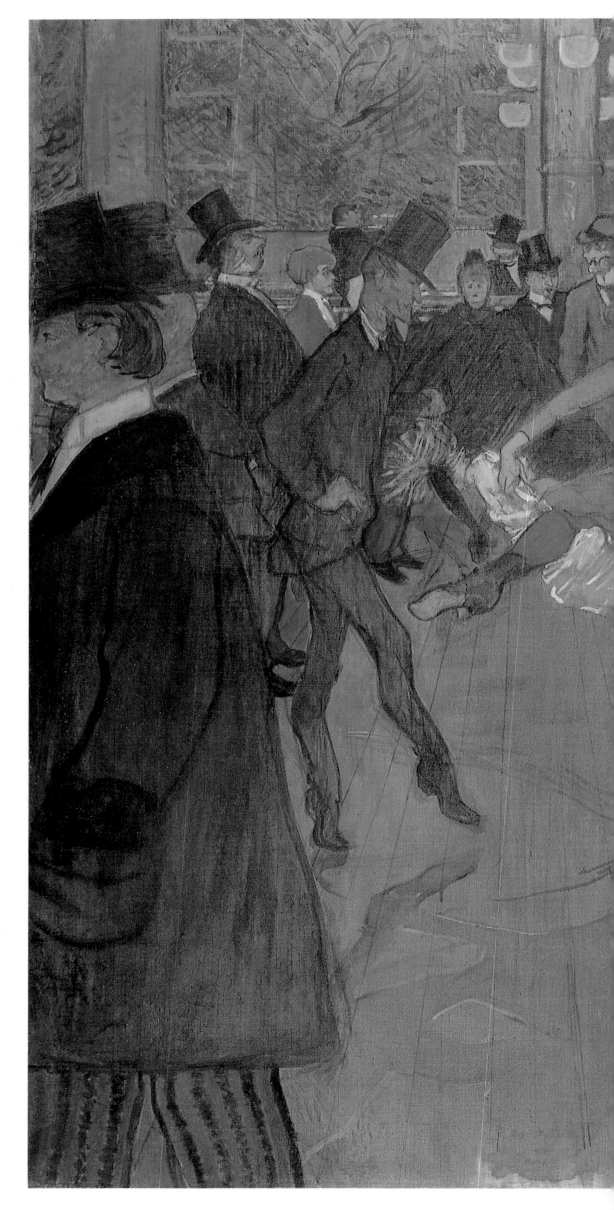

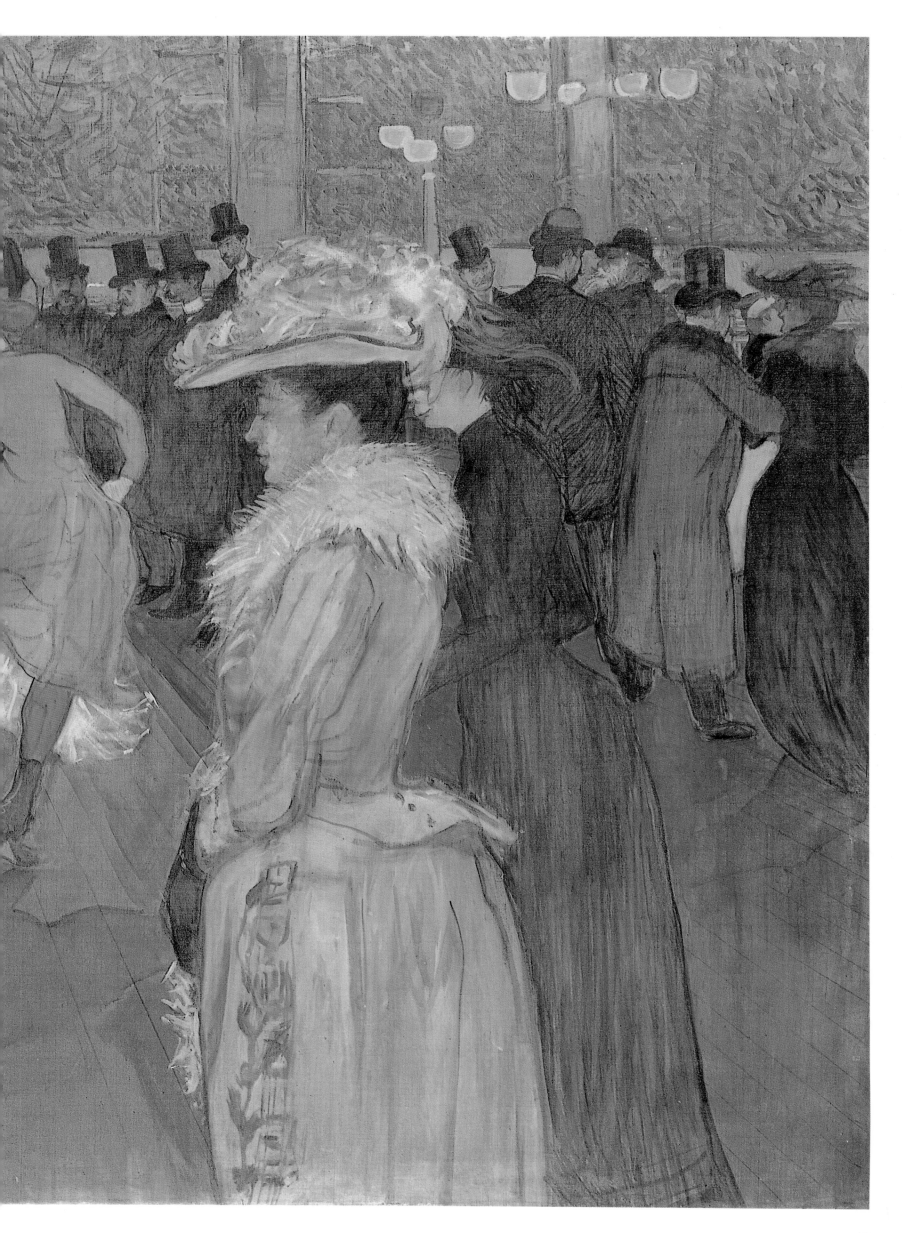

## M. Désiré Dihau, Bassoonist of the Opéra 1890

Oil on board
22⅛×17¾ inches (56×45 cm)
Musée d'Albi

Edmond Duranty (1833-80), in his famous 1876 pamphlet *The New Painting*, wrote that 'by means of a back' an individual's social standing and character could be isolated. Duranty was a close friend of Degas's and his arguments for Naturalist portraiture related so closely to Degas's own practice that some believed that the text had been written by Degas himself. Lautrec's sensitivity to Duranty's *dicta* and his awareness of the varying branches of Naturalistic portraiture, including that of Degas, is especially evident in the substantial group of single male portraits that he made during 1890-91. What Duranty argued for was that the best Naturalist portraits should seek:

The special characteristic of the modern individual – in his clothing, in social situations, at home or in the street. The fundamental idea gains sharpness of focus. This is the joining of torch to pencil, the study of states of mind reflected by physiognomy and clothing. It is the study of the relationship of man to his home; or

the particular influence of his profession on him, as reflected in the gesture he makes, the observation of all aspects of the environment in which he evolves and develops.

Désiré Dihau (1835-1909) was a distant cousin of Lautrec's, and had been painted as a young man by Degas. Degas's portrait showing Dihau playing his bassoon at the Paris Opéra was well-known to Lautrec and hung in the Dihaus' Montmartre apartment. Rather than show Dihau in character at work, Lautrec seized the erect posture that he adopted when reading a newspaper, as though the stiffness of trunk required for his professional playing of an instrument translated into his everyday mundane activities, precisely the kind of idiosyncratic observation that Duranty favored. Like the portrait of Justine Dieuhl (page 74), this was probably painted in M Forest's garden.

Later, in 1895-96, Lautrec produced lithographic illustrations for the covers of Dihau's comic songsheets.

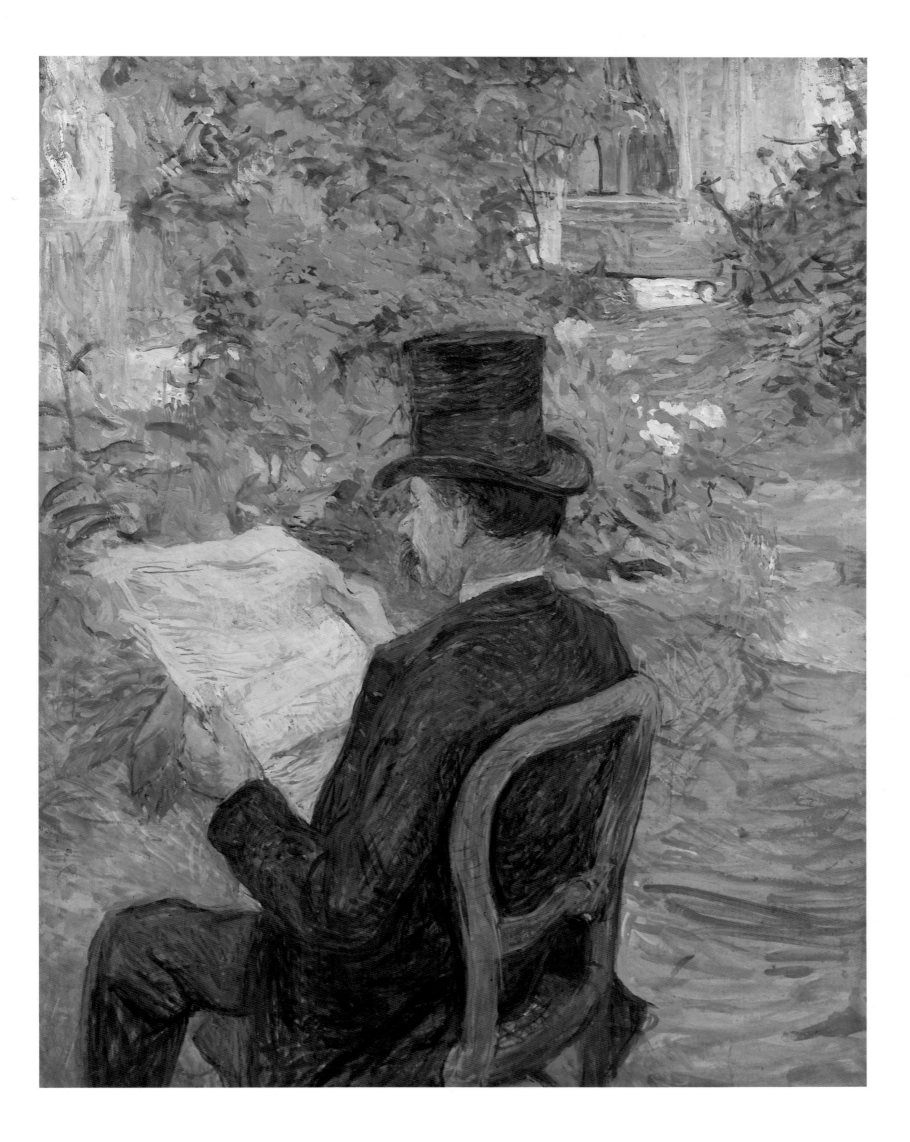

## Marie Dihau at the Piano 1890

Oil on board
24⅞×19 inches (63×48 cm)
Musée d'Albi

Marie Dihau (1843-1935), a teacher of singing and the piano, was a distant cousin of Lautrec's on his mother's side. The apartment in the rue Frochot that she shared with her brothers is the setting for this picture. On the dining-room wall behind the foreground music stand is a barely decipherable portrait of Marie, seated at the piano and painted by Degas in 1869. Unlike the companion portrait of her brother (page 66), in which Lautrec chose a very different pose to that adopted by Degas, this portrait is a direct response to Degas's earlier picture.

When Degas painted Marie, he placed a large area of white sheet music in front of her on the piano, which draws the spectator's attention into the picture past Marie's dark form. Lautrec in contrast, seeking a more jarring connection between spectator space and picture space, placed the cropped music stand with its forceful blank sheet of music actually on the picture surface. This has the effect of suggesting that there is a singer outside the picture frame who is being given a lesson by Marie.

Lautrec greatly admired all the Degas pictures that were owned by the Dihaus. A famous anecdote recounts how, in the winter of 1898-99, after a dinner party that he had thrown in his Montmartre home for the Natansons and Edouard Vuillard, Lautrec made his guests walk to the nearby Dihau apartment off the Place Pigalle and, taking them up to Degas's portrait of Marie and her brother Désiré, said, 'This is your dessert.'

Lautrec exhibited this painting at the Salon des Indépendants in March 1890 and was delighted with the reception that it received. Theo van Gogh singled it out for particular praise when he wrote to his brother. It is likely that Vincent van Gogh saw the painting when he returned to Paris. A painting of Marguerite Gachet playing the piano, which van Gogh painted at Auvers just a month before his death, is very close in pose to this work; further evidence of the admiration that van Gogh had for Lautrec's work.

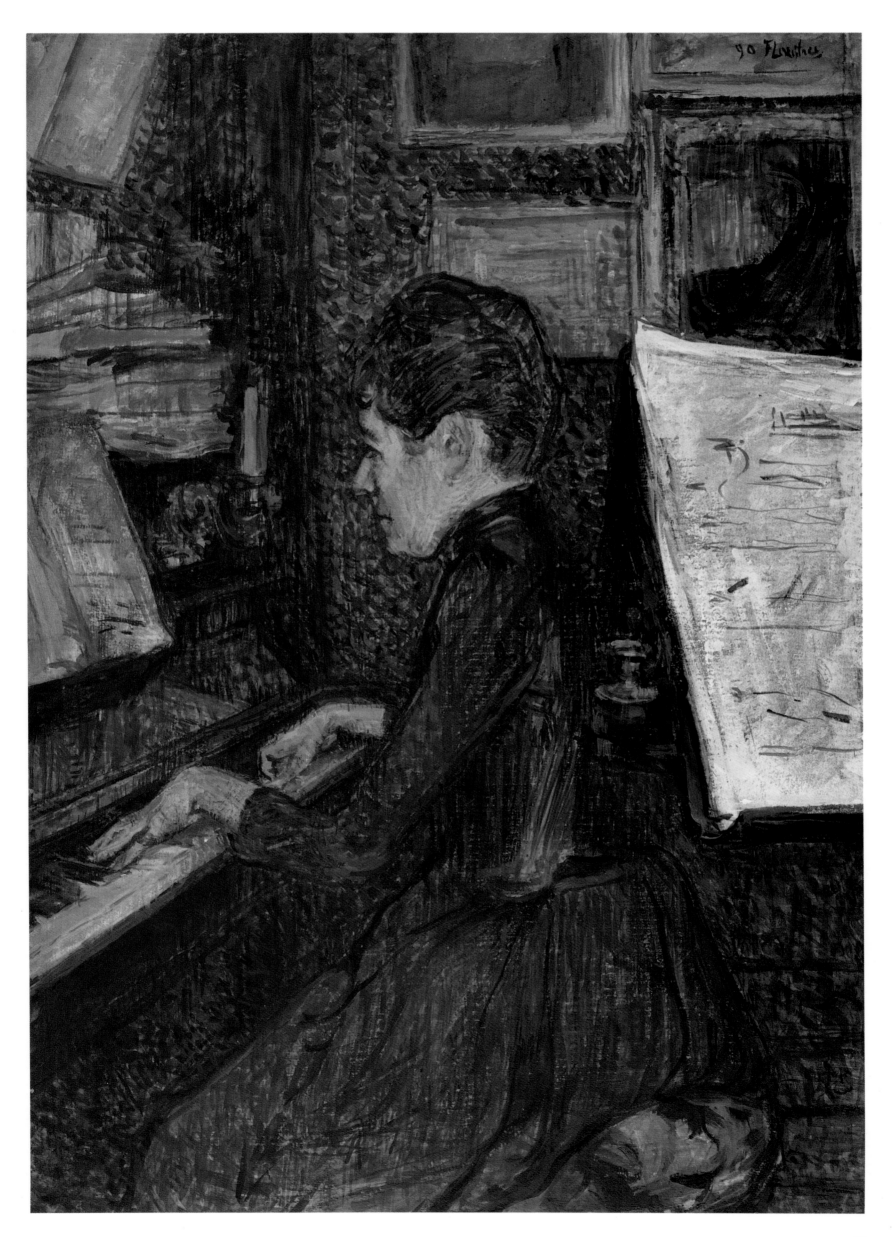

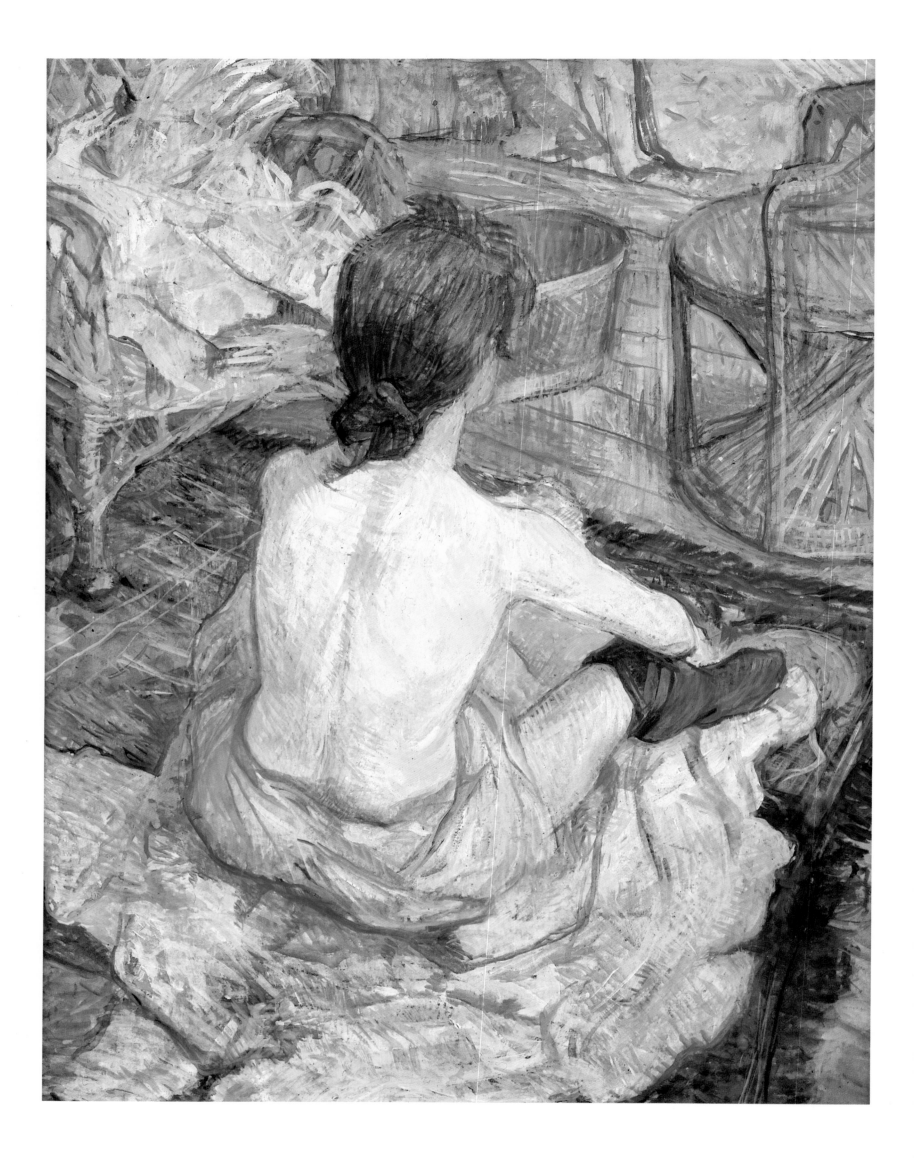

## La Toilette 1889/90/91

Oil on board
24¼×20½ inches (64×52 cm)
Musée d'Orsay, Paris

At the eighth and last Impressionist exhibition in spring 1886, Degas showed his famous suite of pastels of nude bathers; in 1888 a further nine on the same theme were exhibited at Boussod and Valadon's, the rue Montmartre gallery run by Theo van Gogh. This picture, now redated to as early as 1889, is Lautrec's first act of homage and attempted response to Degas's bathers.

Just as Degas so often did, Lautrec shows his model from the back and with her face hidden. The carefully placed basket chairs, and the precise positioning of the model's right foot within a circle in the carpet pattern, provide curved and circular visual puns of the model's own body like those that Degas habitually achieved using jugs, hairbrushes and bathtubs. Whereas Degas posed his model in his studio and then drew or painted her as though she was in her own bedroom, however, Lautrec's model, with her stockings still on and her chemise dropped from shoulder to waist, looks what she is: a posed half-naked figure among his familiar studio paraphernalia.

Degas's aspirations for his bather series were elevated and he seems to have viewed them as a major statement of the place that the female nude could occupy within Naturalism. His emphasis on formal values suggests that he was seeking comparison with classical Renaissance and contemporary academic nudes. Lautrec's strong, buttermilk-skinned, red-haired figure does not suggest such monumental *gravitas*. His reluctance to invent surroundings for his studio-posed figures or portraits has sometimes been seen as characteristic of his particularly thoroughgoing Naturalism.

This is probably the picture that Lautrec exhibited with Les Vingt in Brussels in 1889. Some, however, still prefer to date it to 1891, and see it as part of his series of pictures of women at their toilette and combing their hair. Donated to the French state by Pierre Goujon in 1914, this was one of the earliest of Lautrec's pictures to be put on public display. Naomi E Maurer has suggested that Matisse, seeing it on show at the Luxembourg, was influenced to paint similar pictures of a nude seated within a studio setting.

71

## Tommy the Cocker Spaniel

1890/94

Oil on board
16⅝×22½ inches (42×57 cm)
Private Collection

This painting was given by Lautrec to his friend Maurice Guibert, and is usually dated to 1890. The letter that Lautrec wrote to his mother in late June 1894, however, suggests that a slightly later dating is more likely. 'I'm purging the dog conscientiously as he's rather sickly. The fresh air will finish off the process of curing him . . . I walk as much with Tommy as is possible; that's the dog.' Lautrec had recently returned to Paris from a brief trip to London. There he had certainly bought one dog, a fox terrier called Judy, from the Battersea dog pound for what he regarded as the bargain price of ten shillings. This he dispatched by train to his family near Bordeaux. This second pedigree English gun dog, requiring worming and care, may possibly also have come from the same source, and been intended as a gift for Guibert or Lautrec's mother. In the above letter, Lautrec indicates that he is considering visiting his mother at Malromé, accompanied by Guibert and Tommy.

Lautrec's affection for dogs was lifelong. His early letters are full of enquiries about the health of various animals. Portraits of family house pets and hunting dogs are among his earliest paintings. While in the depths of his alcoholic disintegration in January 1899, Lautrec bought a puppy, which the Comtesse's housekeeper had to get rid of as he was incapable of taking care of it.

Little else is known about Tommy, alertly crouching here upon the floor among the trestles of Lautrec's studio. He lacks any of the slightly anthropomorphic expression or character that Lautrec was wont to give some of his dog drawings and studies, particularly those connected with the circus. Ultimately, this is a straightforward record of the finer points of a superb dog.

## Woman Seated in the Garden of M Forest: Justine Dieuhl 1891

Oil on board
29¼×22⅞ inches (75×58 cm)
Musée d'Orsay, Paris

Near his studio in the Montmartre garden belonging to the photographer Père Forest, Lautrec painted this and a number of other open-air portraits between 1888 and 1891. A fellow-student, Rachou, wrote that after a morning of diligent study at Cormon's atelier, Lautrec habitually worked out-of-doors on portraits.

In his earlier 1882/83 portraits painted on holiday in the grounds of his family estate at Céleyran (see pages 28, 30), Lautrec experimented with the impressionist integration of foliage and figure suffused with sunlight, as well as trying out more conservative modifications of impressionist brushwork. In the group to which this picture belongs, he seems to have been less concerned to harmonize figure and setting with light. Lautrec's model, about whom little is known but her name, sits bolt upright against foliage that is treated simply as a backdrop. Richard Thomson has suggested that Lautrec was more interested in the possibility of the large leaves being used as a visual pun on the sitter's rather elaborate hat.

Lautrec uses a range of tones within each local color, principally to bring variety to his linearity. Differing greens are employed to outline and strengthen the drawn edges of the foliage. Blues ranging from pale to dark are used on the dress, and Lautrec adds his distinctive touches of pure ultramarine over the dark circumscribing outlines of the woman's form. Almost always lost in reproduction, these ultramarine touches give to the original a fluorescent surface animation. Lautrec described these outdoor pictures as his 'punishment works', which suggests that while he may not have sought for a specifically impressionist resolution of the figure in the landscape, he nevertheless considered that outdoor light generated particular pictorial problems of organization and color that he wished to solve.

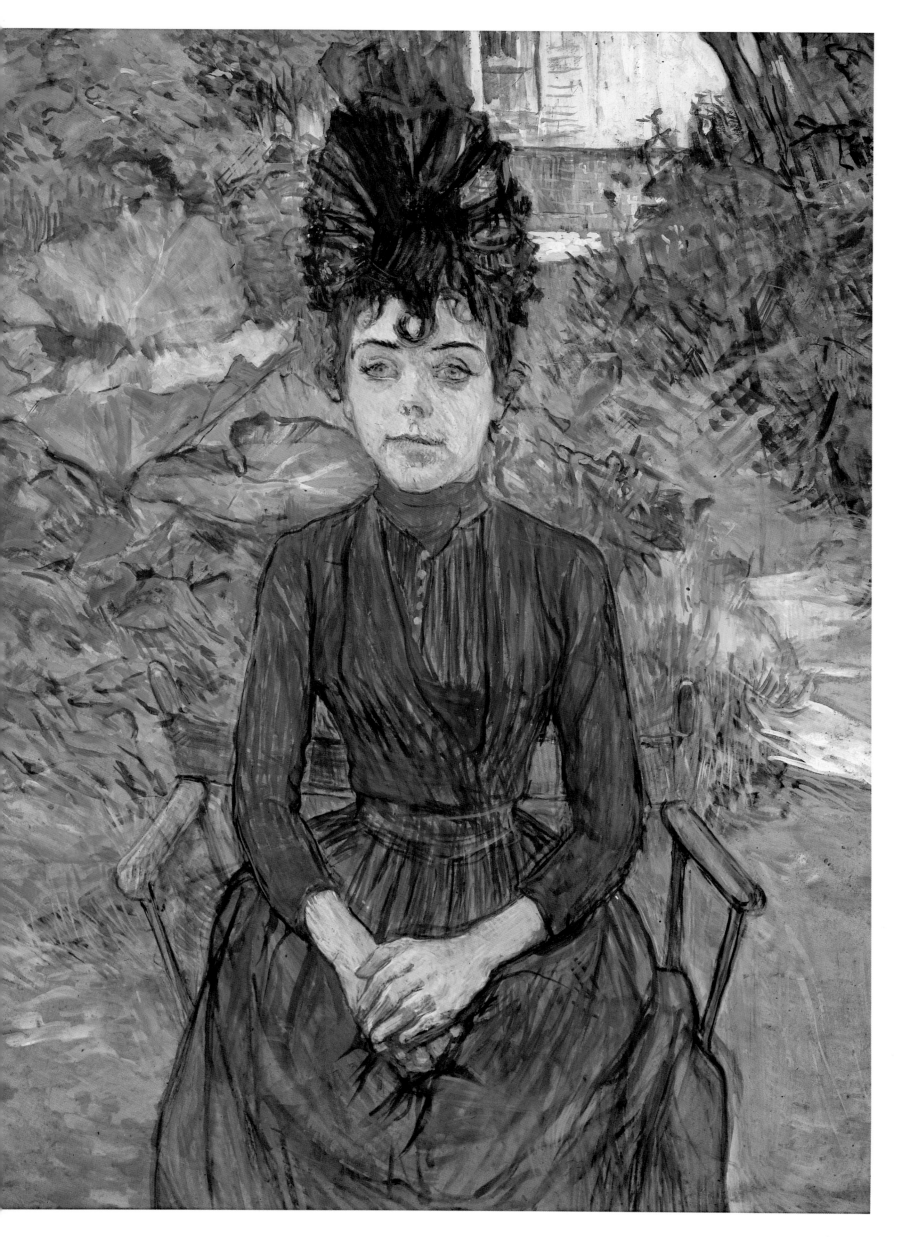

## Portrait of Dr Henri Bourges 1891

Oil on board
31×20 inches (79×50.5 cm)
Carnegie Museum of Art, acquired
through the generosity of the Sarah
Mellon Scaife family, 66.5

This is one of a group of three (and possibly five) similarly posed male portraits that Lautrec exhibited as an ensemble at the Salon des Indépendants in March 1891. Each shows a formally-dressed friend of Lautrec's in a corner of his rue Caulaincourt studio. Each is similarly painted on cardboard, using a limited range of blue and black dilute oil (essence) applied in summary strokes and with large areas of board left blank. Unlike the paintings made in M Forest's garden, Lautrec sought in this group a more deliberate refinement; they have the atmospheric close-toned simplicity of the single-figure portraits set against a neutral background painted by Whistler, and they were undoubtedly intended to attract critical attention.

Dr Henri Bourges (1860-1942) was a close friend of Lautrec's. They shared an apartment from 1887 until 1894, when Bourges married. He eventually gained modest renown for a paper that he published on syphilis. It was on Bourges's recommendation that Lautrec was confined to an asylum to dry out in 1899. Here, as with all the males in this group, Bourges is shown as a *bon viveur*, doing up his glove to leave the studio for the boulevard. On the wall behind is a Japanese *kakemono* scroll (literally 'hanging-thing picture') with an indistinct landscape. Lautrec's indebtedness to Japanese art is evident in this entire group of portraits. The positioning of this vertical scroll is redolent of the panels of text and decoration found on *ōban* Japanese woodblock prints, and the central outlined figure is also akin to single actor and wrestler prints.

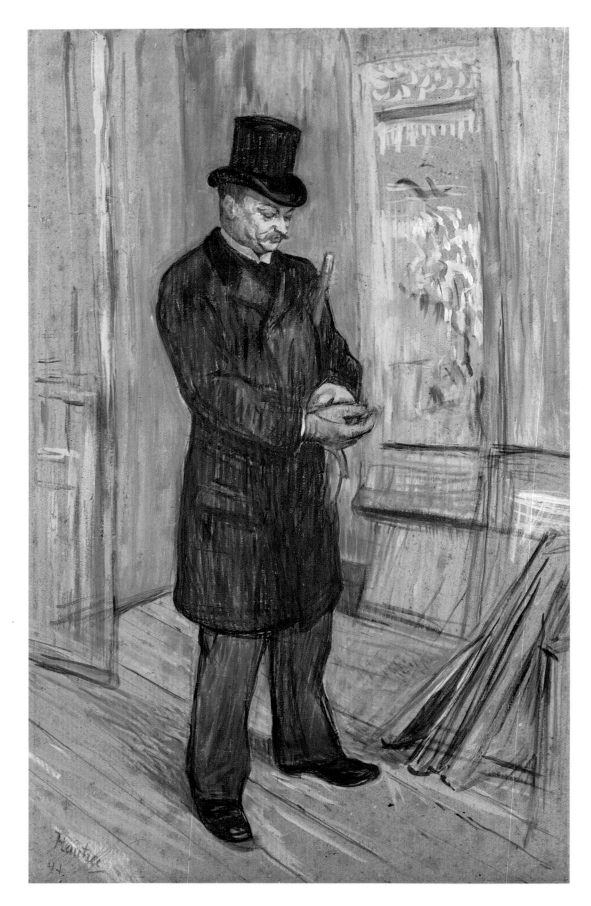

## Paul Sescau 1891

Oil on board
32¼×14 inches (82.5×35.6 cm)
The Brooklyn Museum, New York

This second portrait from the 1891 group of five male boulevardiers was probably exhibited at the Indépendants and certainly shown at the Salon des Arts libéreaux in June 1891. Seeing it there, the critic Félix Fénéon (1861-1944) commented upon it in terms that evoke the *dicta* of Duranty on the Naturalist portrait in his 1876 pamphlet (see page 66). 'Lautrec', Fénéon wrote, 'elucidates the physiognomies' of the dandies that he portrayed. It is clear that Lautrec had successfully sited this and the related works within the Naturalist critical discourse.

The same *kakemono* scroll hangs on the wall as in the Bourges portrait (left), and Lautrec appears to have tied the overall proportioning of this portrait more closely to that of the long narrow format of this scroll. Originally the proportions were closer to that of the Bourges picture, before being elongated with an added piece of cardboard. This adding of an extra piece also has a curious affinity with the construction of certain Japanese scrolls (*kakemono-ye*) made by sticking together three *ōban*-sized woodblock prints.

Paul Sescau was a lifelong friend of Lautrec's. Lautrec highlighted his reputation for the predatory pursuit of women in the lithograph that he made of him in 1899, and in the 1896 poster produced to advertise Sescau's photography shop on the Place Pigalle. Sescau owned this portrait until 1898 when, against Lautrec's wishes, he sold it for 400 francs to the writer and critic Roger Marx. Sescau co-operated professionally with Lautrec and was one of the first to photograph his paintings.

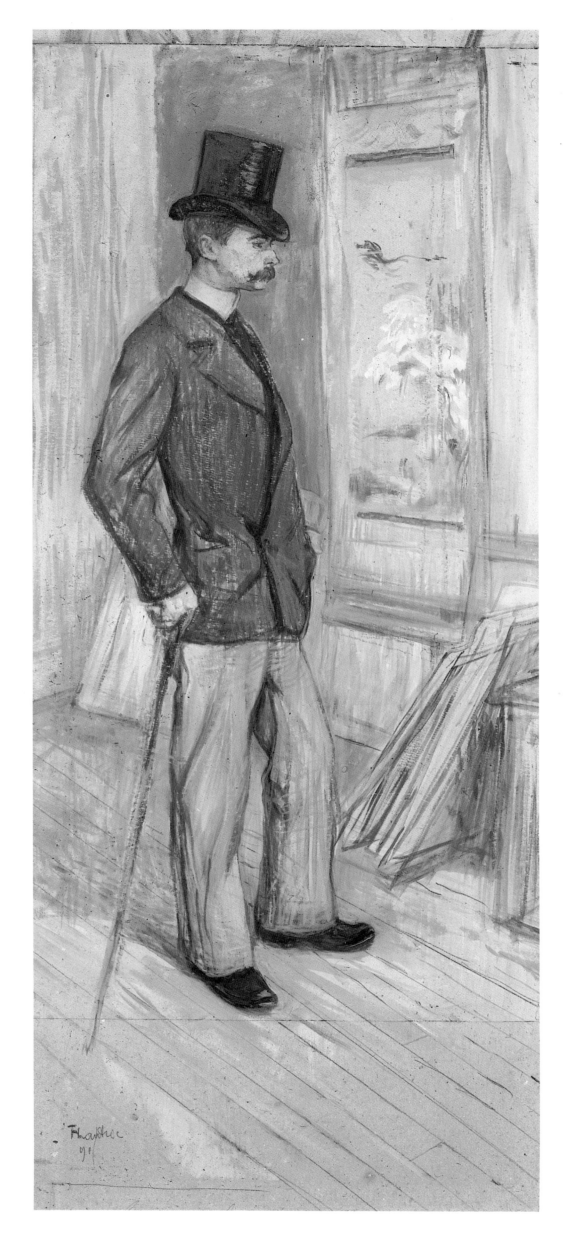

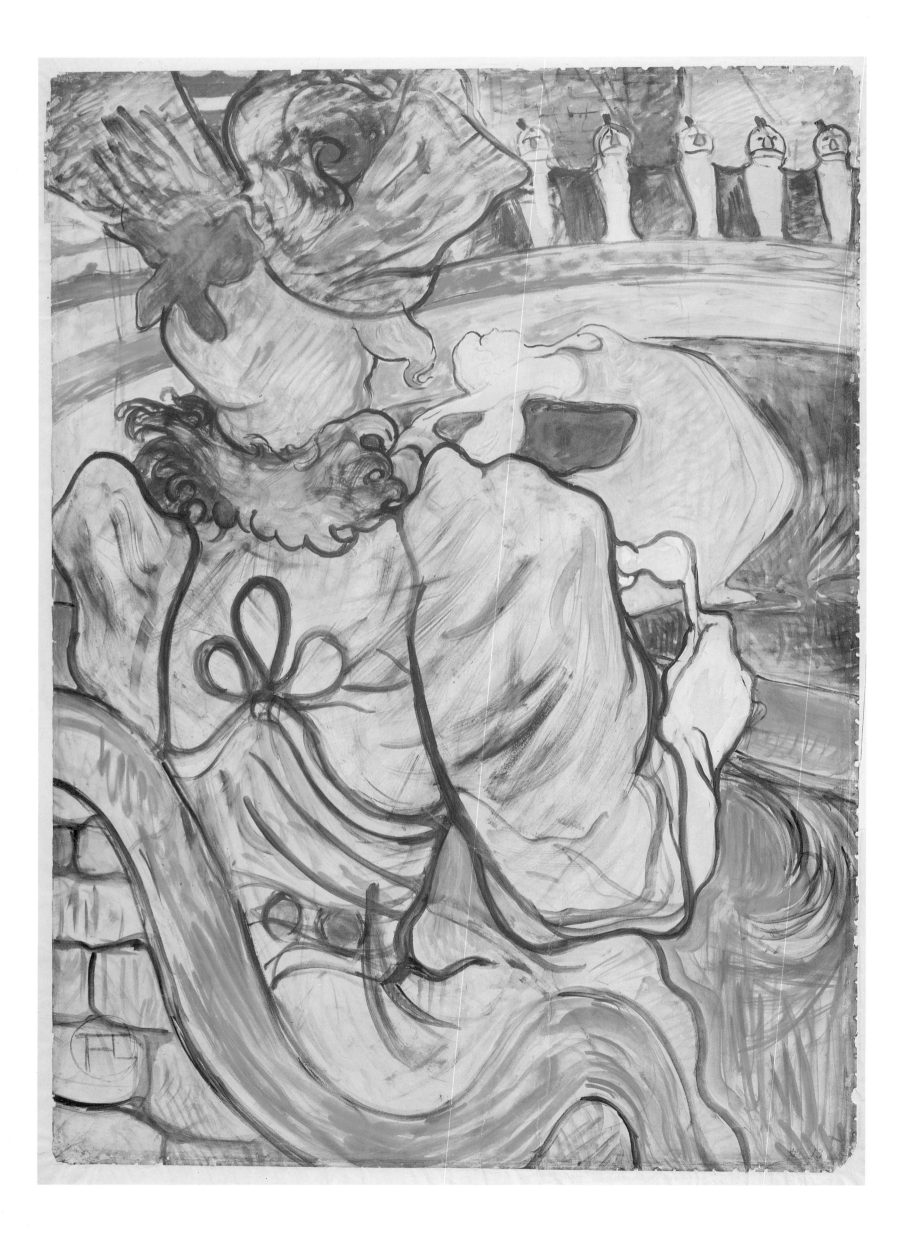

## At The Nouveau Cirque: The Female Clown and Five Stuffed Shirts 1891/2

Watercolor
45¾×33½ inches (117×85.75 cm)
The Philadelphia Museum of Art,
John D. McIlhenny Fund

The Nouveau Cirque in the rue St Honoré was a much smarter and grander venue than the Cirque Fernando in Montmartre. A contemporary English guidebook described its usual performance as:

Of the nature one would expect at a circus, so far as the first portion is concerned. A novel feature, peculiar to the Nouveau Cirque, is the introduction of 'aquatic burlesque'. During the interval the floor of the arena is lowered, forming a basin or pond into which a number of performers are constantly making a fall or plunge in unsuitable attire, at unexpected moments.

For its 1892 performance of the ballet *Papa Chrysanthème*. sets were constructed which included floating Japanese-style lily pads big enough to be danced upon.

Lautrec's intimate view of this production looks over the shoulder of a fashionably dressed young woman toward the lithe blond-haired performer doing her contorted athletic dance in front of the court of her new Japanese husband. The five stuffed shirts in the opposite ringside seats have red noses, short top-knots and stylized grimaces. They are caricature-like samurai uncomfortably thrust into Western evening dress, intended possibly to blur deliberately the borderline between spectator reality and the artifice of performance.

Lautrec used an unusually thin coloring and a very thick black outline for this work, because it is a design for a stained glass window. It was commissioned by Louis Comfort Tiffany at the instigation of Samuel Bing. Bing had already played a major part in fostering the taste for all things oriental, with his gallery on the rue de Rivoli and his publications on Japanese prints and artifacts. His new shop, opened in 1892 in the rue de Provence and called La Maison de l'Art Nouveau, exhibited and sold objects in the recently fashionable and sinuously organic style that soon took its title 'art nouveau' from the name of his shop. Lautrec's design, with its many arcs and counter-curves, suggests that he partially adopted this new house style.

The completed window made from this design (now in the Musée d'Orsay) was exhibited in 1895 at Bing's shop, along with eight others in the same suite designed by Vuillard, Bonnard, Roussel, Denis and Vallotton. Lautrec used a composition related to this for his poster of the *Divan Japonais* (see page 108) made the following year.

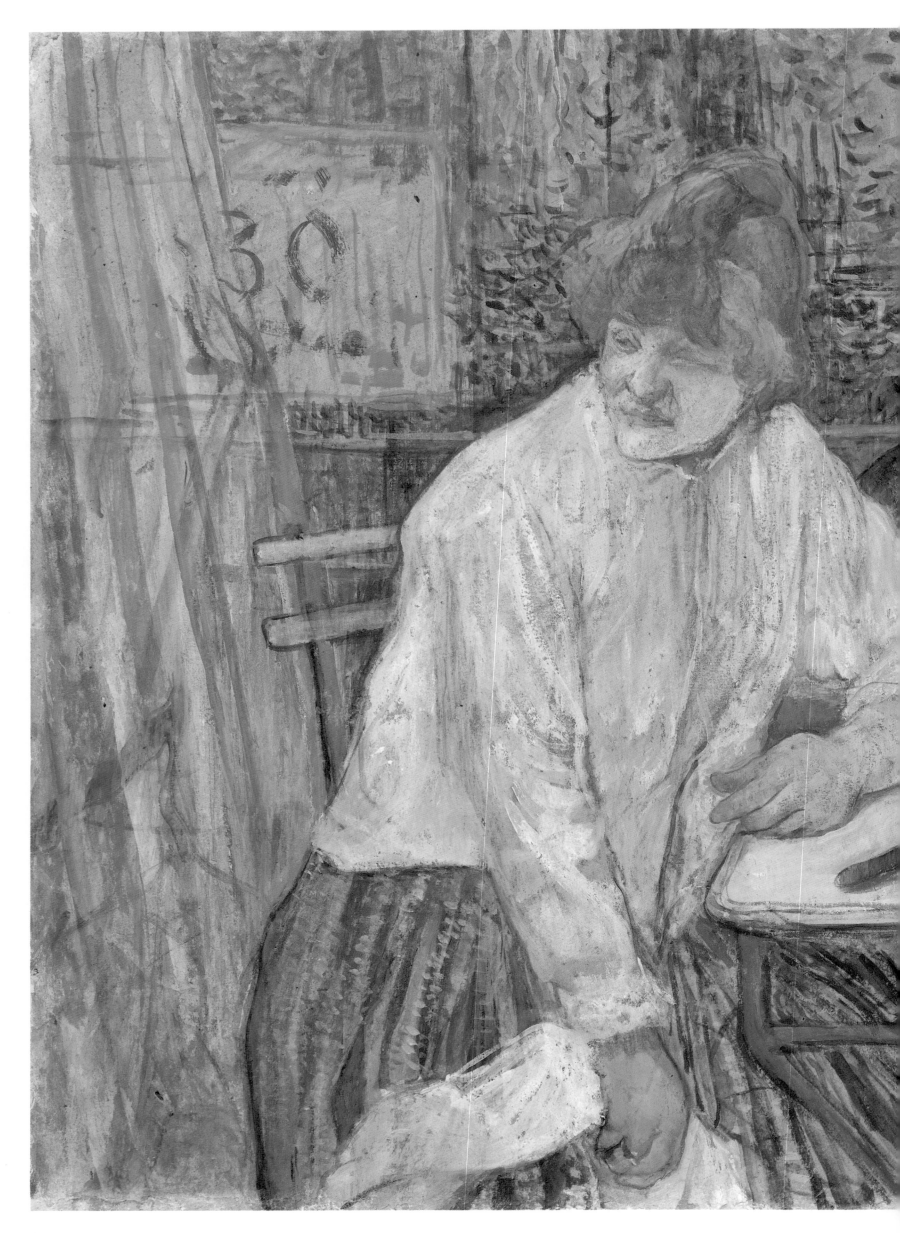

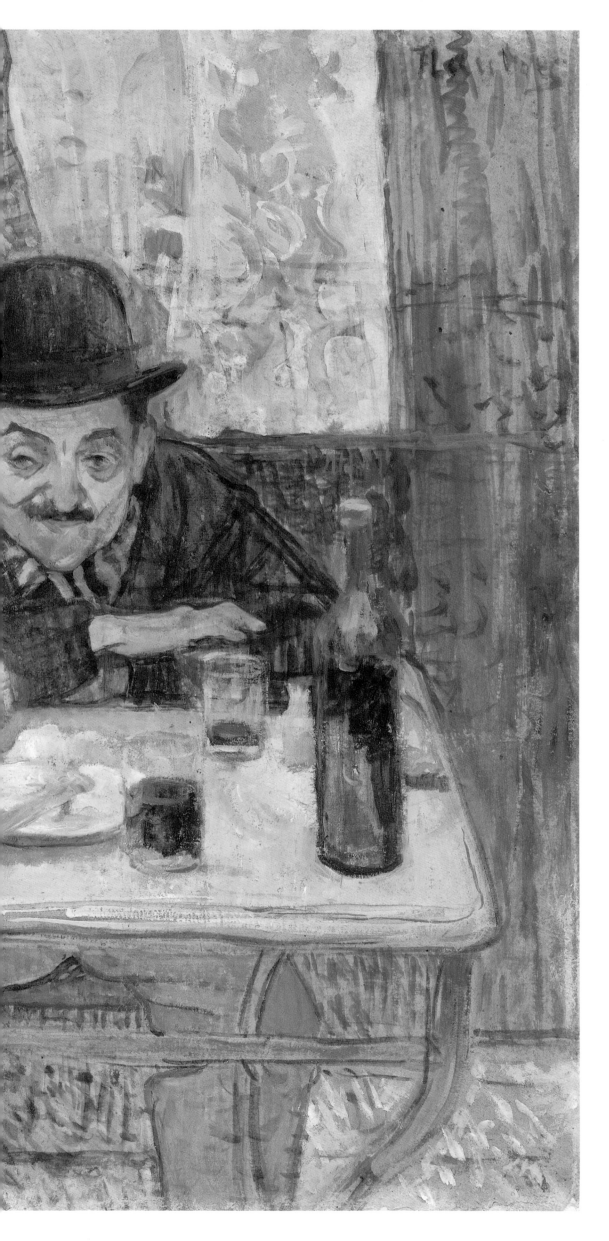

## At La Mie 1891

Oil on cardboard
21×26¾ inches (53×68 cm)
The Museum of Fine Arts, Boston

Maurice Guibert (1856-1913), a close friend of Lautrec's and a fellow *débauché* on the Montmartre nocturnal social round, is shown seated with a woman who is probably a Montmartre model but may be his mistress Mariette Berthaud, with whom he was having difficulties around the time this picture was painted. Guibert was a prosperous agent for the champagne firm Moët et Chandon. The journal *Fin de Siècle* described him as 'of all the capital the man who knows the prostitutes best.' His portly baggy-eyed face appears in several of the drawings that Lautrec made and in at least five other paintings. He accompanied Lautrec on several summer camping, hunting and sailing trips, and seems to have been particularly solicitous over the Comtesse de Toulouse-Lautrec, for whom he made large photographs of the Château de Malromé in 1891, and to whom he sent a banana tree in 1893.

'La Mie', which is the name or nickname of an unknown café, translates as 'the crumb', 'morsel' or 'the soft part of the loaf'. Lautrec's notorious fondness for appalling puns may be at work here, with the implication that this palpably bored and estranged couple represent the leftovers or crumbs of a human relationship. The more specific occasion for their meal is suggested with the prominent red, white and blue piece of drapery on the left, redolent of the banners and flags hung out on Bastille Day. Rather than, as has often been suggested, a serious subject, linked with more powerful images of discord between the sexes like Degas's *L'Absinthe*, this may be no more than a wry skit on the utter tedium of the public holiday.

Guibert was never depicted in a serious fashion by Lautrec. Even the bookplate that he designed for him, based upon a Japanese heraldic *mon* or samurai sword-guard, showed him ridiculously cross-eyed and holding two fingers aloft.

Lautrec exhibited this work at the Salon des Indépendants in 1891.

## Moulin Rouge: La Goulue 1891

Brush and spatter lithograph in four colors on paper
74½×45 inches (191.5×115 cm)
Bibliothèque Nationale, Paris

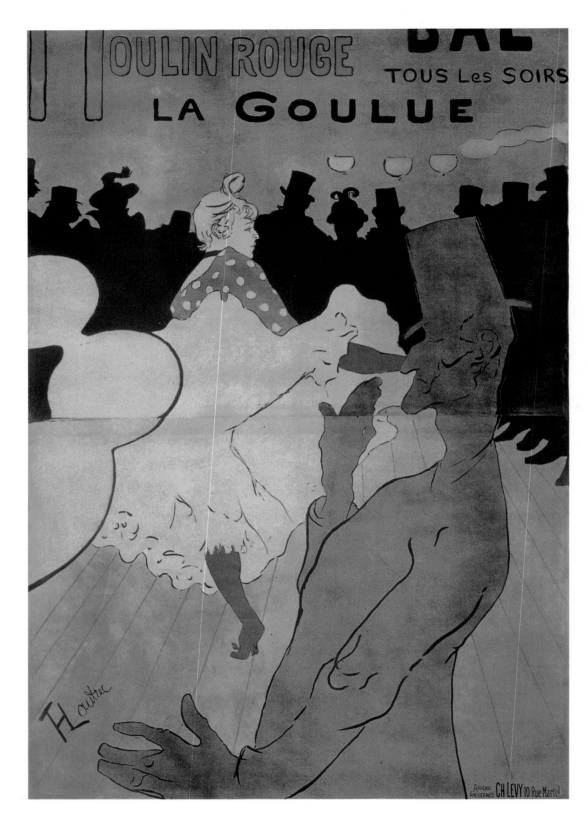

Lautrec's first poster, this appeared on the streets of Paris in October 1891 and brought him overnight success. Until then the indubitable master of the street and kiosk poster had been Jules Chéret (1836-1932). When the impressario Zidler had opened the Moulin Rouge in autumn 1889 and required a poster, Chéret had been his obvious choice. The poster that he produced of a procession of pretty girls riding on donkeys beneath a windmill was a rather generalized evocation of the cabaret. Lautrec, in what must surely be regarded as a competitive riposte, chose for his Moulin Rouge poster a more specific treatment of two stars at work within Zidler's cabaret. With its wonderful simplifications of form and novel typographical repetitions, this image not only extended the visual language of the poster, but also introduced subtle technical refinements to lithographic printing. François Jourdain, who saw it when first displayed, wrote:

I still remember the shock at first seeing the Moulin Rouge poster. . . . carried along the Avenue de l'Opéra on a sort of small handcart, and I was so captivated that I walked alongside it on the pavement.

At the center of Lautrec's poster is the dancer Louis Weber (1870-1929) from Alsace, who had been a major figure in Montmartre cabaret since 1886. Nicknamed 'La Goulue' (the glutton), she is accompanied by the tall shadowy figure of Jacques Renaudin (c. 1845-1906), who augmented his daytime job as a wine merchant with evenings spent dancing. His nickname 'Valentin le Déssossé' (the bone-less) referred to his fluid dancing, which was characterized by a striking angularity in the articulation of his limbs, a feature that Lautrec exploited in this work, contrasting it with the swirling circularity of La Goulue's petticoats.

The critical acclaim which this poster received helped to promote more general interest in all Lautrec's art. Writing to his mother in December 1891, Lautrec commented:

The newspapers have been very kind to your offspring. I'm enclosing a clipping written in honey ground in incense. My poster has been a success on the walls despite some mistakes by the printers. . . .

Over the next three years, Lautrec exhibited this poster at various exhibitions, clearly seeing it as central to his art, a view that would perhaps not be endorsed today, since subsequent images achieved even greater acclaim.

## Jane Avril Dancing 1892

Oil on board
33⅛×17⅜ inches (84×44 cm)
Musée d'Orsay, Paris

Jane Avril (1868-1943) was the daughter of *'La Belle Elize'*, a great Second Empire courtesan, and the Marchese de Font, an Italian aristocrat. Unwanted by her mother and maltreated, she spent part of her childhood receiving treatment for a mental breakdown at the Saltpétrière Hospital. Following a brief career as a cashier then as an equestrienne, she obtained success from 1891 as a dancer at the Moulin Rouge. Her furiously energetic style of dancing led to her being nicknamed *'La Mélanite'*, after a kind of high-explosive. Lautrec's friend Joyant described her dancing as 'like an orchid in a frenzy', and also suggested that she carefully chose both her dress and underwear to complement the mood of each particular dance. A fuller description of her work was given by Arthur Symons (1865-1945), the Symbolist critic and poet. In his recollections in 1929 he wrote:

She danced a quadrille, young and girlish, the more provocative because she played as a prude with an assumed modesty, décolletée to the waist, in the Oriental fashion. She had black curls around her face and had about her an air of depraved virginity.

Shown here, altogether more modestly attired than Symons suggests, and with her famous red rather than black hair, she dances alone. At times Jane Avril did form a quadrille group, but her greatest performances were solo. She holds her leg in the *'port de bras'* with both hands clasped under her thigh, enabling her to wave her lower leg vigorously from side to side.

Lautrec first saw Jane Avril in 1891. They became close friends and she was the model for more of his pictures than any other woman. Unlike her fellow star, La Goulue, she had literary tastes and intellectual curiosity, and she and Lautrec found it easy to talk together. Jane Avril subsquently became an actress in avant-garde theater.

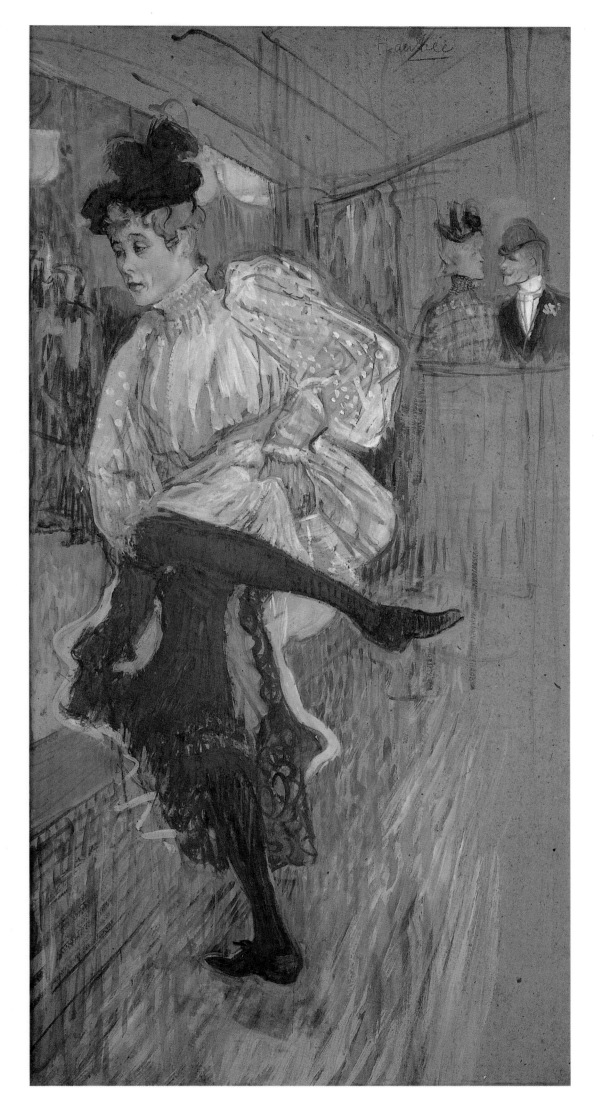

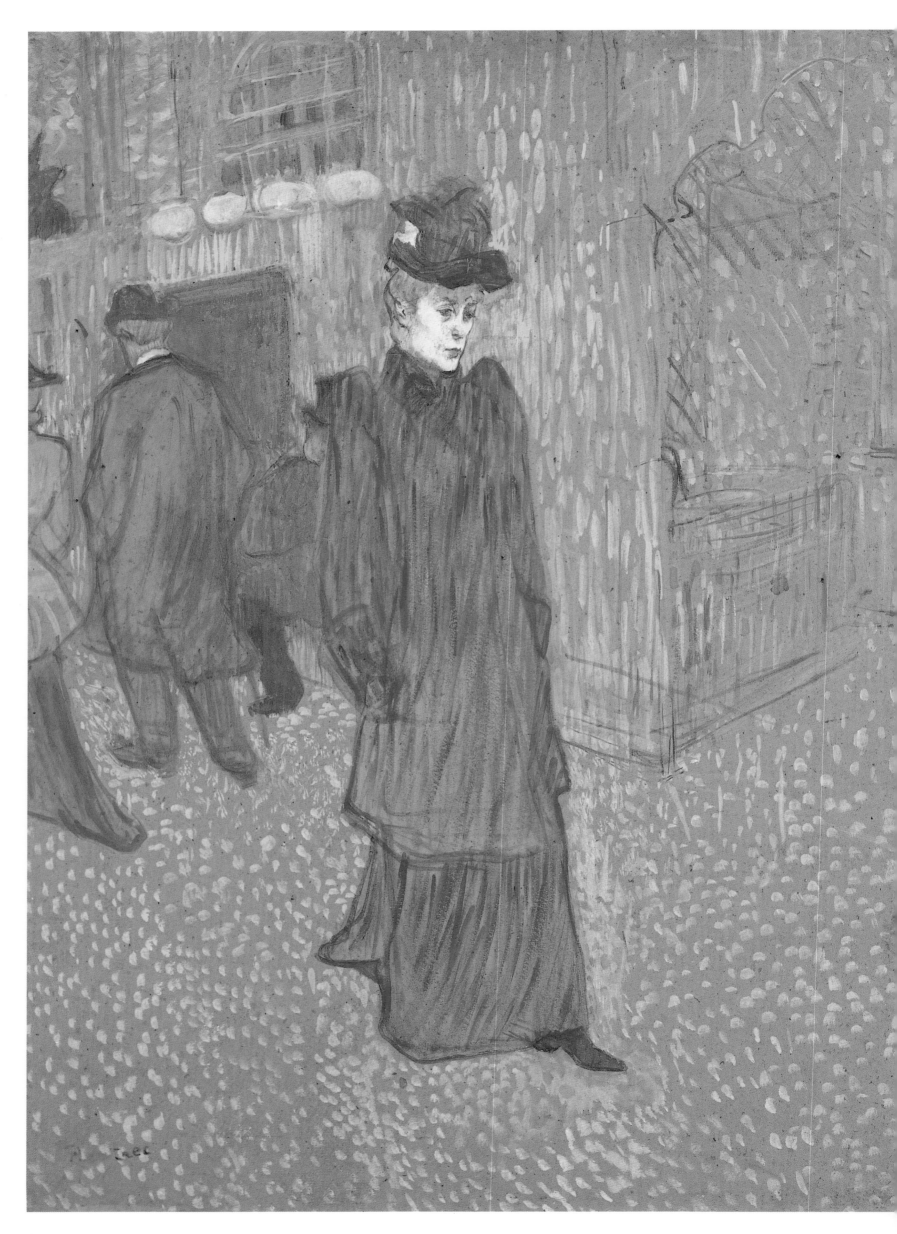

## Jane Avril Leaving the Moulin Rouge 1892

Essence on board
33¼×25 inches (85.8×64 cm)
Wadsworth Atheneum, Hartford,
Connecticut, bequest of George A Gay

The particular quality in Jane Avril's character that Lautrec emphasized in the many pictures that he made of her was her absorbed self-sufficiency and apparent indifference to those around her. Yvette Guilbert and La Goulue required audiences; there was a certain rapport in their performances with other dancers or spectators. Jane Avril seems to have needed neither; she worked for herself. The Symbolist poet Arthur Symons also saw aloofness as part of her distinctive appeal as he indicates in the poem that he wrote about her:

Alone, apart, one dancer watches
Her the mirrored, morbid grace;
Before mirror, face to face,
Alone she watches
Her morbid, vague ambiguous grace.

Before the mirror's dance of shadows
She dances in a dream,
And she and they together seem
A dance of shadows,
Alike the shadows of a dream.

The orang-rosy lamps are trembling
Between the robes that turn;
In ruddy flowers of flame that burn
The lights are trembling:

The shadows and the dancers turn
And, enigmatically smiling,
In the mysterious night,
She dances for her own delight,
A shadow smiling
Back to a shadow in the night.

Shown in this painting leaving the Moulin Rouge unnoticed, Jane Avril is bonneted and pale-faced with her diminutive frame encased in a heavily-padded coat. Dark against a bright background, she is surrounded by a speckled field of yellow dots and dashes: Pointillist marks that suggest the fractured and scattered light from the many gas-lamps. These contrast with the hints of complementary purple in her coat and skirt. Lautrec painted numerous pictures of Jane Avril in 1892-93, and in nearly all of them, she is walking or performing alone.

*The Englishman William Tom*
*Warrener (1861-1934) at the*
*Moulin Rouge* 1892
Oil and gouache on cardboard
34×26 inches (86×66 cm)
Metropolitan Museum of Art, New York,
bequest of Miss Adelaide Milton de Groot
(1876-1967), 1967 (67.187.108)

William Tom Warrener (1861-1934) was an English artist from Lincoln who, having come to Paris in the mid-1880s to study at the Académie Julien, stayed on. In this painting, traditionally alternatively entitled *Flirt*, Lautrec portrays him as a lecherous middle-aged Englishman with a faintly military bearing, of a type that frequently came on a debauch to the capital. A fine portrait study which preceded this painting shows Warrener fresh-faced, good-looking and 30, rather than the baggy-eyed, jowly, yellow-skinned *roué* seen here.

This picture relates to an earlier 1889 image entitled *On the Promenade, Lust* (private collection), in which Lautrec also explored the tense interchange of gazes between a sexually eager man (possibly also Warrener), who perceives himself to be in control of the situation, and a predatory woman who is really in command. The red,

pouting, parted lips of Warrener and the slash of red for the mouth of the foremost woman are particularly striking visual foci in the mercenary dialogue that is taking place. Lautrec also gives a putrescent quality to Warrener's face by his use of green for his moustache. Lautrec used this painting as the basis for one of his first color lithographed prints. As part of the simplification of color and detail required for the print, Lautrec reduced the figure of Warrener to a monochromatic gray form, which somehow lacks the air of depravity of this painted original.

Warrener is not mentioned in Lautrec's surviving correspondence, although he was the original owner of this painting after it was exhibited in London at the Royal Aquarium in 1892. He is also thought to be the figure who is chatting up a woman in the background of Lautrec's painting of Jane Avril dancing.

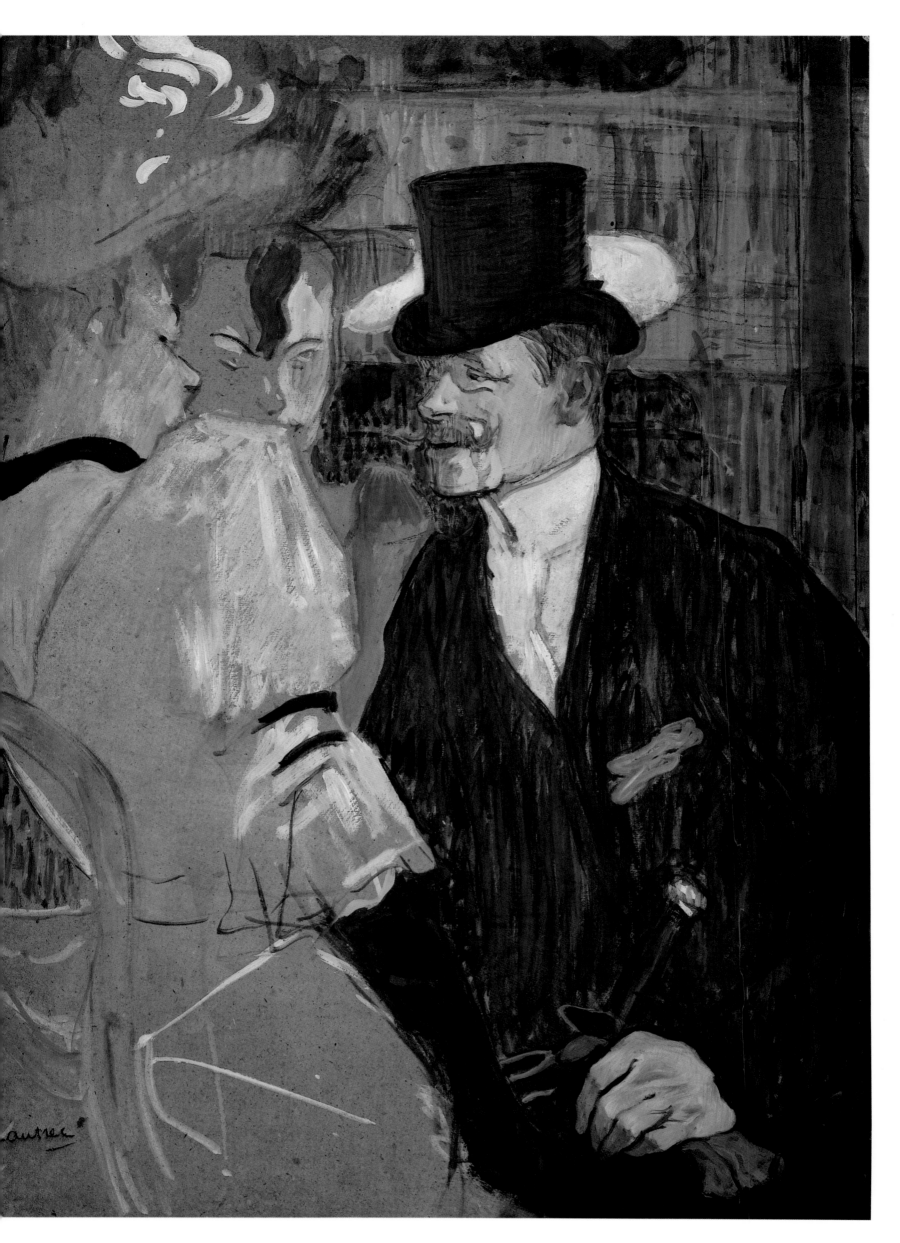

## La Goulue at the Moulin Rouge

1892

Oil on board

31¼ × 23¼ inches (79.4 × 59cm)
Collection, The Museum of Modern Art,
New York, gift of Mrs David M Levy

With a magnificently disdainful sneer upon her face, La Goulue, escorted by two companions, makes her nightly promenade around the cabaret of which she is queen. Her right-hand attendant is possibly her fellow quadrille dancer, Nini Patte en l'Air (Nini, hoof in the air). The woman on the left, whose face and figure is cropped by the picture edge, is an older sister, as corpulent as La Goulue would herself one day become.

Paradoxically a sacrificial air pervades this image of stately progress. La Goulue is like a bride, protected yet pinioned by overdressed minders, and her frothy whiteness stands out against their dark forms. She stares blankly ahead. Her escorts outstare all, ensuring the unhindered progress of their charge. Her success was brief; by 1895 she had left Montmartre.

When Lautrec made this picture, La Goulue was at the peak of her brief fame.

Yvette Guilbert in her memoirs described the extraordinary potency of her appeal:

La Goulue in black stockings clasping a black satin foot in one hand would set the sixty yards of lace in her skirt whirling and display her drawers which were whimsically embroidered with a heart that stretched across her bottom when she took her roguish bows.

Behind the tuft of pink ribbons at her knees an adorable froth of lace reached to her slim ankles, and her lithe, nimble shapely legs would appear and disappear. With a sudden kick she would knock off her partner's hat and then keeping her body erect, do the splits. Her slender waist was wrapped in a sky blue satin blouse and her black satin skirt opened like an umbrella fully five yards all round her. What a magnificent sight. From Paris to New York by way of London's East End all girls wanted a hairstyle like hers and the same colored ribbon around their neck.

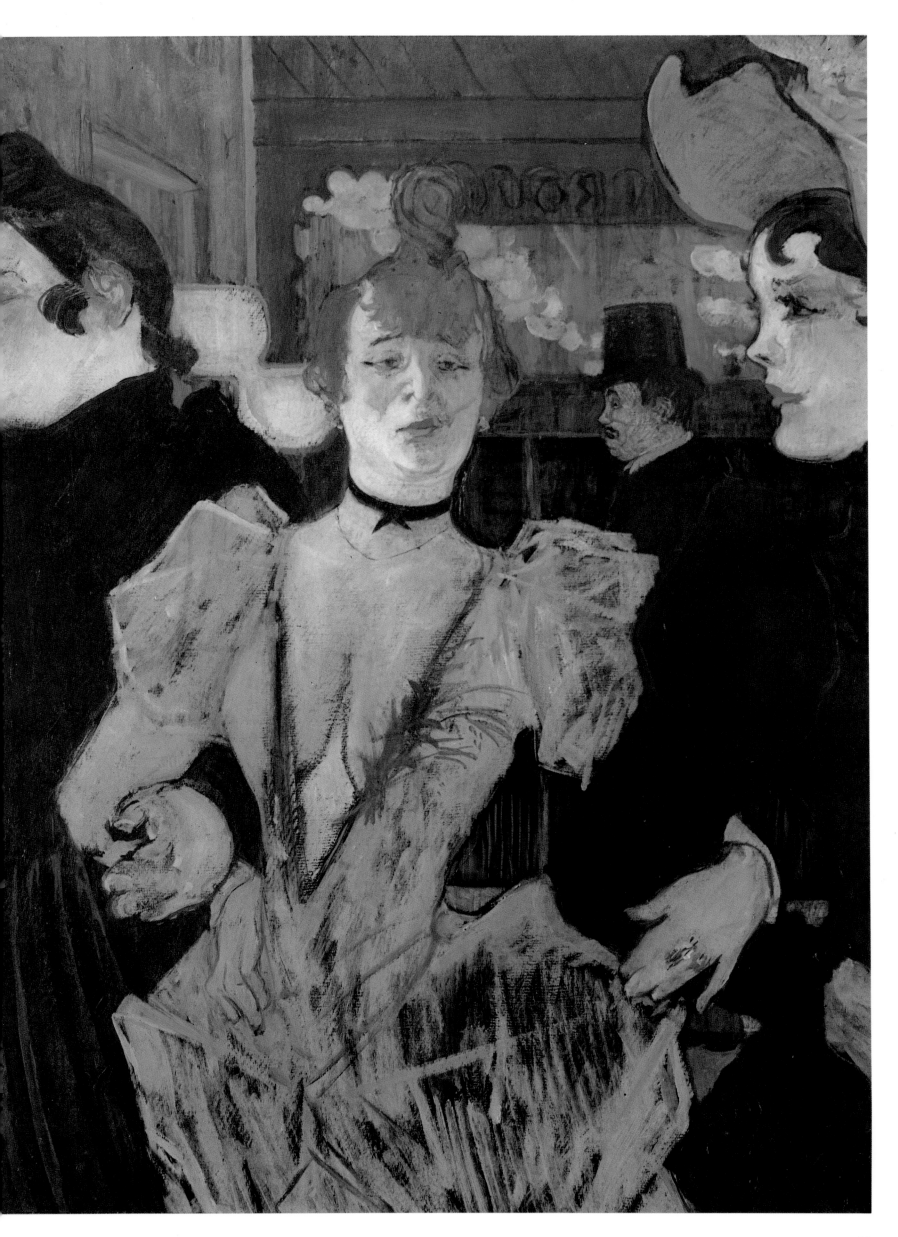

## At the Moulin Rouge, La Goulue and her Sister 1892

Color lithograph
18½×14 inches (46.8×35.4 cm)
The Philadelphia Museum of Art

This study of La Goulue on the arm of her sister was one of Lautrec's first limited-edition lithographed colored prints, published by Boussod Valadon et Cie in October 1892. Until then he had used color lithography principally for the mass production of posters in runs of up to 3000, printed on machine driven presses. As a 'fine art' print on better quality paper, printed on a hand press and individually signed by the artist, this image and the companion print based upon the painting of *The Englishman Warrener at the Moulin Rouge* (see page 86), were sold at 20 francs each.

The figures of the two men on the left are compositionally similar to that used by Lautrec in the Warrener picture. Dortu identifies one as Francisque Sarcey, a writer for *La Dépêche de Toulouse*, one of the journals that Lautrec cultivated in order to obtain reviews of his work. In the marketing of his new venture, Lautrec wrote to critics who had been generally sympathetic to his work. The Belgian poet and critic Emile Verhaeren (1855-1916), who had praised Lautrec's pictures at the Les Vingt Exhibition in 1891, received a letter from Lautrec informing him that:

An original color print of La Goulue at the Moulin Rouge has just been published. The engraving is by me and is based upon my picture or rather it is a highly transposed interpretation of the picture. . . . I hope that it will be only the first in a series that I am doing and will if nothing else have the merit of being very limited and therefore rare.

Roger Marx (1859-1913), editor of *L'Image*, who had shown interest in reproducing in his magazine a photograph of *La Goulue at the Moulin Rouge* (page 88) when it was exhibited at the Indépendants' exhibition in February 1892, was also contacted.

My print is on display at Goupil's and I will be most obliged if you could say a few words about it to your readers . . . don't forget to mention that they are original prints in portfolio. The series will be continued in 100 copy editions.

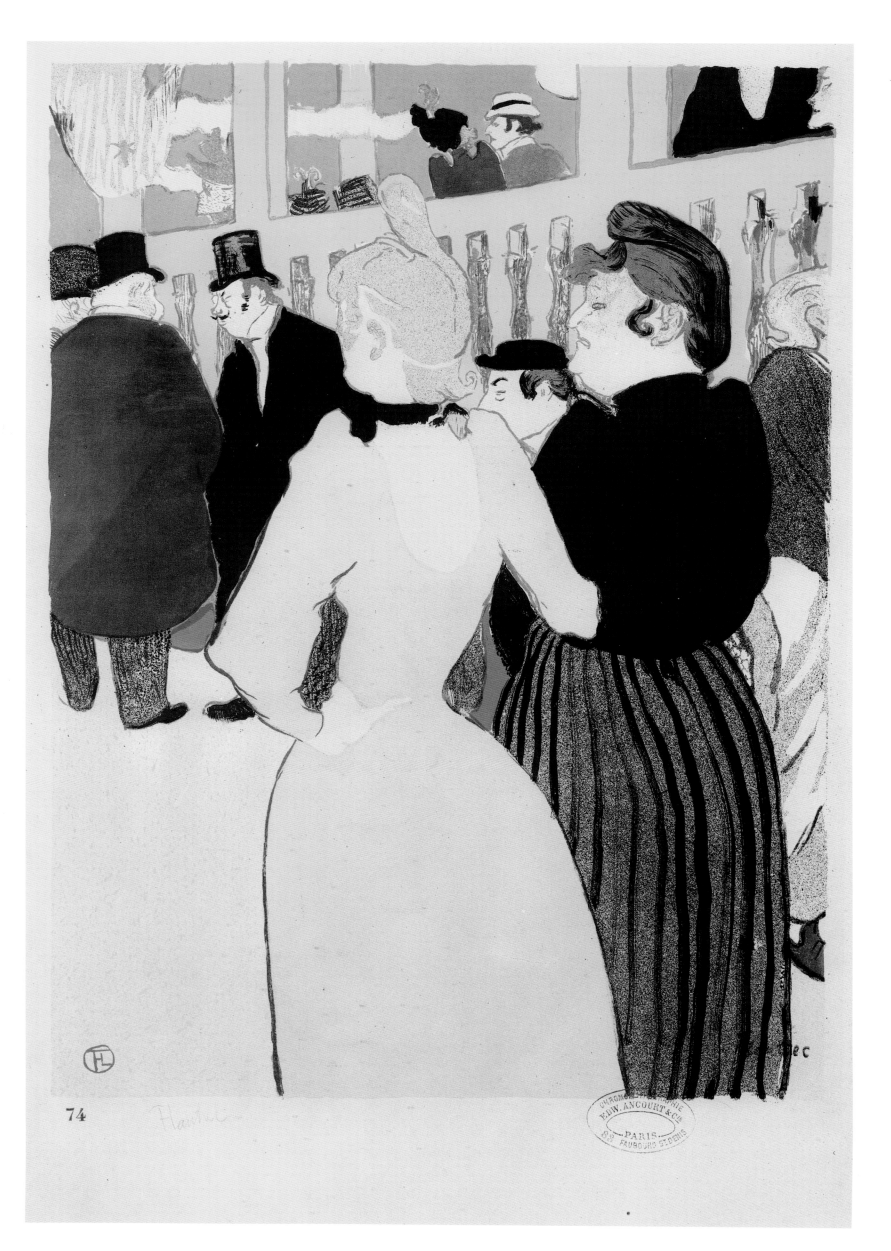

74

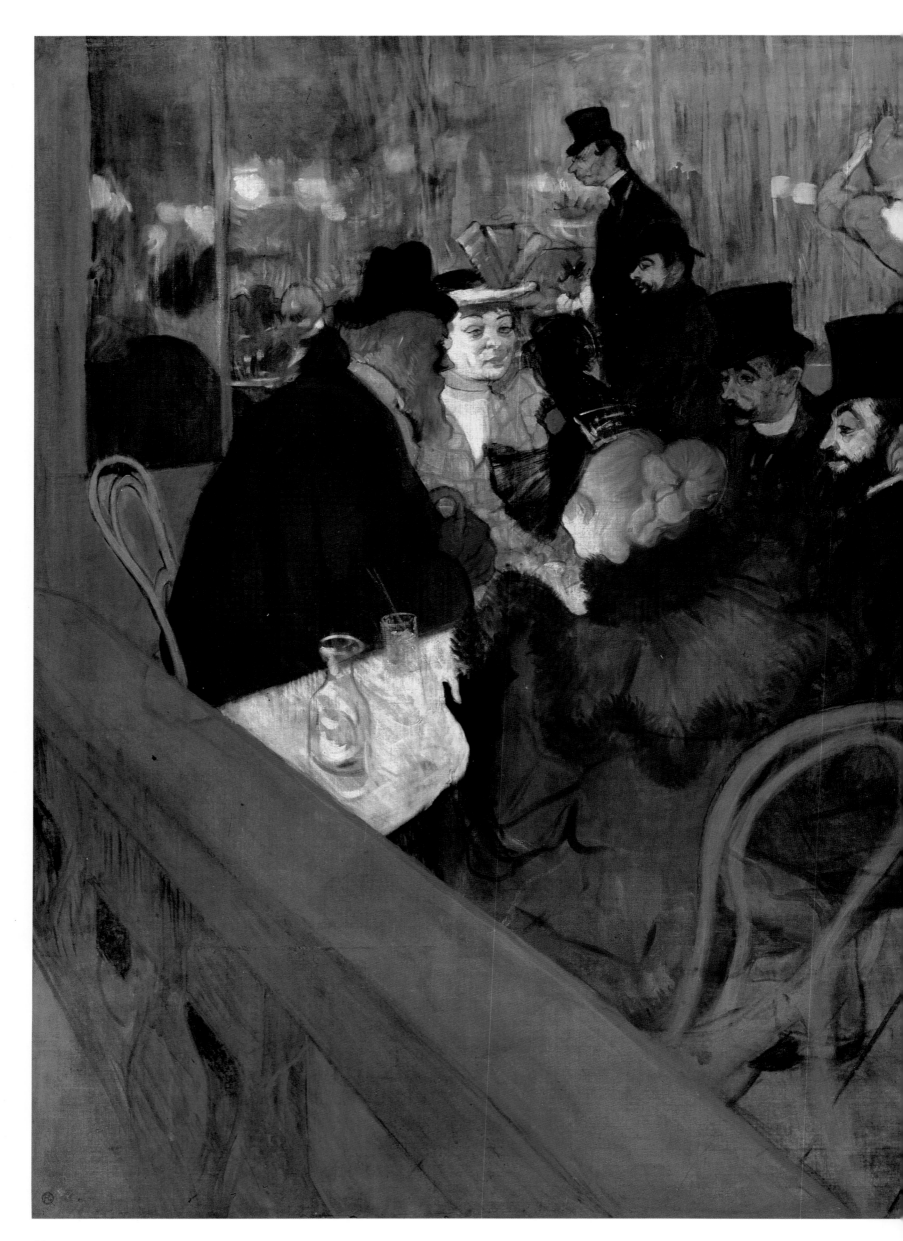

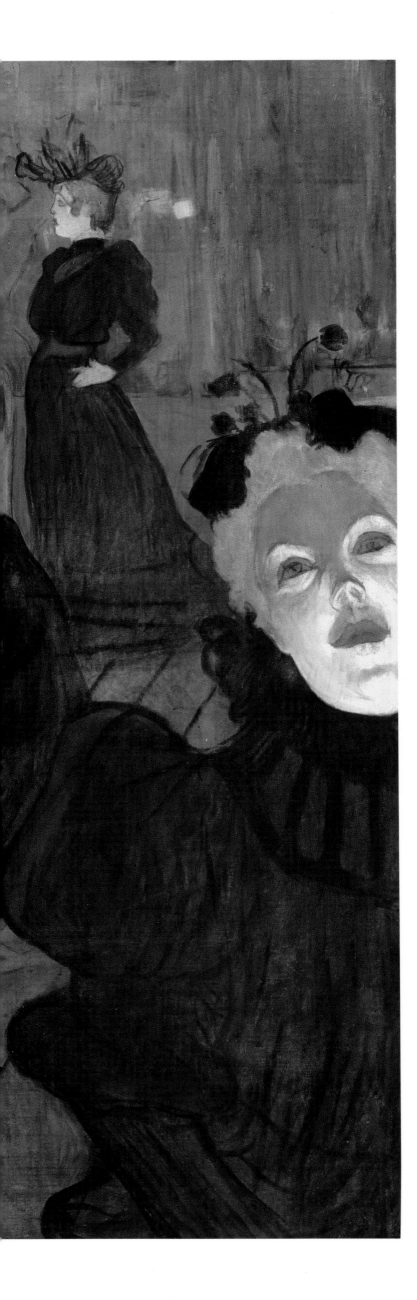

## At the Moulin Rouge 1892-95

Oil on canvas
48½×55⅜ inches (123×141 cm)
The Art Institute of Chicago, Helen Birch
Bartlett Memorial Collection, 1928.610

Adopting a composition that is in essence a reversal of that used for the substantial *Moulin de la Galette* canvas of 1889 (page 62) this, the largest picture that Lautrec painted of the Moulin Rouge, is his masterpiece of the Parisian cabaret society within which he moved. Despite the public setting, this remains a private picture; everyone depicted in this mirrored corner of the Moulin Rouge is a friend of Lautrec's. Seated at the table is the bearded Edouard Dujardin talking to the dancer Macaroni, faced by Paul Sescau and Maurice Guibert, while Jane Avril is seen from behind with hair that glows like fire amidst the aquatic cool of the room. To the rear, La Goulue adjusts her topknot in a mirror, watched by another woman, possibly her sister. At the very center of the picture, the tiny figure of Lautrec strolls by, apparently ignoring his friends, accompanied by the tall loping figure of his cousin, Tapié de Céleyran, who had recently arrived in Paris.

When exhibited in Brussels in 1892, where it was probably entitled *Nocturne*, this picture apparently lacked the strikingly illuminated foreground figure of the dancer May Milton. A side strip of canvas and her ghastly face were probably added in 1895, when Lautrec first met her and produced a cabaret poster for her. Recently it has been suggested that the entire picture was only painted in 1894-95 and that for a while the strip was cut from the side to make the image more attractive. An earlier biographer of Lautrec, Gustave Croquiot, wrote a particularly virulent critique of the face of May Milton. Despite the overblown *fin-de-siécle* tone of Croquiot's comments, he did attempt to find some rationale for the shocking dissonance between the cosy intimacy of the seated group and this fearful visage:

May Milton with a swollen face, with a heavy jaw whitish-yellow in color . . . This painting is a hideous terror. This polished red mouth falls, it opens like a vulva, it has no further defense, it has no further toughness, it opens, it lets everything enter.

More recent suggestions that Lautrec was seeking to produce an updated *vanitas* picture, similar to seventeenth-century Dutch paintings of tavern revellers, seem partially to confirm Croquiot's suggestions.

## At the Moulin Rouge: Two Lesbian Dancers 1892

Oil on board
37½×31½ inches (95×80 cm)
National Gallery, Prague

Among the earliest of Lautrec's depictions of lesbians, this painting shows Cha-U-Kao, the female clown, waltzing with a companion whose name is unknown. Lesbianism appears to have been fairly openly acknowledged at the Moulin Rouge, in a way that male homosexual activity was not. Although this may have been partly due to the proclivities of several of the performers (La Goulue, for example, was the lover of the *danseuse* La Môme Fromage), it was probably accommodated more cynically for its appeal as part of the complex sexual spectacle on offer to the predominantly male heterosexual audience.

Behind the dancing couple is the familiar back of Jane Avril who, as ever, dances her frenetic steps alone. Seated at the far right is Charles Conder (1868-1909), the Anglo-Australian painter who was Lautrec's friend and was much influenced at this time by the paintings of Whistler, Puvis de Chavannes and Monet. The bearded male on the far left is the painter François Gauzi.

This is Lautrec's first depiction of Cha-U-Kao, who appeared in several paintings and prints over the next seven years. He became so familiar with her face that he later drew her from memory in the circus pastels made in 1899 during his detoxification cure. Yet despite this she does not figure in his surviving correspondence, nor does she crop up significantly in anecdotal reports about either the Moulin Rouge or the Nouveau Cirque, at both of which she performed. Her relationship, and that of her lover the *danseuse* Gabrielle, with Lautrec is tantalisingly unclear.

A colored lithograph of this painting was produced in 1897 along with another related print showing Madame Hanneton, the one-eyed manageress of the lesbian Ladybird Bar. They form part of a group of prints connected with lesbian life in Montmartre which suggest that Lautrec was consolidating his more public treatment of lesbian sociability as a possible complement to the intimacy of the *Elles* series (see page 146).

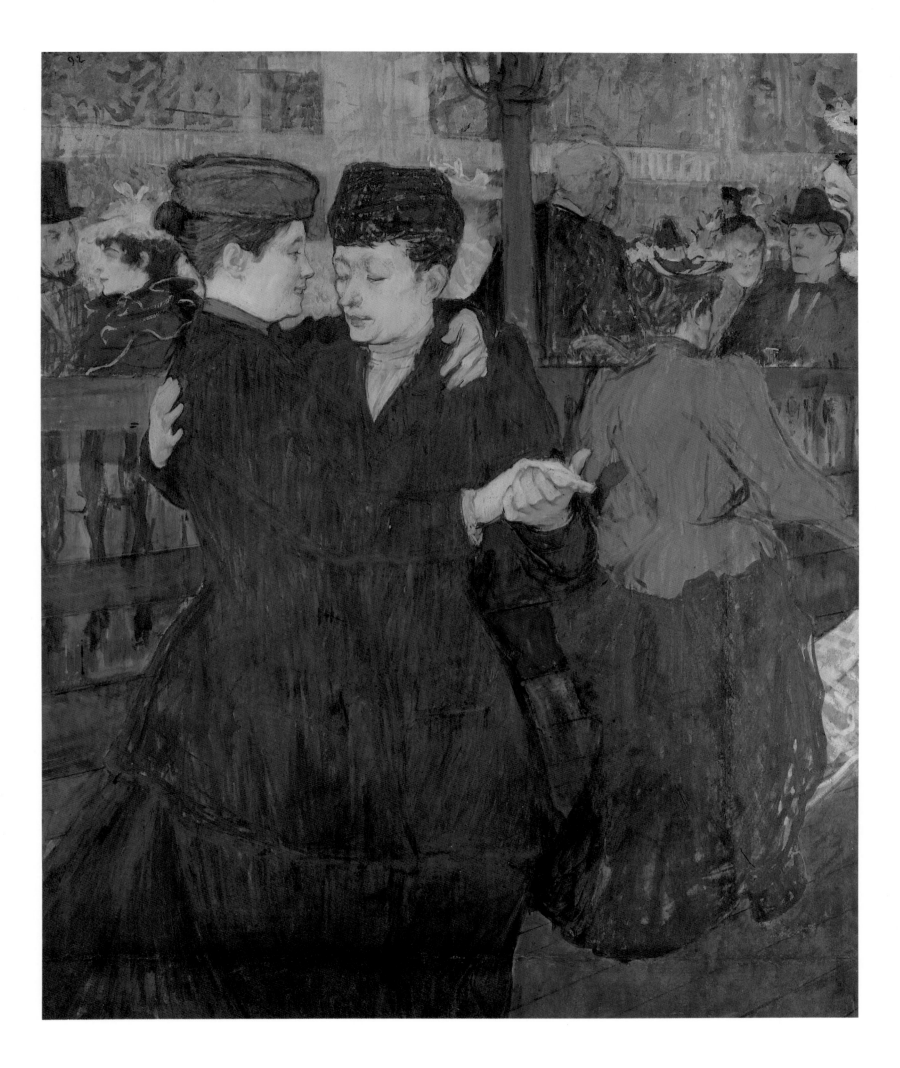

## A Corner of the Moulin de la Galette 1892

Oil on board
39½×35⅛ inches (100×89 cm)
National Gallery, Washington,
Chester Dale Collection

The proportions of this work, and the dominance of the two foreground female figures, suggest that this was conceived as a pendant to the previous picture (page 94). Both were exhibited, possibly together, at Lautrec's February 1893 show at Boussod-Valadon's gallery. Always viewed as an essentially working-class subject and traditionally identified as the Moulin de la Galette, the picture's alternative title *L'Assommoir* refers to Emile Zola's famous 1877 novel of the same name. Zola's account of the alcoholism and moral collapse of Gervaise, a young working-class woman, was partially set in a tavern that, though fictitious, was identified by Zola with his usual uncompromising specificity as being close to the boulevard de Rouchechouart and the area near the Gare du Nord, just east of Lautrec's usual haunts.

Zola's Realism, with its concern for the social improvement of the poor, was at odds with Lautrec's more dispassionate reporting of life around him. While it is just about possible to see the foreground young women as a slightly forlorn Gervaise and assorted factory workers, shop girls and laundresses pouring into Père Colombe's bar, there is no explicit or implicit note of social concern in this picture.

Lautrec's world did include the horrors that Zola described; the very density of Parisian apartment occupancy and his own life in Montmartre guaranteed that. He touched upon alcoholism in his late 1880s series of females as types characteristic of particular Parisian *quartiers* (see page 50), but they were treated as individuals shown in a neutral context. Aside from his pictures of the Moulin de la Galette, Lautrec seems to have been either disinclined or temperamentally incapable of painting a picture that showed the working class *en masse* within their own world, or even their own *demi-monde*. Raffaeli and Steinlen, with whom Lautrec's work has so much in common, illustrated the poor on the streets or at work, while Lautrec's sympathies were bestowed upon individuals not upon classes.

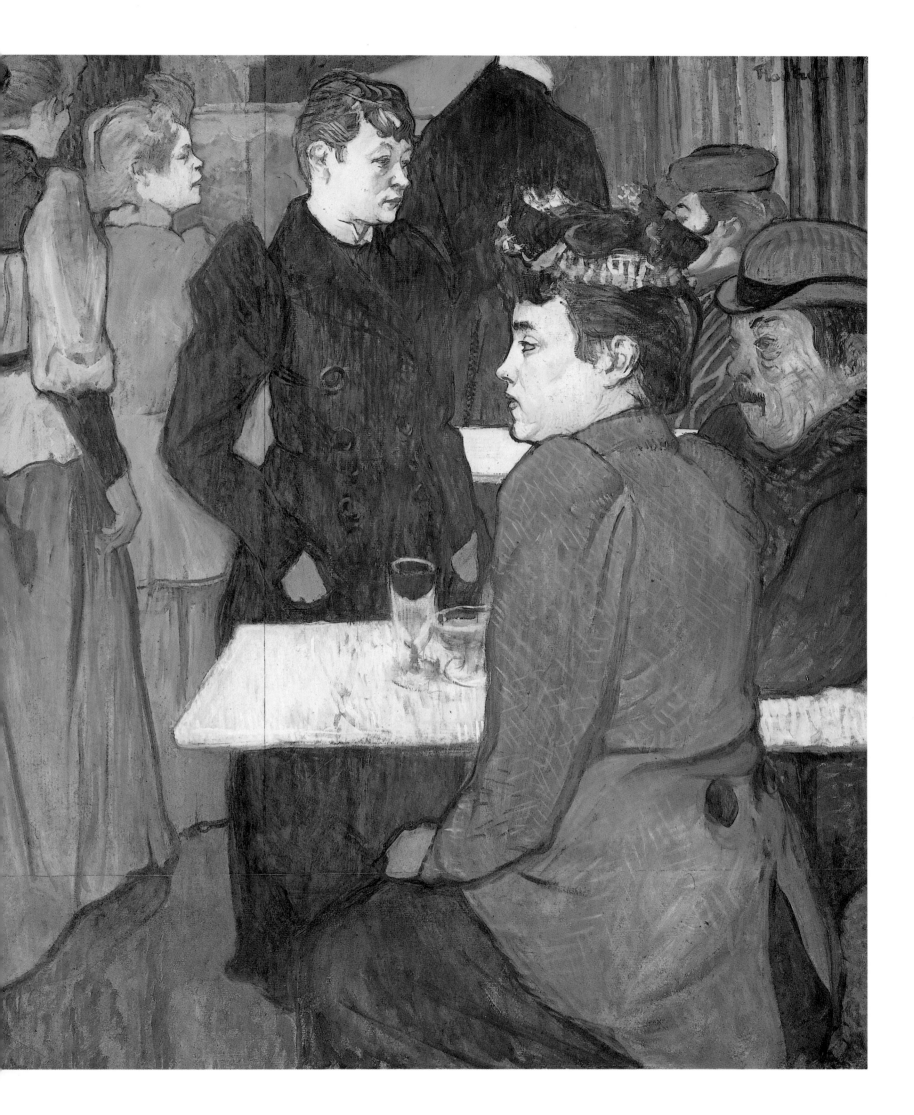

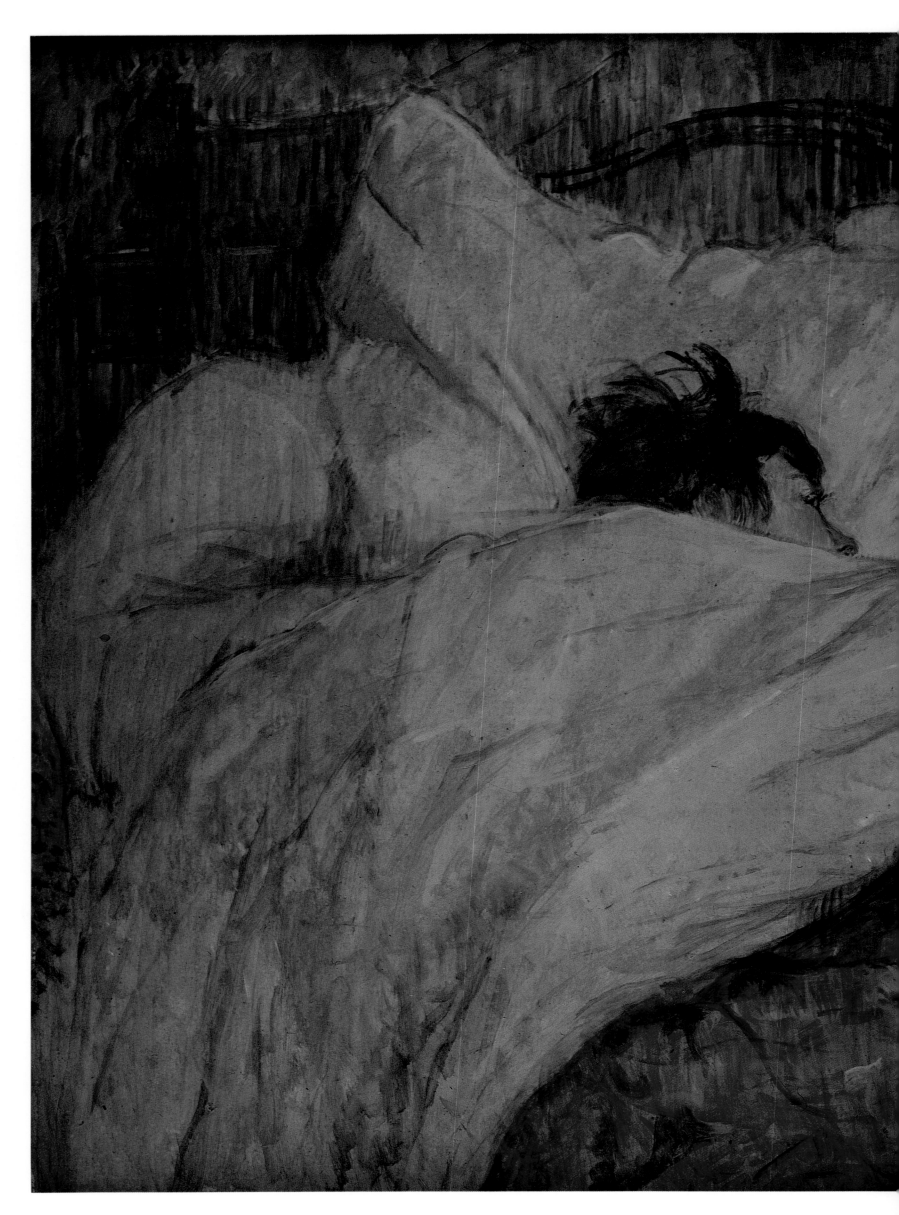

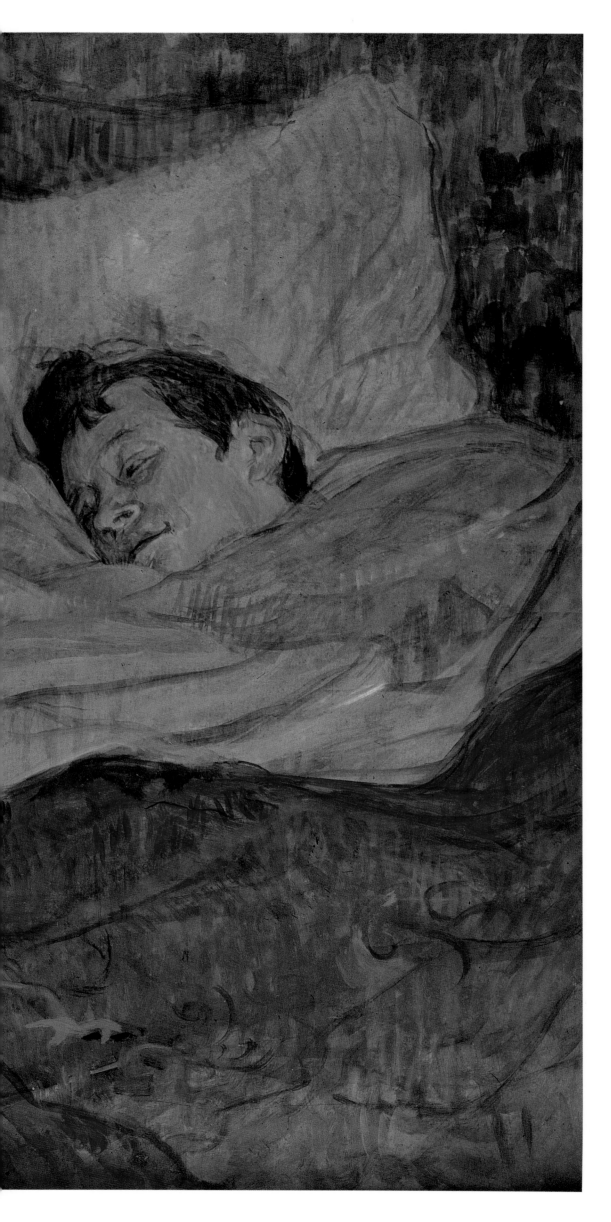

## In Bed 1892

Oil on board
27⅛ × 21¼ inches (64 × 59 cm)
Musée d'Orsay, Paris

Lautrec began depicting lesbian couples together in bed in 1892. Both Thadée Natanson, the editor of *La Revue Blanche*, and the etcher Charles Maurin commented on his absorption with the theme. To the latter he showed a photograph of a couple embracing, saying, 'This is superior to anything, it is the absolute peak of sensual delight.' This picture belongs to a group of four made in 1892/93 that show the same adolescent couple, one slightly *gamine*, the other long-haired and finer-featured. This image and one other show them gazing into each others' eyes, the others depict them with arms entwined in an embrace. Lautrec exhibited one or more of this group at the Barc de Bouteville exhibition in 1892 in the rue Le Pélétier, where they attracted the censorious attention of the Paris police.

Lautrec's inspiration for this subject has usually been linked to the lesbian intimacy that he saw in the brothels that he used, in particular at this time that at the rue d'Amboise. It has become a commonplace of commentary upon these pictures that they express with especial tenderness the affection that these two women share for each other, and it has been usual to contrast their delicacy with the more strident athleticism of the painting of two entwined sleeping lesbians which Courbet painted in 1866 for Khalil Bey, the former Turkish Ambassador to St Petersburg (see page 20). It is just possible that Lautrec actually did see Courbet's famous picture, possibly not when it was publicly exhibited at Durand-Ruel's gallery in 1878, but perhaps later when it had entered the collection of the baritone Jean-Baptiste Faure (1830-1914), a collector of French eighteenth-century art, a patron of Degas, and one who was encouraged into avant-garde purchases by Durand-Ruel.

## Ambassadeurs: Aristide Bruant

1892

Brush and spatter lithograph in five
colors on paper
53$^{15}$/$_{16}$×37$^3$/$_8$ inches (137×95 cm)
San Diego Museum of Art, California,
Gift of the Baldwin M Baldwin
Foundation

You had to see Bruant belching this out in his
brazen voice, see him as I saw him; in profile,
with that look in the sinister shadow of his
deceptively gentle eye, the coal-black nostril of
his upturned nose, and the movements of his
facial muscles, evocative of the jaw motions of a
wild animal eating carrion. . . . What he sang. . .
was quite indescribable. This ignoble lyricism
made up of foul adjectives, obscenities, filthy
slang, the vocabulary of grubby brothels and
clinics for venereal disease.

So wrote the indignant Edmond de Gon-
court in his journal in March 1892, after
attending a drawing-room performance by
Bruant at the home of the publisher Char-
pentier. For de Goncourt, Bruant repre-
sented a near-revolutionary threat.

Aristide Bruant (1851-1925) was famous
for his bitter, poignant yet unsentimental
songs, which focused on the struggle to
survive among Paris's marginalized poor,
particularly those who lived below Mont-
martre and in the industrial slums of
nearby Clichy. In 1885 he had taken over
the Chat Noir cabaret in Montmartre and
renamed it Le Mirliton (the reed pipe).
Here he performed an act which combined
his own songs with abusive monologues
that were often directed at the audience. A
brilliant self-publicist, Bruant produced
from time to time a magazine, also entitled
Le Mirliton, in which he printed his own
lyrics and illustrations, including Lautrec's

first published lithograph. He also allowed
Lautrec to exhibit paintings in his cabaret,
the first public display of his works. This
poster, one of four that Lautrec did of
Bruant in 1892-93, was commissioned by
the singer on the occasion of his transfer in
June 1892 to the Ambassadeurs in the
Champs Elysées. As the most superior of
Parisian open-air café-concerts, the
Ambassadeurs attracted a clientele of
upper-class *boulevardiers* and foreign
tourists during summer evenings, in addi-
tion to the usual shop assistants, clerks and
passing (but rarely drinking) working-
class strollers. At first the manager, Pierre
Ducarré, refused to defray the cost of the
poster's production, but capitulated when
Bruant threatened to cancel his premiere.

Shown in his familiar costume of black
velvet suit, floppy felt hat and red scarf,
Bruant's pugnacious pose is very close to
that commonly used in Japanese wood-
block prints to depict wrestlers (see page
13). While nearly all Lautrec's mature
work owes some debt to the simplified out-
lined masses of Japanese prints, it is pos-
sible that in this case he is quoting more
specifically from an oriental image appro-
priate for such an aggressive performer.

So successful was the poster that a critic
for *La Vie Parisienne* wrote in mock des-
pair: 'Who will rid us of Aristide Bruant's
posters. You can't take a step these days
without seeing him face to face.'

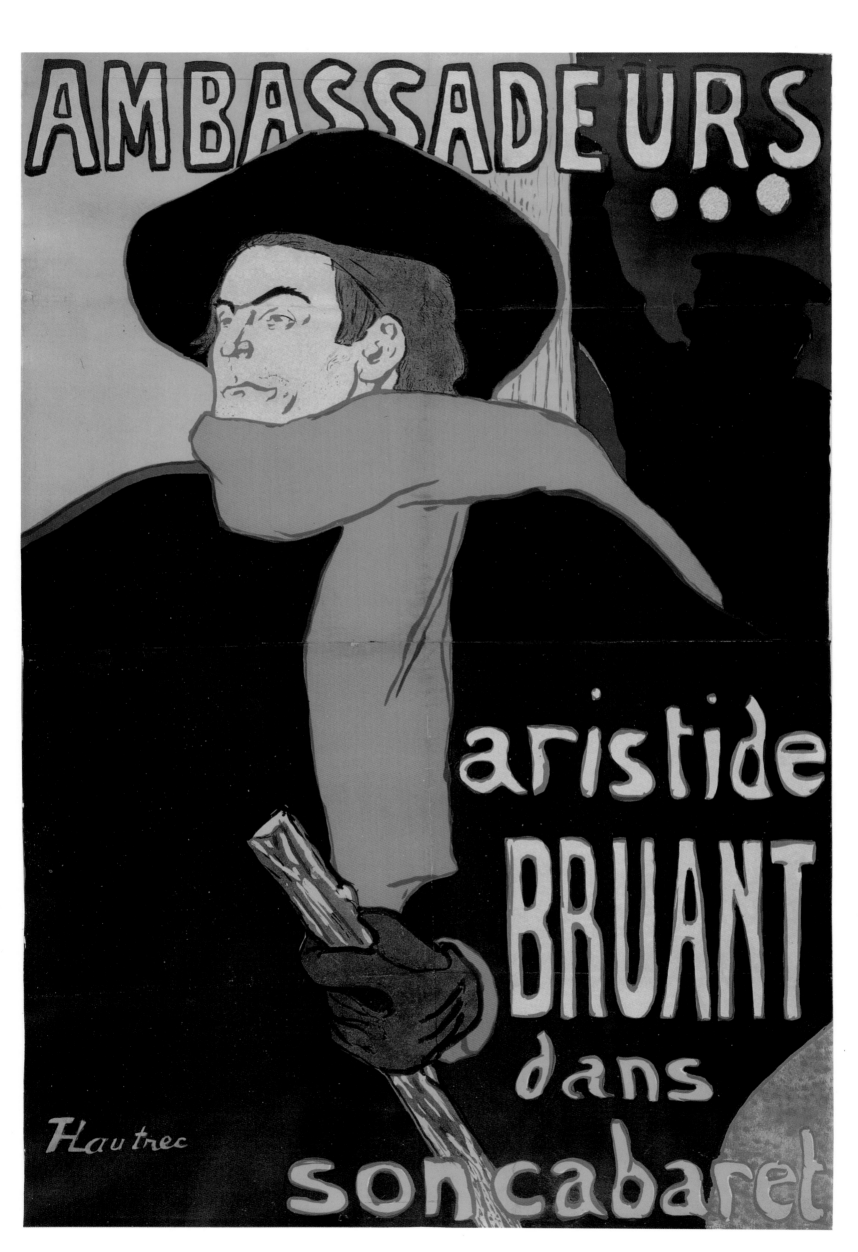

## Reine de Joie 1892

Brush and spatter lithographed poster
58¼×38½ inches (149.5×99 cm)
San Diego Museum of Art, Gift of the
Baldwin M Baldwin Foundation

Victor Joze, the pen name of the Polish writer Victor Dobrski, was a friend of Lautrec's and the owner and editor of the journal *Fin de Siècle* and published his *Reine de Joie* (Queen of Joy – Customs of the Demi-Monde) in 1892. One of the novels from his series *La Menagerie Sociale*, its dustjacket was designed by Bonnard. This poster image in reduced form was used on the title page. Joze had earlier used Seurat to make a cover design for another novel in the same series, published in 1890.

This poster and Joze's novel caused a sensation, principally provoked by their perceived anti-semitism. Lautrec shows the financier Olizac being kissed by the novel's heroine Hélène Roland, and has given him the stereotypical hook-nose, thick lips and caricatured face of the fat Jew involved with money. What caused greatest ire, however, was that one of the novel's characters, Baron de Rosenfeld, was believed by some to have been modeled on the real Baron de Rothschild. Lautrec's posters were apparently torn down and defaced by stockbrokers' clerks, and Rothschild tried unsuccessfully to have the novel suppressed.

Contemporary critical comment on Lautrec's poster tended to agree that he had accurately depicted the corruptness of humanity. Thadée Natanson, the Jewish editor of *La Revue Blanche*, described it as

'the delicious *Reine de Joie*, light, captivating and superbly perverse.' Félix Fénéon, writing for the left-wing *Le Père Peinard*, adopted the crude and calculatedly shocking tone that was virtually a cliché of the Naturalist critical discourse. He described it as showing 'gaga old capitalists having their snouts licked by smart little whores who want to squeeze loot from them.' For *La Plume*, Frantz Jourdain described the prostitute as 'old beyond her years' (not especially evident in the poster), and suggested that Lautrec 'wanted women to be bestial and hideous, with a strange obsessive, nightmarish ugliness.' Curiously, the tone of this criticism closely mirrors that used by certain critics for Degas's display of his *Little Fourteen-Year-Old Dancer* in 1881 and his bathers in 1886, another example of criticism intended perhaps to complement the image but ending up by rather missing the point.

Despite his Catholic Royalist family background, Lautrec was not calculatedly anti-semitic. He did not, however, support Dreyfus, nor did he generally choose to make his political position clear. So entrenched had the stereotypical image of the moneyed Jew become in European art that both Joze, an anarchist sympathizer, and Lautrec were able to use it without apparently considering it as any more than an attack upon shady finance.

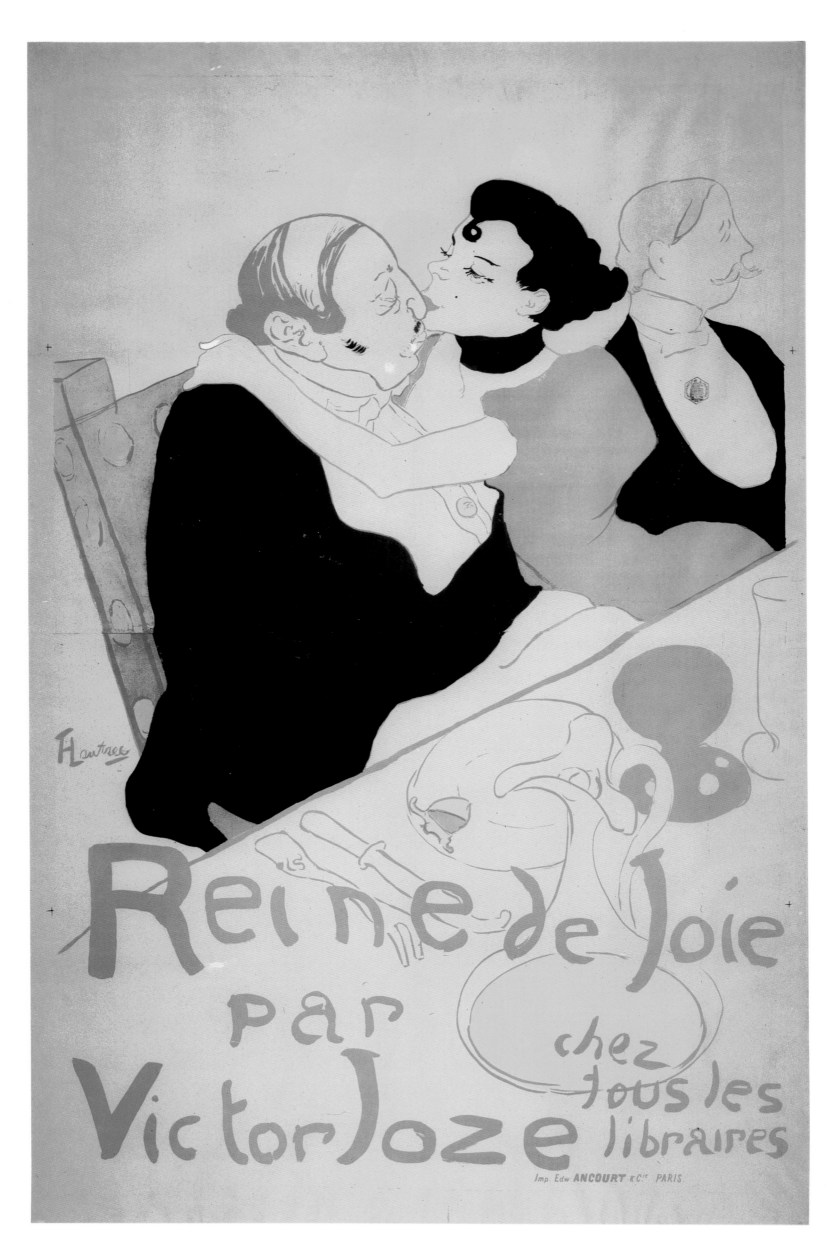

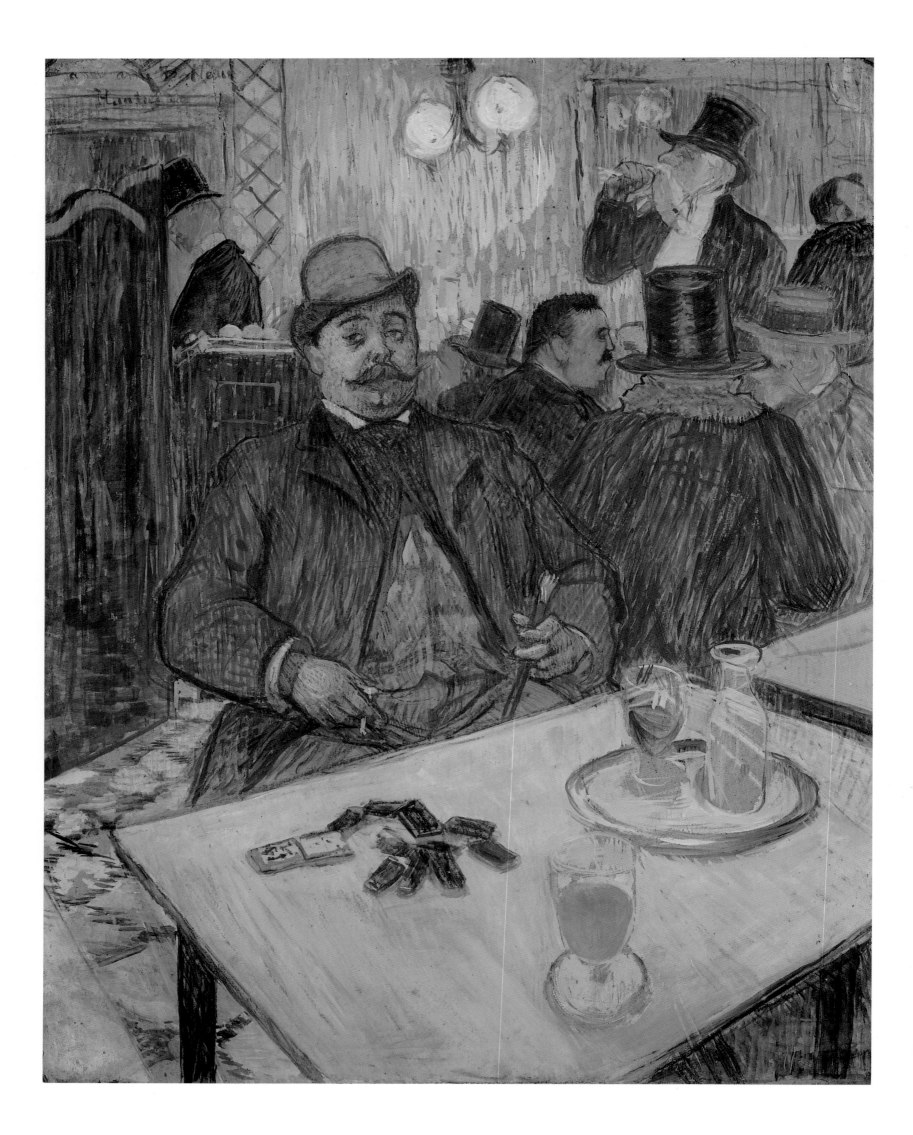

## Monsieur Boileau at the Café

1893

Gouache on cardboard
31½×25½ inches (80×65 cm)
The Cleveland Museum of Art, Hinman
B. Hurlbut Collection 394.25

In contrast to the group of 1891 single male portraits, in which Lautrec de-contextualized his figures by showing them standing aloof in his studio (see pages 76, 77), this and the next painting indicate a return to the more Naturalistic depiction of character within familiar surroundings. They show two quite different classes of men in two quite different classes of café.

Little is known about the identity of M Boileau, despite the suggested intimacy of the 'à mon ami Boileau' inscription at top left. According to one of Lautrec's biographers, he was a journalist who specialized in sensational scandal. He is shown dressed in smart but rather brashly vulgar clothes, unlike the suave elegance of Léon Delaporte in the following picture. Although Lautrec did not exhibit them as a pair, they suggest a common theme and are similar to the contrasting depictions of the Moulin de la Galette and Moulin Rouge of a year earlier. Lautrec's own presence

in the picture is intimated by the foreground glass of absinthe. His father, the Comte Alphonse de Toulouse-Lautrec, is the ridiculous bearded figure tooting his hunting horn in the background. Between the bohemian raffishness of this café and the haut-bourgeois sophistication of the Jardin de Paris, he drifts around like the eccentric antediluvian booby that he was. On his coat he wears the little red ribbon of the Légion d'Honneur, a government honor that would in reality have offended his royalist sympathies. Lautrec's grave adolescent respect for his father appears to have changed by this date to something closer to a benign tolerance. In his letters to his mother, he kept her informed about her estranged husband's minor ailments and relevant details about their mutual finances. Although Lautrec often dined with his father at this period, it is unlikely that the Comte took part in his Montmartre socializing.

## Monsieur Delaporte at the Jardin de Paris 1893

Oil on board
29⅞×27½ inches (76×70 cm)
Ny Carlsberg Glyptotek, Copenhagen

Léon Bonnat, Lautrec's early teacher, barred this picture from entering the French national collections. Four years after Lautrec's death, the Friends of the Luxembourg Museum bought it as an intended donation, but the Conseil Superieur des Musées, of which Bonnat was President, refused to accept it. Bonnat never liked Lautrec, even when he taught him. Lautrec's lifelong friend and executor Joyant, describing Bonnat's rather spiteful conduct, wrote: 'He seemed beside himself. No argument could sway him. In fact he appeared to be afflicted by a kind of religious frenzy about the whole business.'

The identity of the elegant M Delaporte is not clear. He is probably Léon Delaporte, director of the poster advertising firm of Delaporte and Chétard, who had offices at 19 rue Montmartre. Alternatively, he may be the Delaporte who was a Republican member of the National Assembly and a confidant of Lautrec's friend Doctor Bourges. The setting is the newly-opened Jardin de Paris, an expensive café-concert in the Champs Elysées that Zidler and Oller, the owners of the Moulin Rouge, had bought. Each evening when the Moulin Rouge closed its doors at about 11.30 pm, a private omnibus took clients down the hill to carry on their evening's pleasure at the Jardin de Paris. Singers and dancers also came down to do a second performance, and Jane Avril, dressed in purple, is talking to the red-bearded figure just behind Delaporte.

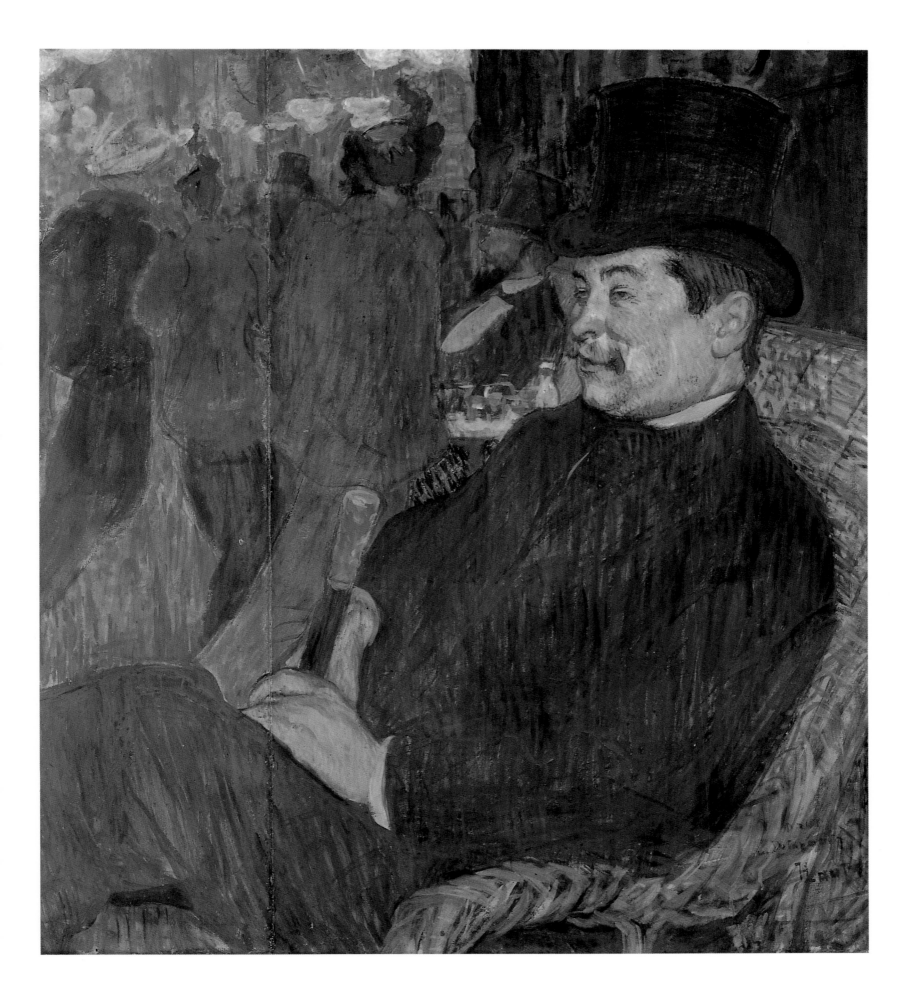

## Divan Japonais 1893

Crayon brush spatter and transferred
screen lithograph
30¹⁵⁄₁₆×23⁷⁄₁₆ inches (78.6×59.5 cm)
San Diego Museum of Art, Gift of the
Baldwin M Baldwin Collection

The Divan Japonais was a small Mont-
martre café-concert at 75 rue des Martyrs.
Kimono-clad waitresses, cheap lacquer,
mock bamboo and paper lanterns contri-
buted to a vaguely oriental ambience. Pos-
sibly taking its name from a verse by Mal-
larmé, it was founded by the poet Jehan
Sarrazinard, and was popular with writers
and artists. The two dominant foreground
figures in this poster are the dancer Jane
Avril, who is seated alongside Edouard
Dujardin (1861-1949), critic, Symbolist
aesthete and founder of the *Revue Wagné-
rienne*.

On stage at top right is the headless body
of the singer Yvette Guilbert (1865-1944).
Her complex career from the age of fifteen,
as mannequin, salesgirl, provincial actress
and failed metropolitan singer, finally blos-
somed into fashionable success at the
Divan Japonais in 1892. Thin, flat-chested
and with a striking rather than beautiful
face, her trademarks were her bright red
hair and graceful, spider-like arms clad to
the armpit in black gloves. These she used
to good effect to punctuate with telling,
and sometimes obscene, gestures the *ris-
qué* songs that she so carelessly drawled. By
so doing she was carrying on a traditional
technique for focusing audience attention
that had also been used by the great earlier
café-concert singer Thérésa, whom Degas
had often drawn and painted in the 1870s
(see page 22).

Yvette Guilbert's songs, like those of
Bruant and those later sung by Piaf, had a
bitter-sweet tone of fatalistic resignation
that was popular with her audiences.
Arthur Symons highlighted this side of her
appeal in the poem he wrote about her:

Laugh with Yvette? But I must first forget,
Before I laugh, that I have heard Yvette.
For the flowers fade before her, see the light
Dies out of that poor cheek, and leaves it white;
She sings of life and mirth, and all that moves
Man's fancy in the carnival of loves;
And a chill shiver takes me as she sings
The pity of unpitied human things.

Several motifs in this work are direct bor-
rowings from Degas's portrait of Lautrec's
cousin, Désiré Dihau, playing his bassoon
in the orchestra pit of the Paris Opéra. The
cropped headless stage figure, linked to
those in the stalls by the neck of a protrud-
ing double-bass, is entirely a Degas inven-
tion. The thoughtful Dujardin chewing his
umbrella handle is also very reminiscent of
Desiré Dihau playing his bassoon.

Lautrec probably first saw Yvette Guil-
bert around 1890 and first met her around
the time of this poster's production. She
became an obsession for him, and he in-
troduced her directly or indirectly into
several subsequent prints.

The Divan Japonais, now differently
titled, still operates as a night-club, specia-
lising in transvestite song and dance acts.

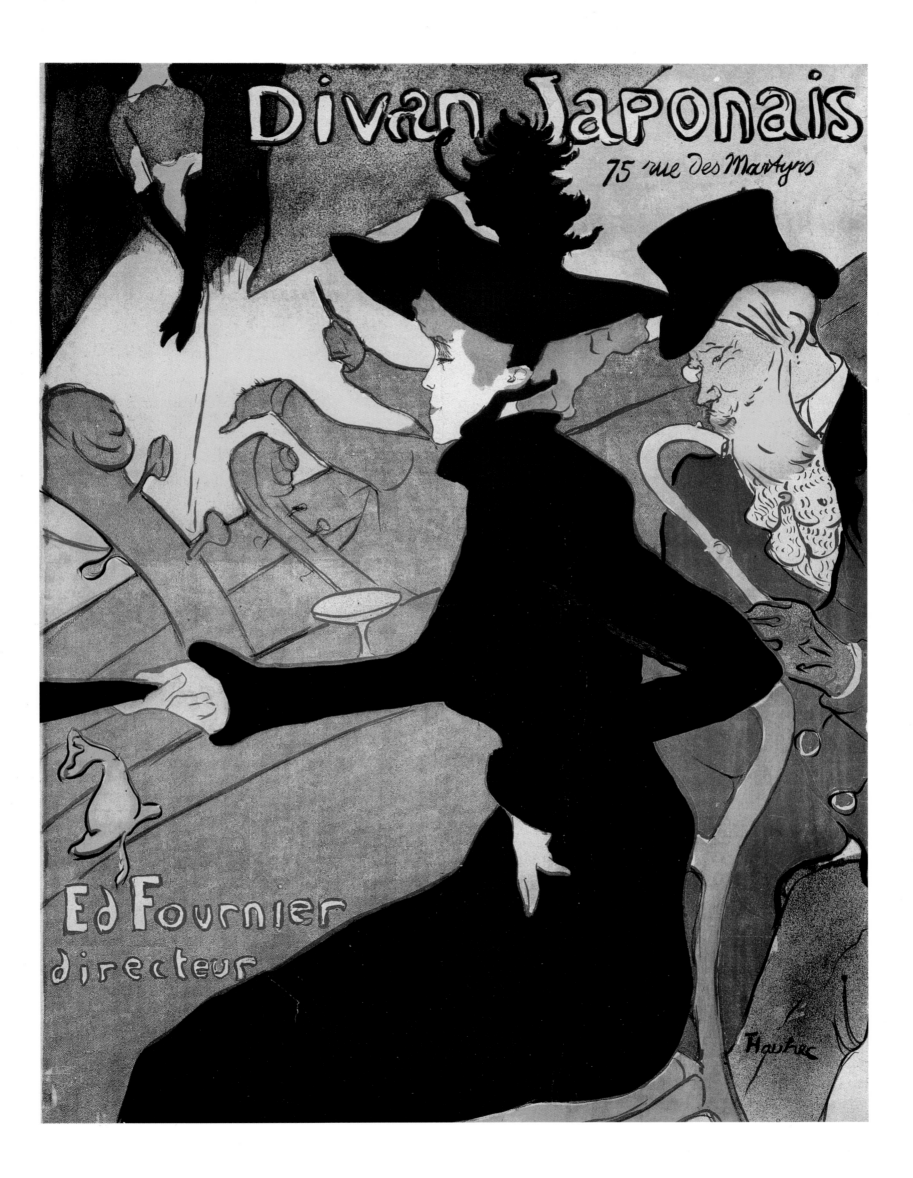

## Jane Avril 1893

Brush and spatter lithograph in five
colors on one sheet of wove paper
50½×37 inches (128.3×94 cm)
San Diego Museum of Art, Gift of the
Baldwin M Baldwin Foundation

Jane Avril may have been influenced in her
decision to commission this poster from
Lautrec for her July 1893 debut at the Jar-
din de Paris by the enormous critical
acclaim received by Bruant's personally
commissioned *Ambassadeurs* poster of a
year earlier. Lautrec first made a many-
colored and complex oil study of Jane Avril
based upon one of her favorite publicity
photographs, before reducing the colors to
the five used here. According to Joyant's
categorization of the colors that she chose
for dance and mood, the distinctive
orange-vermilion dress that she wears sug-
gests her 'Scottish' steps, although her
dance seems closer to the *port-de-bras* step
that Lautrec showed her using in his paint-
ing of her at work in the Moulin Rouge
(page 83).

In Lautrec's first poster in 1891, he used
a ghostly textured foreground image of
Valentin le Désossé. Here he uses a similar
ghostly format for the distorted cello neck,
huge hand, grotesquely caricatured
musician's face and surrounding frame
that contains the stage. The adoption of
traditional perspectival recession to
describe the stage might in lesser hands
have produced a cluttered image, but

Lautrec tones it down and integrates it
with the faintly legible name of Jane Avril.

To virtually discard the impact that let-
tering can achieve in a poster was in itself
extraordinarily novel. What Lautrec
understood was that Jane Avril herself, in
characteristic pose, was information
enough, and he perhaps recognized that
the Parisian public, bombarded with
posters, was perfectly capable of respond-
ing to the 'less is more' subtlety of this
poster's approach. In that respect he was
among the first to appreciate the common
understanding that exists between an
advertiser and an audience, based upon
foreknowledge and patterns of expecta-
tion. Because of the success of this image,
he continued boldly to subordinate letter-
ing to image in his posters.

Altogether between 1000 and 3000
copies of this poster were made, with a pre-
liminary edition of 20 on vellum paper,
signed and numbered by Lautrec and sold
at 10 francs each by Kleinmann, the princi-
pal Paris dealers in contemporary posters
and lithographs for collectors. Two Paris
journals pressed their claims to be the first
to reproduce the poster after its first
appearance on the streets.

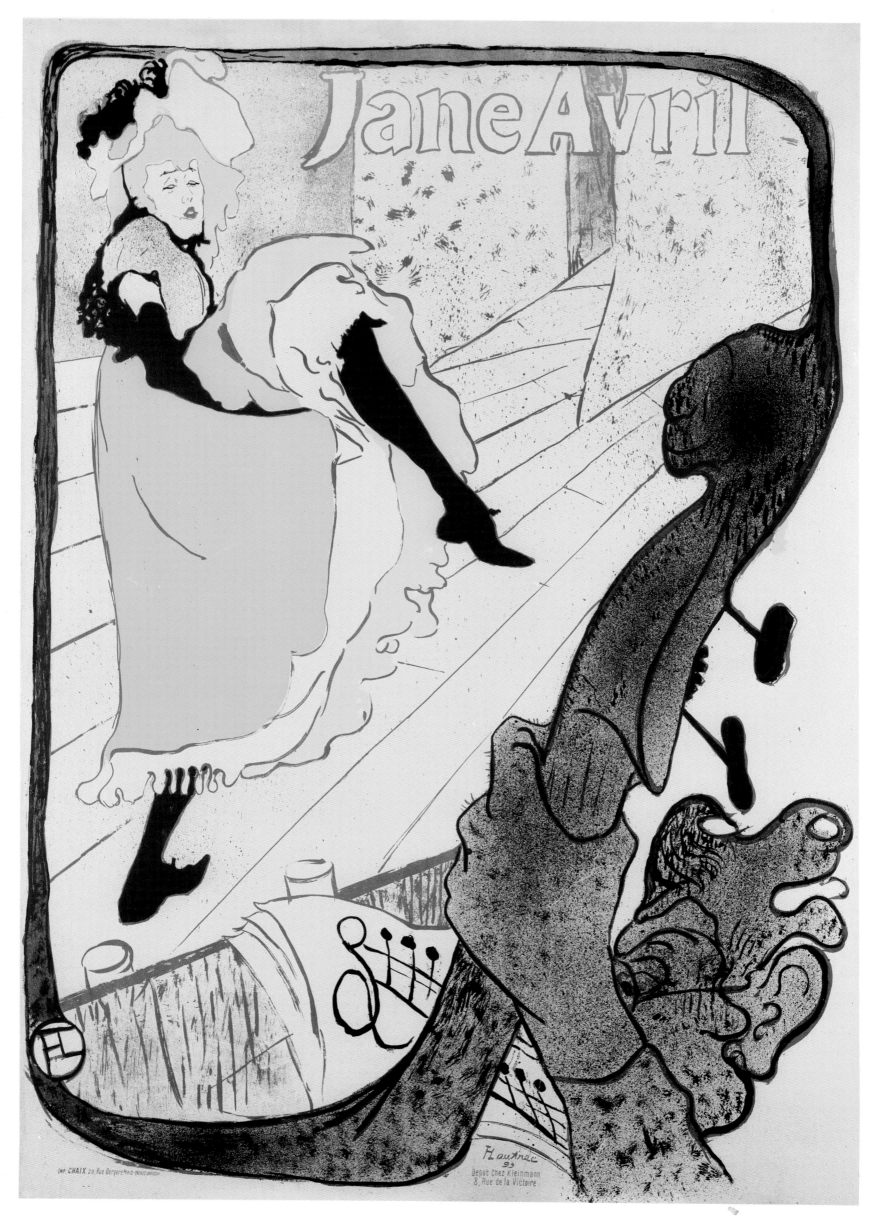

## Loïe Fuller 1893

Brush and spatter lithograph in at least
five colors with gold highlights
14¼×10 inches (36.8×26.8 cm)
The Brooklyn Museum, New York

The Chicago-born Loïe Fuller (1862-1928)
made her debut at the Folies-Bergère in
November 1892. Her extraordinary danc-
ing, under colored electric spotlights,
brought her brief international fame and
led to a proliferation of less successful im-
itators. Here she performs her *danse du
Feu*, which she later patented in 1894 to
prevent copying. Standing still or walking
slowly, she manipulated large hand-held
tulle veils that were attached to sticks. Her
swirling arabesques in cloth, comple-
mented by synchronized gyrations of her
body, were one of the most perfect ex-
pressions of the newly fashionable Art
Nouveau style, with its emphasis on sin-
uous curves and counter-curves. Lautrec
also perceived a classical resemblance; her
movements reminded him of the wind-
swept drapery of the antique statue of the
*Winged Victory of Samothrace* in the
Louvre.

This is one of an edition of 50 litho-
graphs, some of which were individually
hand-colored by Lautrec after printing,
some were separately colored by variations
in the inking of the lithographic stone.
Direct comparisons are suggested between
these techniques and those involved in the
production of Japanese woodblock prints.
For example, the wiping of ink from the
block to achieve graded tone within one
section of color, particularly in areas of
sky, was commonplace in the landscape
prints of Hokusai and Hiroshige. Orange
sunsets were also on occasion incorpor-
ated into blue-inked sky blocks by a

smear of ink added prior to the printing of
each individual print. Lautrec also imitated
the practice of scattering mica or other
metallic dusts that is found on special
Japanese *Surimono* prints. Several of these
lithographed images of Loïe Fuller are
dusted with gold and silver powder. The
specifically Japanese qualities of this print
and the apparently oriental expressiveness
of Loïe Fuller's dance were discussed in *Le
Figaro Illustré* shortly after it appeared.

Chéret was commissioned to design a
poster for Loïe Fuller, and Lautrec may
have been hoping for a commission in pro-
ducing this print. Loïe Fuller was not ap-
parently part of Lautrec's social circle. In
March 1895, in a fanciful menu card that he
lithographed for his friend Paul Sescau,
Lautrec included as part of the hors
d'oeuvre '*Foies gras de l'oïe Fuller*'.

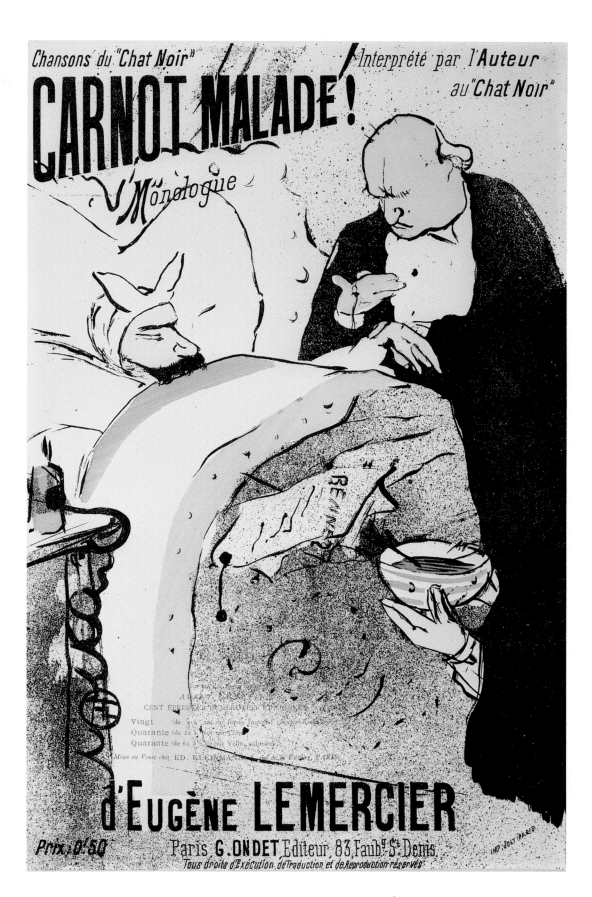

### Carnot Malade 1893

Brush and spatter lithograph in black ink
with color stencilling on paper
9⁷⁄₁₆×7¼ inches (24×18.5 cm)
San Diego Museum of Art, Gift of the
Baldwin M Baldwin Foundation

Among Lautrec's 364 prints are a group
used as music sheets, including covers for
songs sung by Yvette Guilbert and lyrics
written by his cousin, Désiré Dihau.
Lautrec's usual practice was to allow a
print publisher to pull 100 images without
letters on superior quality paper, which he
then signed or monogrammed indivi-
dually. The image was then transferred to
another lithographic stone for use by the
songsheet publisher, who added the re-
quired text. On this completed music
cover, in small red type, are printed details
of the three separate categories of earlier
collectors' prints which Lautrec had pro-
duced. Twenty were available on Imperial
Japanese paper, forty on china paper and a
further forty on wove paper. This last
group also had the additional stenciled
colors that are seen here.

The subject of this print, and of Eugène
Lemercier's monologue, is Sadi Carnot
(1837-1894), who was elected President of
France in 1887. George Clemenceau, who
proposed him as a compromise candidate,
is supposed to have suggested cynically,
'let's vote for the stupidest one.' Dull, con-
servative, but with impeccable Republican
credentials, Carnot tried to project an
image for his presidency of honest
stability, in contrast to the financial cor-
ruption of the previous incumbent. Un-
fortunately the collapse of the Panama
Canal Company amid charges of bribery of
government ministers, the industrial re-
cession of 1893, and the stepping-up of
political violence among anarcho-syndi-
calists, made Carnot the object of consider-
able popular criticism. His illness in sum-
mer 1893 provided the pretext for the title
of this monologue, which catalogues his
various political 'ills'. Carnot recovered
from his illness, only to be stabbed to death
by an anarchist in 1894. This cover is one of
the very few occasions in Lautrec's oeuvre
when he touches on the political upheavals
in contemporary French life, and predic-
tably he treats the subject without malice
or satirical bite.

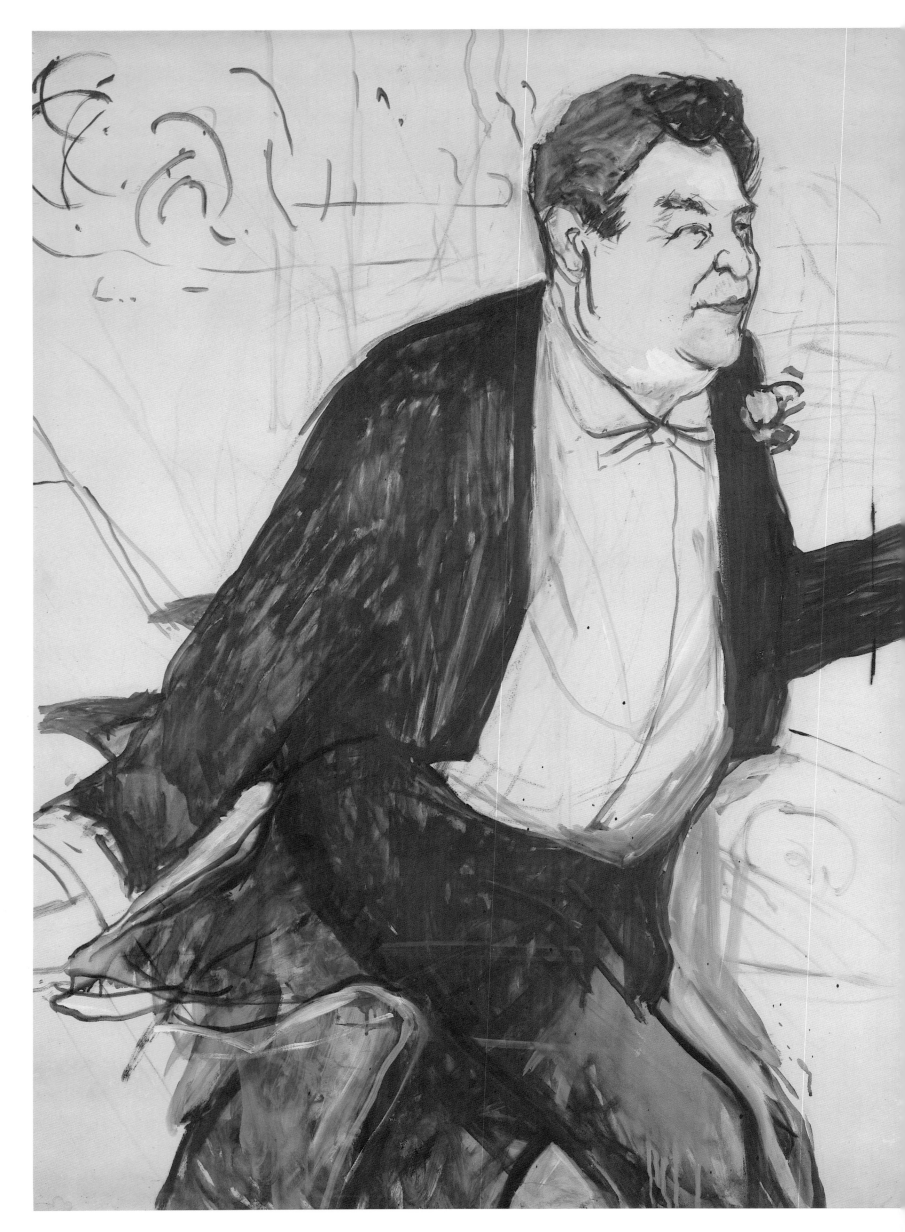

*Caudieux* 1893
Charcoal and oil on paper
45×34¾ inches (114×88 cm)
Musée d'Albi

The comedian Caudieux appeared at the Eldorado and the Ambassadeurs, but was best known for his performance at the Petit Casino, a café-concert that opened in February 1893. Sited on the boulevard Montmartre which, despite its name, was near the center of Paris, it was part of the smarter orbit that Lautrec began to move within around this time. This largescale study is virtually the same size as the poster that was ultimately produced from it, and there is also a related charcoal study on a similar scale. The poster was possibly commissioned in connection with the Petit Casino's opening.

In order to obtain the precise sense of Caudieux's wonderfully energetic dash, Lautrec overpainted and reworked the positioning of his legs, adding and obliterating an edging overpaint of white which gives a hazy slipstream to his movements that is unfortunately absent in the finished poster. At top left are the summarily sketched letters 'Caudieux', the only title required. Lautrec's only substantial addition on the poster to the image as depicted here was the inclusion of a rather demented looking prompter at bottom right, suggested in this study by the oval shape beneath Caudieux's arm. Later in 1893, Lautrec produced a series of 22 lithographs on the theme of the café-concert, and Caudieux was included in a pose that gave greater emphasis to the movement of his big panda paw-like hands, which are cropped in this image.

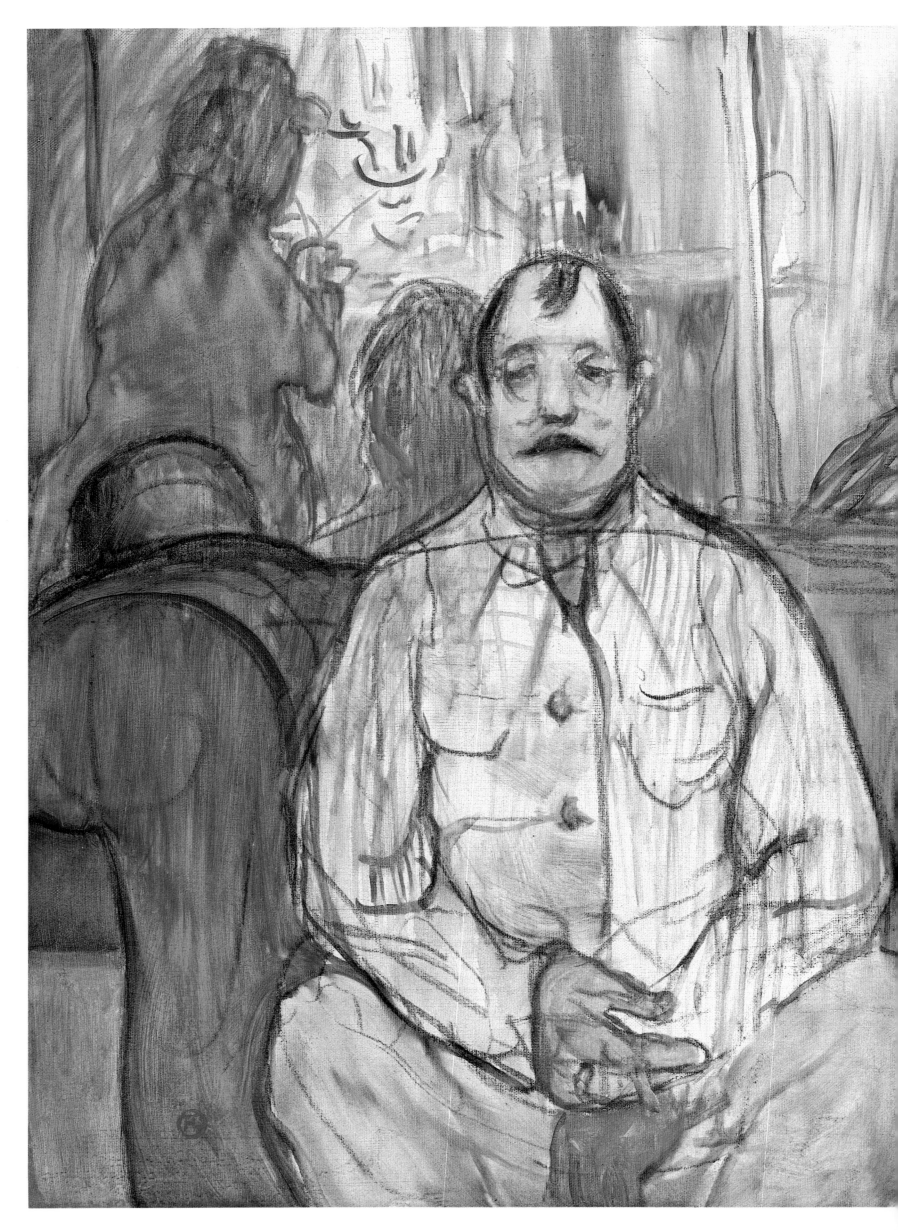

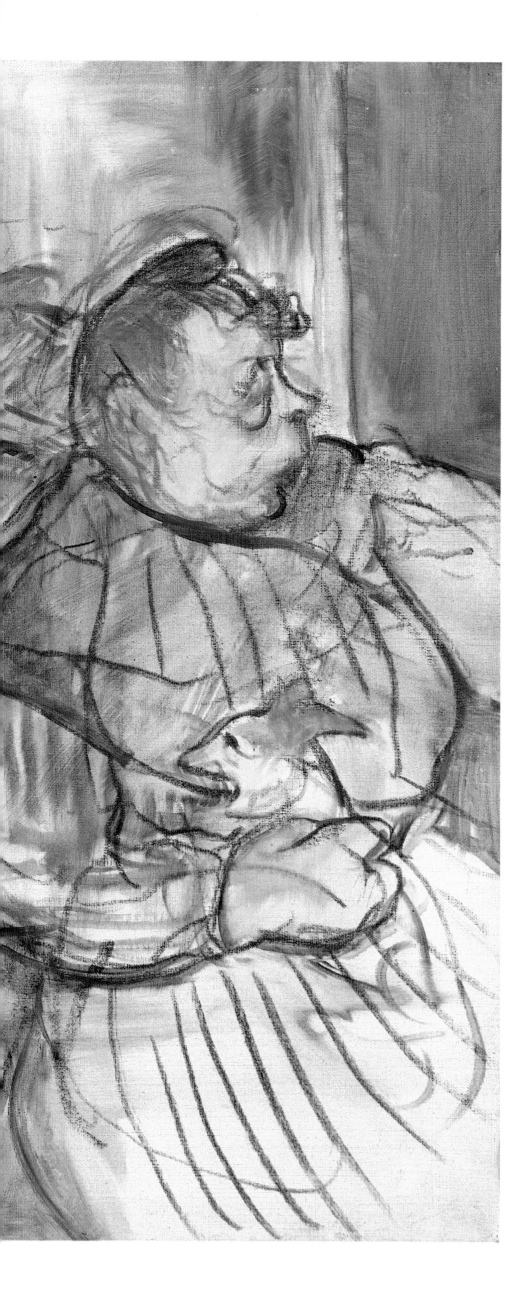

## Monsieur, Madame and the Dog

1893

Oil on canvas
19×23⅝ inches (48×60 cm)
Musée d'Albi

In the waiting room of a run-of-the-mill local Parisian brothel, far removed from the splendours of the rue des Moulins, a tradesman nervously smokes his cigarette and fingers his wedding ring while awaiting the prostitute of his choice. She may be the sketchy orange-clothed standing figure reflected in the large background mirror, who seems to be preoccupied with money or some other object that she holds before her. Seated next to him is an older woman (probably the brothel madame) at whom he intentionally does not look. She in turn looks away, while her small lapdog stares back reproachfully at this man who has apparently rejected his mistress's charms. When Degas showed bourgeois and petit-bourgeois clients in his brothel monotypes, he too focused on the awkward, faintly ludicrous embarrassment that they felt about the pre-carnal practicalities that had to be dealt with in the brothel's more public spaces.

It is unusual for Lautrec to imply a narrative in a picture, especially one that so comically concentrates on the tension between the sexes. Götz Adriani suggests that Lautrec intended us to see this pair as married; she is the madame and he a keeper of order in the brothel that they manage. He argues that, just as a picture like Jan van Eyck's *Arnolfini Wedding* represents an ideal image of the harmonious embarkation upon marriage, this may be read as Lautrec's ironic comment on the ultimate destiny of human love. The bowler hat of the man which is left perched on the sofa arm suggests that he will not be staying long and is perhaps customer rather than staff.

Lautrec's earlier picture suggesting estrangement between the sexes, *At La Mie* (page 80) showed his close friend Maurice Guibert. It is possible that the male figure shown here is also based upon Guibert's corpulent frame, given its similarities to drawings of him that Lautrec made in Bordeaux in 1900.

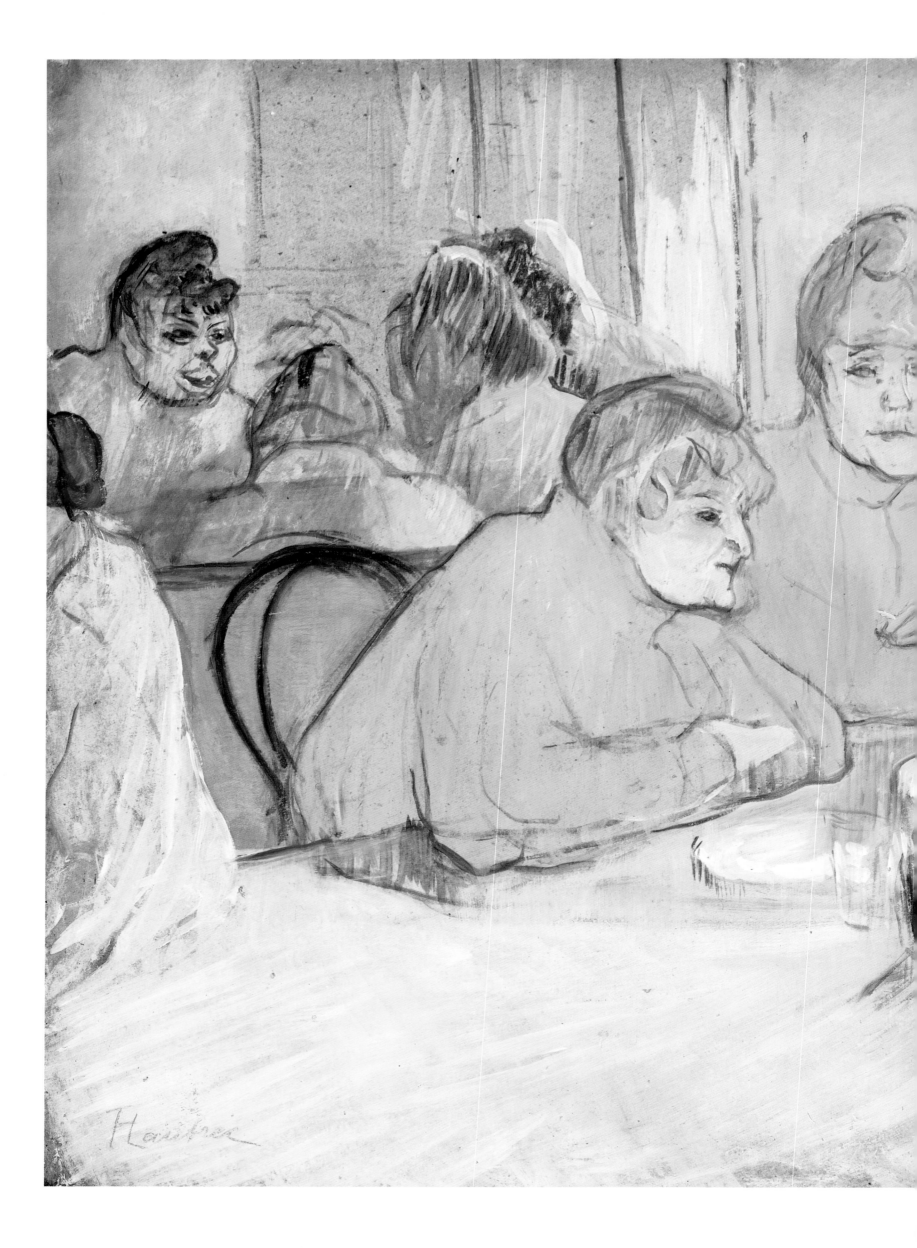

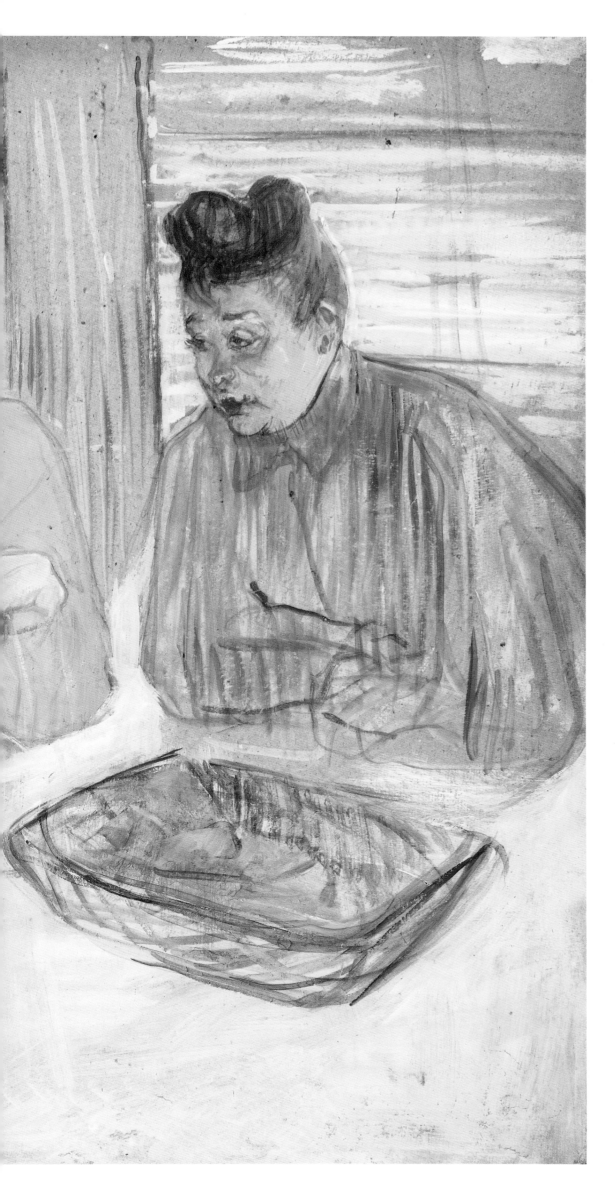

## Women in a Refectory 1893

Oil on board
24⅛×32 inches (60.3×80.3 cm)
Museum of Fine Arts, Budapest

Similarities of size, the degree of finish in the paint-handling, and most especially the implication of some narrative, link this image of prostitutes at a table to the previous picture of *Monsieur, Madame and the Dog* (page 116). Several of Lautrec's paintings show prostitutes bored with their work; this, however, is his only picture that suggests their boredom with each other. Both of the women wearing high-necked pink dressing gowns appear in the foreground of Lautrec's monumental painting of the following year, *The Salon at the Rue des Moulins* (page 122). Seated opposite them and reflected in the mirror is the face of an upright woman with a large and conspicuously open mouth, whose vocal outpourings seem to elicit indifference from those hunched over the table-top. The setting, unlike the velour plush and ornate carving of brothel salons, is a relatively simple room with Thonet bent-wood chairs, suggesting a café or basic restaurant as much as the brothel 'refectory' which is used in the traditional title.

Lautrec liked to boast that he lived in brothels, despite its being strictly against police ordinances for any male to do so, and he was undoubtedly very familiar with off-duty life at the rue des Moulins. In considering his intentions for this image it has been usual to group it with other views of hunched figures and to see these as evidence of Lautrec's sensitivity to the stupe-fying tedium of brothel life. When taken with the previous picture, however, it indicates rather that he was putting together an ensemble of comic prostitute subjects which might easily have translated into illustrations for a humorous magazine. They are quite distinct from the loving intimacy of the 1892 kissing couples (see page 98), the salacious tone of the Rolande group (page 126) or the grandeur of the mid 1890s series (pages 127, 128). There is also no suggestion of the lesbian involvement that might have resulted in censorious action. Steinlen and Forain were among the several illustrators who made similar humorous images of street- and brothel-based prostitution for various Paris journals.

### Yvette Guilbert Taking a Curtain Call 1894

Oil on photographic enlargement of a lithograph
19×11⅛ inches (48×28 cm)
Musée d'Albi

Following his successful January 1893 poster for the Divan Japonais showing Yvette Guilbert on stage, Lautrec over the next few months incorporated her image into prints, magazine illustrations of Paris café concerts, and lithographs made for the sheet music covers of her most popular songs. The most ambitious print project undertaken by him in the following year was the *Yvette Guilbert Album* containing 16 lithographs alongside a text by Gustave Geffroy. An edition of 100, each signed by the artist and singer, was offered for sale at 50 francs a copy. This superbly economical oil study relates to one of these lithographs.

As a piece of personal publicity, the *Album* could have backfired. One critic, Jean Lorraine, writing in *L'Echo de Paris*, suggested that it helped to perpetuate 'the cult of ugliness'. George Clemenceau, however, wrote enthusiastically in the ultra-radical *Le Justice*, as did the critic of the conservative *Le Figaro*.

This study is made over a photographic enlargement of an earlier lithographic image, and it is possibly connected with the unsuccessful bid that Lautrec made in spring 1894 to produce a poster of Yvette Guilbert. She had already commissioned Steinlen to make one for her summer 1894 season at Les Ambassadeurs, but Steinlen's stiff unexpressive image has none of the arachnid grace and faintly predatory menace of the pale-faced singer seen here taking a bow.

Lautrec was on friendly terms with Yvette Guilbert by the time he made this work, and provided sketches of some of his projects for her to study. In July 1894 she wrote to him:

For heaven's sake don't make me so ugly. A little less if you don't mind. People visiting me screech with horror when they see your colored studies. . . . Not everyone appreciates the artistic merit of it. . . . a thousand thanks, with gratitude, Yvette.

Despite any personal reservations that Yvette Guilbert may have had, she was well aware that she had found in Lautrec a brilliant translator into poster and print form of her own idiosyncratic stage character.

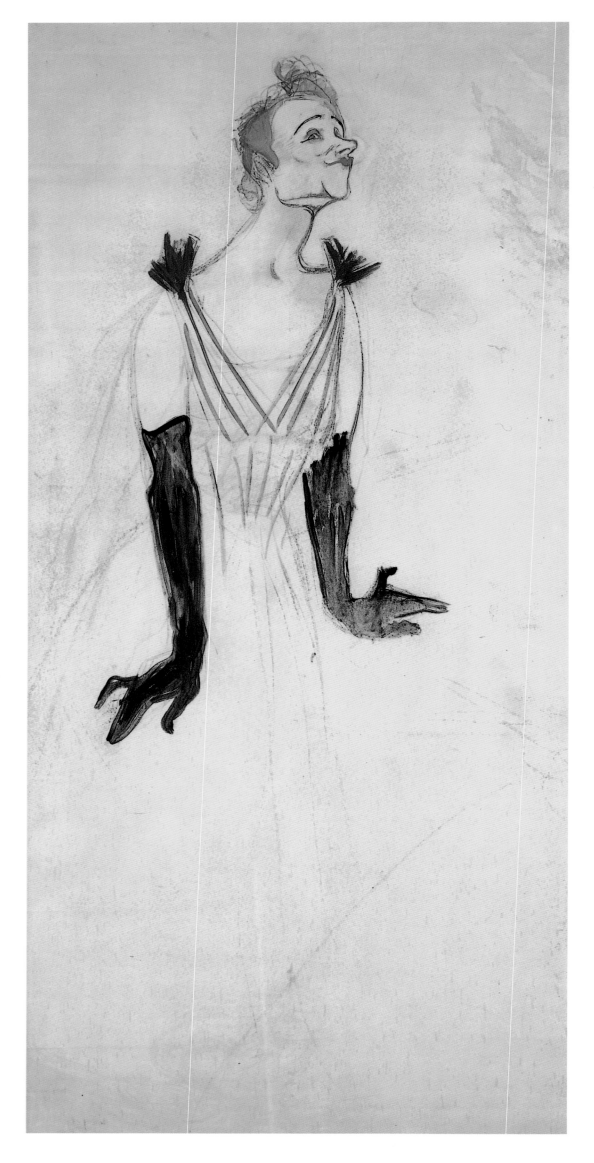

## Doctor Tapié de Céleyran in a Theater Corridor 1894

Oil on canvas
43½ × 22⅛ inches (110 × 56 cm)
Musée d'Albi

Dr Gabriel Tapié de Céleyran (1869-1930) was Lautrec's first cousin. From his arrival in Paris in 1891 to complete his medical studies, he became Lautrec's frequent companion on the nocturnal social round. Tall, shy and awkward, he was devoted to his cousin and was the butt of many of his jokes. 'Tapir de Ceylan' and 'Tapir de Scélerat' (villainous tapir) were just two of the execrable puns coined by Lautrec, rather unkindly dwelling on the huge proboscis-like red nose upon which de Céleyran perched his gold pince-nez. His figure appears in several of Lautrec's paintings and this depiction of him shambling splay-footed through the corridor of the Comédie Française is among the most striking of all Lautrec's portraits.

In an earlier theater painting of c.1889/90 (see *Woman in Evening Dress at the Entrance to a Theater Box*, page 60), Lautrec had employed a complex spatial interplay between open doors, mirrors and partially glimpsed views. Similar concerns are evident here. To the left of de Céleyran is the open door of a theater box. The box itself is in shadow, but beyond can be seen the bright glow of the illuminated theater auditorium, where a top-hatted figure stands confidently quizzing with his opera glass the occupants of other tiered boxes. At first sight this bright shape appears to be a mirrored reflection.

Behind de Céleyran in the curved theater corridor is a bizarre group that includes a caricature-like woman. She is reminiscent of the notorious 'Madame Cardinal' in Ludovic Halévy's famous popular stories about the family who pursued rich 'protectors' for their two daughters, who were dancers at the Opéra. Lautrec's lampooning of his cousin did include teasing him over the unwanted and uninvited attentions of women of doubtful virtue (see *Interval at a Masked Ball*, page 162), but here the innocent Tapie de Céleyran ambles on oblivious to any sexual commerce around him.

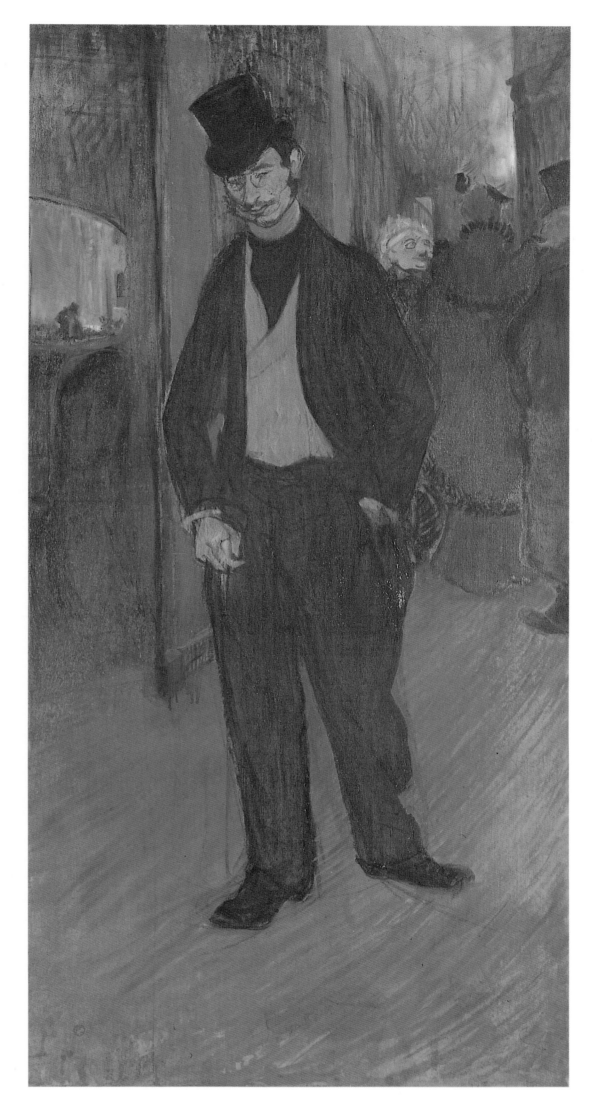

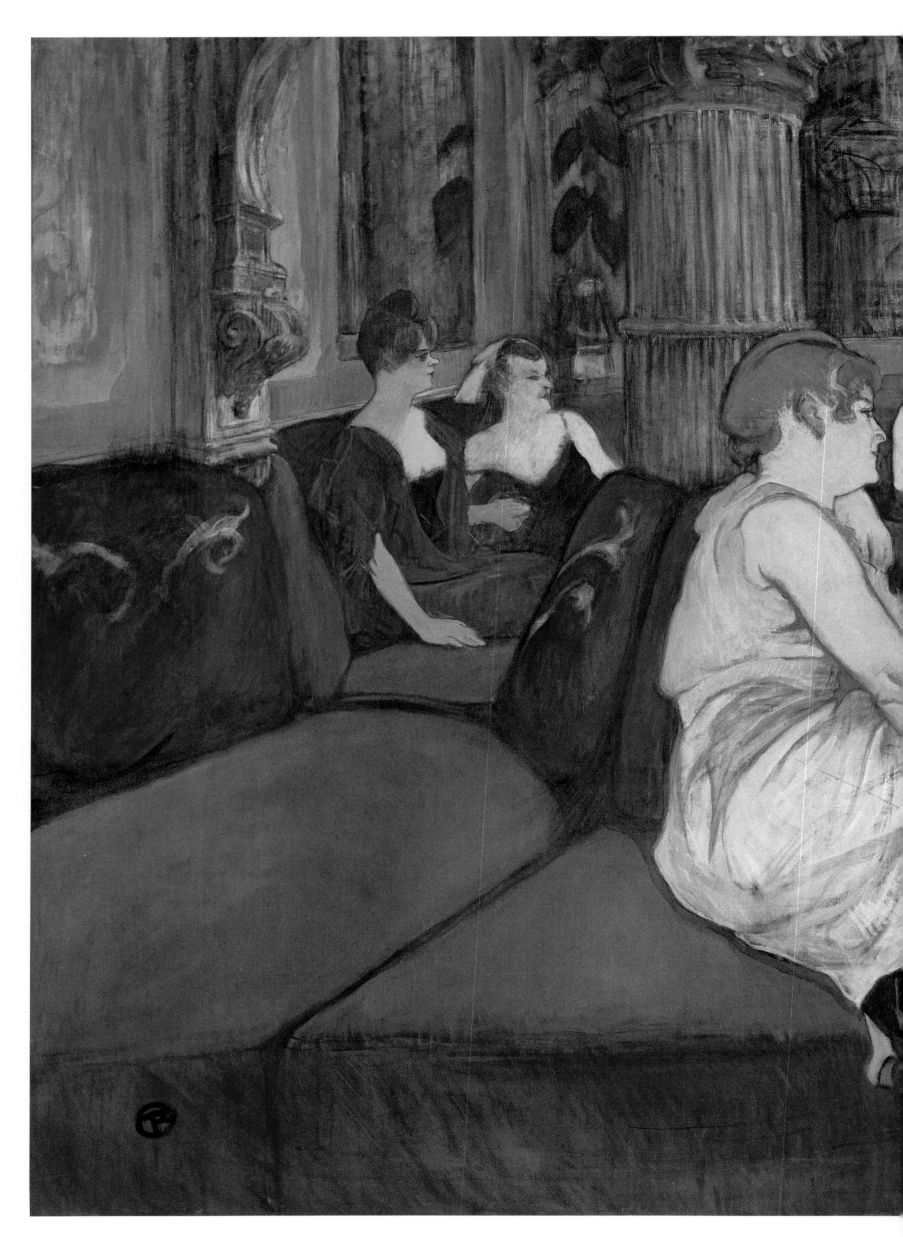

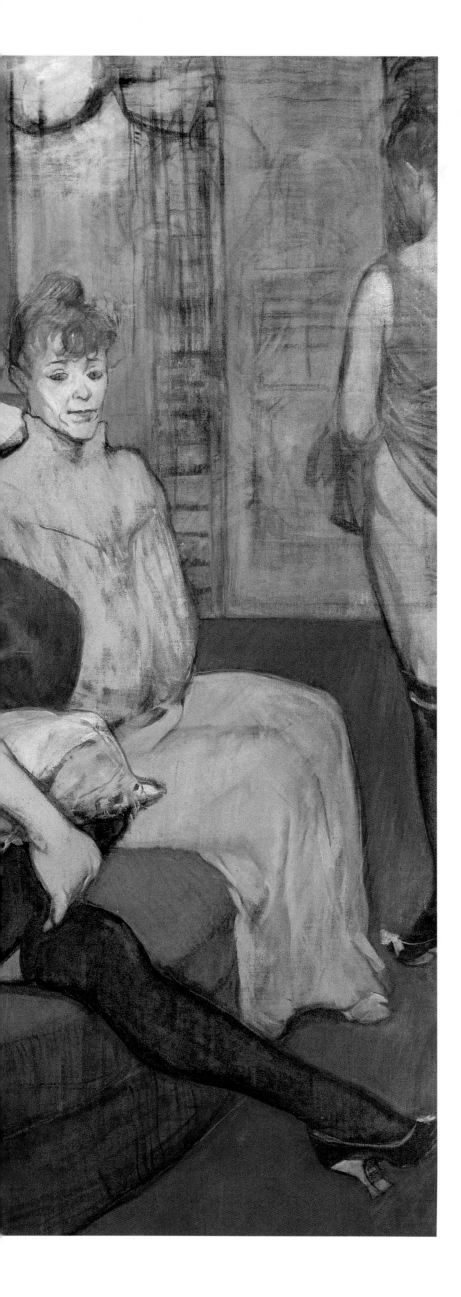

### The Salon at the Rue des Moulins 1894

Oil on canvas
44×52¼ inches (111.5×132.5 cm)
Musée d'Albi

La Rue des Moulins, set up in 1894, was
one of two premier Parisian brothels. The
luxurious rooms, decorated in Chinese,
Japanese, Oriental and Gothic styles, were
used by a *grande monde* clientele who were
able to act out their sexual fantasies in en-
vironments no less sumptuous than the
palaces that several usually occupied.
Lautrec switched his patronage there from
another major brothel, Le Rue d'Ambois,
during 1894. This painting is his most im-
portant summation of the life conducted
within the public spaces of the brothel and
shows a number of prostitutes whom he
knew well seated on the broad divans of
the Moorish decorated Salon. The snub-
nosed profile of Rolande (see page 126) is
visible at the rear, and the woman in the
foreground clasping her leg is usually
thought to be Mireille, a favorite of the
artist. Lautrec told Gauzi that when he
asked for her she was sometimes hidden
from him, so he paid for her to have days
off to spend in his company. She later,
against his advice, left France to seek her
fortune in Argentina in the company of a
meat packer.

Lautrec focuses on the sheer tedium of
waiting for custom. Like shop assistants,
who are never off-duty even if the store is
empty, these women are obliged to retain a
semblance of attentiveness despite hours
with nothing to do. Keeping watch over
them is the more demurely dressed
Madame Baron the '*taulière*' (literally,
'gaoler'), who kept the official police
register of the women attached to her
brothel, as well as managing the finances of
the organization. Her women worked for a
basic fee plus tips. Between 50 and 60 per
cent of the brothel's income was paid in tax
to the government.

In one of his periods of 'residence' in
this extremely well known brothel,
Lautrec received in this room his embar-
rassed dealer Paul Durand-Ruel, who had
unwittingly called after having been told
by Lautrec that it was his studio. Although
Lautrec did several sketches and oil studies
of separate groups of women for this major
work, the painting was actually done in his
real studio at the rue Tourlaque, with the
women coming to pose individually for
him.

## Rue des Moulins: The Medical Inspection 1894

Oil on cardboard
32⅞×24⅛ inches (83.5×61.4 cm)
National Gallery of Art, Washington,
Chester Dale Collection

Tolerance of prostitutes by Parisian authorities was conditional upon registration with the police, conformity to a string of ordinances governing how and where trade might be conducted, and regular inspection for venereal disease. Women who chose to register with a specific brothel gathered each week for the doctor's diagnostic visit, and it is this that Lautrec depicts here, in his most baldly matter-of-fact and yet paradoxically most pitiful painting.

Lautrec's choice of venereal disease as a subject was not in itself unusual. The theme had been darkly intimated, if perhaps less often clearly confronted, by other Naturalist writers and painters. It was, however, never depicted with such pathos. These impassive, obedient women are shown shamed and thoughtful by the forced male scrutiny, which will decide whether they carry on working or are instead forcibly put into the care of the Sisters of St Lazare for treatment. To continue working once diagnosed as diseased resulted, if caught, in a prison sentence of between three months and a year.

At the end of the nineteenth century, syphilis held the same terror that now attaches to Aids. On one level it aroused fear simply because it was a major killer, causing between 14 and 15 per cent of deaths (Manet, de Maupassant, Daudet, Jules de Goncourt all died directly or indirectly from its effects, and it compounded Lautrec's own physical disintegration). On another level, its spread was held by several French social and political commentators to indicate a more general crisis in the moral and patriotic 'health' of the French nation. A not uncommon prejudice suggested that defeat by the Prussians in 1870 had been the result of French troops being quite literally 'clapped-out' –

a belief supported by several nationalistic German critics, who were only too happy to add their own denunciations of French cultural degeneracy.

The two women awaiting inspection are Gabrielle the *danseuse*, followed by a red-haired and squint-eyed figure whose features are close to those of the model painted in *At La Mie* of three years earlier. Behind them is the capacious back of a supervising madame. Despite the links that this subject has with the previous painting, it is unlikely that these women were prostitutes who ever worked for the exclusive Rue des Moulins brothel. It is more probable that they were employed simply as models to pose for the subject in Lautrec's studio.

Gabrielle's place in Lautrec's life is still unclear, and she may have been closer to him than surviving documents or reports indicate. During his mental collapse in a bout of particularly heavy drinking in January 1899, Lautrec was comforted by a 'big Gabrielle' whose identity is not certain. She is mentioned in letters written by Berthe Sarrazin, the Paris housekeeper of Lautrec's mother, who describes going to Lautrec's apartment:

This morning, I went at 8 o'clock. He didn't let me in. The wineseller's boy told me he had brought some shortbread (you know how he likes his shortbread!) and that he had two women in bed with him. Gabrielle and another one. I went back at 11 o'clock but he had bolted the door.

The figure of Gabrielle clasping her chemise to her stomach has been linked with the National Gallery portrait by Rembrandt of his wife Saskia lifting her shift to bathe in a stream, both for compositional similarities and its shared sense of vulnerability.

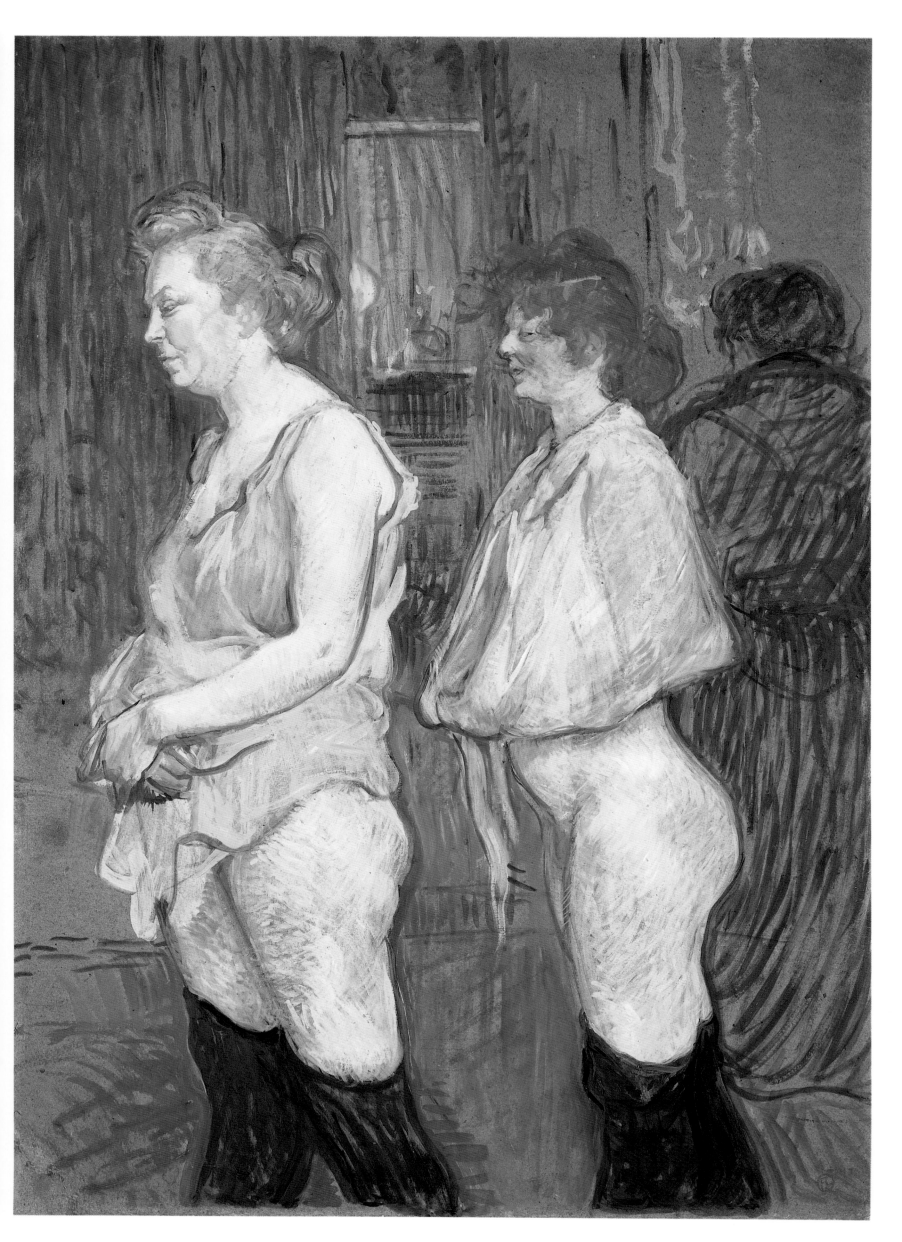

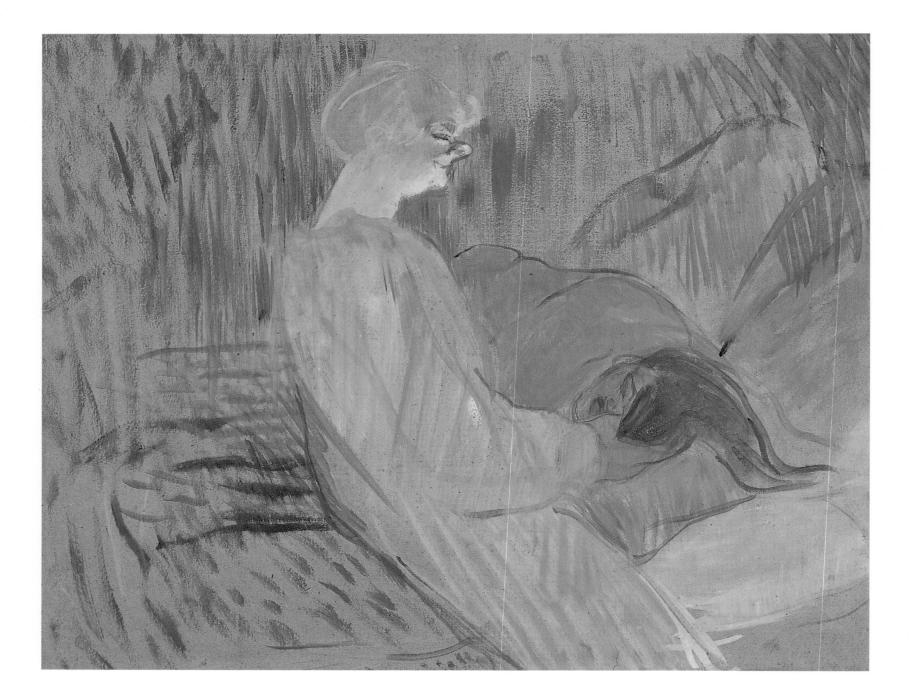

**The Divan: Rolande** 1894
Oil on board
20⅜×26⅜ inches (51.7×56.9 cm)
Musée d'Albi

The pert long nose of the seated woman identifies her as Rolande, one of Lautrec's favorite models among the Rue des Moulins prostitutes, who appeared more elegantly posed and less luridly lit seated in the background of *The Salon at the Rue des Moulins* (page 122). This is one of a group of three similarly-sized pictures of Rolande and her dark-haired lover which read as a sequential unfolding of before, during and after, lesbian sexual intimacy. This, the most modest, is the prelude to their activity.

There is a slight degree of finish in these works compared to Lautrec's later group of four lesbian couples and the 1892 group to which *In Bed* (page 98) belongs. This sug-

gests that, in his experiments with a distinct series of paintings upon this theme, Lautrec decided not to work up into a fully resolved state these most graphic moments of intimacy. He settled instead for a more tranquil engagement of lovers relying on their shared gazes. This judgment may have been based as much upon the formal compositional possibilities as upon any deliberate censorship of content. This and the third picture in the group remained in Lautrec's studio and eventually passed to the museum at Albi. The central most explicit picture was bought by, or given to, Gustave Pellet (1859-1919), the publisher of Lautrec's *Elles* series and of erotic prints by other artists and illustrators.

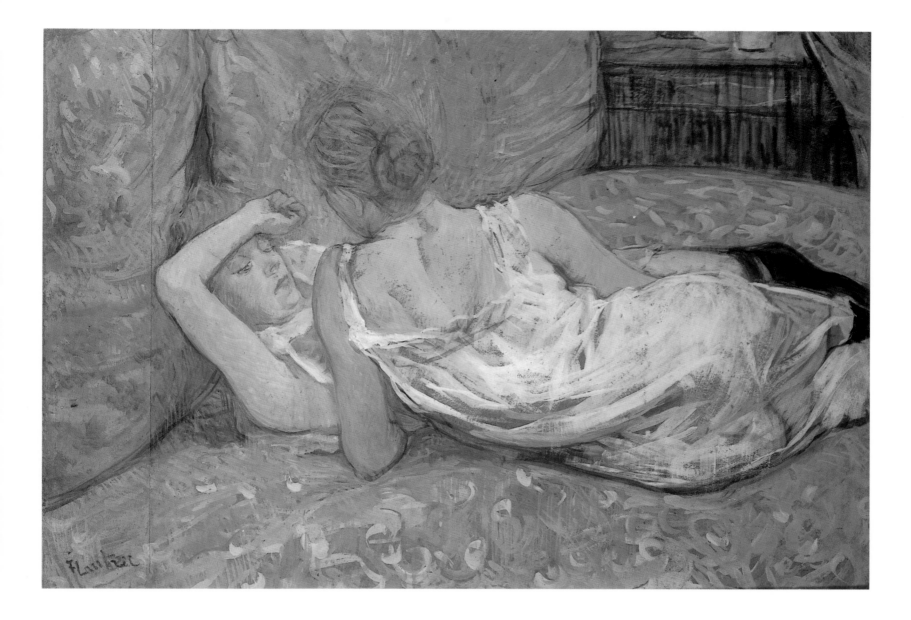

## L'Abandon or The Two Friends

1895
Oil on board
17¾×26⅜ inches (45×67 cm)
Private Collection, Switzerland

Like nervous beasts on the seabeach lying,
Their yearning eyes to horizon turning,
Limbs aching for arms embracing hold
Such honeyed touch – so bitter too.

The poet and critic Arthur Symons wrote that Lautrec told him one of his sources of inspiration for his group of lesbian pictures was the poem *Les Femmes Damnées* by Baudelaire. Published in *Les Fleurs du Mal* in 1857, it was part of a group that dealt explicitly with lesbian sexuality and conversational intimacies. Perceived as obscene by the French Ministry of Justice, these were banned following Baudelaire's prosecution. This painting is close in sentiment to the languorous intensity of Baudelaire's lines; the first verse of *Les Femmes Damnées* is quoted above. Perhaps appropriately given Baudelaire's own love of classical structuring in his poetry, this picture is also among the most classically conceived of all Lautrec's depictions of women. Connections have most frequently been made with Velázquez's *Rokeby Venus* in the

National Gallery in London, which shares a similar graceful serpentine sweep of back and buttocks viewed from behind. In a more general way it evokes the nudes of Giorgione and the early Titian.

It is possible that Lautrec may have seen Velázquez's Venus when it was exhibited at the Royal Academy in London in 1890 (it was not purchased for the National Gallery until 1905). However, he is much more likely to have been directly influenced by the famous antique statue of the Borghese *Hermaphrodite* in the Louvre, which is often viewed as one of the prototypes for Velázquez's picture. The plump cushions and expanse of divan in the Louvre sculpture recalls those in this painting, while the relationship of forearm to face in the sleeping sculpted figure suggests that of the woman seen here lying on her back.

The strip of board added at the right gave Lautrec the opportunity to distance the figures and to bring greater overall balance to the empty areas to left and right.

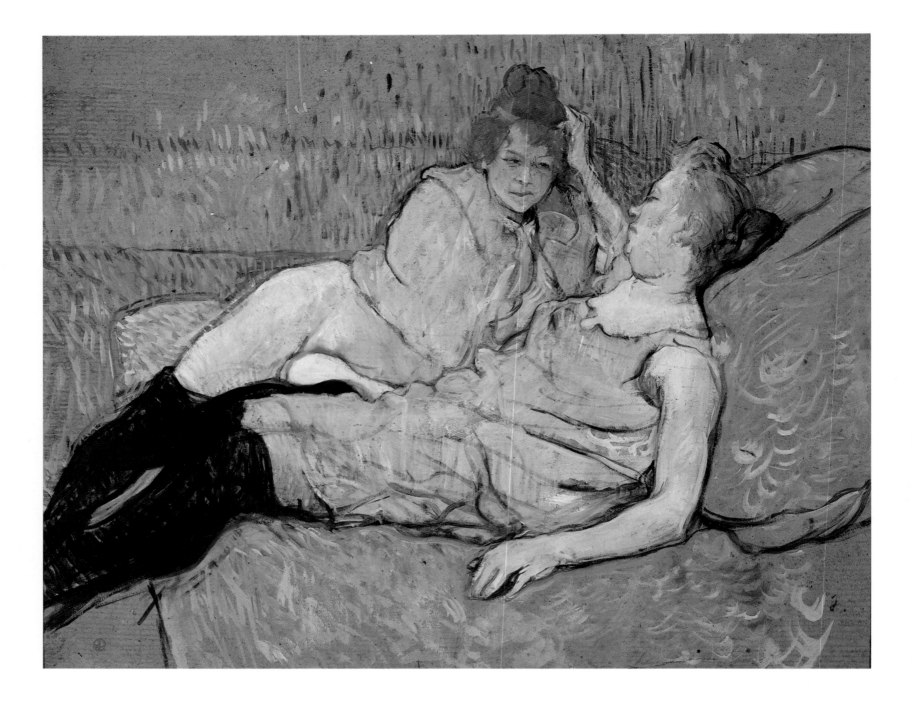

### The Sofa 1894-5

Oil on cardboard
25×31 inches (63×80 cm)
Metropolitan Museum of Art, New York,
Rogers Fund, 1951 (51.33.2)

Set upon the same divan with grand cushions as that used in *L'Abandon* (page 127), this second of the group of four major lesbian pictures made by Lautrec in 1894-5 is an altogether more specific image of brothel life. Chemises which, in the previous picture, evoke the graceful line of classical drapery here have all the crumpled ordinariness of everyday life.

The foreground woman in this painting is Gabrielle, used by Lautrec for one of the figures in *Rue des Moulins* (page 124). The red-haired woman is similar to, but less coarsely featured than, the other woman in the same picture. Lautrec's particularly strong diagonal emphasis in this picture incorporates both figures. He prevents this emphatic line from simply cutting the painting in half by his use of the woman's red hair as a centering focus. Subtlety of

color organization is particularly evident in this work. The warm delicately-textured yellows and yellow-greens of the divan upholstery are played off against the cold acidic stridency of the delineated figures, and their blue-toned flesh and garments. This middle mass is in turn set off by the fire-like orange glow of hair, together with a very slight edging of orange pubic hair, a small accent of similar orange in the shadow of her chemise, and the red of Gabrielle's lips. Together these produce a complex central triangular linkage of warm colors against cool.

Richard Thomson, in considering this group of four lesbian paintings as a whole, suggests that they explore different moments of 'psychological interaction' between a couple; mutual suspicion is the characteristic he suggests is evident here.

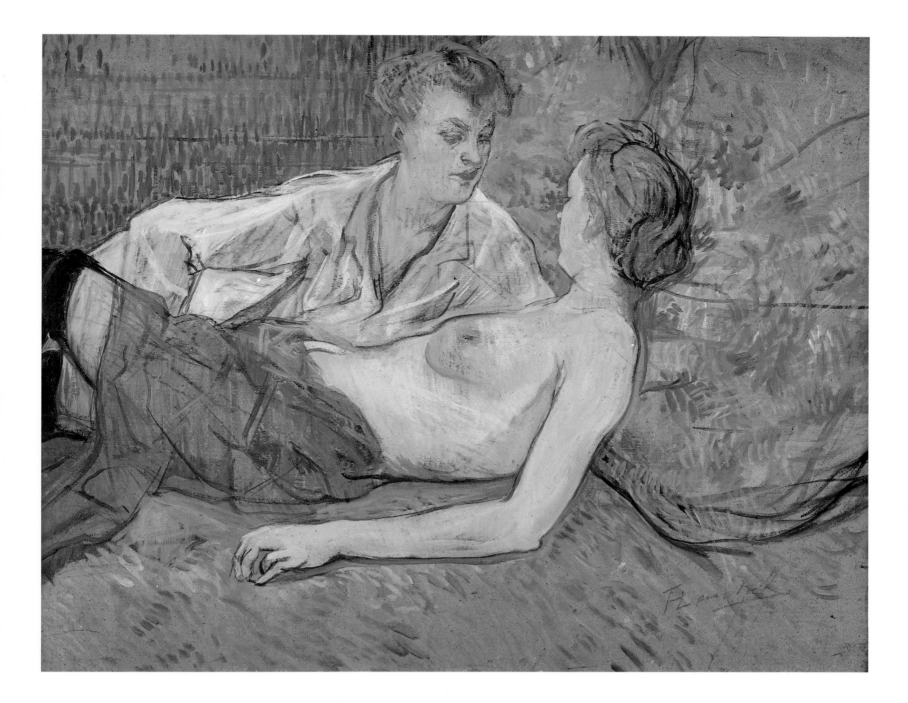

## The Two Friends 1895

Oil on board
25½×33¼ inches (64.5×84 cm)
E G Bührle Foundation, Switzerland

Among the visual sources claimed as an influence upon Lautrec's lesbian pictures are the erotic Japanese woodblock prints of Utamaro, and in particular the *Poem of the Pillow* series published in 1788. Although Utamaro's prints are of heterosexual couples, their calm depiction of figures shown lying down and their simple massing of shape and outline suggest affinities with this aspect of Lautrec's work. While Lautrec certainly knew such prints, the location by historians of his suggested inspiration in Utamaro springs in part from the difficulties that they have had in finding Western precedents for these images. Their very stillness, gentleness and intimacy remove them from the raw and ribald energy of most European erotic pictures. Although a few of Lautrec's brothel pictures present women in stereotypically gross or demeaning postures, the majority, like this, do not.

In this third picture from the 1893/94 lesbian series, Lautrec depicts younger, thinner models, and this has the strongest erotic overtones of the entire group. The women wear half-removed street clothes, and a masculine/feminine divide is inti-

mated between the two, as starched shirt rubs against red skirt.

It is unclear whether Lautrec ever exhibited this group as a whole. They were certainly never shown publicly. That they were intended to be seen as a distinct group or series seems beyond doubt. When any artist produces a series of pictures on a related theme, it is usual to seek for the significance of such a move. In Lautrec's case, given his acute sensitivity to the status that Degas held as the master of Naturalism, it is difficult not to view this group as another attempt to emulate Degas's own achievement at the 1886 Impressionist Exhibition when he exhibited his 'suite' of women 'bathing, washing, drying themselves, wiping themselves, combing themselves or being combed.' Degas made clear his intentions to the critic George Moore at the time in words that might well sum up Lautrec's approach for this group:

Hitherto the nude has always been shown in poses that presuppose an audience, but these women of mine are simple straight-forward creatures only concerned with their physical habits.

### Two Lesbians 1895

Oil on board
25⅝×31⅞ inches (60×80 mm)
Staatliche Kunstsammlungen, Dresden

The death of a beautiful woman is without doubt the most poetic subject in the world
– Edgar Allan Poe.

The Symbolist artists and writers with whom Lautrec exhibited and mixed socially dwelt frequently on the condemned nature of feminine beauty. *Femmes fatales* consumed in part by their own decrepitude appear in paintings that are reminiscent of the *vanitas* panels by sixteenth-century artists like Grünewald and Baldung Grien. Lautrec's paintings of older prostitutes have traditionally been sited within the Naturalist camp and seen as examples of his merciless objectivity. Some, including this, might perhaps be more appropriately linked to *fin-de-siècle* Symbolist allegory. In all his other images of paired lesbians, the spectator viewpoint involves a glance at subjects not knowing themselves seen, but here a rather menacing return stare greets the viewer with confrontational directness. The lithe woman on the bed behind, her body so evidently younger and more beautiful, represents another of the several ages of woman.

Lautrec's friend François Gauzi photographed a group of six of the regular staff at the Rue des Moulins brothel. Posed both clothed and half-naked, they are predominantly younger women in their twenties, with two who might be in their thirties. A portly, smiling woman in Gauzi's photograph resembles the foreground woman in this picture. Lautrec's figure also looks a little like Gabrielle the *danseuse*, one of his favorite models, but her caricatured grossness in this picture goes well beyond any straightforward reportage, and it is scarcely conceivable that such a woman could have been employed at one of France's premier brothels.

Lautrec's painting of older women with baggy bodies has often been seen as simply a predilection, like the one he had for redhaired models. Here, however, there is also a trace of the Baudelairian mixture of attraction and revulsion felt toward these women who:

Ignoring Hades and Purgatory's pain,
Enter into the blackest night,
Outfacing even the face of Death
Like newborns lacking malice – or remorse.

## Marcelle Lender Dancing The Bolero in 'Chilperic' 1895

Oil on canvas
57⅛×59 inches (145×150 cm)
National Gallery of Art, Washington DC

'When you are singing, your skin scintillates imperceptibly in the light and that's what I'm looking for,' was what Lautrec is reported to have said to Marcelle Lender (1862-1926) when she posed at his studio in 1895 for this, the largest theatrical painting that he undertook. While she posed, Lautrec apparently persuaded her to sing over and over again the same lines from the operetta *Chilperic*.

Revived in February 1895 at the Théâtre des Variétés, Hervé's *Chilperic* was a great success. The setting for the action was the Merovingian court of the French king Chilperic. In this scene Chilperic watches his Spanish bride Galasthwina dancing the bolero that was the highpoint of the show. Her unlikely eighth-century Spanish national costume includes huge artificial pink poppies in her hair and a dress that draws particular attention to her very ample *décolletage*.

Lautrec apparently attended 20 performances of *Chilperic* and is supposed to have made many sketches, although only a few have survived. For a while he was obsessed with Marcelle Lender. The several prints that he made of her included his most sophisticated printed image, using eight separate plates, which was reproduced in *Pan*, a German avant-garde magazine.

Lautrec said that he was especially attracted by Marcelle Lender's back. In another view of her dancing the bolero in Chilperic, which he made into a lithograph, he showed her very pronounced shoulder blades looking curiously similar to her cleavage in this painting.

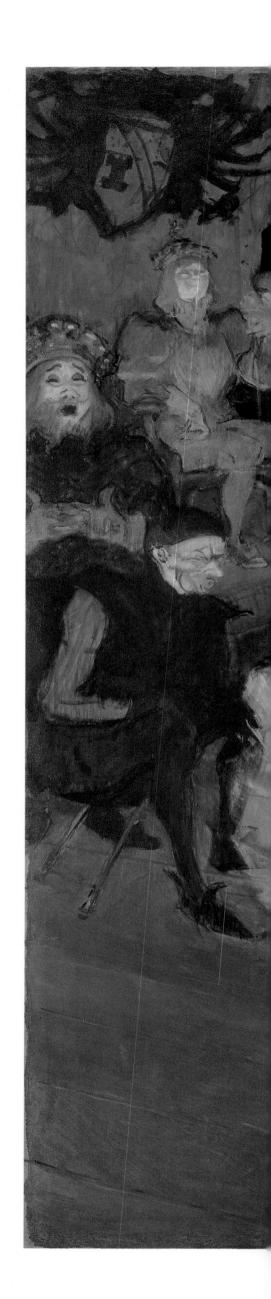

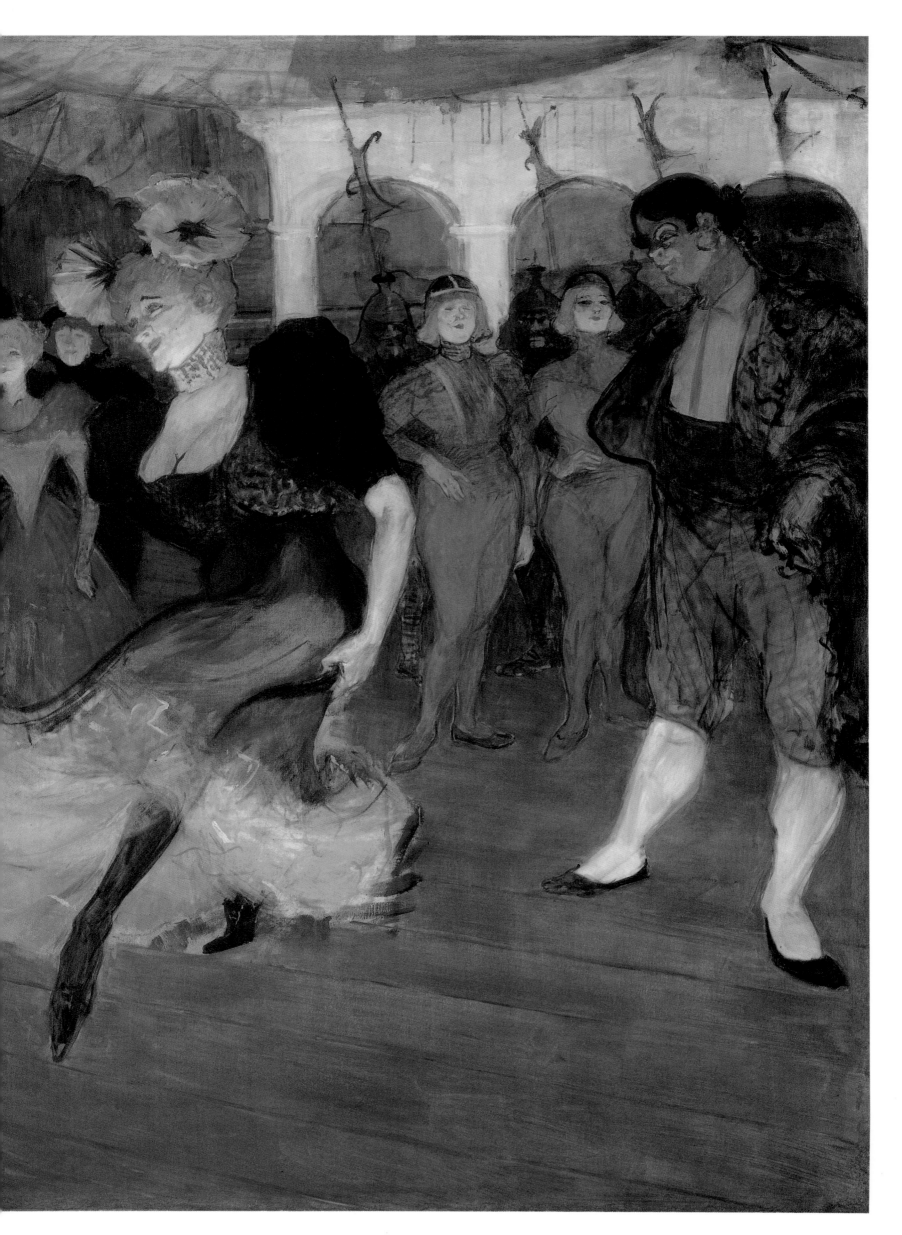

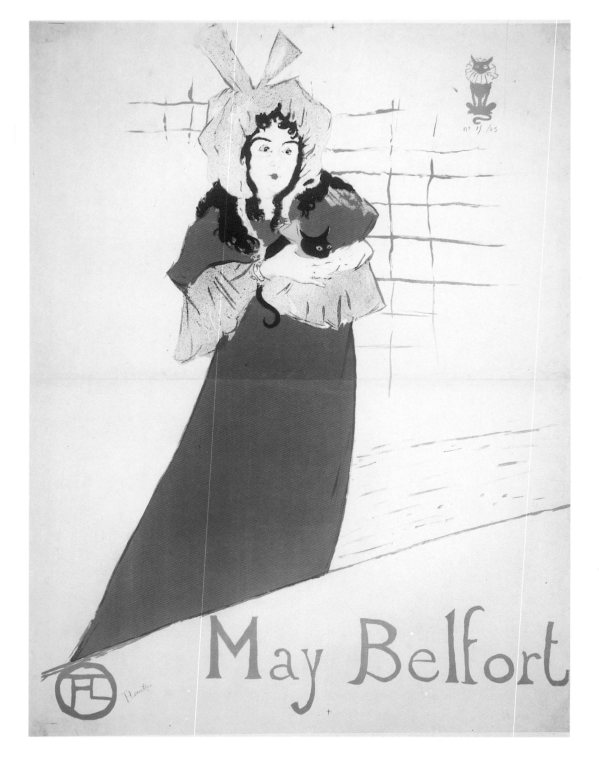

### *Miss May Belfort* 1895

Brush, spatter and crayon lithograph
31×23⅝ inches (79.4×60.4 cm)
British Museum, London

Lautrec first saw the Irish singer May Bel-
fort (May Egan) in early 1895 at the café-
concert Les Décadents in the rue Fontaine.
Five paintings of her preceded the produc-
tion of this poster, which appeared for her
debut at the Petit Casino. Lautrec made a
further six lithographs of her during 1895,
designed her 1896 Christmas card and a
menu card, and included her in the port-
folio of lithographs of French and British
actors and actresses which resulted from
his 1898 collaboration with the London
publisher W H B Sands. Despite Lautrec's
enthusiastic advocacy she was not popular
with his friends, with whom she had a
reputation for sadism, and her success in
Paris was short-lived.

Typically in this image, May Belfort is
shown holding the small black cat that she
usually carried and stroked during an act
that included her most notorious song:

Daddy wouldn't buy me a bow-wow,
Daddy wouldn't buy me a bow-wow,
I've got a little cat, and I'm very fond of that,
But I'd rather have a bow-wow-wow.

With the singer dressed in her ludicrous
Kate Greenaway frock and bonnet and
singing in a piping child-like lisp, the
song's euphemistic lyrics evincing her
wish for sex became double salacious. May
Belfort appears only once in Lautrec's sur-
viving correspondence. In late 1895 he
wrote to his friend, Maxime Dethomas:
'Miss Belfort is asking around for a hus-
band for her cat. Is your Siamese ready for
this business? Drop me a line, if you please
and name me a date.'

When Lautrec later made a poster for
May Milton, the lesbian lover of May Bel-
fort, he deliberately matched the composi-
tion to this poster.

### Yvette Guilbert 1895

Ceramic tile, edition of 10
20¼×11⅛ inches (51.4×28.2 cm)
San Diego Museum of Art,
Gift of Mrs Robert Smart

In her memoirs, Yvette Guilbert described the events surrounding the production of this ceramic tile, the only one in Lautrec's oeuvre:

Lautrec . . . one day admired a large turquoise tile table that I had and I said I wanted him to make me a tile so that it could be made into a small tea table. He said nothing but later brought me a caricature of myself to sign. I wrote '*Mais petit-monstre, vous avait fait une horreur*!! Yvette Guilbert' (But little monster you have made me a horror!!)

Lautrec had about ten similar ceramic plaques made by the potter Emile Muller. Whether he had the rudimentary outline and writing photolithographically offset on to each tile before incising into the soft clay, or alternatively copied each from a tracing, is now uncertain. Each tile is slightly different in color. His design is related to the group of drawings and oil studies that he produced in mid-1894, when he unsuccessfully tried to persuade Yvette Guilbert to commission a poster from him. The pert thrust of her face is also reminiscent of one of the earlier lithographs that he produced for *The Yvette Guilbert Album*.

Yvette Guilbert's affectionate diminutive for Lautrec is revealing of the parameters of their friendship. He apparently had long intimate conversations with her, and on one occasion confided that he only believed in desire and that for him love did not exist. Her role as confidante was never extended to that of lover, although it is likely that Lautrec would have wished it.

Despite her *risqué* songs, Yvette Guilbert's respectability remained intact. She survived to become a *grande dame* of twentieth-century popular music, after suitably modifying her repertoire to fit her advanced years and increased rectitude.

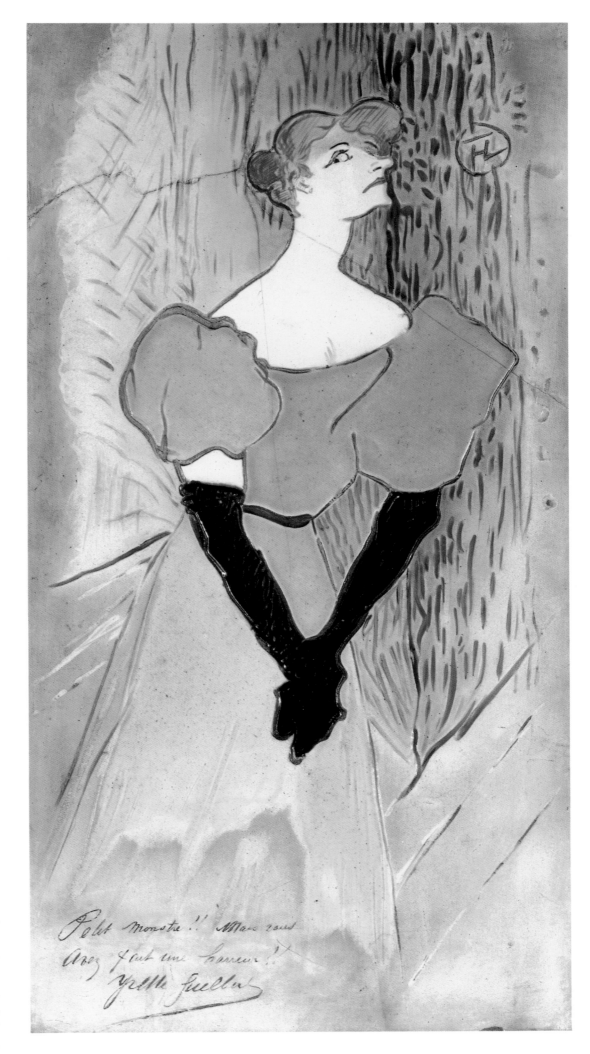

## La Goulue Dancing: (Les Almées) 1895

Oil on canvas
118¼×118¼ inches (300×300 cm)
Musée d'Orsay, Paris

'The colors are crude, the drawing incredible, but it is really amusing and the artist has indulged himself in a touch of irony by putting Oscar Wilde in the foreground,' wrote a commentator for *La Vie Parisienne*, describing this large canvas panel, one of two that Lautrec produced for a fairground booth belonging to La Goulue. La Goulue's career as a star at the Moulin Rouge, on a weekly salary of 3,750 francs, drew to a close in 1894. Her increasing weight and changing fashions are the explanations usually offered, but she also had pregnancy and a stillborn child to cope with. Setting up a booth was an attempted comeback.

The *Foire au Pain d'Epice* (gingerbread fair), held annually from Easter Sunday for three weeks, was the largest of Paris's two surviving ancient fairs. Three miles of street booths were centered around the large Place de la Nation, formerly the Place de Trône; the *Foire de Trône* was its more popular name. Traditionally booths or *barques* were decorated with paintings on either side of their entrance. George Sala, in his 1889 guidebook to Paris, summed up the quality of these paintings, 'Pictures – dimensions colossal, vehicle oil. Style, grand smudge. Name of artist, presumably Rapin de la Daube.' When Lautrec agreed

to La Goulue's request in April 1895 to produce something for her at very short notice, he was gamely entering into one of the lowliest areas of work that any artist could be involved with, in order to help his friend.

On the companion canvas to this, he painted La Goulue with Valentin le Désossé at the Moulin Rouge. On this canvas he shows her in vaguely oriental dress doing a belly dance. The pianist is M Tinchaut from the Chat Noir cabaret, and the spectators include Lautrec, Félix Fénéon and Jane Avril. Adding Wilde was savagely topical. Although Lautrec is not believed to have met him until the following month, the drubbing that Wilde and all avant-garde art was receiving in the British press during April 1895 would perhaps have been known to Lautrec from his contact with the *Revue Blanche* circle.

Belly dancing became popular in Paris following its inclusion in the Egyptian displays at the 1889 Exposition Universelle. Why Wilde's watching it was perceived as ironic by the *La Vie Parisienne* commentator is not clear. Given his known homosexual tastes, it may be in some way linked to the possibility that certain belly dancers were transvestite young men.

This canvas was cut up in 1926 by a subsequent owner, who hoped to make it into more saleable parts. These were reunited when it entered the Louvre in 1929, the same year that La Goulue died in poverty while working as a brothel servant.

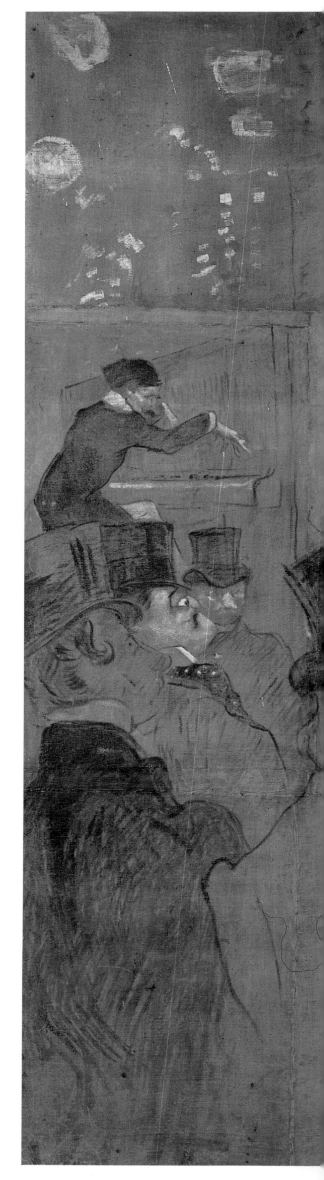

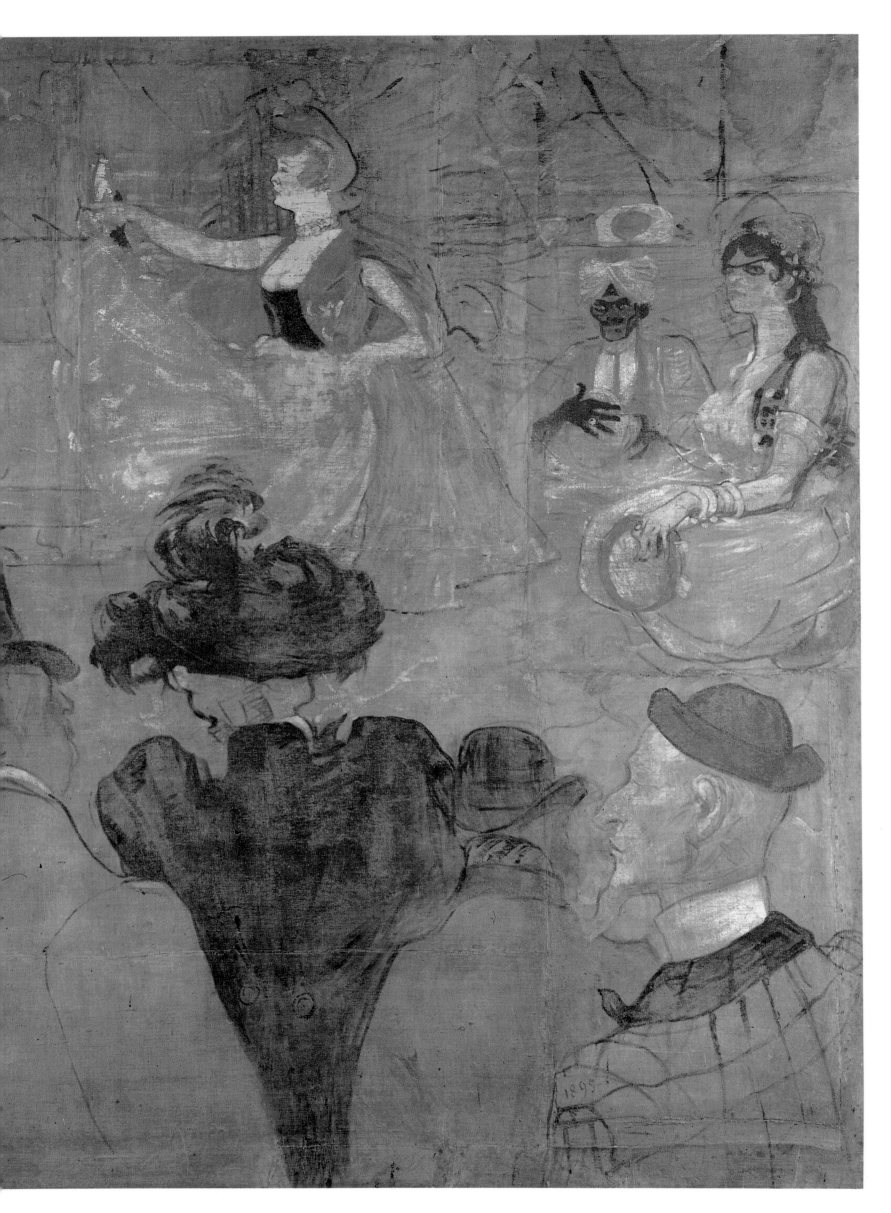

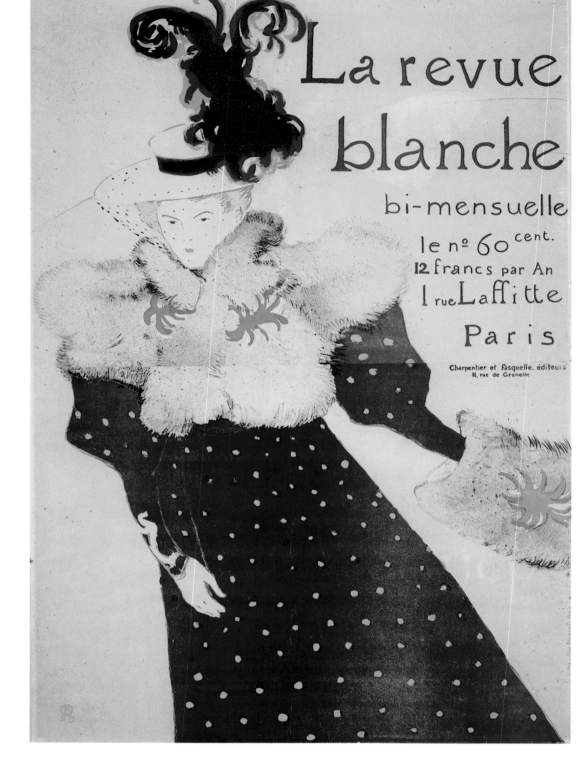

### *La Revue Blanche* 1895

Brush spatter and crayon lithograph in
four colors on paper
49⅜×35 inches (126.7×89.6 cm)
San Diego Museum of Art, Gift of the
Baldwin M Baldwin Foundation

Misia Godebska (1872-1950), daughter of
an impecunious aristocratic Polish family,
became, as the child-bride of Thadée
Natanson, the center of what was perhaps
the most important late nineteenth-
century Parisian avant-garde literary salon.
Marcel Proust considered her gatherings to
have been among the finest that he ever
attended. Thadée Natanson's fortnightly
magazine *La Revue Blanche*, which he
published in Paris between October 1891
and April 1903, was at the heart of this in-
tellectual milieu. It was particularly sup-
portive of Symbolist poets like Mallarmé,
Regnier and Gourmont. André Gide and
Strindberg were contributors, and Claude
Debussy wrote the music column.

Thadée Natanson was strongly attracted
to Lautrec's posters, from their first appe-
rance on Paris walls in 1891. In February
1893 he wrote in praise of them in his own
magazine. Commenting on their superior-
ity to the posters of Chéret, he singled out
'the near painful tangibility of Toulouse-
Lautrec's disturbing creations' as their
especial merit. From about this time
Lautrec also became a regular visitor to the
Natanson house in the rue Saint Florentin.

Natanson commissioned this poster in
1895. Although Lautrec made two prepara-
tory oil sketches, the composition is sub-
stantially a reversal of a similar figure used
for the poster of the singer May Belfort on
stage (page 134). It is not as powerful an
image as earlier posters. Misia's strong dia-
gonal pose, cropped feet and ankles do not
really suggest motion. Lautrec perhaps
chose a frosty theme for the poster as a
snowy pun on the *Blanche* of Natanson's
magazine title.

## Portrait of Oscar Wilde 1895

Oil on card
23⅝×19¾ inches (60×50 cm)
Private Collection

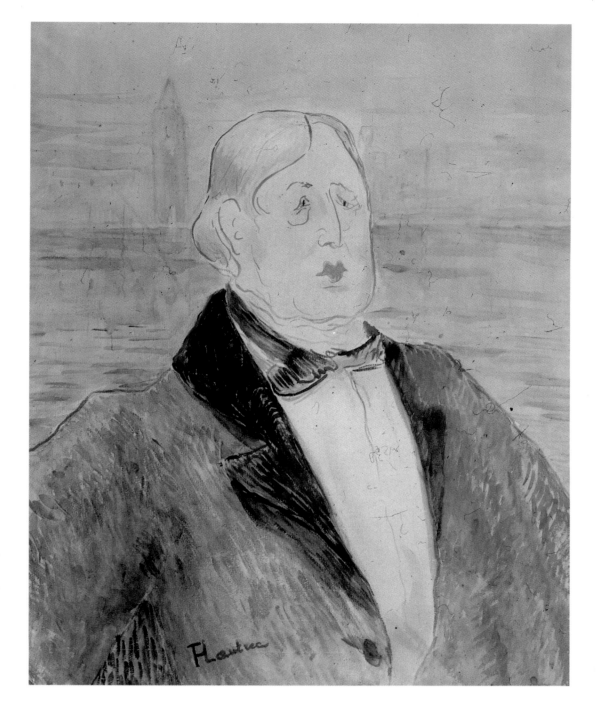

The ever acerbic Degas told Sickert that when Oscar Wilde first visited his studio in 1883, he 'looked like someone acting Lord Byron in a suburban theater.' Wilde's notorious attitudinizing and his conversation full of paradoxes were well-known among the Parisian artistic and literary avant-garde, of which he was sporadically part. Lautrec is believed to have met him first in early May 1895 in London, at the time that Wilde was involved in the first of two trials that ultimately led to his two-year imprisonment on conviction of sodomy. Wilde refused to sit for Lautrec, but allowed him to look at him. This resulting portrait is among the least flattering images that Lautrec ever created; an almost caricature-like treatment of Wilde's bloated features and broad girth, which is closer in spirit to the drawings of Max Beerbohm.

Behind Wilde's exaggeratedly erect form (it has been suggested that Lautrec studied and drew Wilde while he was actually standing in court) is a hazy image of the Thames, full of reflections. It is evocative of similar nocturnal Thames views painted by Whistler, whom Lautrec also met on the same 1895 London visit. The tower of Big Ben, with its illuminated clock face, can be read as a symbol of the rigid British laws proscribing homosexual activity which led to Wilde's downfall.

In France there was considerable sympathy for Wilde, and the May 15th, 1895 issue of *La Revue Blanche* contained an illustration based upon this portrait. Lautrec again used this format for a theater program commissioned by the actor Lugné-Poë for the Théâtre L'Oeuvre performance of Wilde's play *Salome*, premiered in February 1896 after it had been banned in London.

Upon his release from jail, Wilde spent the last three years of his life, from 1897 to 1900, exiled in Paris, using the pseudonym Sebastian Melmoth to avoid publicity. Lautrec may have met him again in 1899.

## Napoleon 1895

Lithograph on paper
23¹⁵⁄₁₆×18⅛ inches (59.3×46 cm)
Private Collection

Lautrec first produced the oil painting upon which this lithograph is based for a poster competition to advertise a forthcoming biography of Napoleon by William Milligan Sloan, due to be published in *The Century Magazine* in the United States. Organized by his dealer Boussod and Valadon, the competition attracted 21 entries with the prize going to Lucien Métivet, a former student of Lautrec's master, Cormon.

It has been suggested that, in deference to the conservative taste of the competition jury, which was headed by the academic artist Jean-Léon Gérôme (1824-1904) famous for the 'licked finish' of his own paintings, Lautrec took unusual care over precise details of uniform, buttons and decorations. Ultimately, however, his pale figure of Napoleon and the brighter background forms of a Mameluke warrior and an unknown marshal are rather generalized images. With their eyes averted or turned toward some distant goal, emerging like specters through a hazy mist, they evoke the vanguard of some cloud-wreathed heavenly apotheosis rather than any more down-to-earth military campaign.

Lautrec's inclusion of a Mameluke may have been inspired by his summer 1895 visit to Madrid, where he could have seen in the Prado Goya's painting of the massacre of Madrid citizens at the Puerta del Sol in May 1808 by Mamelukes. This lithograph, produced in an edition of 100 at Lautrec's own expense, does not differ substantially from the original oil.

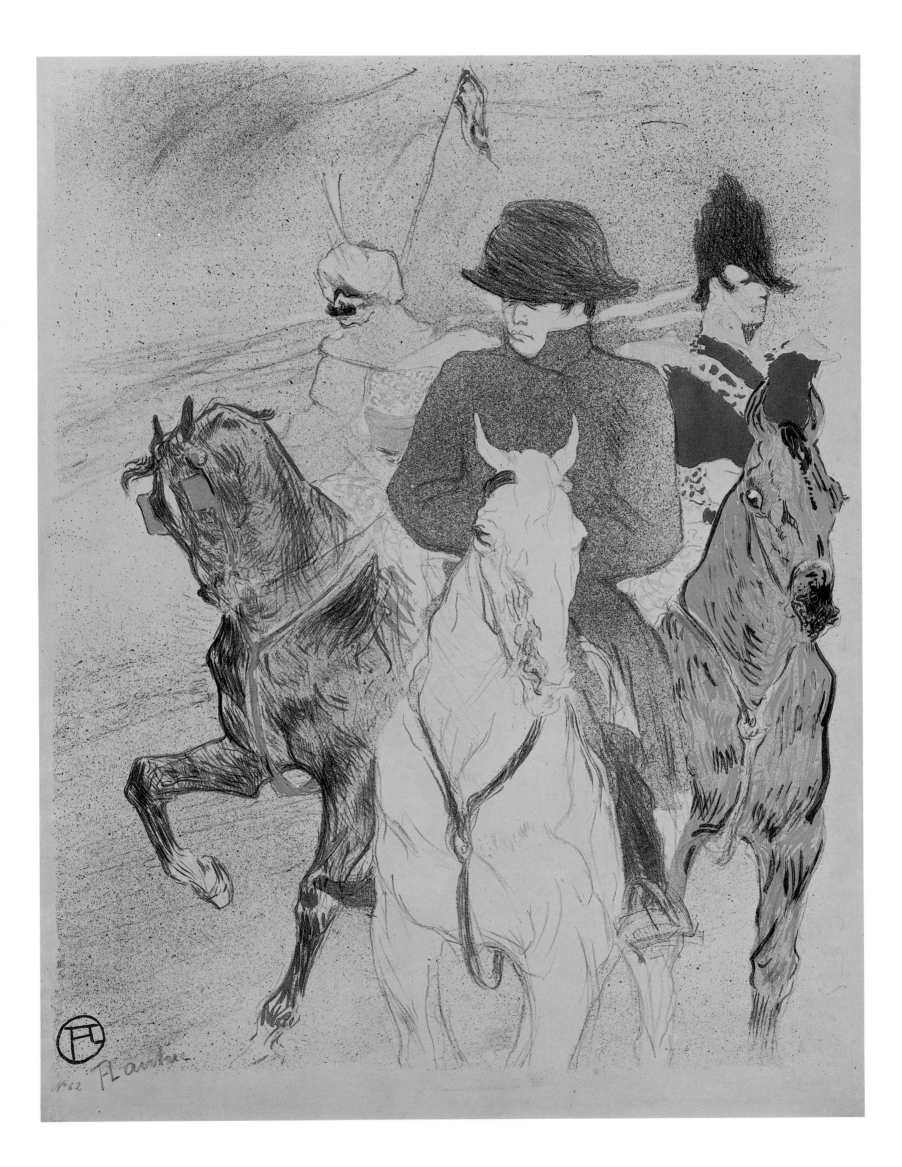

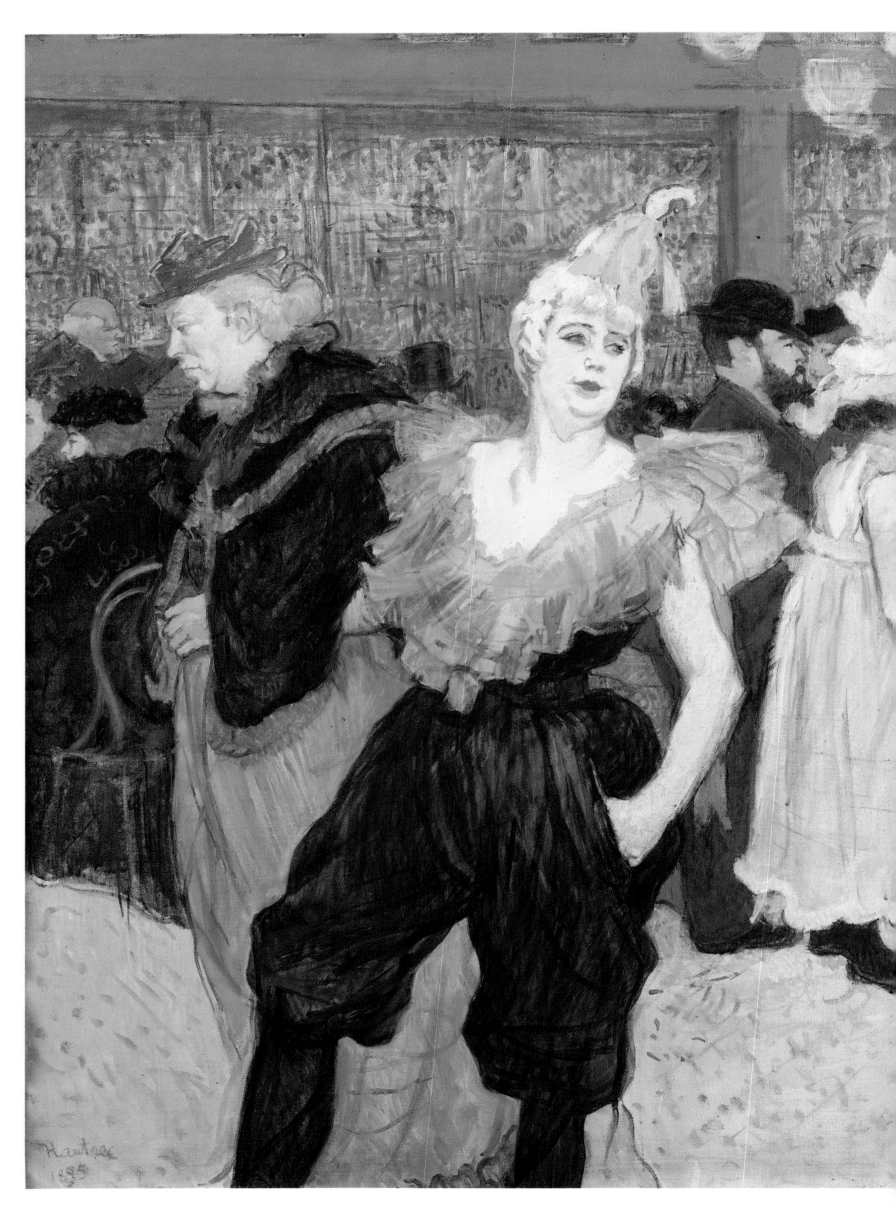

## At The Moulin Rouge, The Clown Cha-U-Kao 1895

Oil on canvas
29½×21¾ inches (75×55 cm)
Oskar Reinhart Collection, Winterthur

These two women with their faintly vapid expressions, who appear to pull in contrary directions, are the clown Cha-U-Kao and her lover the *danseuse* Gabrielle, shown crossing the floor of the Moulin Rouge. One of the last pictures that Lautrec made that was inspired by the Moulin Rouge, it has similarities in conception with his earlier depictions of La Goulue making her nightly progress on the arm of his sister (page 90).

Lautrec's use of repetition is particularly evident in this work. Behind Cha-U-Kao is the bearded and bowler-hatted profile of Tristan Bernard (1866-1947), the writer and cycle-track manager who was a friend of Lautrec's and who appears in exactly the same pose for his portrait standing in the Buffalo Velodrome. Gabrielle is also portrayed as she appeared in *The Moulin Rouge* (page 92) of the previous year. Lautrec first painted her in two portraits, c.1890, as part

of the series of figures shown in M Forest's garden. According to Lautrec's fellow student Gauzi, she was 'a regular model' for those in the Cormon atelier.

Lautrec exhibited this at his one-man show at Joyant's gallery in the rue Forest in January 1896. When he sold it along with a circus painting, he wrote to his grandmother:

Foreigners are definitely most kind to painters. I have just sold two paintings to King Milan of Serbia. I'll be able to put Painter to the Court of Sofia on my cards, which will be all the more absurd since Milan has fallen.

Milan IV, ex-king of Serbia, lived in Paris after his abdication in 1888, using the curious title Count of Takova.

Lautrec's publisher, Pellet, produced a superb color lithograph of this image in 1897 in an edition of 20, which he sold at 50 francs each.

## Cha-U-Kao, The Female Clown

1895

Oil on canvas
25¼×18¼ inches (64×49 cm)
Musée d'Orsay, Paris

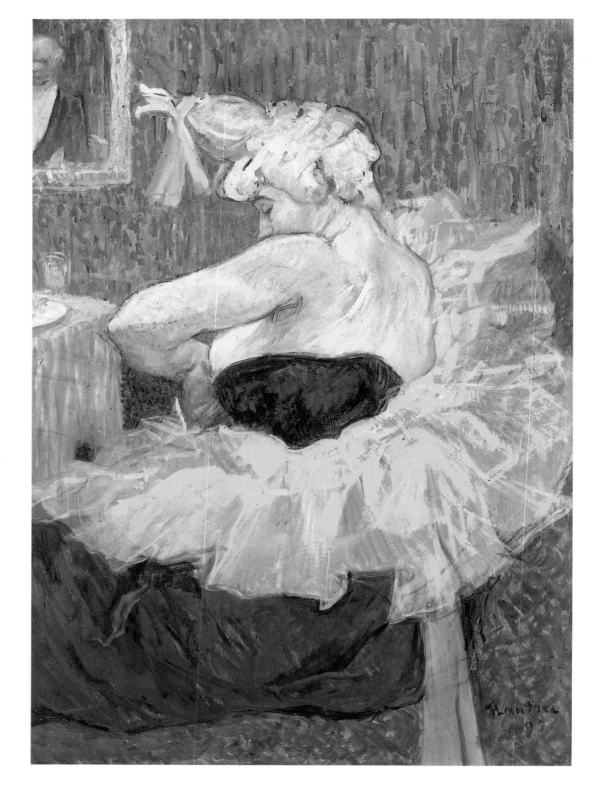

The name of Cha-U-Kao, read on the printed page, looks deceptively Japanese. It is, however, a phonetic spelling that, when spoken aloud, reveals itself as a combination of 'Chahut', the older name for the high-kicking can-can, and 'Chaos', suggesting the frenzy with which it was often danced. It is not clear how Cha-U-Kao danced, or how it fitted in with her clowning and acrobatics. Her costume broadly conforms with traditional European clowning gear but also gives her the generally Japanese look that she sought. Her hair, which almost parodies La Goulue's striking top-knot, is redolent of the elaborately coiffeured tresses of women in Japanese tea-house prints. Her exaggerated frilly collar is a little like the heavy bordering of certain kimonos, and her baggy pants evoke those of a Japanese workman.

If the inspiration for her own appearance lay in Japanese art, Lautrec, when he came to paint her, if anything intensified this oriental emphasis. He treats her very like a single-figure Japanese print. Her solid bulk is divided into simple outlined shapes. The lack of tonal differentiation between foreground couch and background wall invites a reading of the picture as flat, and the cropped portrait or mirror in the top right-hand corner is similar to the framed panels of text that lie on the surface of so many Japanese prints.

It has been suggested that Cha-U-Kao may be here depicted in a private supper room awaiting an admirer or friend, who is shown reflected in the corner mirror. Lautrec's principal concern in this work, however, remains formal rather than narrative.

144

## The Seated Clowness –
### *Mademoiselle Cha-U-Kao* 1896

Crayon, brush and spatter lithograph
with scraper in five colors on paper
20½×15¾ inches (52×40 cm)
San Diego Museum of Art, Gift of the
Baldwin M Baldwin Foundation

This magnificent color lithograph of Cha-U-Kao is from the *Elles* series which Lautrec exhibited at the Salon des Cent in April 1896. The series as a whole is perhaps his most sustained homage to Degas. With its images of the boudoir life of women, it parallels Degas's own great bathers series exhibited at the last Impressionist exhibition in 1886. This print has always posed problems; it eludes obvious integration into the *Elles* series, which is generally viewed as subjects set in brothels and based upon ideas gleaned by Lautrec during his periodic sojourns in the rue des Moulins.

Naomi Maurer has put forward the convincing alternative suggestion that the series is concerned not so much with prostitutes specifically, as with the private world of lesbian co-habitation generally. She argues that Cha-U-Kao was included because she was a well-known lesbian and suggests that she and her lovers are the subject of other plates in the series. Images may in certain cases be of brothels, but that is not the principal focus. Maurer also suggests that after the 1892 police raid upon his lesbian pictures exhibited at the Barc de Bouteville Gallery, Lautrec was perhaps wise to have retained a certain ambiguity in his presentation.

When offered to the public as a portfolio of ten prints and cover, priced at 300 francs, the *Elles* series did not sell well, although this plate showing Cha-U-Kao's more public persona was popular. The setting suggests a masked ball, possibly at the Opéra, at which she is neither masked nor otherwise disguised. The slumped lassitude of her pose also suggests indifference to her surroundings. Tiredness and the suggestion of world-weariness are sub-themes of the entire series.

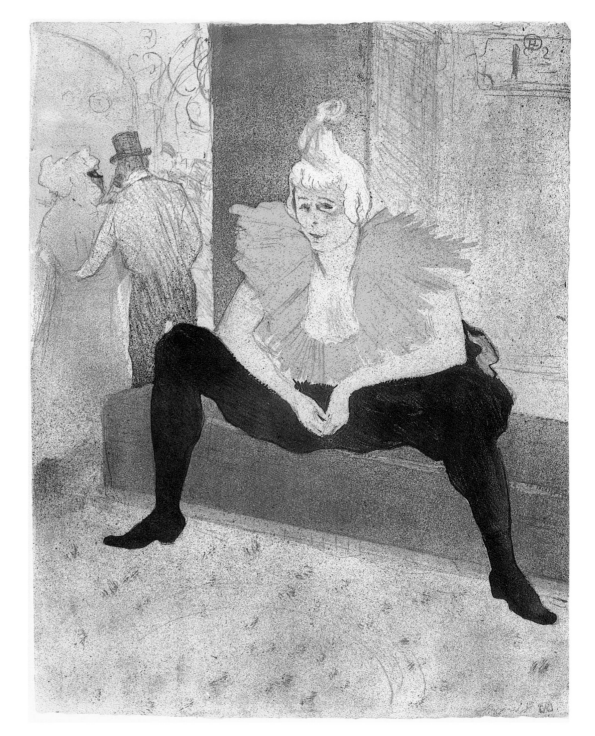

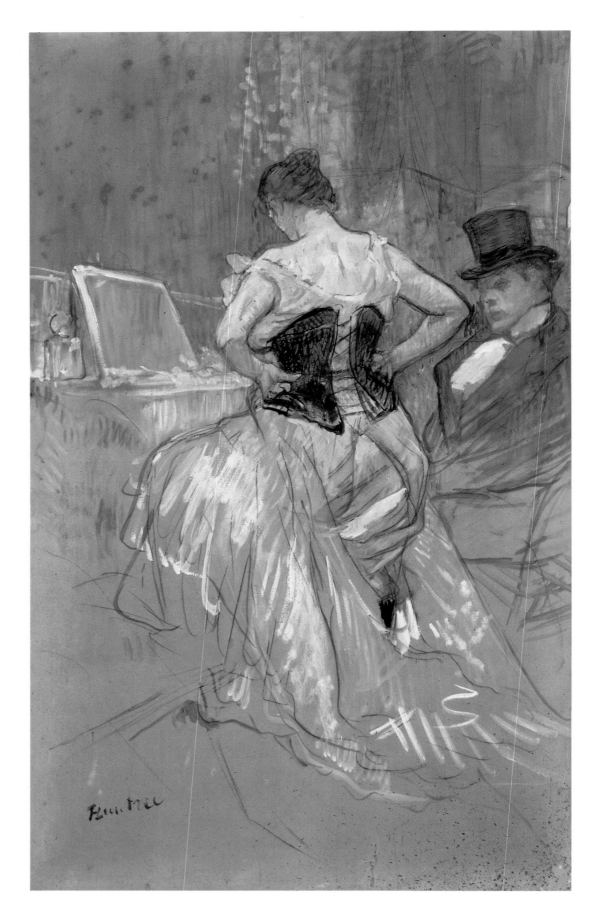

## Woman Doing up her Corset 1896

Oil on canvas
40¾ × 25⅝ inches (103 × 65 cm)
Musée des Augustins, Toulouse

This oil study was used as the basis for the ninth plate in the *Elles* series of lithographs. Traditionally the subject has been assumed to be that of a male in evening dress scrutinizing a prostitute undressing, and connections have often been made with a similarly posed pair of figures in Manet's painting of *Nana*, 1877, and with Degas's brothel monotype of a man watching a prostitute combing her hair. Dortu suggested that the man was modeled upon Lautrec's artist friend, Charles Conder.

Naomi Maurer, in her case for the entire *Elles* series being an account of lesbian intimacy, suggests that the seated figure is a transvestite woman, possibly the female clown Cha-U-Kao. Her bosom, which is so evident in this painting, was, Maurer suggests, reduced for the print, in order to maintain sufficient ambiguity to prevent police censorship. There are also affinities between the pose and general bulkiness of the standing woman and the view of Cha-U-Kao in the earlier portrait of her putting on her ruff (*Cha-U-Kao, The Female Clown*, page 144). Other prints and paintings by Lautrec of Madame Hanneton's bar and the lesbian La Souris bar in Montmartre show women wearing starched shirts and men's tailored suits.

Comparisons have been made between the *Elles* series as a whole and Degas's 1886 suite of bathers. The principal differences are that at times Lautrec's women stray into caricature and that the specific beauty of the models' faces is occasionally made clear. Six of the eleven plates do follow Degas's usual rather distanced view from the side, back or top, with the face averted or invisible and this powerful back view is the image that most closely approximates to the formal clarity of Degas's conception.

It is possible that Lautrec may have seen pastels and paintings made by Degas during the 1880s of women taking off and putting on their corsets.

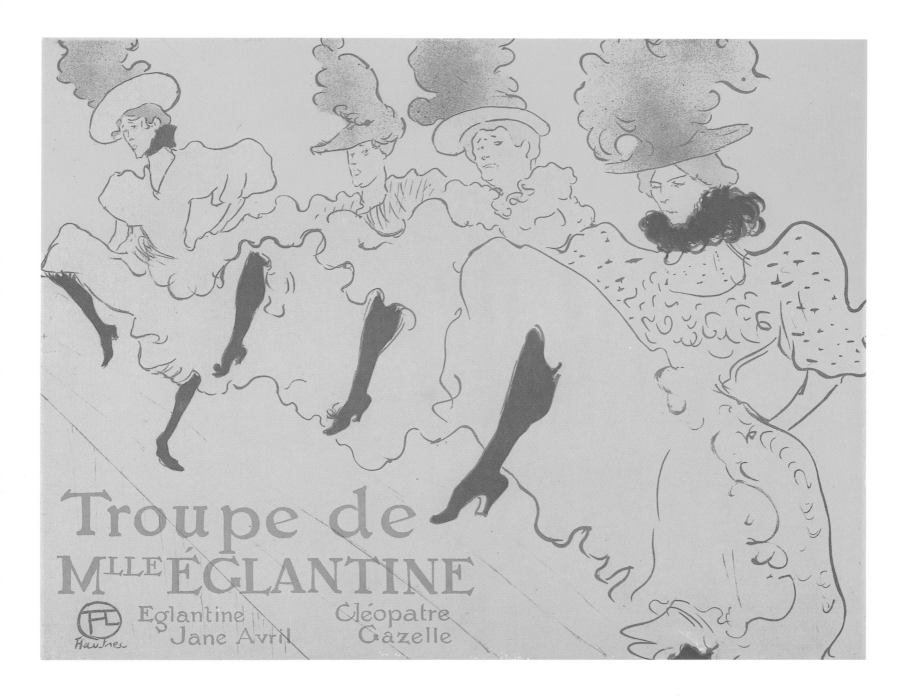

## The Troupe of Mlle Eglantine

1896

Brush spatter and crayon lithograph in
three colors on paper
24¼×31½ inches (61.5×77.5 cm)
San Diego Museum of Art, Gift of the
Baldwin M Baldwin Foundation

Jane Avril, the angular figure on the far left,
commissioned this poster from Lautrec in
January 1896 for the appearance the fol-
lowing month of Mlle Eglantine's *Quadrille
Naturaliste* troupe at the Palace Theater in
London. Lautrec used a photograph as the
basis for his image, but adapted it by elon-
gating the line of dancers so that Jane Avril
stands slightly apart from the unified mass
of the three dancing in step. Her preference
for dancing alone, which Lautrec had high-
lighted in his earlier paintings of her, is
hinted at here both by her more idiosyn-
cratic step and by her greater individual
characterization. Her pose is also evocative
of that used for Marcelle Lender in the
*Chilperic* painting (page 132) of the pre-
vious year.

Jane Avril intended the poster to act as a
general advertisement for the tour of Mlle
Eglantine's troupe, and instructed Lautrec
not to include specific details of the
theater. She was also apologetic about the
short time in which it was required.
Lautrec did not produce a full-size drawing
for the poster, and his oil study is rather
perfunctory. A monochromatic lithograph

of the poster was reproduced in *Le Courrier
Français* on February 16, 1896.

The Eglantine troupe was not especially
well received in London. Gerstle Mack, in
his 1938 biography of Lautrec, suggested
that this was due to their being too re-
strained and respectable for the audience.
He also indicated that there were divisions
within the troupe, with Eglantine and Jane
Avril aligned against Gazelle and Cléo-
patre.

As with several of Lautrec's 30 posters,
the lettering that appears here was added
later and designed by another hand.
Lautrec's familiar signature and circular
'*mon*' were accompanied in a first version
of this poster, prior to letters, with a small
remarque of a running negro figure in a
raincoat carrying an umbrella, perhaps
erased on second thoughts because it
risked confusion.

Jane Avril's loyalty to Lautrec for her
posters was consistent. When his creative
powers were waning during early 1899, she
commissioned from him a further poster of
herself that was never lettered or used
publicly.

147

## The Passenger in No. 54 1896

Brush crayon and spatter lithograph in
seven colors on paper
25¹⁵⁄₁₆×15¾ inches (66.5×40 cm)
San Diego Museum of Art, gift of the
Baldwin M Baldwin Foundation

Lautrec adored sea journeys. For his sum-
mer 1895 trip to his mother at Malromé, he
traveled with Maurice Guibert by the cargo
liner *Chili* from Le Havre to Toulouse.
During the two-day journey, he apparently
became besotted with the beauty of one of
his fellow-travellers, the woman depicted
in this large lithograph. Known only as the
passenger in cabin no. 54, she was ap-
parently the wife of a colonial official *en
route* to join her husband in Senegal.
Lautrec was not formally introduced to
her. His drawing, upon which this print is
based, was made from memory and from a
photograph (probably taken illicitly) of
her seated in a deck basket chair.

When the ship reached Toulouse,
Lautrec refused to get off and was ap-
parently prepared to travel all the way to
Dakar to retain sight of this woman. Gui-
bert's forceful remonstrations led to his
capitulation and they both disembarked in
Lisbon, travelling overland via Toledo and
Madrid to Malromé.

Lautrec first issued this print in autumn
1895 in an edition of 50. A second edition
of 50 was used partly for distribution to
subscribers to a deluxe edition of *La Plume*
magazine for October 1895. Overprinted
with letters, a further 1000 or more were
used as the poster advertising an inter-
national poster exhibition held at the pre-
mises of the Salon des Cent between
October 1895 and March 1896, and again
for the Libre Esthétique exhibition held in
Brussels in February 1896.

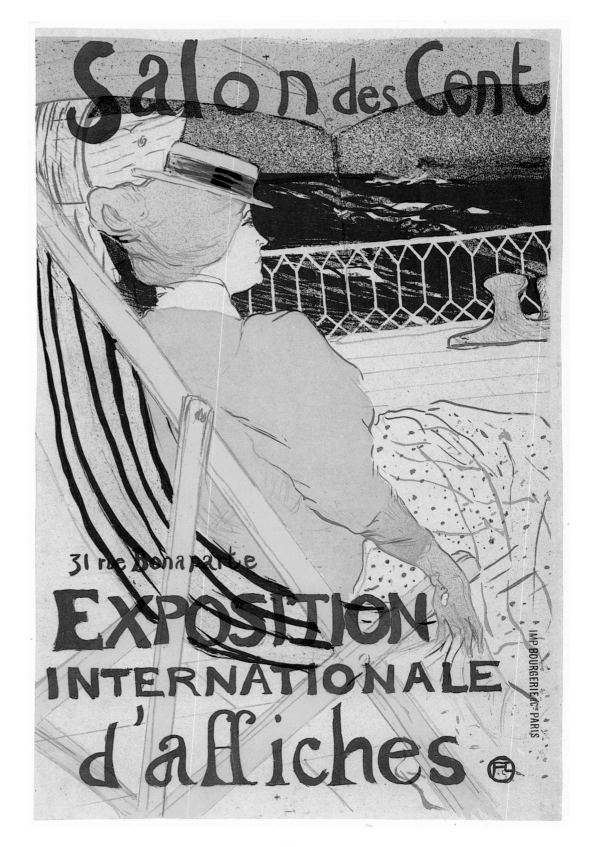

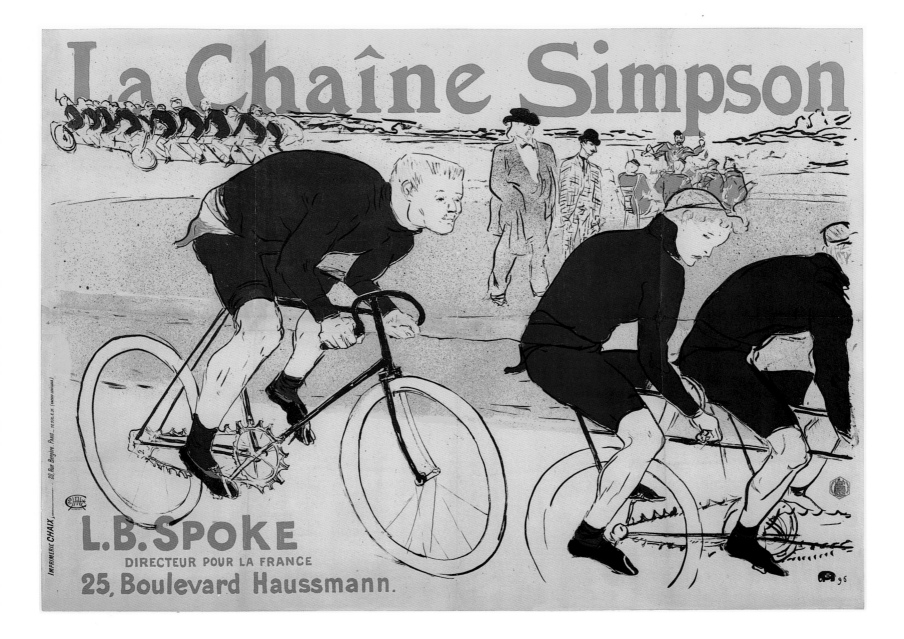

### The Simpson Chain 1896

Brush crayon and spatter lithograph in
three colors on paper
33⅞×47 inches (86×119.4 cm)
San Diego Museum of Art, Gift of the
Baldwin M Baldwin Foundation

During the 1890s, as the craze for cycling
swept French society, timed races by pro-
fessional cyclists became a popular sport-
ing spectacular at newly built *Velodromes*.
Technical improvements in the construc-
tion of bicycles, not least Dunlop's inven-
tion of the pneumatic tyre in 1889, made
machines faster and more efficient. Lautrec
was a close friend of Tristan Bernard
(1866-1947), the poet, playwright and
member of the *La Revue Blanche* circle,
who also edited the *Journal des Vélocipé-
distes* and managed two cycle tracks. An
article by Bernard published in *La Revue
France–Americaine* accompanied the first
cycle print that Lautrec produced, a small
lithograph of the American cyclist Zim-
merman who became the French 200-
meter spring champion in July 1894.
Through Bernard, Lautrec gained access to
the world of championship cycling, and to-
gether they often made Sunday visits to the
track.

This poster arose out of the five-day trip
to London that Lautrec made in May 1896,
with a French team headed by the Welsh
cyclist Jimmy Michael and his manager

Louis Bougle. Describing this to his
mother Lautrec wrote:

I was with a team of bicyclists who've gone
there to defend the flag the other side of the
Channel. I spent 3 days outdoors and have
come back to make a poster advertising 'Simp-
son's Lever Chain' which may be destined to be
a sensational success.

The poster was commissioned by Louis
Bougle who, for his Paris bicycle business,
called himself by the improbable alterna-
tive name of 'L B Spoke', thus punning
both cycle wheels and his own distinctive
taste for English tailoring. Bougle rejected
Lautrec's first design for this poster
because the chain as depicted would not
have driven a cycle. This second acceptable
format shows the French cyclist Constant
Huvel on the rear of a tandem with the
chain's inventor W S Simpson and Bougle
in the center near an English army band.
The cyclist at the left, whose bicycle pos-
sesses the Simpson chain, is about to over-
take the champion tandem riders; thus
proving the superior merits of Simpson's
invention.

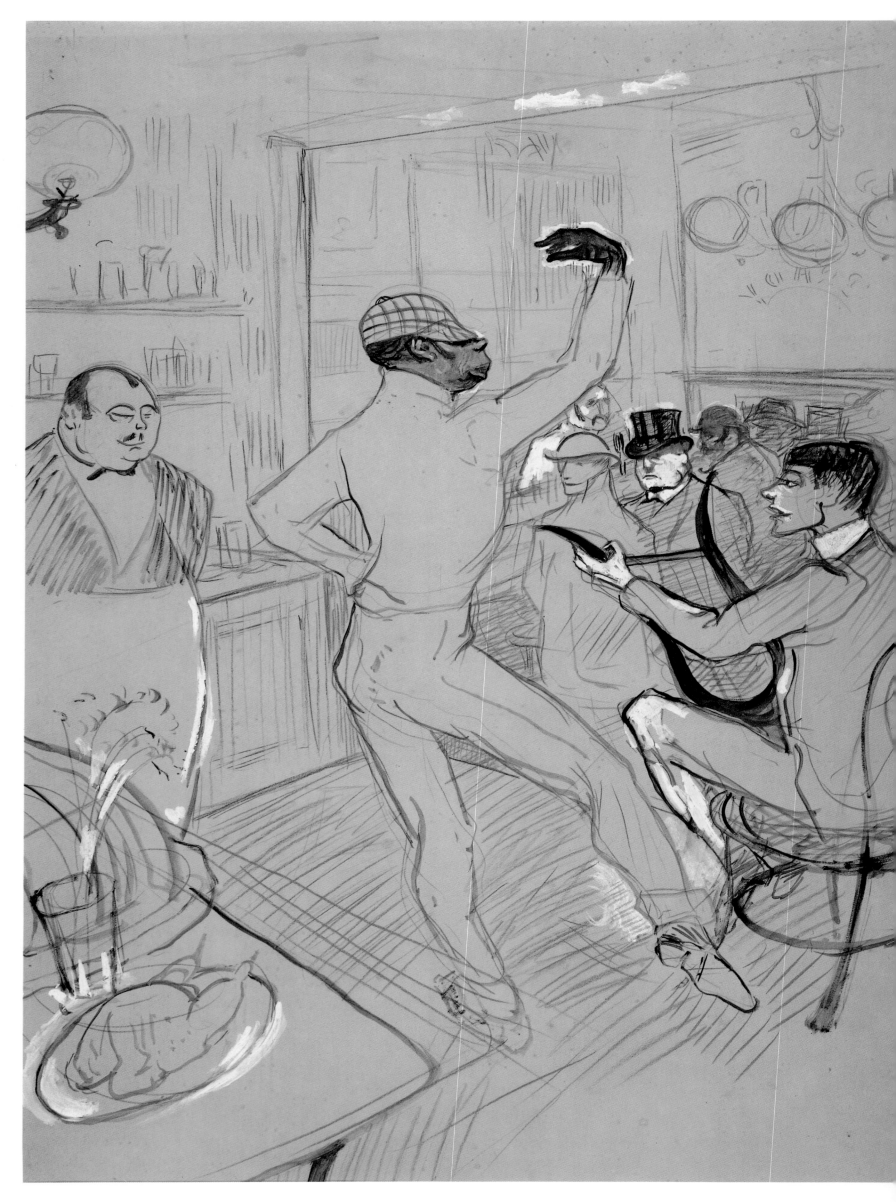

## Chocolat Dancing in the Irish-American Bar 1896

Black ink, chalk and wash on paper
25¼×19½ inches (65×50 cm)
Musée d'Albi

Lautrec's nocturnal promenading from 1895 onward took in the rue Royale near the Madeleine where, near to fashionable restaurants like Weber's, there were late-night and all-night bars that catered for hardened drinkers like himself. The Irish-American bar was a long narrow room fitted out with heavy mahogany panelling and hung with sporting prints, in what aspired to be the style of a London pub. Lautrec's preferred perch was a table at the rear, in a small room slightly above the principal floor area, from which he could view the regular clientele of jockeys, trainers, coachmen and sporting types.

Ralph, the corpulent barman, famous for his lethal cocktails, is the half-Chinese, half-American Indian who supervises pro-ceedings. Chocolat, the elegant dancing figure, was a negro from Bilbao and part of a clown double-act with George Footit at the nearby Nouveau Cirque. Lautrec had earlier drawn Chocolat with Footit performing in the circus ring for a supplement that he produced in 1894 for *La Revue Blanche*. Here he shows him in a more private relaxed mood, dancing to the accompaniment of a lyre. His steps appear to be an Irish or Scottish jig. The impassive square white face of the man who is watching Chocolat is that of Tom, coachman to the Rothschilds. Lautrec used his striking features in several lithographs.

This drawing, adapted as a magazine illustration, appeared in *Le Rire* on March 28th, 1896.

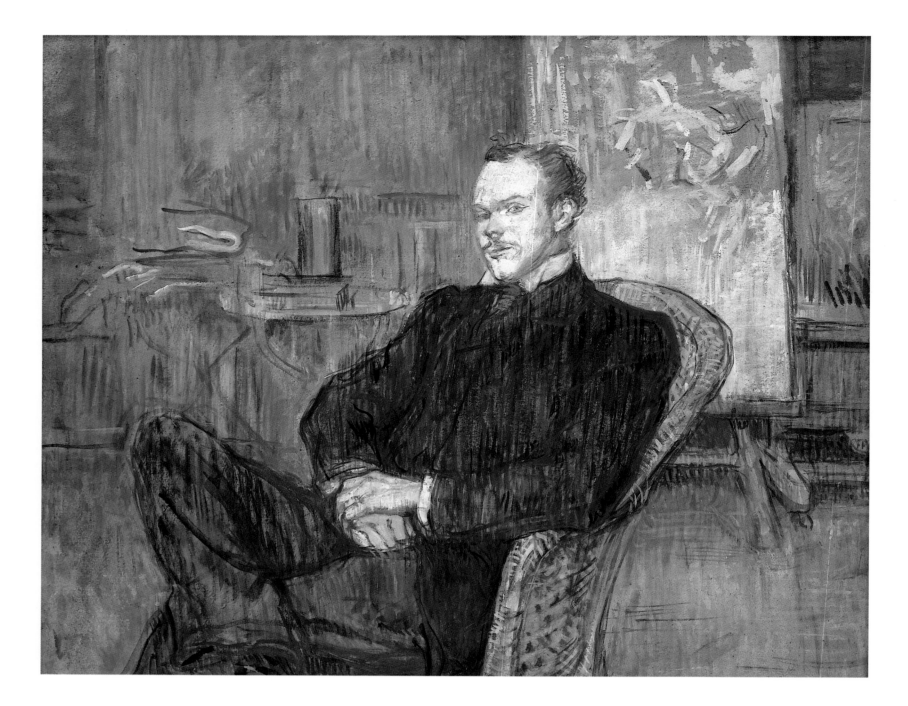

## Paul Leclerc 1897

Oil on board
21¼×25¼ inches (54×64 cm)
Musée d'Orsay, Paris

Paul Leclerc (1871-1957) was a writer, poet and the founder editor in 1889 of *La Revue Blanche*. 'A young man of the world and of the best' was how Lautrec described him to his mother in a letter that he wrote warning her that he planned to bring his friend to her home at Malromé for a summer visit. Although Lautrec intended to paint this portrait at Malromé, it was in fact done at his new studio on the avenue Frochet in late 1897.

In his earlier 1891 group of male portraits posed in his studio, Lautrec used a formula derived from Whistler and Degas. Here, too, there are compositional precedents in Degas's work. The central diagonally positioned figure of Leclerc, silhouetted against the interlocking rectangles of a background that is parallel to the picture plane, is characteristic of a number of Degas's female portraits and hair-combing pictures.

Lautrec seems to have sought for a greater-than-usual organizational tautness

in this picture. His use of emphatic vertical brushstrokes helps integrate the paint surface, as does his selective use of black outline and the small patches of parallel hatching. Only the background easel painting of a woman from the *Elles* series has a vari-directional texture that breaks with this vertical consistency.

In Leclerc's reminiscences of his sittings for this portrait, he said that for a month he went three or four times a week to be painted, but that because of distractions he only sat for three or four hours in total.

He would stare closely at me through his glasses, screw up his eyes and put a few liquid paintmarks on the canvas after careful scrutiny. He was silent while he painted, and licked his lips as though tasting something delicious. Then he would burst out singing the *Chanson de Forgernon* [a filthy popular song], and after putting down his brush, would suddenly say 'that's enough work, the weather is too good', and off we went for a walk.

## Madame Berthe Bady 1897 (?1894)

Oil on board
27⅝×23⅝ inches (70.3×60 cm)
Musée d'Albi

Two of Lautrec's finest 1894 theatrical lith-ographs (including *The Swoon*, page 21) depicted the avant-garde Belgian actress Berthe Bady playing opposite her husband Aurélien Lugné-Poë in the Théâtre L'Oeuvre production of Maurice Beaubourg's *Image*, an idealist play with a plot that revolved around a husband falling in love with his wife's portrait. Berthe Bady played the wife in a long black dress with large padded sleeves and a boa wrap. This portrait, usually dated three years later, shows her in similar costume; the precise dating of the picture, however, is by no means certain. There are precedents in earlier single female portraits (in particular *Woman with a Black Boa*, c.1892, Museé d'Orsay) for the separate vertical parallel brushstrokes used to describe a dress that are such a distinctive feature in this portrait.

Commentators upon this picture have emphasized the exaggerated quality of its portrayal. Götz Adriani, for example, argued that 'Everything in this portrait aims at an almost theatrical effect'. When it was exhibited in Chicago in 1979, the cataloguer Naomi Maurer dwelt on the 'dramatic overtones' of the characterization. Exaggeration might be singular in a conventionally-conceived portrait, but such strong simplifications and bravura paint handling might perhaps be precisely the required format for a portrait intended as part of a stage set, a possible original use for this picture in Lugné-Poë's 1894 production of *Image*.

Lautrec's chosen pose for Berthe Bady is far removed from the accidentally glimpsed Naturalism of some of his other female portraits. It more closely resembles earlier nineteenth-century portraits by classical painters like Ingres, and was preceded by one of his finest and most detailed red chalk drawings. Few portraits by Lautrec reveal better his idiosyncratic use of thin diluted oil applied onto his favored cardboard support, enabling him to achieve a matt build-up of overlapping yet separately visible paint marks which, above all, retain their distinctively graphic character.

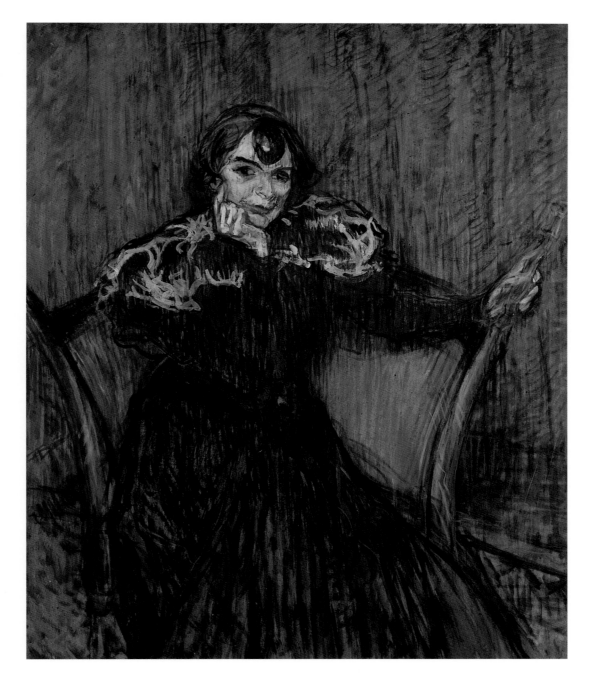

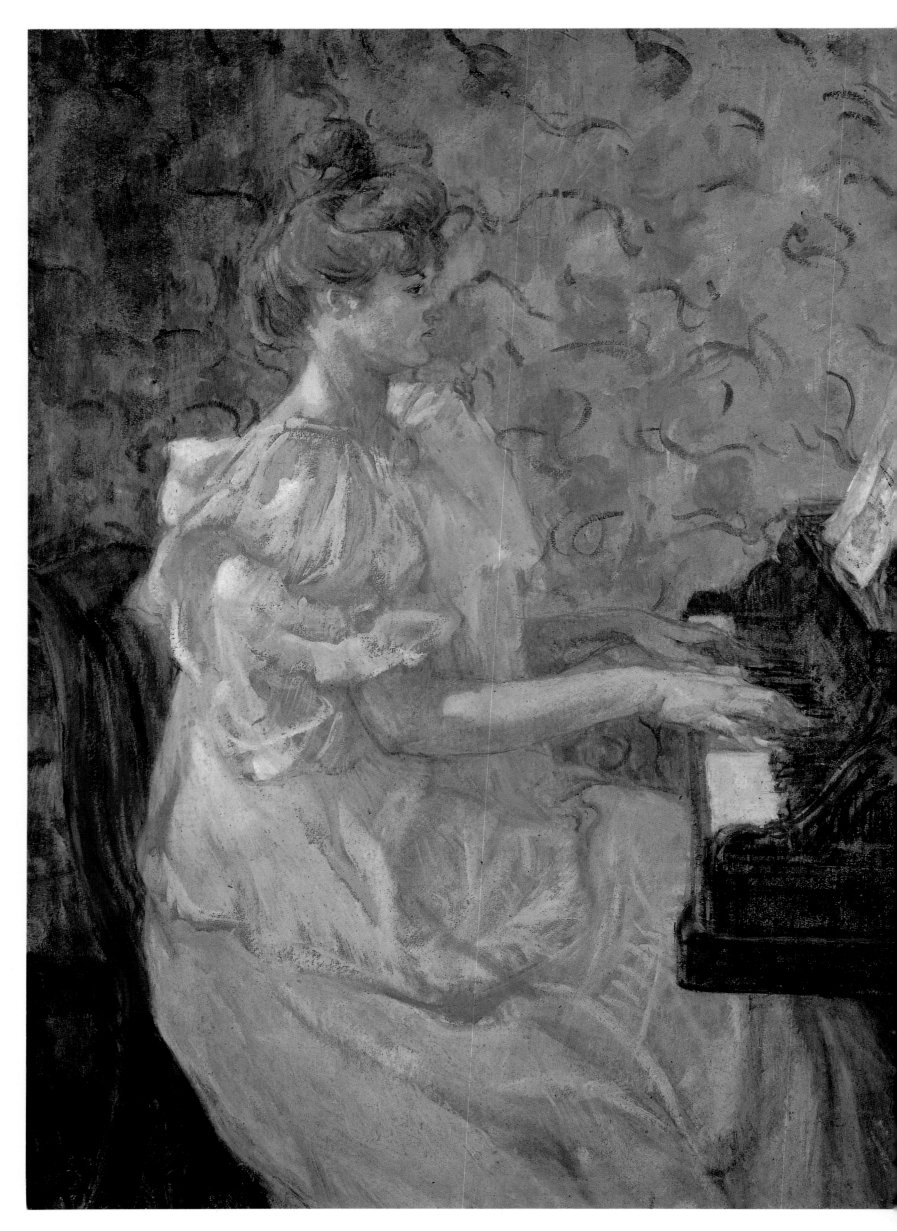

## Misia Natanson Playing the Piano 1897

Oil on board glued to wood panel
32×37½ inches (82×96 cm)
Kunstmuseum, Berne

Misia Godebska was not only painted on several occasions by Lautrec, but also by Bonnard, Vuillard and Renoir. Verlaine dedicated poetry to her, and Mallarmé once wrote her a poem on a fan. Lautrec first painted her for the *La Revue Blanche* poster of 1895 (page 138). This portrait arose from the visit that he made in 1897 to the country house at Villeneuve-sur Yonne which belonged to Misia and her husband, Thadée Natanson. Lautrec (and also Vuillard) chose to paint her in profile, playing the piano. It is a composition closely based on Manet's portrait of his wife playing the piano which Lautrec's friend Joyant owned, and which is now in the Musée d'Orsay.

Misia's piano playing was extremely proficient. As a child and adolescent, she received her musical education from the composer Fauré. However, the truth and legend about her abilities have tended to become confused. Renoir in particular seems to have enjoyed embroidering accounts of her eccentric talents. He told his son Jean Renoir that, in the palace that Misia had grown up in, she had the use of thirty pianos, with up to six in one room, and that she believed that because no two instruments were the same, a Bach fugue could not be played on a piano suitable for a Schubert melody. Renoir invented extra husbands for her in addition to the two that she had subsequent to Natanson, and also suggested that she had more or less single-handedly brought about Diaghilev's visit with Nijinsky and the Ballet Russes to Paris in 1911.

Lautrec's enchantment with Misia does not appear to have extended much beyond mild flirtation. She recounted in her memoirs that he loved to tickle her feet with his paintbrush when they sat in the garden and that this portrait shows her playing a work that he especially loved – Saint Saens's adaptation for piano of Beethoven's *Ruins of Athens*, which acted as an inspiration for Lautrec while he worked on the picture.

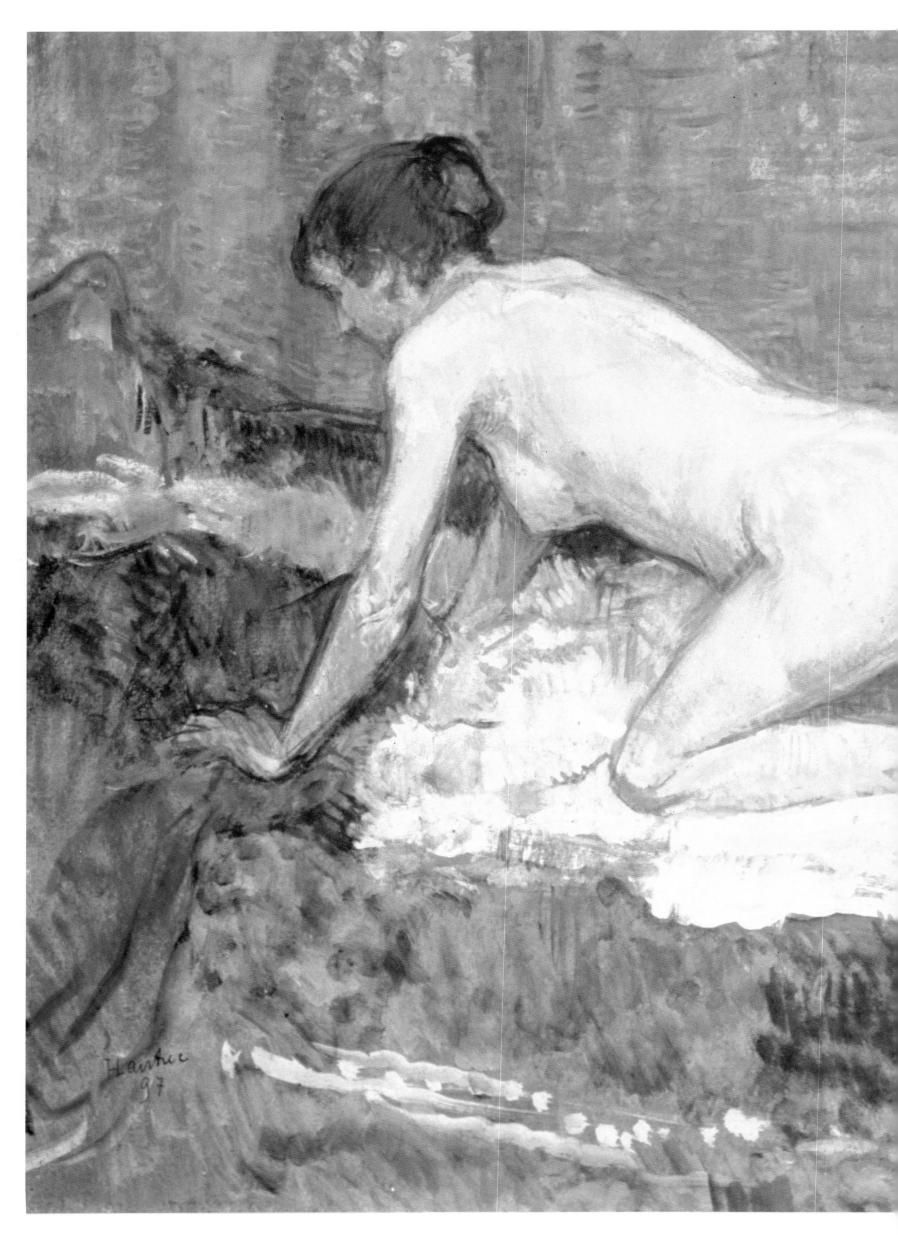

## Redheaded Nude Crouching 1897

Oil on board
18¼×23⅝ inches (46.3×60 cm)
San Diego Museum of Art, Gift of the
Baldwin M Baldwin Foundation

In depicting a female nude without stockings, boudoir props or other contextual bric-à-brac, Lautrec returned with this and a companion painting that is now in the Barnes Foundation to his most systematic exploration of the traditional, nude, studio-posed figure since 1886. Modeled with a slightly greater tonal range, these works have generally been viewed as part of Lautrec's retrenchment of form and his move toward rather more weighty subject matter. The adoption of the back view by the model recalls that used in *L'Abandon* (page 127) and her build and chignon suggest that she may be the same model. Recent commentaries upon this painting made when it was exhibited in 1979 and 1988, while describing the strong thrust of the model's buttocks, tended to de-emphasize any provocative sexuality inherent in this position by suggesting that Lautrec had softened his line and underplayed suggestiveness.

Lautrec used a related pose to this twelve years earlier in a drawing illustrating Emile Zola's novel *La Curée*, showing a naked woman embraced by an adulterous priest. Richard Thomson suggests that the pose also has affinities with a monotype by Degas, showing a kneeling woman playing with a dog on a bed. In seeking for a place for this image in the broader context of French art, it is the prominent rouged bottoms of Fragonard's bathers that are most clearly recalled.

The setting for the picture is Lautrec's new studio in the avenue Frochot, with its walls decorated with straw matting.

Madrid Pâques 1899
à Arsène Alexandre
"souvenir de ma captivité" Lautrec

## At the Circus, the Clown as Animal Trainer 1899

Colored chalks on paper
10⅜×17⅙ inches (25.9×43.3 cm)
Statens Museum for Kunst, Copenhagen

Following Lautrec's physical and mental collapse in late February 1899, he was compulsorily admitted, on the advice of his friend Dr Bourges, to a luxurious psychiatric clinic at Neuilly. Complete rest and enforced detoxification led to his being able, within three weeks, to work again and to show convincing signs of sanity. This is one of a series of 39 chalk, ink and colored crayon drawings that he made on the theme of the circus during his eleven-week enforced confinement. Lautrec's later comment to Joyant, 'I bought my freedom with my drawings,' indicates that the series as a whole was produced with the intention of convincing his family, friends and medical supervisors that he was fit to be allowed out. Although his friend Arsène Alexandre, to whom this work was inscribed 'A souvenir of my captivity', wrote an article in *Le Figaro* on March 30th, 1899, asserting that Lautrec was fit again, he had to wait six weeks to be released.

Working entirely from memory, the loss of which was supposed to be a characteristic of his illness, Lautrec conjured up familiar images of the circus. The stern-faced clown, whose whip commands an emaciated male poodle to sit up and beg, is Georges Footit. The baby elephant on a wooden tub is also possibly under Footit's authority. However, his lifted rear leg is suspiciously close to the position adopted by a urinating dog. Prior to his confinement, while suffering from *delirium tremens*, Lautrec had signed his usual monogram within the outline of an elephant on four lithographs and on a number of drawings. Later, when released, he described his family-appointed guardian as 'my elephant keeper'. The theme of animal obedience within the controled spectacle of the circus may have appealed to him as an apt metaphor for his own condition. While nobody watches from the tiered ranks of ringside benches, the elephant (as patient) gives perhaps an honest expression of his views on the surrounding strategies for his containment and control.

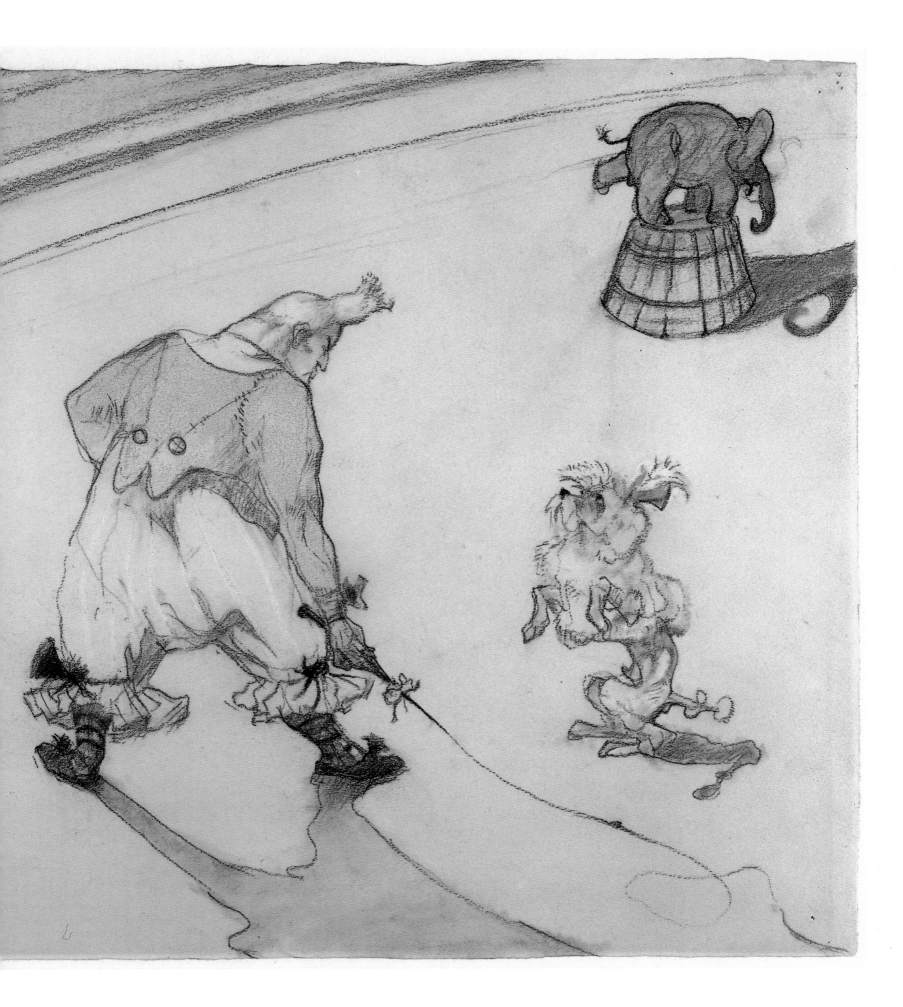

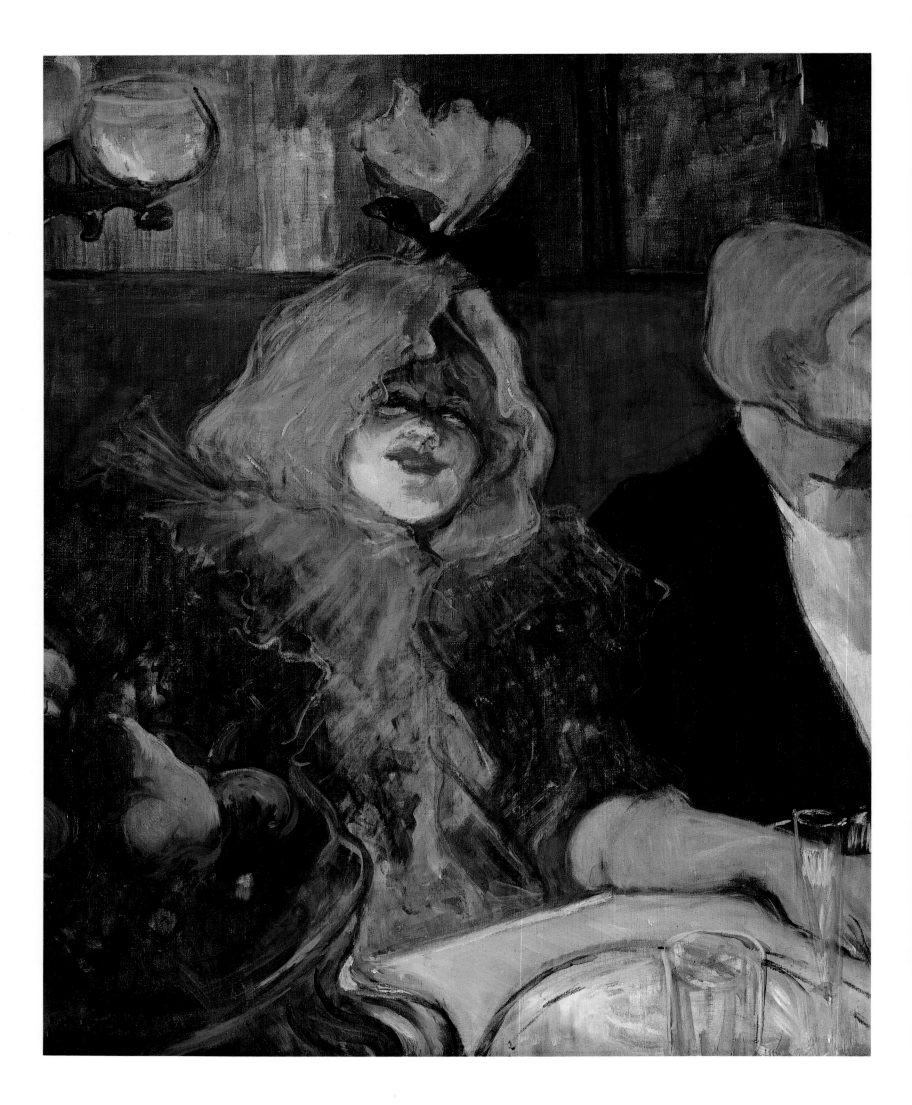

## Tête-à-Tête Supper 1899

Oil on board
21⅝×18⅛ inches (55×46 cm)
Courtauld Institute Galleries, London,
Courtauld Collection

Courtesans like Lucy Jordain, the woman depicted here, occupied the upper strata of the many-layered hierarchy of Parisian prostitutes. *Fille, lorette, cocotte, fille de plâtre, grosse dormeuse, grand horizontale, demi-mondaine*: whether euphemistically guarded or bluntly descriptive, the titles and nicknames gave the measure of the woman's social status, almost as complex a business in its graduated subtleties of price and availability as the rank order within French society as a whole.

The Rat Mort in the Place Pigalle was an expensive restaurant with private dining rooms, in one of which Lucy Jordain is being entertained by the young blond-haired man with whom she sits, or by a larger party of friends. Lautrec did not usually paint courtesans, confining himself for models to lowlier *filles* or the more specialized world of the brothel, and it is possible that this is a commissioned por-

trait by someone who was one of Lucy's *abonnés* – a mysterious 'Barone W' is one suggested traditional, but perhaps fanciful candidate.

Painting in the autumn of 1899 following his release from his detoxification cure at Neuilly, Lautrec used rich dilute glazes, with less attention given to circumscribing line and a greater concern with tone. The face of Lucy Jordain, puffy, pig-eyed, blowsy and tinged with green shadows, has a fleshy, putrescent fullness that links it with the large urn of ripe fruit in the bottom left corner. In this work, Lautrec strays beyond affectionate mockery or caricature into something rather malevolent, and it is difficult to unravel his attitude to the sitter. This is, after all, a portrait of a well-known woman and not simply some concocted visage or matter of fact glimpse of an event that Lautrec happened to see.

## Interval at a Masked Ball 1899

Oil and gouache on cardboard
22½×15½ inches (57.6×39.7 cm)
Denver Art Museum

Lautrec's cousin, Dr Gabriel Tapié de Céleyran, is the startled and ridiculous-looking man being unsubtly propositioned by the woman who is adjusting her mask. The occasion is a masked ball at the Paris Opéra. Each Saturday, from December until Shrove Tuesday, the orchestra pit and stalls of the Opéra were boarded over to create a dance floor. Tickets sold at 10 francs each (less for women) admitted anyone from midnight until 5.00 am, provided that they were costumed, masked, or wore formal dress. The high price kept out the lower classes but did not prevent, nor was intended to prevent, the busy commerce in prostitutes, dancers and actresses which was such an essential part of the pleasure. For society women, the masked balls offered an opportunity for illicit liaisons in public that were otherwise difficult to arrange. Edward King, describing a typical opera ball in 1868, wrote:

Do not flatter yourself it is a stately affair where grave masks dance genteelly with grotesque figures, it is a mad whirlpool, wherein all that is graceful is cast away and unlimited license of attitude takes possession of the field. It is a *salmagundi* of all ages, classes and conditions; an apotheosis of embracings, of whirlings, of jumpings.

Lautrec's gross female figure, in her diaphanous costume, makes clear her amorous intentions. She bears an uncannily close resemblance, with her red hair, enormous mouth and gauze headdress, to the portrait that Lautrec painted at about this time of the courtesan Lucy Jordain dining at the Rat Mort. There are also very strong compositional similarities in the use of red velvet seating, mirrors and the positioning of the male figure.

The ludicrous mask that Gabriel wears emphasizes rather than hides his already prominent owl-like gaze and huge red nose. With his center-parted hair plastered down with pomade, he is a caricature of his everyday self, incapable of disguise. This is one of a pair of pictures that Lautrec painted at about this time of his shy and long-suffering cousin. The other shows him, somewhat improbably, groping the buttocks of a half-clothed woman.

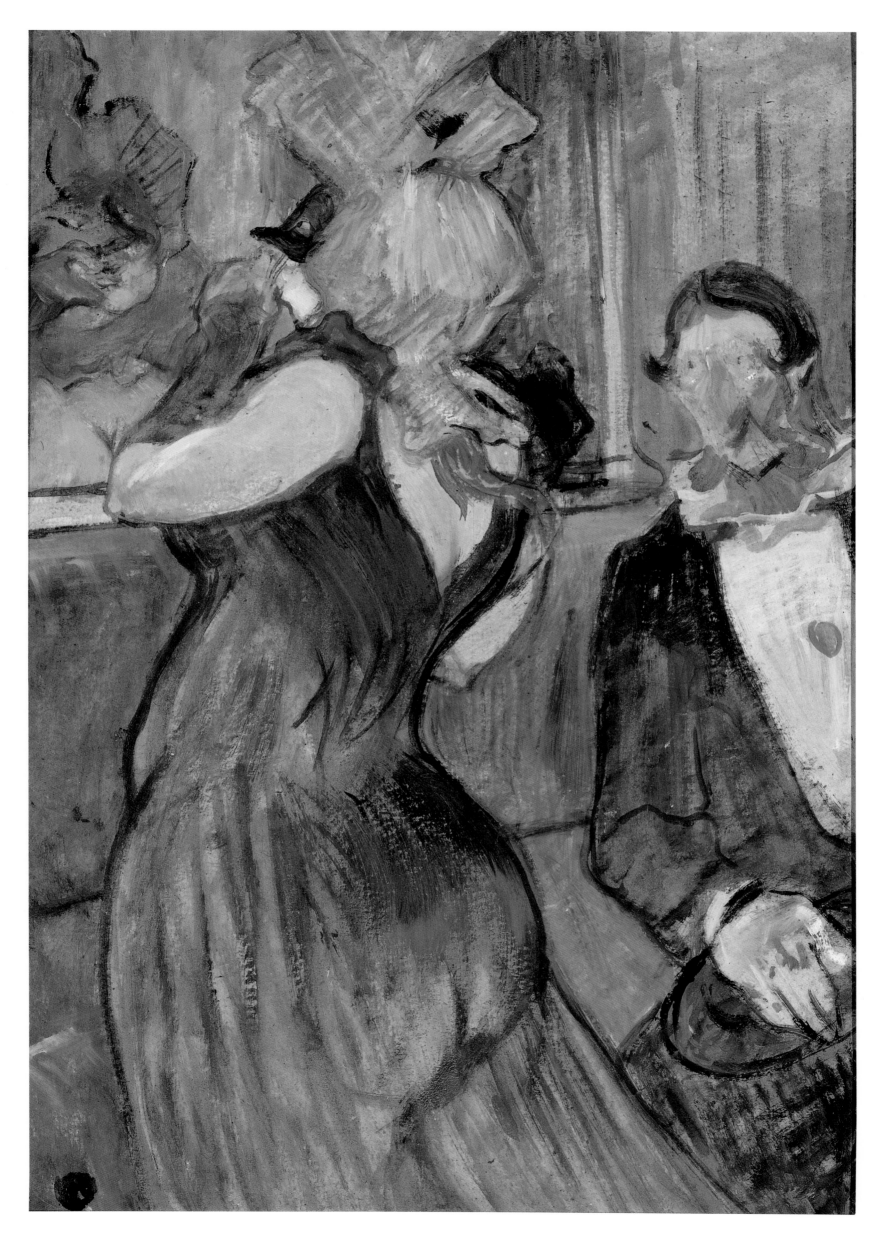

## The Jockey 1899

Crayon brush and spatter lithograph
20×14 inches (51.3×36 cm)
San Diego Museum of Art, Gift of the
Baldwin M Baldwin Foundation

Toward the end of 1898, Lautrec revived his interest in the horse racing subjects that had so filled his boyhood and adolescent paintings. In May 1899, during his detoxification cure at Neuilly, he was visited by his printer Stern and a publisher, Pierrefort, who wished him to produce a series of lithographs entitled *Les Courses*, with subjects covering the race and the milieu of the track. Although the project proved abortive and only four prints were made to either a finished or trial state, Lautrec maintained a sporadic interest in the theme almost until his death. This print is the finest that resulted.

Predictably Lautrec's inspiration for this image lay with Degas. However, rather than showing the moment just prior to or just after a race, when the horse is reined

in, it is the careering progress of the race itself that is here celebrated. As with his earlier works, Lautrec was attracted to the more energetic side of the hunt or race.

Lautrec's positioning of the horse's legs suggests that while he was aware of the high-speed photographs by Eadweard Muybridge and others, showing the true look of rapid movement in the horse, he still retained something of the time-honored 'rocking-horse' positioning that, despite inaccuracies, was both a more elegant and a more convincing mode of rendering the speed of a horse race.

Lautrec made almost 100 images of this print, with 12 on Japan paper. He also worked two images over in oil, and may have been considering an autonomous group of paintings based upon this theme.

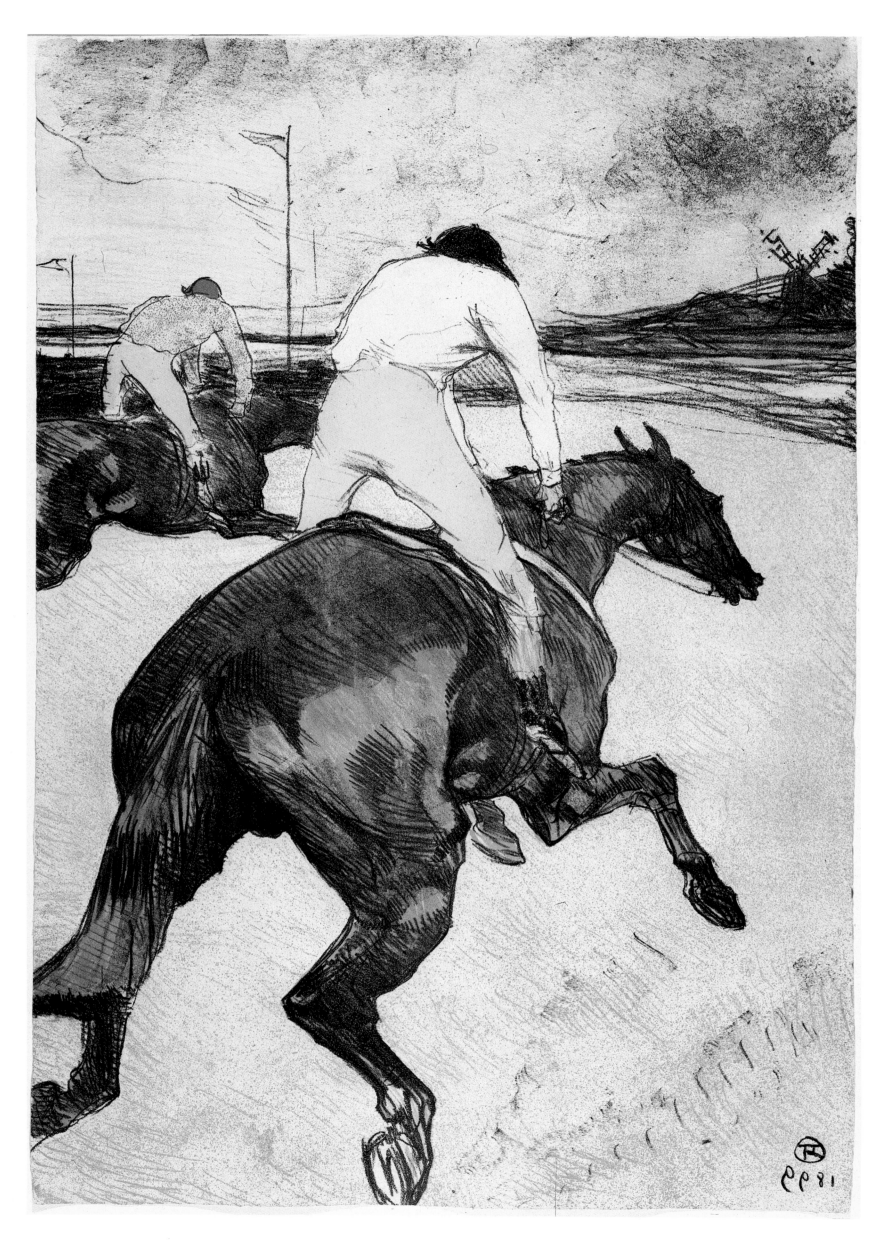

## Messalina 1900

Oil on canvas
18⅛×24⅛ inches (46 × 61 cm)
Musée d'Albi

This and the following picture are from a series of six *Messalina* subjects that Lautrec painted in Bordeaux in 1900. These are the only examples in his mature work of canvases which invite consideration as history paintings. Usually regarded as showing Lautrec's declining powers, they suggest that he may have been trying at this period to inject increased *gravitas* into his work. Both pictures were inspired by the 1900-1901 winter programme at the Grand Theater in Bordeaux, which included two classically-based productions, Offenbach's *La Belle Hélène*, derived from the story of Helen of Troy, and Isadore de Lara's operetta *Messalina*. Although Lautrec drew figure studies from both performances, he was more attracted by the altogether darker and more degenerate story of Messalina, the nymphomaniac wife of the Emperor Claudius.

De Lara's libretto was based upon a story by Théophile Gautier, which in turn drew upon contemporary Roman accounts by Tacitus, Seutonius and particularly Juvenal. To help him construct his pictures, which he clearly did not intend to be simply derived from the Bordeaux production, Lautrec wrote to his friend Joyant in Paris. He needed photographs and programs from previous metropolitan performances, along with de Lara's libretto. Given Lautrec's own classical education until the age of 16, he may also have been familiar with the famous passage in Juvenal's Sixth Satire, describing Messalina's proclivities:

Messalina, preferring a brothel couch to her palace bed, sneaked out while her husband snored. Wearing a cloak and hood, disguised with an ash-blonde wig, she went alone or with a single servant. She sped to her brothel cell – the one with the door marked 'wolf woman'. After exposing her gilded nipples and that belly that had brought forth a prince, she sold herself all night long to anyone, until, exhausted, unsatisfied and dirty with lamp oil, she crawled back home.

In a second version of this painting, taking a viewpoint from the wings towards the enthroned Messalina, Lautrec distributes the figures like a flat frieze across the picture surface. The image shown here, which includes only Messalina and her attendants behind the throne, is a tauter resolution of the subject, with the artist using a vertical format and a close-up view.

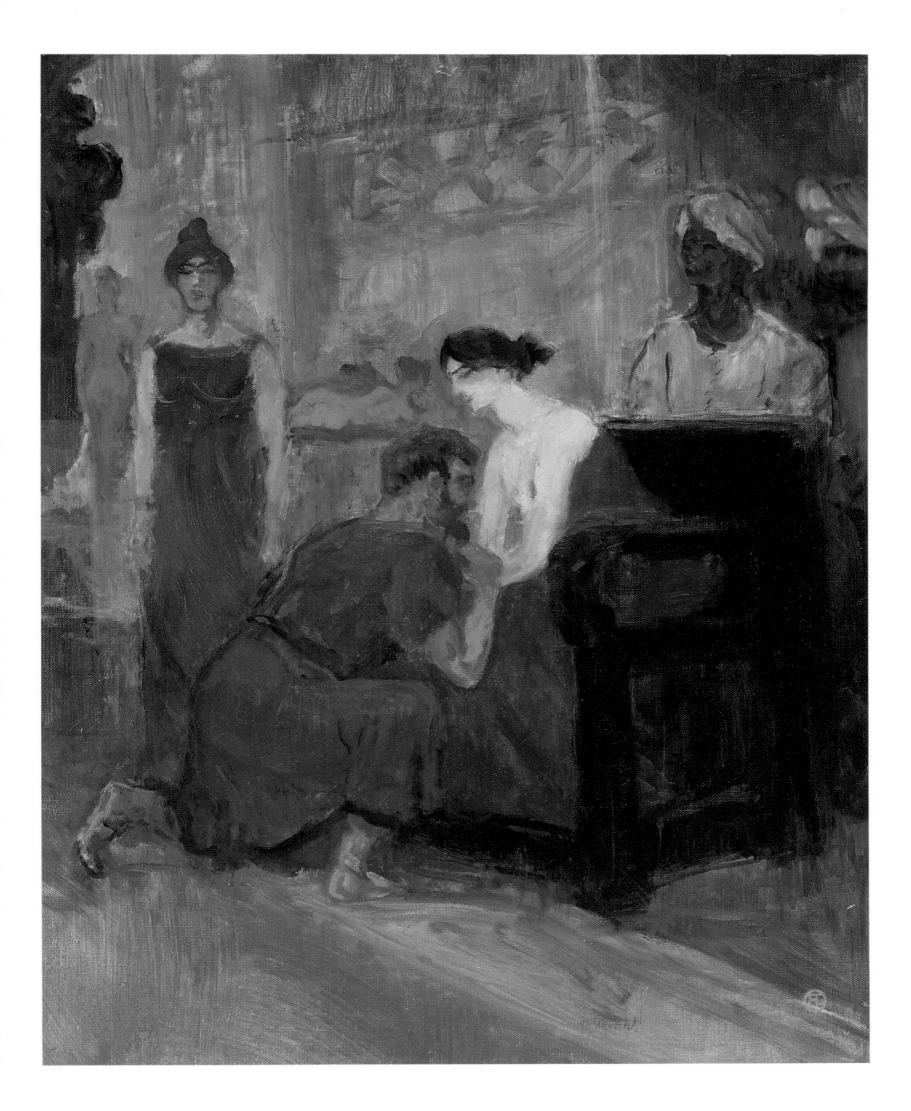

## The Opera Messalina at Bordeaux 1900

Oil on canvas
39×28½ inches (100×73 cm)
Los Angeles County Museum of Art,
Mr and Mrs George Gard De Sylva
Collection

Messalina, strikingly dressed in red symbolizing both her unbridled passion and the bloody violence of her eventual death, stiffly descends a staircase lined with her attendants. On the staircase balustrade is placed, in half shadow, a wolf statue. Seen from behind, with its rear legs apart, this strongly evokes the famous ancient bronze statue of the Capitoline Wolf, revered as one of the most important images of Roman probity. Here, parodied with its tail raised and haunches proffered for sexual congress, it visually puns Messalina's brothel nickname of 'wolf woman'. It is unlikely that such a lewd prop was part of the Bordeaux set, and it almost certainly represents Lautrec's own symbolic extension of the story's essential theme.

From the bright, well-lit staircase, Messalina moves toward a foreground filled with a huge soldier whose heavy hand grasps his red-tipped sword handle. He and his helmeted companion are strongly outlined in black. The exaggerated contrasts of stage light and shadow, particularly in their faces, contribute to their menace. As members of Claudius's Praetorian Guard, they will share Messalina's sexual favors and eventually be ordered to kill her by Narcissus, secretary to the Emperor. The discovery that Messalina had overreached herself in pursuit of power by contracting a form of bigamous marriage with the consul designate, Gaius Silvius, made her a threat to Claudius's life.

It is not particularly surprising that Lautrec was attracted by the sexual piquancy of the Messalina story. However, given that he was at the time near death as a result of alcoholism, as well as riddled with syphilis, to have chosen to produce a series of grandiloquent canvases describing a woman who had perished through hedonistic excess suggests something akin to remorse – or perhaps there were hidden depths to Lautrec's notorious black humor and capacity for self-mockery.

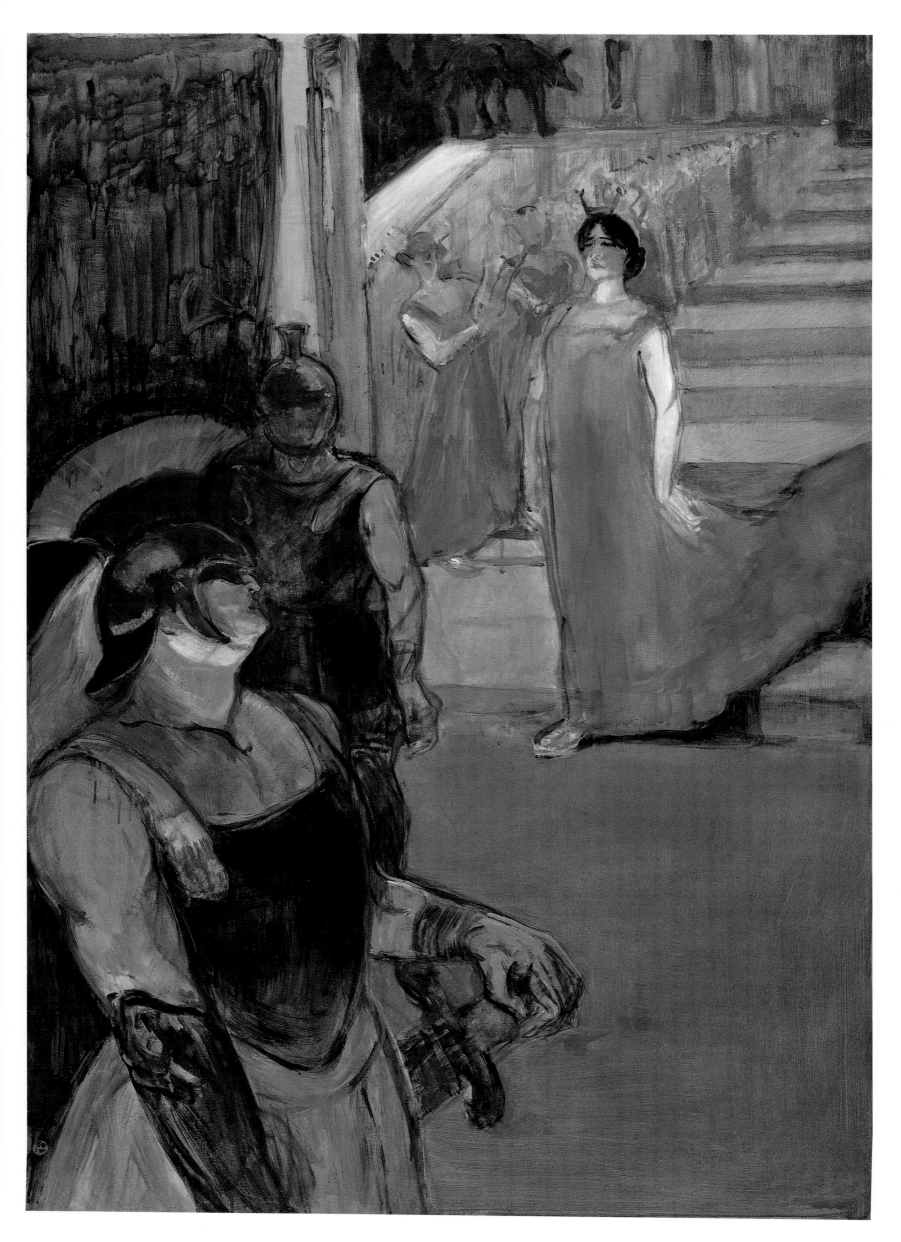

## The Milliner 1900

Oil on panel
24×19½ inches (61×49.3 cm)
Musée d'Albi

Among the wittiest and most cheerful of all Degas's pictures are the early 1880s group of his friend Mary Cassatt shopping at various milliners. In these, Degas painted hats looking like giant, beribboned, multi-colored cabbages; quite unlike the depressing selection shown in this picture. Despite Lautrec's oft-voiced admiration for Degas, he did not in this instance set out to emulate his work. The inspiration for this solitary millinery painting in Lautrec's oeuvre came from his friends, who suggested that, given his interest in female costume and dressing-up, he might find a milliner's shop a worthy subject. They also wanted to keep him away from bars and alcohol.

Lautrec's model, according to Joyant, was his friend Mademoiselle Margouin, although Dortu and Huisman argue that she was Louise Blouet. With her large mound of red hair, she conforms to Lautrec's preferred type of female beauty.

Her pale blouse and face are lit by a warm beam of sunlight, shining through the shop window into the almost subaquatic green-tinged gloom of the interior. The hats which surround her and upon which she is working are without exception covered with black feathers. Aside from being fashionable formal daywear at this time, they were also *de rigueur* for funerals. To depict youthful female beauty surrounded by objects that connote death, was a common branch of seventeenth-century Dutch *vanitas* pictures, and it is not inconceivable that this work, painted shortly after Lautrec obtained release from his enforced detoxification 'cure', was intended to be considered in such a light. A contrary view is that of Anne Roquebert, who has argued that the unusually meditative stance of the modiste viewing her products renders this 'the opposite of the *vanitas* in ancient art.'

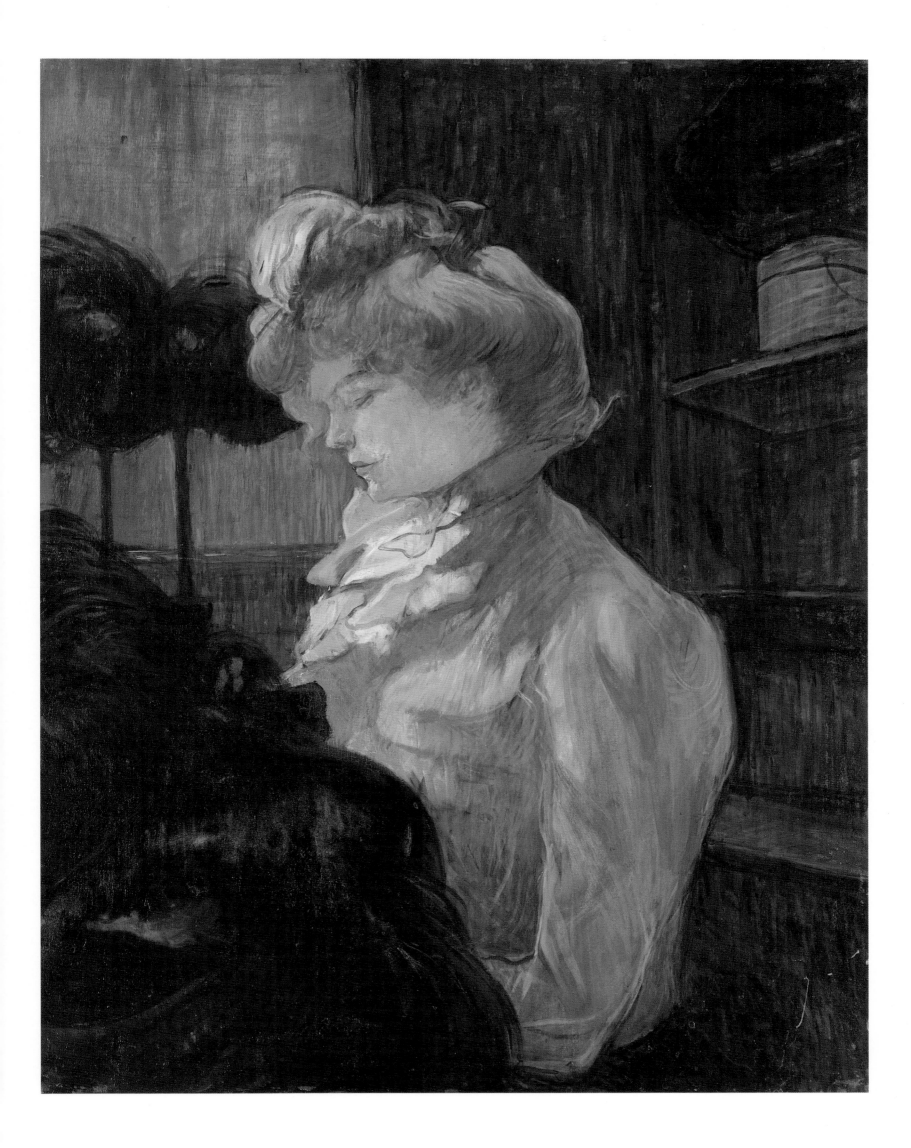

## An Examination at the Faculty of Medicine, Paris 1901

Oil on canvas
25⅝×31⅞ inches (65×81 cm)
Musée d'Albi

Tapié de Céleyran, having been merci-
lessly lampooned in earlier paintings by his
cousin Lautrec, at last achieves some dig-
nity in this work painted to celebrate his
oral examination for his Doctorate in
Medicine at the University of Paris. This
was among Lautrec's last paintings, made a
few weeks before his death, and executed
in Paris. De Céleyran, pink-faced and with
his huge hands clenched, faces his
examiners, the red-robed Professor Robert
Wurtz and Professor Fournier, across the
table.

Technically Lautrec adopts the same
complex fluid overlapping brushmarks,
and a similar lack of emphasis upon
graphic line, which he employed on the
1900 *Messalina* series and, as with the *Mes-
salina* pictures, there is an unusual gravity
in this picture's conception. Götz Adriani
has suggested a similarity with certain of
Daumier's images of criminals before
judges. An even more elevated pedigree for
this image may, however, lie in certain of
Rembrandt's top-lit groups of figures
seated around tables, in particular, his
*Christ at the Supper of Emmaeus*, now in the
Louvre. Lautrec here adopts a rather staid
format, possibly at the wish of Professor
Wurtz, the picture's original owner, whose
son later gave it to the museum at Albi.

172

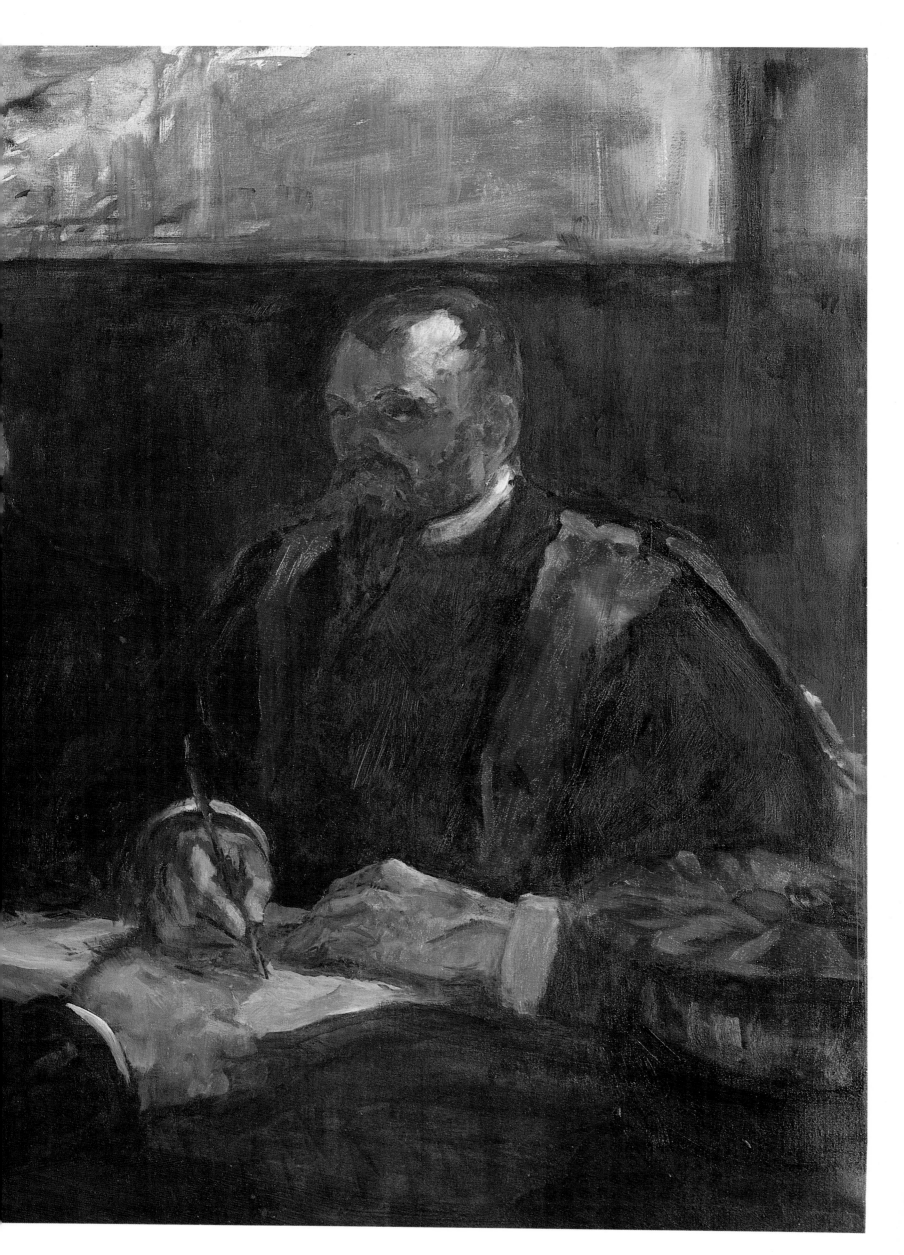

# Index

# *Bibliography*

Adriani, Götz, *Toulouse-Lautrec*, London, 1987

Adriani, Götz, *Toulouse-Lautrec: The Complete Graphic Work*, Royal Academy London, 1988

Arnold, Mathias, *Henri de Toulouse-Lautrec*, Cologne, 1987

Bouvet, Jean *Toulouse-Lautrec*, London, 1964

Caproni & Sugano, *L'opera completa di Toulouse Lautrec*, Milan, 1977

Castleman, Riva & Wittrock, Wolfgang, *Henri de Toulouse-Lautrec: Images of the 1890s*, Museum of Modern Art, New York, 1985

Desloge, Nova; Frey, Julia & Cate, Phillip Dennis, *Toulouse-Lautrec*, San Diego Museum of Art, 1988

Denvir, Bernard, *Toulouse-Lautrec*, London, 1991

Dortu, MG, *Toulouse-Lautrec et son oeuvre*, 6 volumes (catalogue raisonné of paintings, watercolors & drawings), New York, 1971

Hughes, Robert, *Nothing if not critical*, London, 1990

Huisman, Philippe & Dortu, MG, *Lautrec by Lautrec*, London, 1973

Lucie-Smith, Edward, *Toulouse-Lautrec*, Oxford, 1977

Milner, Frank, *Degas*, London, 1990

Purrochet, Henri, *Toulouse-Lautrec*, London, 1960

Rewald, John, *Post-Impressionism from Van Gogh to Gauguin*, New York, 1956

Sala, GA, *Paris, Herself Again*, London, 1889

Sanger, WM, *History of Prostitution*, Oxford, 1913

Schimmel, Herbert & Murray, Gale B, *The Letters of Henri de Toulouse-Lautrec*, Oxford, 1991

Stuckey, Charles & Maurer, Naomi, *Toulouse-Lautrec*, Art Institute, Chicago 1979

Symons, Arthur, *From Toulouse-Lautrec to Rodin*, London, 1929

Thomson, Richard, *Toulouse-Lautrec*, London, 1977

Thomson, Richard, et al, *Toulouse-Lautrec*, South Bank Centre, London, 1991

# Acknowledgments

The author would like to thank Professor Götz Adriani, Rosemarie Weber and Kate Garmeson (Sotheby's, London) for their help in obtaining transparencies; Lynda Rea for her assistance in preparing the manuscript; Martin Bristow, who designed this book; Pat Coward, who indexed it; and Jessica Orebi Gann, the editor. We would also like to thank the following agencies, institutions and individuals for supplying illustrative material:

The Art Institute of Chicago: pages 54/55 (the Joseph Winterbotham collection, 1925.523), 62/63 (Lewis Larned Coburn Memorial Collection, 1938.458), 92/93 (Helen Birch Bartlett Memorial Collection, 1928.610)

Baltimore Museum of Art: page 8 (bequest of Wilmer Hoffmann)

Bettmann Archive: pages 6 (both), 13 (top)

Bibliothèque Nationale, Paris: pages 7 (bottom), 15 (both), 16 (top), 17 (all three), 19, 21 (both), 82

British Museum, London: page 134

Brooklyn Museum, New York: pages 77, 112

Carnegie Museum of Art: page 77 (acquired through the generosity of the Sarah Mellon Scaife family, 66.5)

Cleveland Museum of Art, Ohio: page 104 (Hinman B Hurlbut Collection, 394.25)

Courtauld Institute Galleries, London (Courtauld Collection): page 160

Denver Art Museum: page 163

ET Archive: page 11 (top)

Forbes Magazine Collection, New York: page 32

Foundation E G Bührle, Switzerland: page 129

Harvard University Art Museums: pages 56/57 (bequest of the collection of Maurice Werthern, class of 1966)

Kunstmuseum, Berne: pages 154/55

Los Angeles County Museum of Art: page 169

Metropolitan Museum of Art: pages 87 (bequest of Miss Adelaide Milton de Groot (1876-1967), 1967, 67.187.108), 128 (Rogers Fund, 1951, 51.33.2)

Courtesy of Frank Milner: pages 7 (top left), 13 (bottom), 14

Musée d'Albi: pages 10 (top), 11 (bottom), 12, 16 (bottom), 23 (top), 25, 28, 30, 33, 34, 61, 67, 69, 114, 116, 120, 121, 122/23, 126, 150, 153, 167, 171, 172/73

Musée des Augustins, Toulouse: pages 52, 146

Musée des Beaux-Arts, Lyon: page 22

Musée d'Orsay/photo courtesy of Réunion des musées nationaux: pages 9, 10 (bottom), 58/59, 70, 75, 83, 98/99, 136/137, 144, 152

Museo Cornere Quaderia Venezia: page 18

Museum Boymans-van Beuningen, Rotterdam: page 7 (top right)

Museum of Fine Arts, Boston: pages 80/81

Museum of Fine Arts, Budapest: pages 118/119

Museum of Modern Art, New York: pages 53 (the William S Paley Collection), 89 (gift of Mrs David M Levy)

National Film Archive, London: page 23 (bottom)

Nationalgalerie, Prague: page 95

National Gallery of Art, Washington: pages 51 (collection of Mr and Mrs Paul Mellon), 97 (Chester Dale Collection), 125 (Chester Dale Collection), 133/34 (gift, partial and promised, of Betsey Cushing Whitney in Honor of John Hay Whitney)

Ny Carlsberg Glyptotek, Copenhagen: page 107

Oskar Reinhart Collection, Winterthur: page 142

Philadelphia Museum of Art: pages 65/65 (the Henry P McIlhenny Collection), 78 (the John D McIlhenny Fund)

Phototèque des musées de la ville de Paris, © Spadem: pages 20, 26/27

Private collections: pages 38, 44, 45, 73, 127, 139, 141

San Diego Museum of Art, California: pages 101, 103, 109, 111, 113, 138, 145, 148, 149, 156, 164 (all gifts of the Baldwin M Baldwin Foundation), 135 (gift of Mrs Robert Smart)

Staatliche Kunstsammlungen, Dresden: pages 130/31

Statens Museum for Kunst, Copenhagen: page 158/159

Tate Gallery, London: page 40

Thielska Galleriet, Stockholm: pages 42/43

Toledo Museum of Art: page 91

Vincent van Gogh Foundation/Vincent van Gogh Museum, Amsterdam: pages 46, 48

Von der Heydt Museum, Wuppertal: page 36

Wadsworth Atheneum, Hartford: page 84 (bequest of George A Gay)